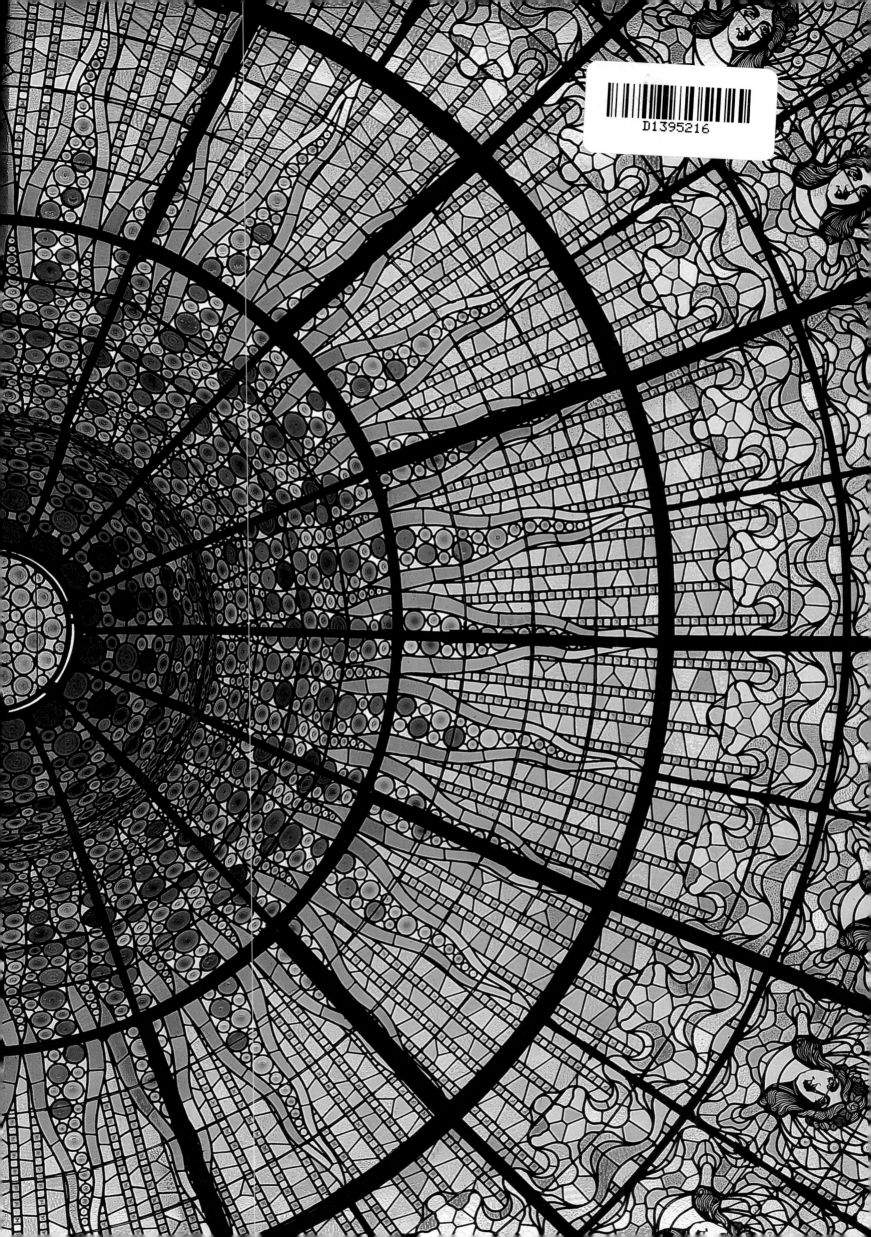

ART NOUVEAU
IN
CATALONIA

This book was printed on 100% chlorine-free bleached paper in accordance with the TCF standard.

EVERGREEN is an imprint of Benedikt Taschen Verlag GmbH

© for this edition: 1997 Benedikt Taschen Verlag GmbH
Hohenzollernring 53, D–50672 Köln
© 1991 ATELIER D´ÉDITION «LE SEPTIÈME FOU», Geneva
Illustrations, layout and conception: Michel Saudan and Sylvia Saudan-Skira, Geneva
Text: François Loyer
Translation: Alayne Pullen in association with First Edition Translations Ltd., Cambridge, UK
Cover: Mark Thomson, London

Printed in Germany
ISBN 3-8228-8255-0
GB

ART NOUVEAU
IN
CATALONIA

FRANÇOIS LOYER

EVERGREEN

CONTENTS

Lluís Domènech i Montaner
Cover design
Fortuny, 1882
Josep Yxart

PRELUDE

At the end of the nineteenth century Barcelona was not only the largest
city in Spain, it was also the most dynamic – a proud rival to Madrid
and the vital centre of a country that depended on the sea. Barcelona was
the Catalan equivalent of both Manchester and Liverpool, with indus-
tries ranging from the weaving of Egyptian cotton to metal processing,
its blast furnaces making it the industrial capital of Spain. It was also
one of the principal cargo ports of the Mediterranean, a "Gateway to the
Orient" that outshone Marseilles, Genoa or Naples. From the time of
the Universal Exhibition, held in Barcelona in 1888, to General Primo de
Rivera's military uprising (which, in 1923, marked the end of provincial
autonomy) the city's rapid growth kept pace with the increasing size of
its population: 350,000 in 1878, 509,000 in 1897 and 587,000 in 1910.
In one generation the city had almost doubled in size and the optimistic
plans for the demolition of the city walls and expansion into the new
quarter known as the *Eixample* (the increase), which the engineer
Ildefons Cerdà had begun in 1854, proved to be justified.[1]

 This urban explosion was accompanied by an intellectual and cul-
tural awakening called the *Renaixença* movement (named after the cele-
brated avant-garde journal founded in 1881) which in itself symbolized
the extraordinary blossoming of literature and the arts that took place at
the turn of the century. It was comparable in many ways to the Belgian
Art Nouveau movement with its Brussels-based journal, *L'Art Moderne*,
and the group of artists known as "Les Vingt". Barcelona was a pivotal
city exposed to many different influences and cultures. It was perhaps
the most French of Spanish cities but, because of its trade with Egypt,
which had been under British rule since 1882, it was also that most open
to reverberations of Anglo-Saxon culture. It was also affected by the
Arab culture of the East, with which it had strong connections as, for
many years, Spain had held territory in North Africa. In addition, until
the loss of Spain's American colonies in 1898, it maintained firm links
with the New World. Out of this multicultural environment Barcelona
developed a strong and original personality of its own.

 The economic revolution brought by industrialization during the
middle of the century saw the meteoric rise of élite groups. The art
schools, which at first had been mere annexes of the Academia de San
Fernando in Madrid, now demanded and secured autonomy for
themselves. From these schools a great many artists emerged, among
them some of the most famous of the modern era, including such lumi-
naries as Pablo Picasso and Salvador Dalí, who were to have such an
impact on the twentieth century. But it was the architect Gaudí, no less
significant a figure than his fellow-artists, who decisively signalled the
birth of modern architecture and, perhaps to excess, became, its symbol.

A cultural comparison of Paris and Barcelona is not easy. From David to Renoir, Paris had been the art capital of the world, whereas Barcelona was a relative newcomer whose artistic movements were very much the result of external influences. When Santiago Rusiñol and Ramon Casas returned from Paris their obvious admiration for Gustave Caillebotte and Edgar Degas made them appear only secondary figures in the avant-garde; it would be equally unfair to compare Théo van Rijsselberghe with Georges Seurat, on whose work Van Rijsselberghe so heavily depended. The same is not as true, however, of Isidre Nonell (whose contemplative nature at times reveals that interiority more usually associated with the painting of Balthus) or of such remarkable sculptors as Eusebi Arnau and Josep Llimona. Indeed, the question of influence ceases to apply as one reaches the new generation of artists, that of Picasso and Gargallo, who declared their break with the Impressionist tradition in favour of a social message expressed through art, whose hidden violence and taste for caricature reflected the political tension of their time.

The transition from easel painting to architecture and town planning unleashed a remarkable cultural revolution in Catalonia from the middle of the nineteenth century onwards. Among this outstanding generation were the founders of Catalan "modernism" – a variation of the "constructive rationalism" of the French – which was to produce its own, very particular form of Art Nouveau, though the two schools were often (and not without reason) confused under the same title. These pioneers were Elies Rogent (who established the School of Architecture), Joan Torras (the engineer), Josep Fontserè and Joan Martorell. All embraced the French diocesan school's concern with the plastic aspect of construction that was to give the Catalan movement its originality, drawing inspiration from the nineteenth century's twin focus on ornament and structure. Following close behind came their pupils, Josep Vilaseca and Lluís Domènech, soon to be overtaken by Antoni Gaudí and the young and brilliant Josep Puig, whose intuitive nature reflected the decorative style of the end of the century before moving on to new developments such as *noucentisme* in the first decade of the twentieth century.

This array of talent, the rivalry between artists working at a particularly lively time and the variety of their aesthetic approaches (reflecting widely different political and ideological convictions) made the Art Nouveau period in Barcelona a highly stimulating one. The Els Quatre Gats café became a literary meeting place, where, under the aegis of the celebrated Pere Romeu and with the active collaboration of the period's most distinguished writers and musicians – Raimon Casellas, Eugeni d'Ors, Isaac Albéniz, Matthieu Crickboom, Pau Casals and Enric Granados – the movement took shape. In the case of both musicians and painters, the nature of their work made it possible for them to achieve international fame; however, it should not be forgotten that the architectural and urban surroundings in which they met today constitute one of the greatest collections of modern art in Spain.[2] Nor should one forget that Antoni Gaudí, inspired though he was, was not the only creative figure involved; neither was it simply a matter of the stimulating rivalry that existed between Gaudí and Lluís Domènech or Josep Puig. Work in

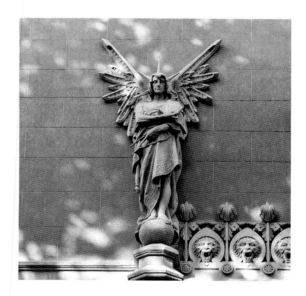

Josep Domenèch i Estapà
Royal Academy of Science and Art
Barcelona, 1883
Detail of the façade on La Rambla
Sculpture by Manuel Fuxà

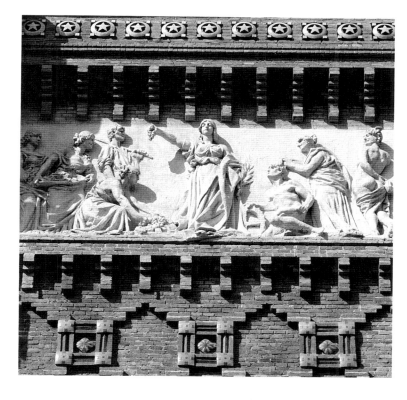

RIGHT:
Josep Vilaseca i Casanovas
Triumphal Arch at the Universal Exhibition
Barcelona, 1888
Entablature frieze sculptures by Josep
Llimona, Josep Reynès, Torquat Tasso and
Antoni Vilanova

BELOW:
Lluís Domènech i Montaner
Palau Montaner
Barcelona, 1889–1893
Panels on the upper level
Décor by Alexandre de Riquer

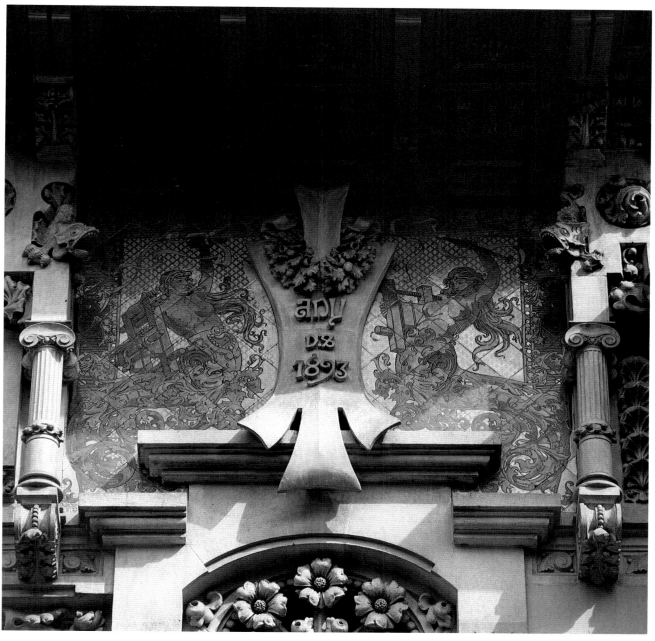

LEFT AND BELOW:
Arnau Calvet i Peyronill
Hidroèlectrica de Catalunya
Barcelona, 1905
Façade on the Carrer dels Arcs

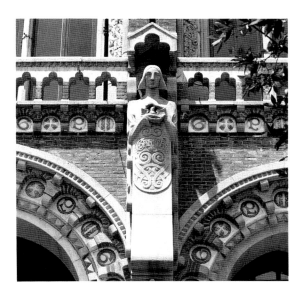

Lluís Domènech i Montaner
Santa Creu i Sant Pau Hospital
Barcelona, 1902–1911 (first phase)
Administration building, 1903–1909
Arcade pillar, angel by Pau Gargallo

this field was as abundant and diverse as the temperaments of the artists responsible. Indeed, Barcelona, alongside Vienna and Brussels, was one of the Art Nouveau capitals of Europe.

Yet Barcelona was different from Vienna. As Joan Lluís Marfany correctly states, "In short, Freudian psychoanalysis, Austro-Marxism, the cynicism of Schnitzler and the eroticism of Klimt were not only absent but totally unthinkable in turn-of-the-century Barcelona".[3] And to this perceptive comment one might add that the disenchanted, harrowing, almost metaphysical dandyism of Robert Musil could have had little in common with the positive spirit of an industrial city in full expansion. A further, cultural difference of the exponents of Art Nouveau in Catalonia was their desire to impose an ideology, an attitude that was far from negative. It was not until the black days of the anarchist bombings and the Semana Trágica of 1909 that such a mood emerged, an expression of profound disarray heralding the major divisions that would lead to the Spanish Civil War.

The *noucentisme* movement fully revealed the profound optimism of Catalan culture. The "Mediterranean" aesthetic ideal, championed by the critic Eugeni d'Ors[4] and the sculptor Aristide Maillol, sought permanent values in art and culture that went beyond the capriciousness of fashion and taste reflected in Art Nouveau. The nihilism for which the avant-garde was often criticized by politicians was therefore quite alien to the Catalan movement.

The belated conversion of Josep Puig to the ideology of modern classicism, whose abstract nature made it timeless (and his application of it through a highly "beaux-arts" oriented urban art permeated with a neo-Haussmannian aesthetic) is generally seen as a betrayal of the ideals of Art Nouveau, of which he had been one of the most outstanding exponents. His change of direction does, however, confirm the attachment of Catalan architecture to rationality and its exemplary nature, in the face of any aesthetics-led or critical trend. It was a matter of usefulness and of the fundamental significance of architecture as a collective act. Gaudí was making a similar statement when he shut himself away on the Sagrada Família site to spend his later years conducting the mystic dialogue between his architecture and the Christian faith. Each, in his own way, looked to the new art and architecture to provide those certainties the period so badly needed, to reflect those values threatened or challenged and to establish these as true in the face of all others. Rather than a formal art movement, Art Nouveau – and particularly the Catalan version – was a meeting place where ideals came face to face before fate transformed this confrontation into conflict. More than a century later we are now better able to understand the disputes at issue but can also perceive a complementarity, which, from behind the barrier between their forms of expression, reveals a common quest for the absolute. The task that the modern world has given its artists is a demanding one. Not only must they provide a reflection of their own time but they must also be missionaries for the future. Catalan art, more than any other, has adhered firmly to this task and the history of Art Nouveau bears witness to this fact. We must, therefore, look beyond the formal divisions of style and seek out the legacy of the movement in all its contradictions.

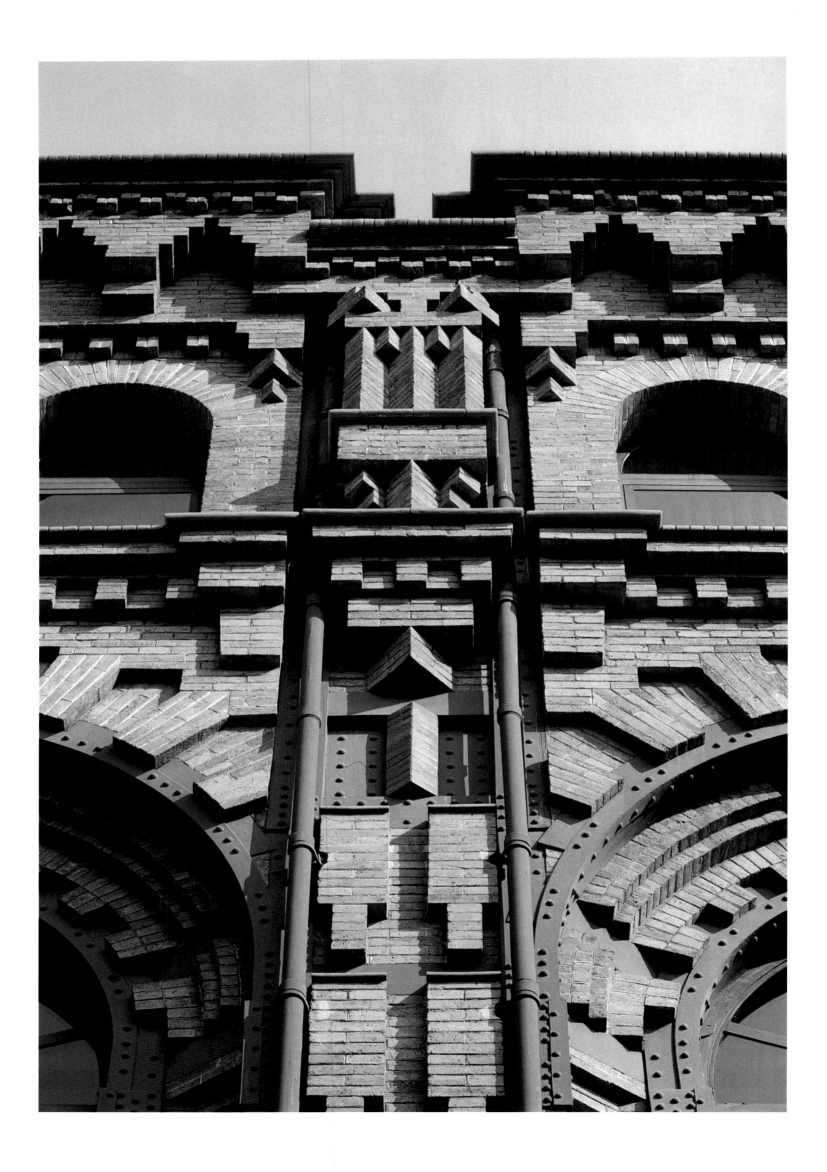

I

ART AND INDUSTRY

From the second half of the nineteenth century, building technology, which had hardly changed since the end of the Middle Ages, underwent an extremely rapid transformation in all the major countries of Europe. The appearance of new, modern materials encouraged this within a context of continuous technical and formal innovation. However, this innovation concerned the production of the materials themselves more than their application, which remained for the most part strongly traditional. It is indeed a paradox of the period that technological progress was combined with an increasing refinement in craftsmanship: the rationalization of the building site went hand in hand with the development of the skills of those working there. It was a golden age in the history of construction, as a renaissance in both art and craft skills coincided with the creation of a whole series of new products – glass, iron and clay – spectacularly increasing the range of materials available on the market.

Architects of the period happily exploited these twin opportunities, combining them to even greater advantage. Art Nouveau architecture was, above all, founded on materials, dedicated to their artistic celebration and to highlighting the opportunities they offered. The academic tradition, with its abstract perfection, had only concerned itself with materials in order to conceal their appearance and accentuate form and line. This was superseded by an imaginative and wide-ranging approach to the selection of materials – chosen for their specific tactile qualities – and an even more sophisticated choice of methods used in their application. Delight in materials replaced pleasure in design; the mark left by the tool erased the illusory artist's impression.

The study of materials therefore became of great importance. The creation of new products provided intellectual stimulation for more than half a century. Just as in London, with the opening of the museums in South Kensington, relations between art and industry now took centre stage. Barcelona hosted a series of exhibitions: the 1851 exhibition was devoted to construction; the 1860 exhibition led to the setting up of an "Art and Industry Circle", which was the springboard for the long-term collaboration between artists and manufacturers. The idea which was also to inspire the *Werkbund* had clearly travelled a long way. But, above all, it was Salvador Sanpere i Miguel's European journey that set things in motion. In 1870 the Barcelona authorities sent him to France, England and Germany to find out about the relations between art and industry in those countries. His resulting proposals led, in 1880, to the organization of a major exhibition of the decorative arts and their application to industry, and to the publication of his work entitled *Aplicació de l'Art a l'Industria ...* (1881). The Barcelona Universal Exhibition of 1888 provided an opportunity to bring together, in the famous Café-

restaurant built by Lluís Domènech i Montaner, the most notable examples of collaboration between art and industry. With the creation in 1894 of the Barcelona Centre for Decorative Arts (and the publication of its journal, *El Arte Decorativo*), the industrial arts achieved full recognition as the century came to a close.[1]

It is, however, important to qualify this approach as there is a great difference between the passion for the decorative arts demonstrated during the final years of the nineteenth century and the interest shown by the previous generation in relations between art and industry. The distinction arising during this period within the industrial arts between *sumptuary* and *applied* arts provides a guide. While furniture, objects, fabric and wallpaper come within the decorative arts proper, there is a whole range of products and activities that are directly connected to construction and decoration and it is these that are the true "applied" arts. There was to be a spectacular development in this field during the third quarter of the century that completely transformed the architectural expression of buildings whatever their style of reference. Thus the celebration of the materials themselves became the guiding light of the new architecture.

For the third generation of the nineteenth century – the generation of the 1870s – the plastic values of the wall took on paramount importance, marking a decisive turning point in the history of European culture. A change in building methods, however radical, would, in fact, have been of only minor importance had it not been given more far-reaching significance by the spirit of the age. This change expressed the fascination felt for the haunting reality of the world of the object and its laws, made all the more difficult to accept as it was no longer justified by the existence of God. The extraordinary arbitrariness of the real was disconcerting because, with every step, it revealed a wealth of invention, as if the entire world were merely a playful act devoid of all meaning. That science was staggered by the proliferation in nature was connected to art's evolution in the direction of total formalism.

The only bastion against this temptation was the positivism of the scientific outlook, which re-established true values: the spirit of enterprise and the perpetual inventiveness of the human intellect. The recourse to industrially produced materials can also be viewed in another way. In the struggle to rule over nature man demonstrates the mind's capacity to transform the real, to change inert object into living structure, turning man into a demiurge. The pride in industry so typical of the nineteenth century was rooted in this concept which was so much more positive than the contemporaneous notion of the meaninglessness of the world.

But the scientific spirit had another resource available. It could apply to construction the abstract planning methods that were common in industry. Construction began to turn into art – and architecture into the expression of this art. Constructive rationalism (of which more later) provided a reassuring response to the aesthetic obsession with pure form and re-established the link between form and meaning. By giving clear visual expression to the intellectual computation of architectural forces, the affirmation of the rules of construction introduced a new order, whose Cartesian logic reorganized the world. Whereas the rhetoric of

Gaieta Buïgas i Monravà
Monument to Christopher Columbus
Barcelona, 1881–1888
Skeleton built by the Joan Torras i Guardiola workshop
Base of column

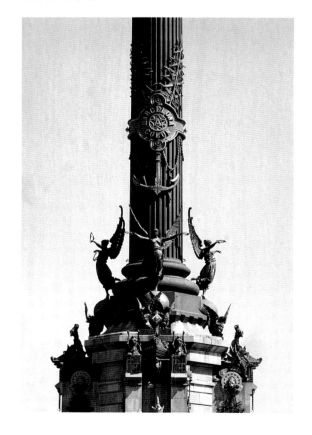

Lluís Domènech i Montaner
**Café-restaurant at the Universal Exhibition
or "Castell dels Tres Dragons"**
Barcelona, 1887–1888
Belvedere

classical architecture was, to a great extent, a metaphor for a sacred order based on Platonic concepts of universal harmony, constructive rationalism was the expression of a daring ascendancy over reality; it would contribute to controlling reality and organizing it in the service of man. Its major role in the architectural expression of the last quarter of the century gave contemporary society a dynamic self-image by offering the only alternative to the art's volatility and, at the same time, provided a satisfying explanation of the world. This double message, in all its ambiguity, was conveyed through architecture. The arbitrariness of form was no less significant than its rationality. But the love affair between art and industry was not simply one of form – in some strange way it placed the world in perspective.

Moreover, the architectural "renaissance" (to use an expression often associated with Catalan art) that marked the last quarter of the century was, above all, an industrial revival that went far beyond the genuine importance of the progress engendered by these industries. Involving industry was not an imperative: it was a deliberate choice made in spite of huge technical and economic difficulties and often even against all logic. This "tour de force" art posed particular problems where iron was concerned, as technology only just kept pace with the architectural inventiveness of the period (experience has shown us that the reverse can also be true). The architectural visions of Hector Horeau and Deane and Woodward were technically impossible to construct. It took all the skill of a man like Joseph Paxton or William Fairbairn to make the Crystal Palace in London or the Natural History Museum in Oxford a reality.[2] This was even more the case in Barcelona, which lacked the technical and professional infrastructure of Britain's vast industry. Thus the production of materials was inadequate, the cost high and application often erratic.

Consequently, the story of iron was in the first place the story of the metallurgists who produced a reliable material, did the calculations and achieved its practical application. Great figures of their period, they controlled the whole production process from the supply of iron ore to the detailed execution of a structure and the management of the site. Gustave Eiffel in Paris and Joan Torras i Guardiola in Barcelona[3] played key roles in this technological and cultural advance.

In Paris, the Universal Exhibition of 1867 had demonstrated the change that was taking place. The real advance was not in production but at the processing stage, with the material now emerging in a form that was ready for immediate use – sheet metal, rods and metal sections that an ironsmith would have no difficulty employing and that would not pose the same compatibility problems as pieces made in cast iron, which were often difficult to assemble. Sheet metal replaced cast iron in the structural framework of both the Bibliothèque Nationale in 1868 and of the Moulin de Noisiel in 1871. And the dialectical combination of these two materials pursuant to the traditional rule of post and girder (cast iron under compression, iron under flexion or traction) soon gave way to a unitary construction; this was perfected at the end of the 1880s in Chicago with the Second Leiter Building, 1889–1891. In twenty years this radical, new technical development forced both engineers and manufacturers to rethink entirely the way they used metal in construction.

It is easy to understand how each new building became an adventure, each new project a challenge. The creation of the "fly wing" truss represented perfectly the forces at work in the structure and is one of the most significant examples of this continuous inventiveness in construction. Joan Torras, who had first used it in the structural frame of the industry pavilion at the Barcelona Exhibition of 1888, did not even wish to patent the invention as it seemed to him as self-evident as the solution to the problem of Columbus's egg.

Development in terracotta was every bit as remarkable as that in metal. Not only did industrial production mean that a standardized product of exact dimensions was now available, making it easier to use, but advances in the firing process were to change the nature of the material completely. This improvement came from combining two materials: clay and glass. Since the 1870s, Emile Müller had been trying to perfect a superior glazed brick and he gradually achieved a process that produced sharp fired polychrome stoneware of superb quality for the Chicago Exhibition of 1893.[4] Whereas faïence was too fragile to be used out of doors, enamelled terracotta or stoneware were weather-resistant. Tiles (until then glazed only to protect them from the wear and tear of feet) now began to move onto walls, covering them with a shiny, waterproof surface.

Barcelona had an exceptional role to play in this field and was, without doubt, the most important city in Europe in terms of construction in terracotta. In Anglo-Saxon countries the only interest shown in stoneware was in its waterproof qualities and the protection it afforded against fire as a facing for metal structures in high-rise buildings, particularly in Chicago. In Germany and Holland brick remained the prime material. However, by the end of the century enamelled terracotta and stoneware were to play a dominant role in Catalan architecture. This had been an ambition of French architects but they achieved this only in a few exceptional buildings, most of which have now disappeared, such as the building by Léopold Hardy constructed for the 1878 Exhibition and the Ville de Paris building by Joseph Antoine Bouvard, the Printemps building by Paul Sédille of 1882 and the Beaux-Arts pavilion by Jean Formigé constructed for the Exhibition of 1889. In Barcelona the use of these materials became an everyday reality.

The visionary spirit of Antoni Gaudí and his passion for artistic revival have a great deal to do with this success. One of his first clients, Manuel Vicens i Montaner, owned a brick and tile company; in 1878 Gaudí began to exploit these materials in a spectacular fashion for the house he designed in the Carrer de les Carolines which was built a little later, in 1883. Gaudí's steps in this direction were soon followed by his friend Lluís Domènech whose Montaner i Simon printing works date from 1879. There followed a remarkable boom in the industrial production of terracotta in Catalonia. Architects' designs were advertised in catalogues by the major brand names of the terracotta industry such as Pujol i Bausis and Escofet, Tejera y Cía, to mention only the largest.[5] And if something special was required there was no shortage of skilled craftsmen to fulfil such commissions, notably the Antoni Serra i Fiter art porcelain and stoneware factory. The production capacity available in the terracotta industry meant that it became a commonly used, if not

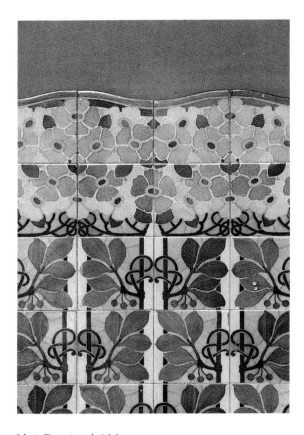

Lluís Domènech i Montaner
Pere Mata Institute
Reus, 1897–1919
V.I.P. Building, stairwell
Ceramics by Pujol i Bausis

mundane, type of finish, competing with plaster on both the façades of buildings and in the most modest of interiors.

It is easy to understand the fascination this material had for architects. It lent itself to all types of applications: it could be used decoratively, laid and combined in many different ways just like common wallpaper, providing a building with a sumptuous finish at a very reasonable price. It was tile, more than brick, that became the key material of the new architecture. In building it was both easier to use and had wider application than iron. It could be attached anywhere, on any type of base and it also combined effortlessly with even the crudest of traditional masonry techniques.[6] It was, in short, a universal material, which offered architecture the most fantastic decorative possibilities. And, when Gaudí revived the popular tradition of *trencadís* (tile fragments) in order to adapt the tiles for the more complex surfaces of his sculptural architecture, he created the ultimate finish – a continuous decorative facing, the architectural skin of which modern masonry had always dreamt. Far from being a traditional material, terracotta had in fact become one of the most felicitous innovations of the new, turn-of-the-century architecture.

Lluís Domènech i Montaner
Casa Lleó Morera
Barcelona, 1903–1905
Main first-floor living-room:
Decorative mosaic panel by Gaspar Homar
i Mezquida
Porcelain features by Antoni Serra i Fiter

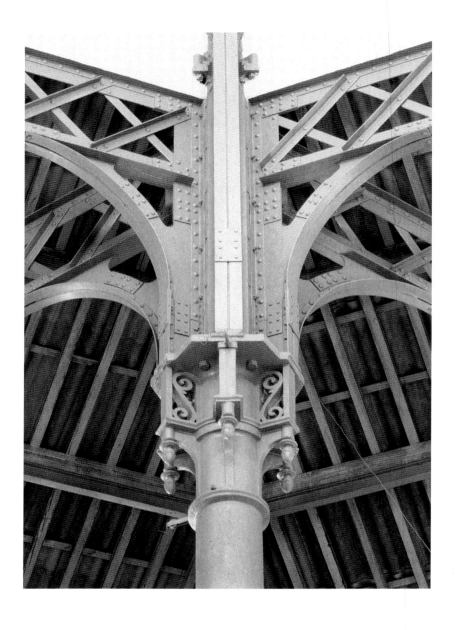

Iron, Cast Iron and Steel

Although, more than any other material, iron symbolized the industrial revolution, it was, nevertheless, rarely used, being both expensive and difficult. Solid manufacturing and transport infrastructures were required, first to obtain coal and iron ore and then to process it at a competitive price. Most difficult of all was obtaining iron from the smelt. In Barcelona there were at first only two foundries (Nuevo Volcano, established in 1836 and the Compañía Barcelonesa de Fundición, in 1839); these were superseded in 1855 when the Maquinista Terrestre y Marítima company was created and then in 1873 by the works founded by Joan Torras, who was responsible for important advances in the Catalonian metal industry. He was professor of construction at the School of Architecture and perfected a purification process for cast iron; he then transformed the use of metal by replacing flat-rolled iron with angle iron sections for truss beam construction (1875) and invented the highly logical "fly wing" design for structural trusses (1888). Comparing El Born market built in 1873 with the Sant Antoni market designed a year earlier shows how quickly the procedure was applied. Torras's influence on Catalan architects was far more decisive than that of the more distant Paris Exhibition of 1889. The great achievement of combining brick and metal did not, however, meet with the same degree of success in Catalonia as it did in France for obvious reasons of cost. Nevertheless, Torras's passion for iron played a large part in the disappearance, after the turn of the century, of cast iron as a structural or even ornamental material.

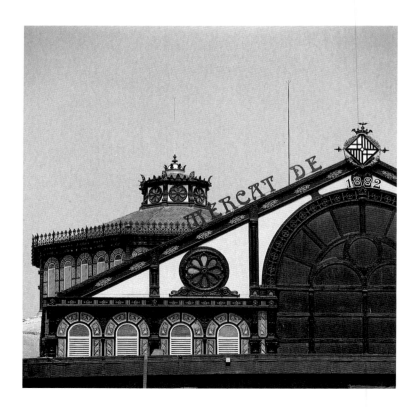

Antoni Rovira i Trias
Sant Antoni market
Barcelona, 1872–1882

Facing Page Above:
Detail of the interior structure
Below and Facing Page Below:
Façade details

Right:
Josep Fontserè i Mestres
El Born market
Barcelona, 1873–1876
Façade detail

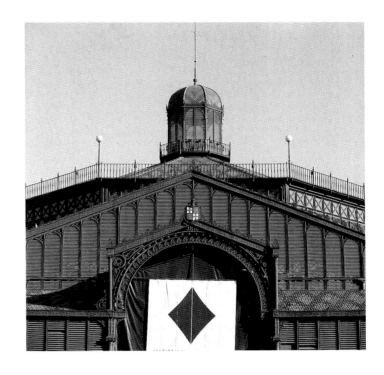

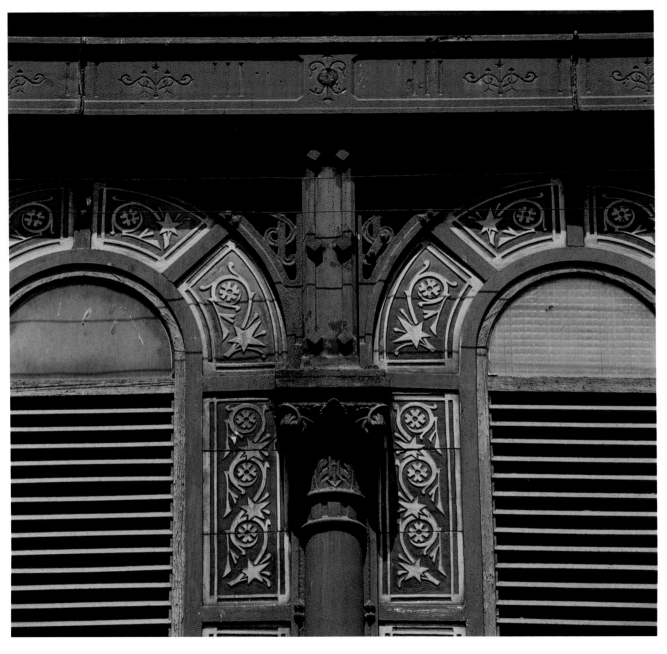

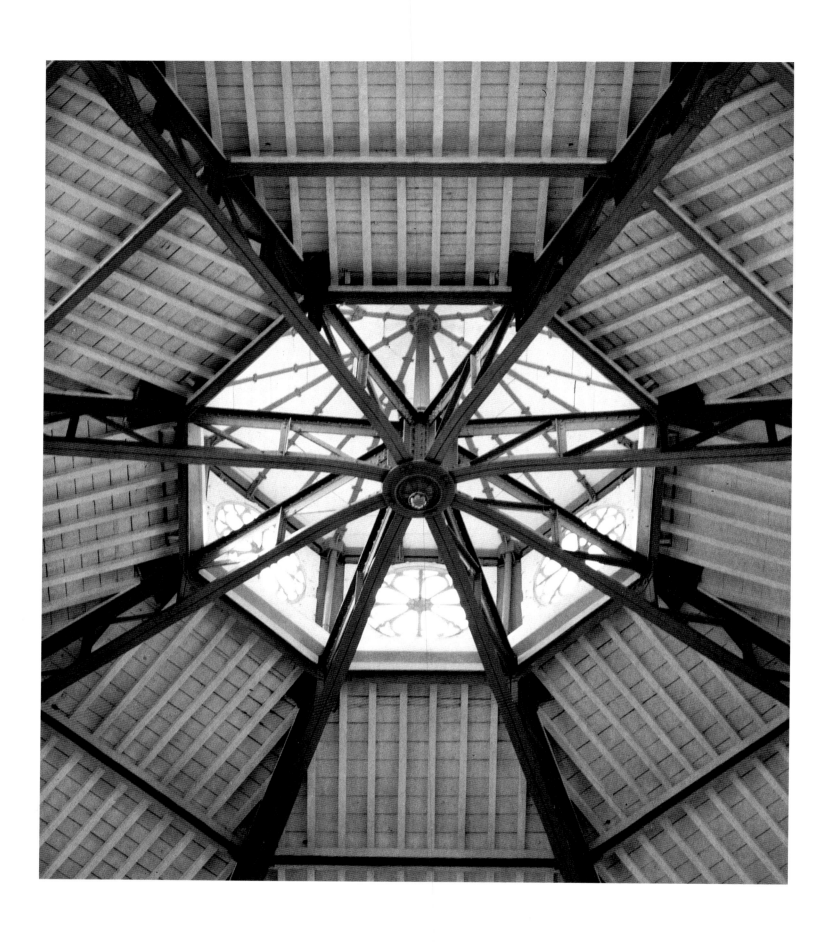

Facing Page:
Antoni Rovira i Trias
Sant Antoni market
Barcelona, 1872–1882
Interior structure
Josep M. Cornet i Mas, Engineer

Right and Below:
Pere Falquès i Urpí
Central Catalana d'Electricitat
(power station)
Barcelona, 1897–1899
Façade on the Avinguda de Vilanova
Windows

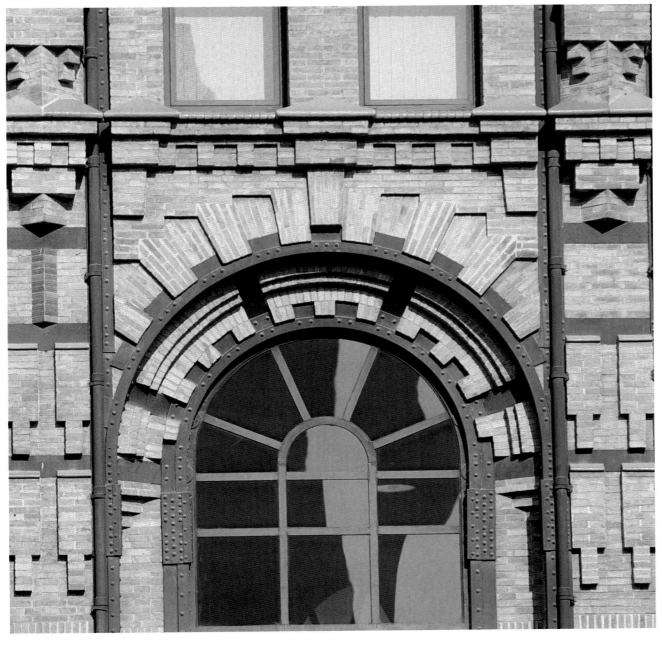

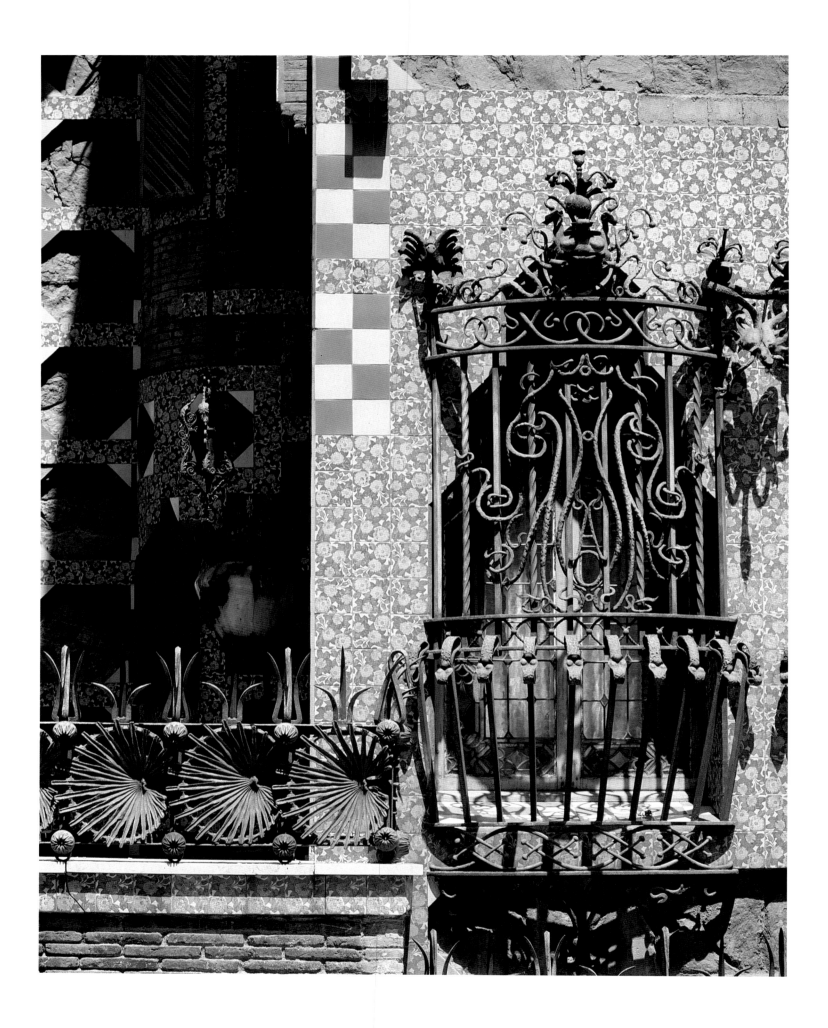

Wrought Iron

The industrial production of sheet metal and metal sections led to a complete transformation in wrought iron as an art form. By freeing the craftsman from the constraints of manufacturing the material, it enabled him to develop applications and compositions that were far more sophisticated. The architects of the period did not pass this opportunity by and the designs they produced bore no resemblance to the traditional use of flat or square iron embellished here and there with sheet metal. Wrought iron became an art form, a study in solids and space, not dissimilar to the ornamental virtuosity of embroidery, graphic work, cut-outs and layering and making use of all the products available in the marketplace. This almost immoderate passion, inspired by a careful study of the *Dictionnaire de l'Architecture* by Viollet-le-Duc, waned towards the beginning of the twentieth century. There was an effort to reduce the quantity of materials used and the flamboyance of the designs so as to display more clearly the assembly of the different elements and to highlight the economy of their use. This transformation led from passion for ornament to concentration on structure itself, from form to linear drawing, from delight in design to faith in the material and the tool. And the pivotal force in this revolution was Art Nouveau.

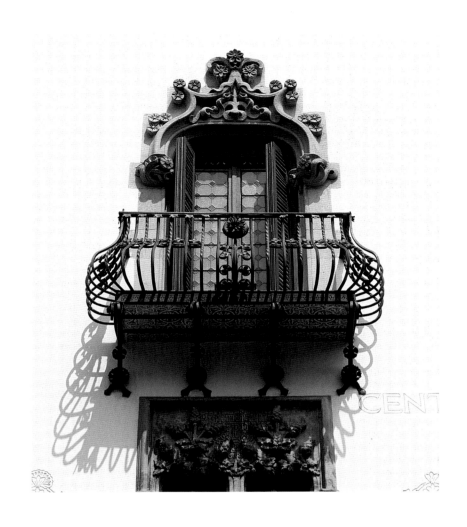

Facing Page and Below:
Antoni Gaudí
Casa Vicens
Barcelona, 1883–1888
Ground-floor
Window grilles

Above:
Josep Puig i Cadafalch
Casa Macaya
Barcelona, 1898–1901
Façade on the Passeig de Sant Joan
Balcony rail

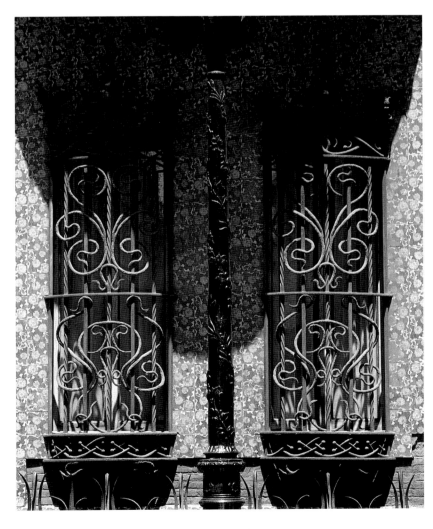

Antoni Gaudí
Finca Güell
Barcelona, 1884–1887

<small>ABOVE:</small>
Portal detail
<small>LEFT:</small>
Pedestrian entrance detail

Antoni Gaudí
Les Teresianes College
Barcelona, 1889–1894

<small>RIGHT:</small>
Window grilles
<small>BELOW:</small>
Entrance porch grille

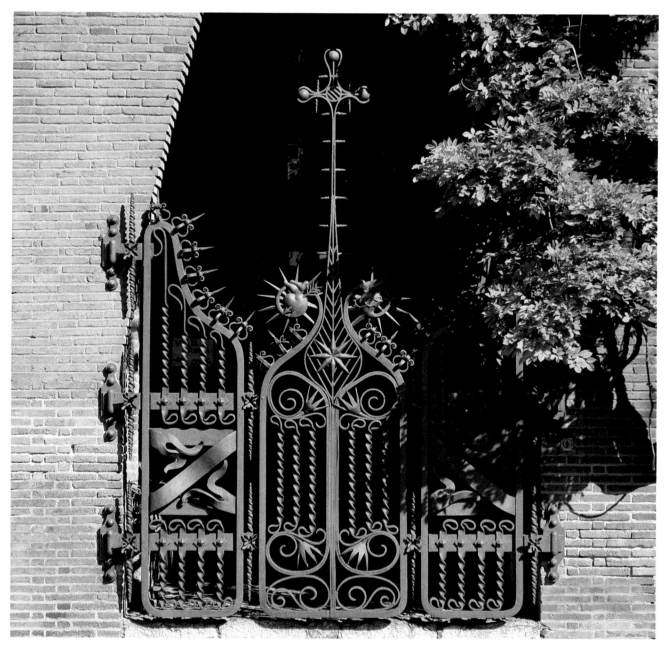

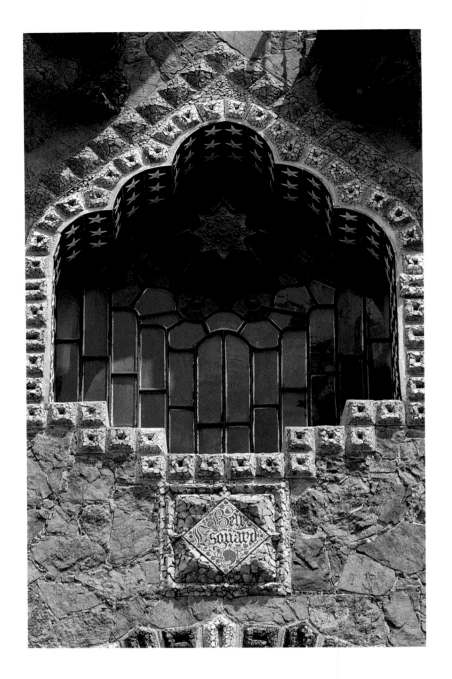

Stained Glass and Mosaic

The advances that took place in the glass industry during the nineteenth century were just as significant as those in ironworking. From the end of the eighteenth century rolling techniques had made it possible to obtain glass sheets of consistent thickness and standardized dimensions at reasonable prices. Chemical colorants considerably increased the range of stained glass available, making painting on glass, except for figures and drapery, almost redundant. Ornamental stained glass was an exercise in pure geometry that would play a very important role in the applied arts, competing so successfully against figurative stained glass that the original representational function was abandoned completely. The effect of the framework combined with the pattern of the lead created a graphical screen, the "accidental" nature of which itself created the design. Like mural decoration, using stained glass for plate glass, walls and lustres became one of the principal methods of architectural ornamentation, of which it was the natural extension.

The industrialization of glass production led naturally to the mass production of enamels, and consequently to the renaissance of mosaic work in faïence and enamelled terracotta. Molten glass and stoneware also replaced marble, which had a limited application due to its porosity and difficulty of cutting. Mixed materials began to appear, such as glazed or vitrified ceramics and shaped tesserae in molten glass. These could be used to imitate the appearance of traditional mosaic or to create new forms, for example, by scattering small fragments over a freshly coated surface. Glass, like iron and terracotta was a key material of the period, and the combination of industrial production and craft application created a new relationship favourable to the blossoming of the decorative arts.

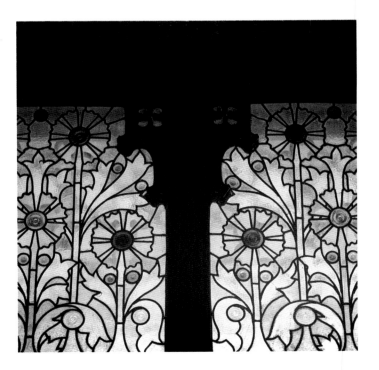

FACING PAGE AND ABOVE:
Antoni Gaudí
Torre Figueras or "Bellesguard"
Barcelona, 1900–1902
Stained glass in the entrance hall
Interior and exterior views

LEFT:
Josep Puig i Cadafalch
Casa Coll i Regàs
Mataró, 1897–1898
Ground-floor living room
Stained glass door panels

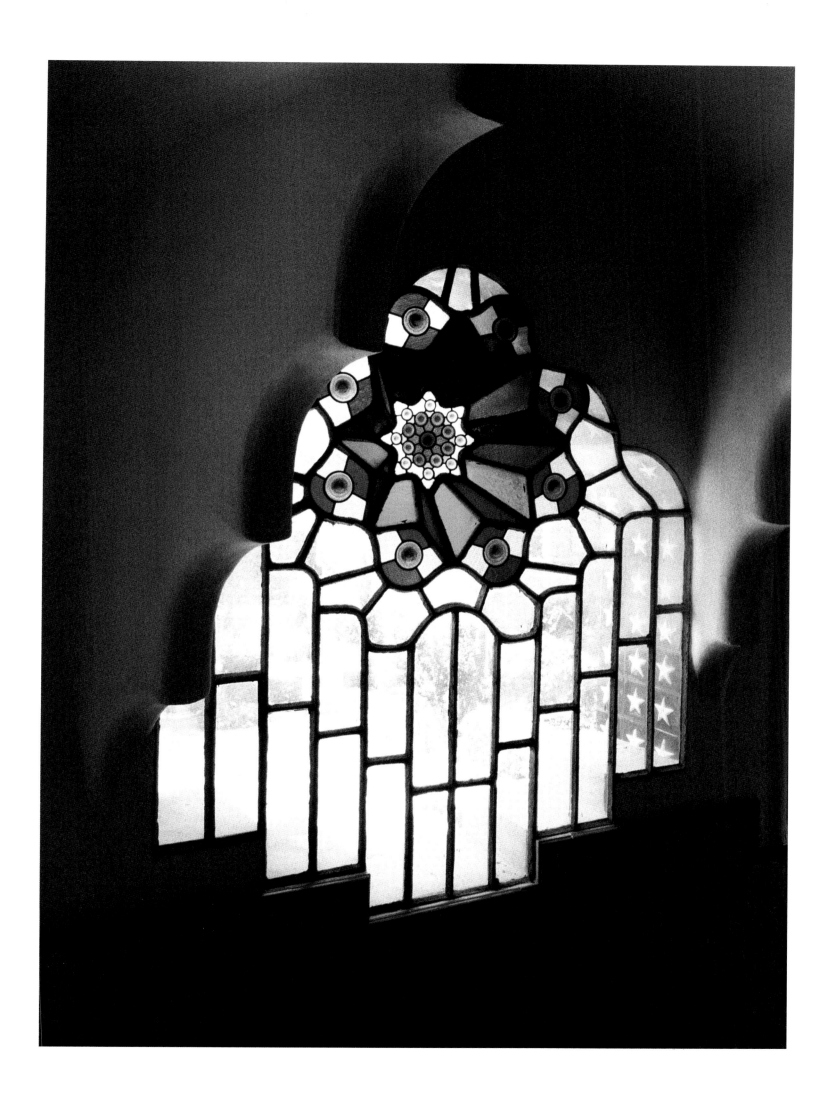

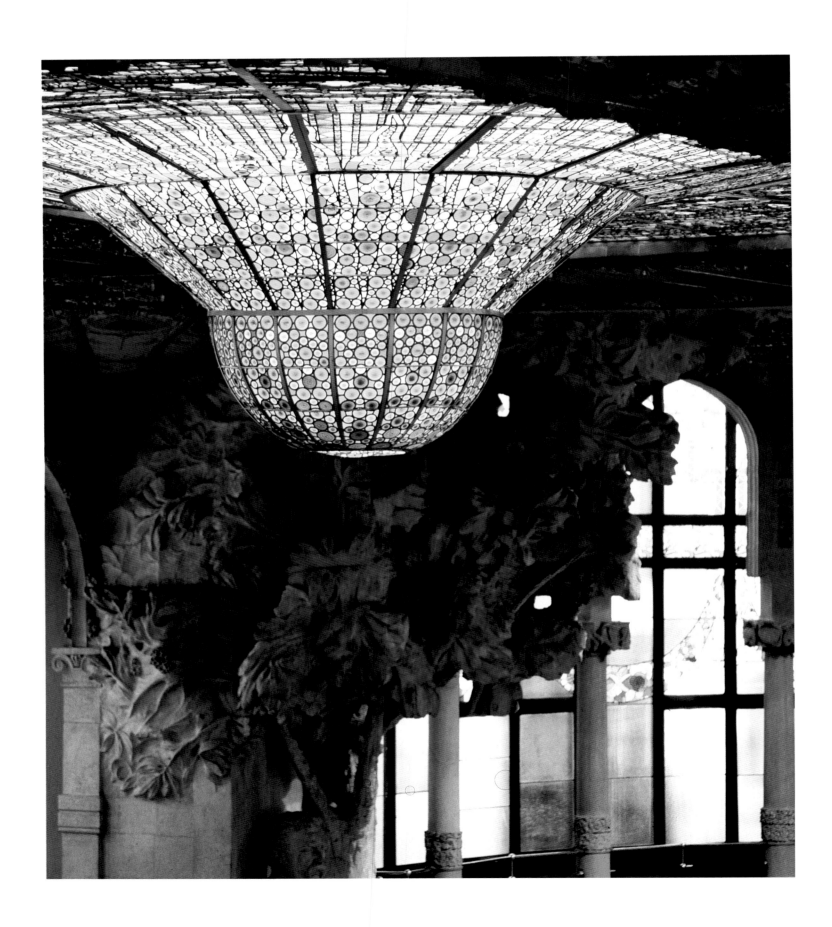

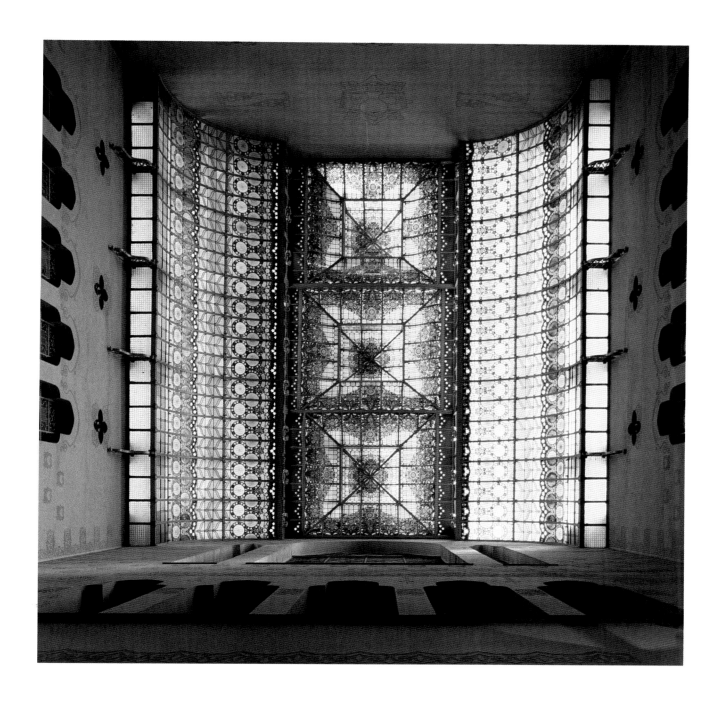

FACING PAGE AND RIGHT:
Lluís Domènech i Montaner
Palau de la Musica Catalana
Barcelona, 1905–1908
Concert hall
Glass ceiling feature and detail
Stained glass by Antoni Rigalt i Blanch

ABOVE:
Jeroni Martorell i Terrats
Savings Bank
Sabadell, 1906–1915
Glass screen in the central hall
Stained glass by Lluís Rigalt i Corbella

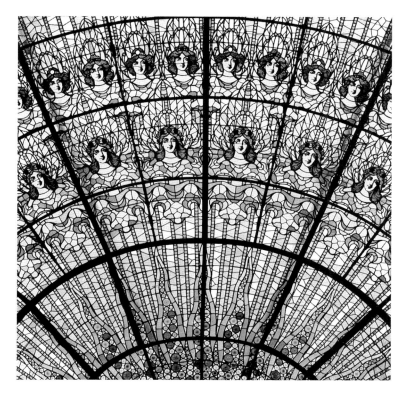

Below:
Lluís Domènech i Montaner
Santa Creu i Sant Pau Hospital
Barcelona, 1902–1911 (first phase)
Administration building, main staircase
Vaulting detail
Mosaic by Lluís Bru i Salellas

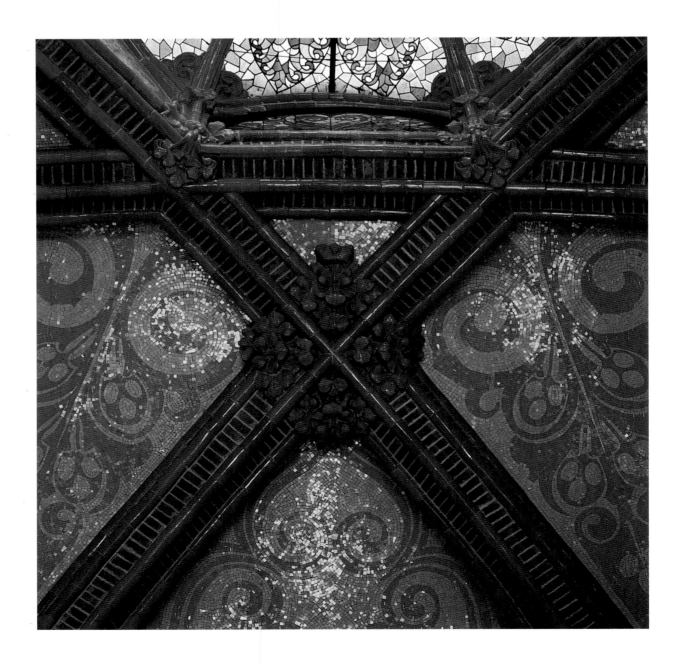

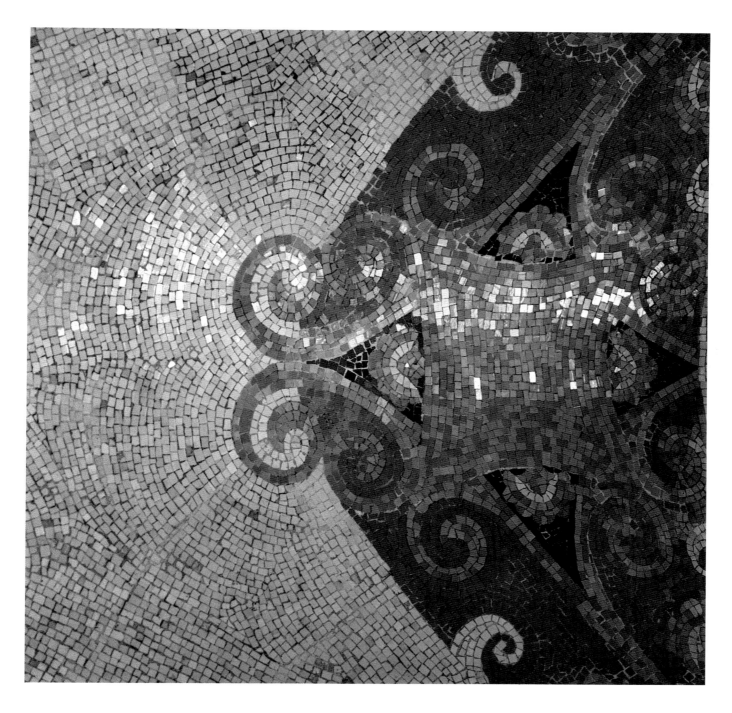

FACING PAGE ABOVE,
RIGHT AND ABOVE:
Lluís Domènech i Montaner
Santa Creu i Sant Pau Hospital
Barcelona, 1902–1911 (first phase)
Administration building, first-floor gallery
Ceiling vaulting

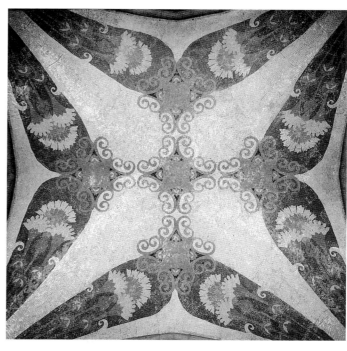

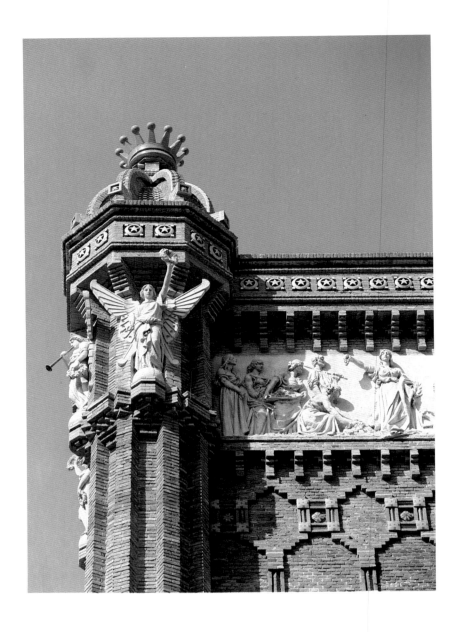

Brick

Roman brick, celebrated in a work by J. Lacroux, *La brique ordinaire*, published for the Paris Exhibition of 1878, is the oldest and most common building material and the only one to permit perfect construction at a low cost. In Spain, however, it had traditionally been used more for aperture facings than for wall masonry. Therefore little attention was paid to the decorative effect of bricklaying styles; these subtleties were apparently restricted to the northern European tradition. In contrast, the "dialogue" between the frame and its infilling was the main focus of attention and was expressed in a considered study of the constructional organization, the lines of the bricks emphasizing arches and buttresses, delineating pilaster strips, framing apertures and outlining the shape of the building with extraordinary volubility.

Brick was both pretext and pleasure, providing the opportunity to create an outstanding ornamental rhetoric that it would be difficult to resist. In the purely graphic artistic style that dominated the turn of the century, every arrangement was valid, providing it enhanced the wall by emphasizing its flatness through a powerful use of line. Although this architecture did not use iron, brick became its metaphorical interpretation – the slender elegance of metal and its strange proportions could be recognized in the use of brick.

Viollet-le-Duc had been tempted by this technique in the *Entretiens ...,* which became a convention of modern architecture, whether applied directly to rendering (and often simply to the rough surface of mortar walling) or combined with moulded terracotta plaques, as is the case with Gaudí's Finca Güell where he wished to revive the tradition of raw clay form construction. Brick displays beauty and evidence of work that seems to embody the very act of creation far better than dressed stone with its smooth and barely visible face or a coating imitating this. Brick, more than any other, is the material of labour.

ABOVE:
Josep Vilaseca i Casanovas
Triumphal Arch at the Universal Exhibition
Barcelona, 1888
Corner pillar

LEFT AND FACING PAGE:
Lluís Domènech i Montaner
Café-restaurant at the Universal Exhibition or "Castell dels Tres Dragons"
Barcelona, 1887–1888
Thermal window, corner tower

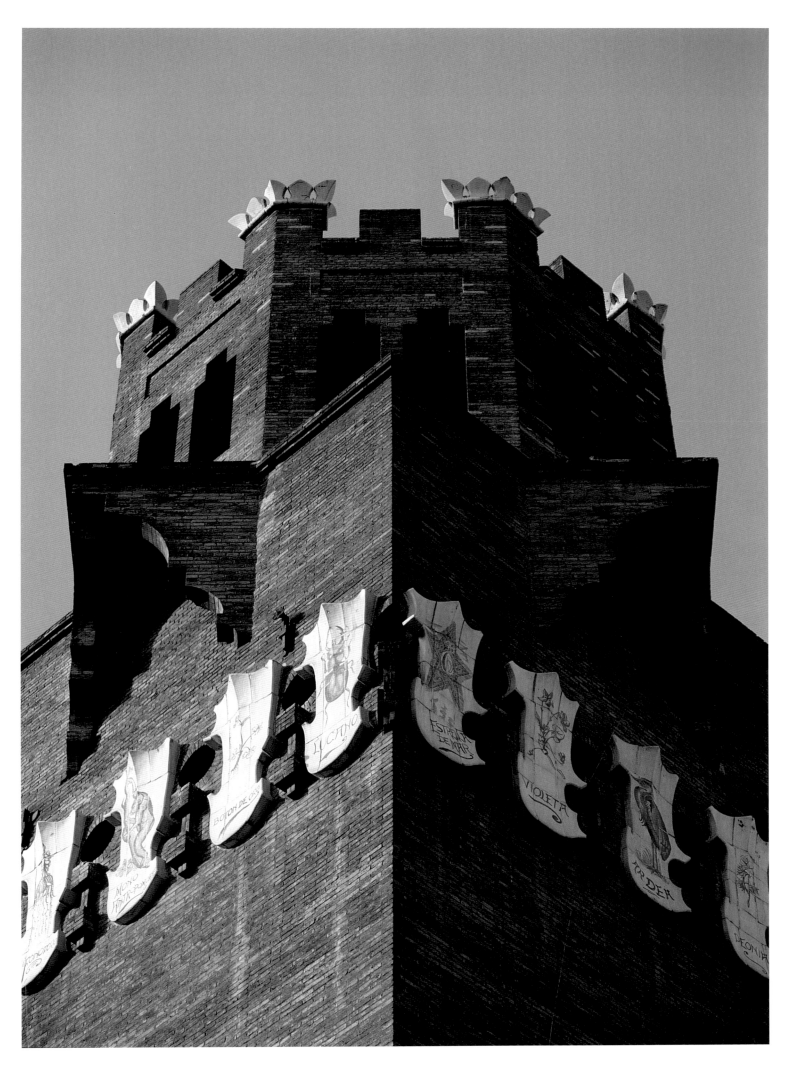

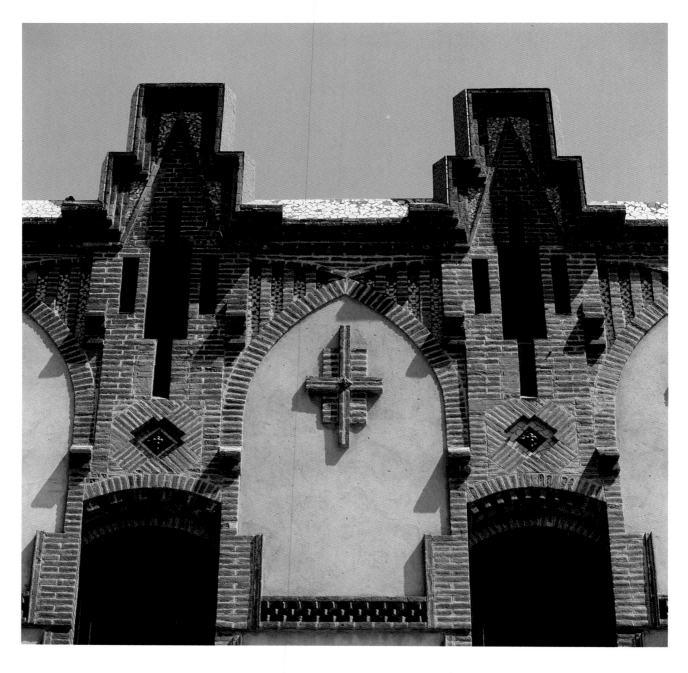

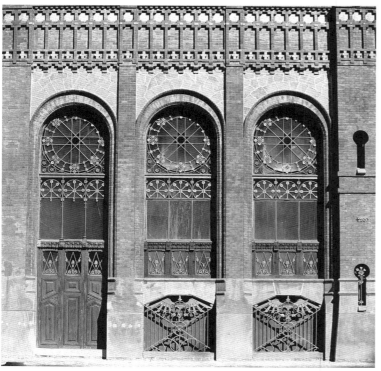

ABOVE:
Josep Domènech i Estapà
"Empara de Santa Llúcia" Institution
Barcelona, 1904–1909
Façade on the Carrer de Teodoro Roviralta

LEFT:
Lluís Domènech i Montaner
Montaner i Simon Publishing House
Barcelona, 1879–1886
Façade on the Carrer d'Aragó

FACING PAGE:
Antoni Maria Gallissà i Soqué
Casa Llopis i Bofill
Barcelona, 1902–1903
Façade on the Carrer de València

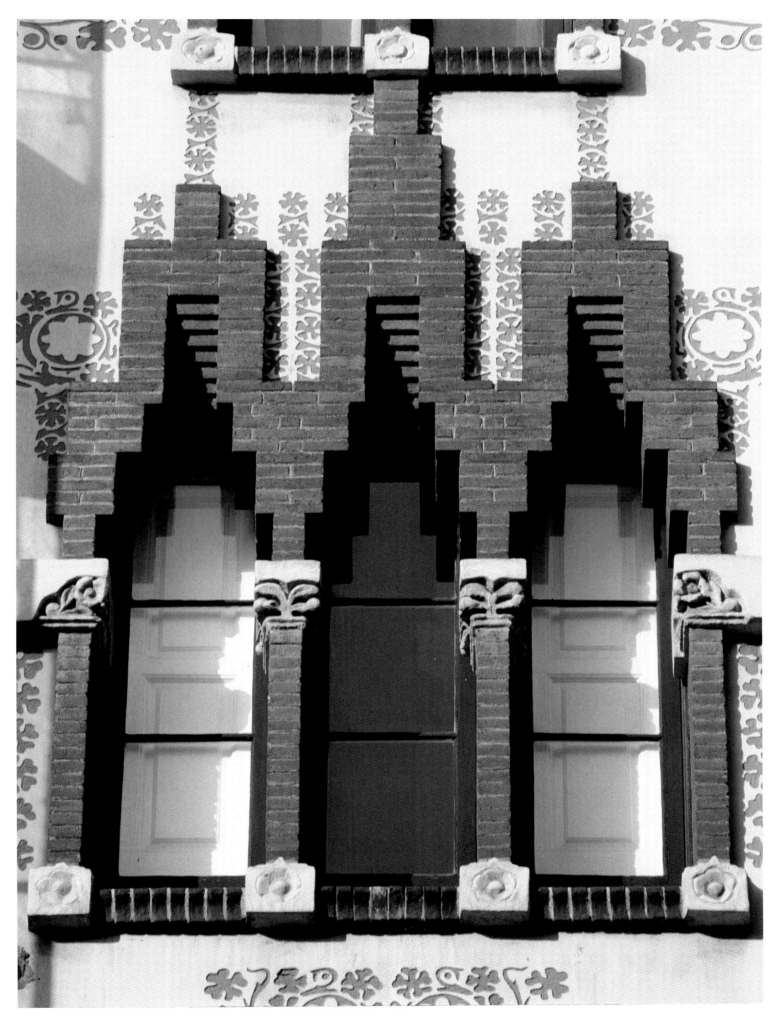

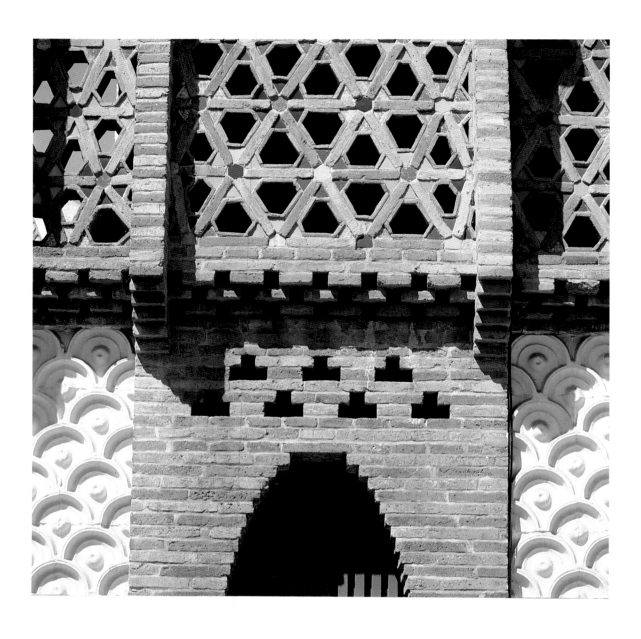

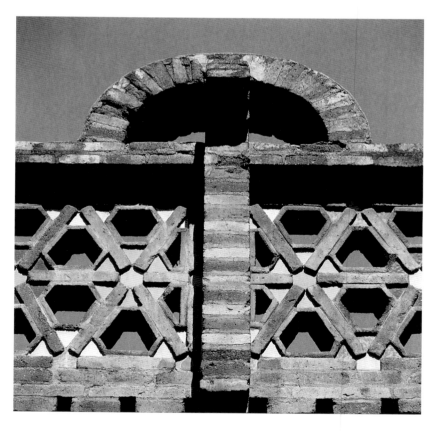

Antoni Gaudí
Finca Güell
Barcelona, 1884–1887
Entrance lodge

Above:
Façade on Avinguda de Pedralbes
Left:
Perimeter wall

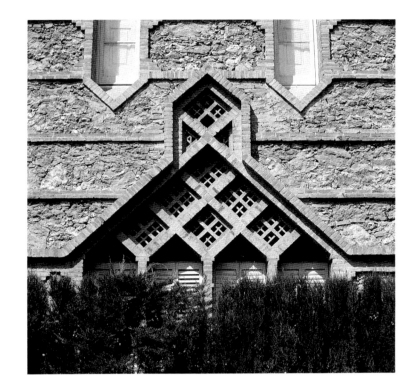

RIGHT AND BELOW:
Joan Rubió i Bellver
Colonia Güell, Can Mercader
Santa Coloma de Cervelló, 1900
South-west façade views

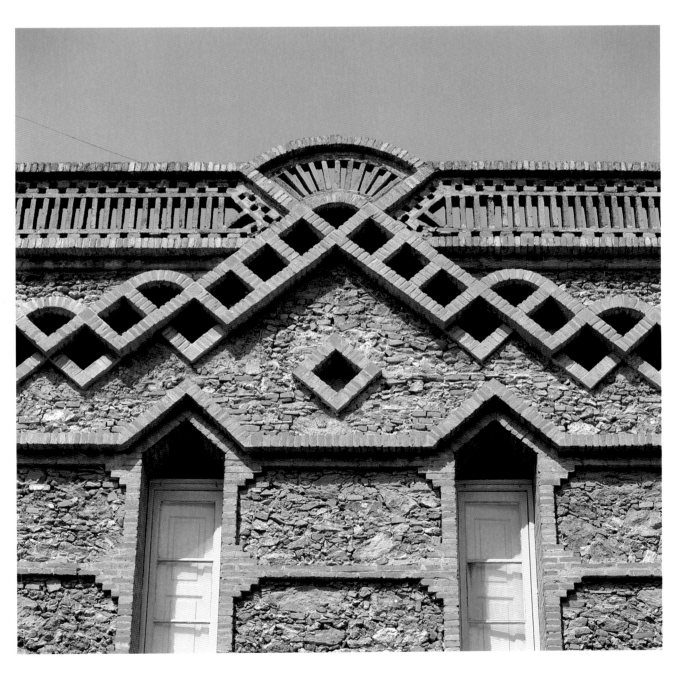

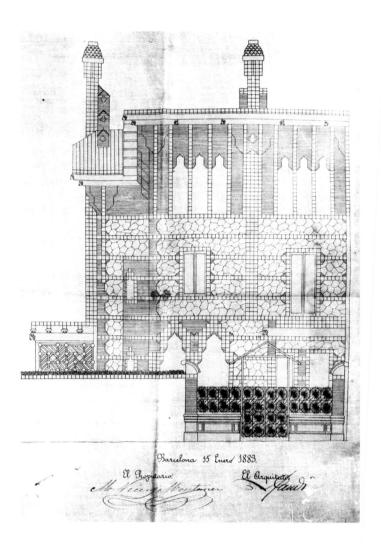

Tiled Façades

But it was the use of tiles that was the most fanciful feature of the period. Towards the end of the century advances in the firing process made it possible for tiles to be used outdoors as well as inside for high-temperature vitrification of stoneware made tiles more resistant than simple glazed faïence. Viollet-le-Duc, inspired by the Menier factory at Noisiel-sur-Marne and its glazed brick décor (which was created in 1871 at the Grande Tuilerie at Ivry by the Alsation inventor of fired stoneware, Emile Müller), had the idea of replacing this with a light facing of decorative faïence. This utopian project, which the following year brought the *Entretiens* ... to a close, would become the bible of the new generation; but would not be laid to rest until the problem of ceramic vitrification had been resolved.

Gaudí used floor tiles on the façade of the Casa Vicens in 1883 and created a chequerboard effect using tiles of contrasting colours and dressed the façade with alternating strips of brick and tilework under the protective canopy of a large overhanging roof. The boldness of this exercise in ornamentation, which enhances the strong points of the façade – the oriel and top floor of the building – should be compared with the conventional use made by his colleagues of decorative faïence borders to highlight architraves or decorate the soffits of wrought-iron balconies.

Antoni Gaudí
Casa Vicens
Barcelona, 1883–1888

ABOVE:
Elevation, 1883

Façade on the Carrer de les Carolines
LEFT:
Detail of wall finish
FACING PAGE:
Corner belvedere

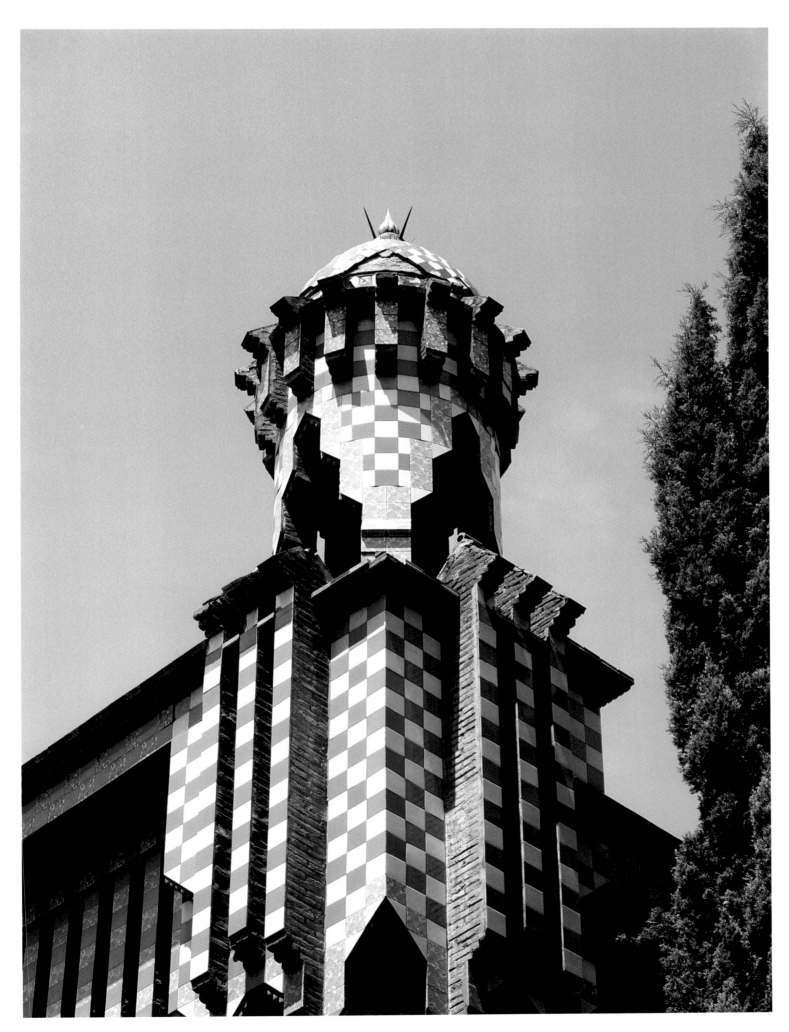

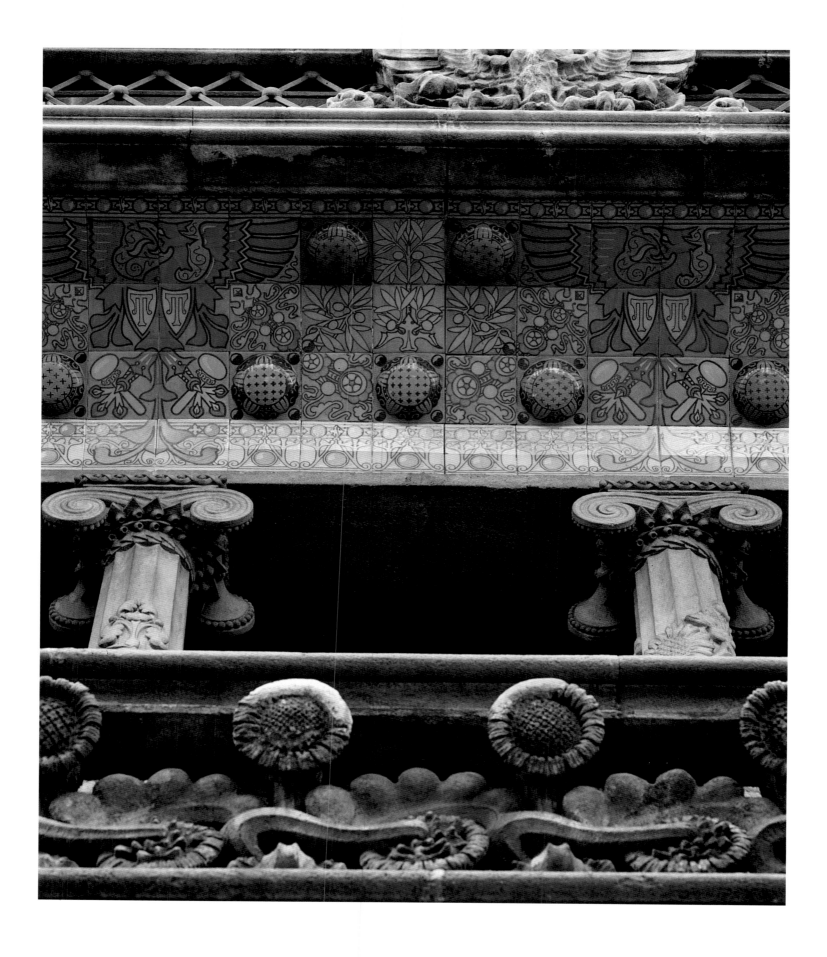

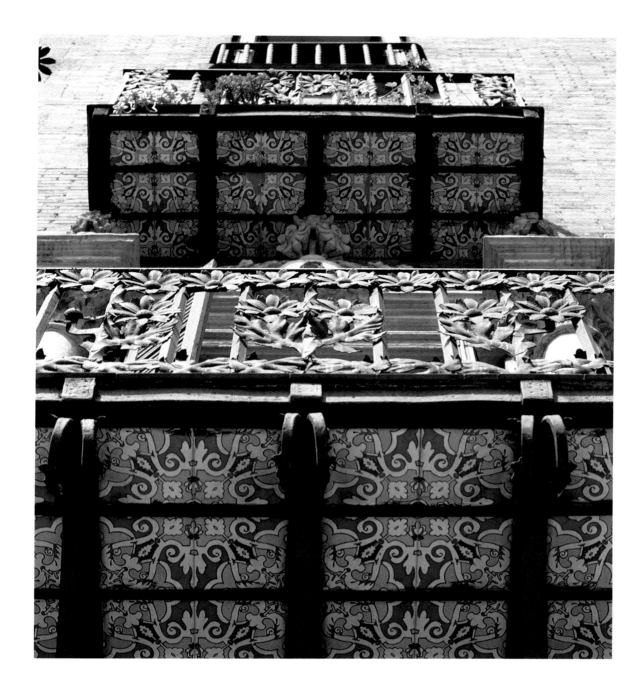

FACING PAGE:
Lluís Domènech i Montaner
Casa Thomas
Barcelona, 1895–1898
(Raised section 1912)
Coffered balcony ceiling

RIGHT:
Lluís Domènech i Montaner
Casa Joaquim de Solà-Morales
Olot, 1913–1916
Decorated eaves

ABOVE:
Josep Puig i Cadafalch
Casa Terrades or "Casa de les Punxes"
Barcelona, 1903–1905
Coffered balcony ceilings

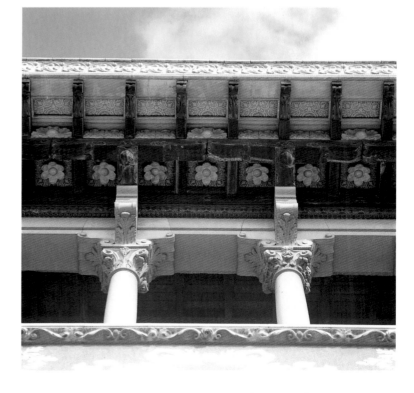

Josep Puig i Cadafalch
Casa Coll i Regàs
Mataró, 1897–1898
Drawing room and cloakroom on the ground floor

LEFT AND BELOW:
Wall tiles

RIGHT:
Tile design

From Tiling to Tile Fragments

The technique of glazed tiling that had been perfected for use on floors also provided many opportunities for decorative innovation within the repertoire of the neo-Gothic tradition. Some time had passed since the disappointments experienced by Félix Duban at Blois and his pupils Lassus and Viollet-le-Duc at Sainte-Chapelle de Paris had been overcome; it was now possible to produce the most complex of décors without fear of damage from wear and tear. Josep Puig i Cadafalch, a descendant of the historicist school, applied himself diligently to this task, creating marvellous geometrical décors that owed as much to his admiration for the Middle Ages as to his own innovation in form.

The success of the undertaking was such that faïence décor completely covered walls and ceilings and every available space. The durability of the product made all types of liberties possible. It also incorporated the already ancient tradition of staff ornamentation, such that Lluís Domènech combined tiles, mosaic and relief pieces to create a total décor merging wall and ceiling.

The dialectical interplay of surface with surface ornamentation moved gradually towards a global vision of space in which the walls were no more than an outer shell. Gaudí's use of tile fragments – a clever distortion of the orthogonal style associated with the tile – meant that the material took on a unifying role, covering every surface, making delight in plastic form and the material the prime objective. Tiling had first been used to divide up surfaces and to distinguish their function and status in the organization of buildings but it now served to meld those surfaces together under the living sheath of a structure in tension – like skin over bone. The ideology of Art Nouveau played its part in this transformation, questioning the analytical aspects of architectural rationalism and applying to them the rules of a total art form based on pure plastic expression.

Josep Puig i Cadafalch
Casa Coll i Regàs
Mataró, 1897–1898
Drawing room and cloakroom on the ground floor

ABOVE AND RIGHT:
Washstand details

Lluís Domènech i Montaner
Pere Mata Institute
Reus, 1897–1919
V.I.P. building, dining-room

Above and Right:
Wall tiles
Facing Page:
Ceiling tiles
Ceramics by Lluís Bru i Salellas

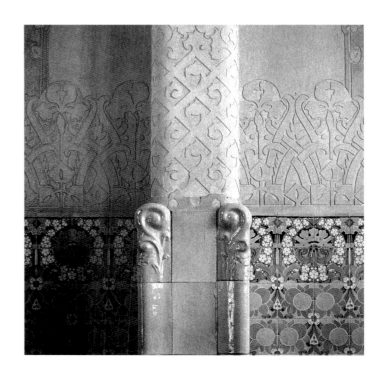

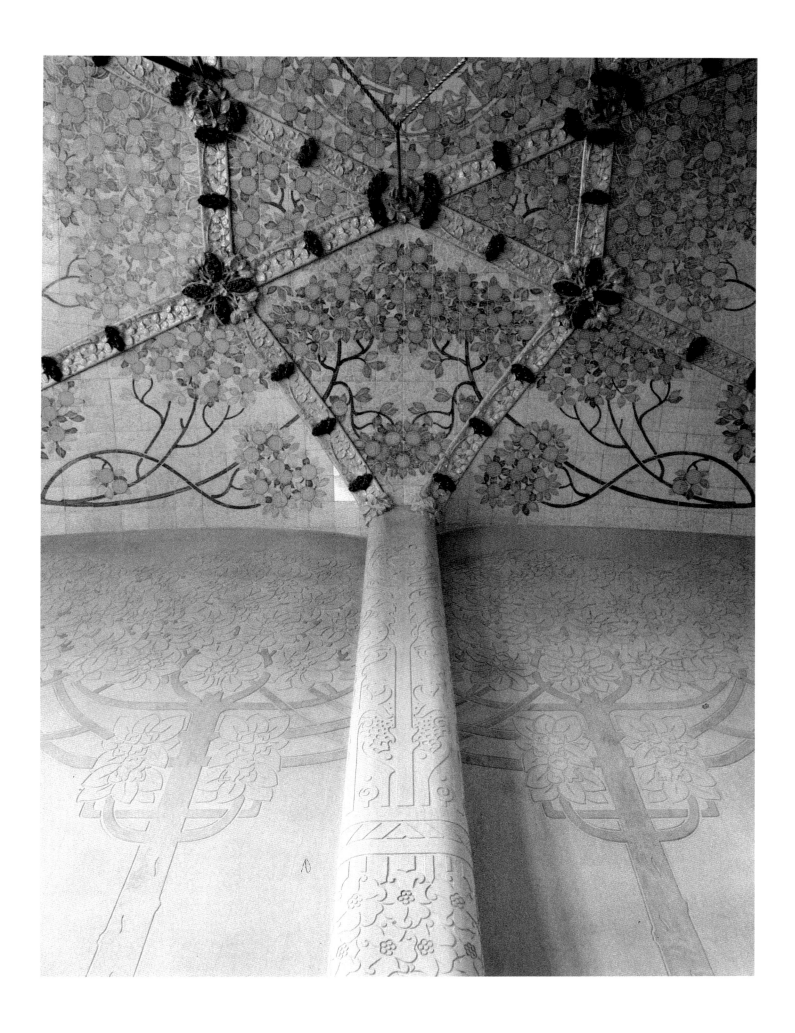

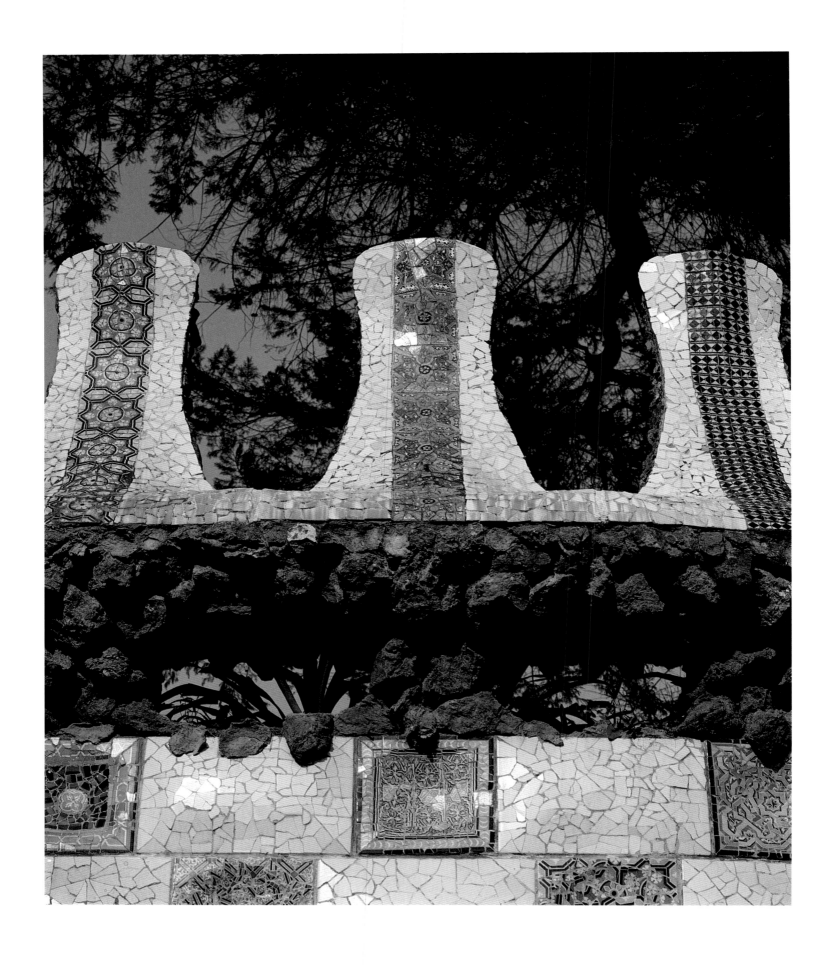

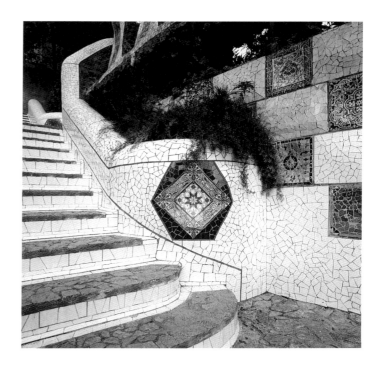

Antoni Gaudí
Parc Güell
Barcelona, 1900–1914
Main steps

FACING PAGE:
Crenellations on the retaining wall
RIGHT AND BELOW:
General view and detail
Walls decorated with tile fragments
(trencadís)

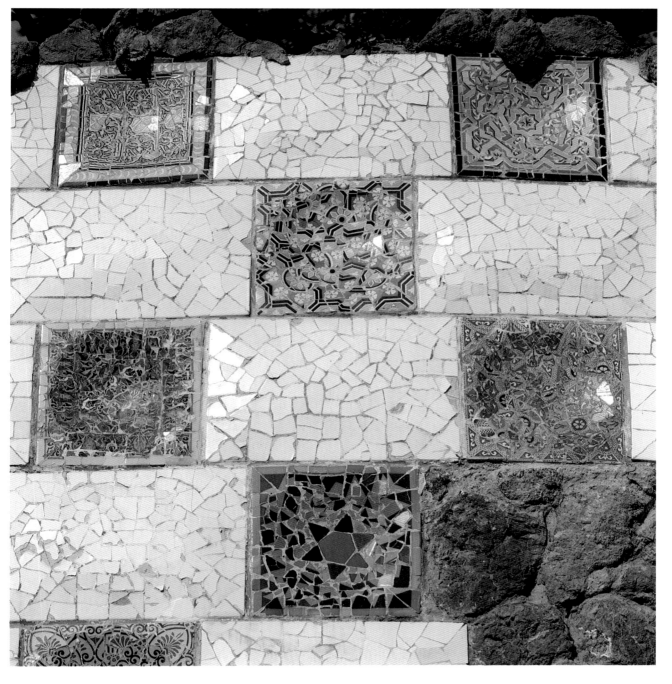

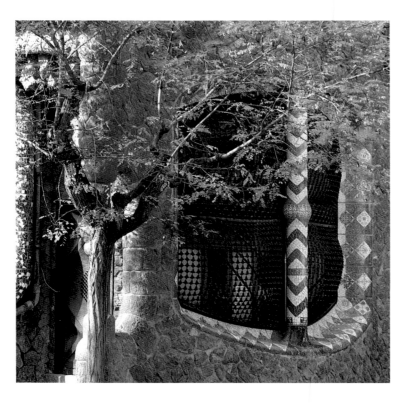

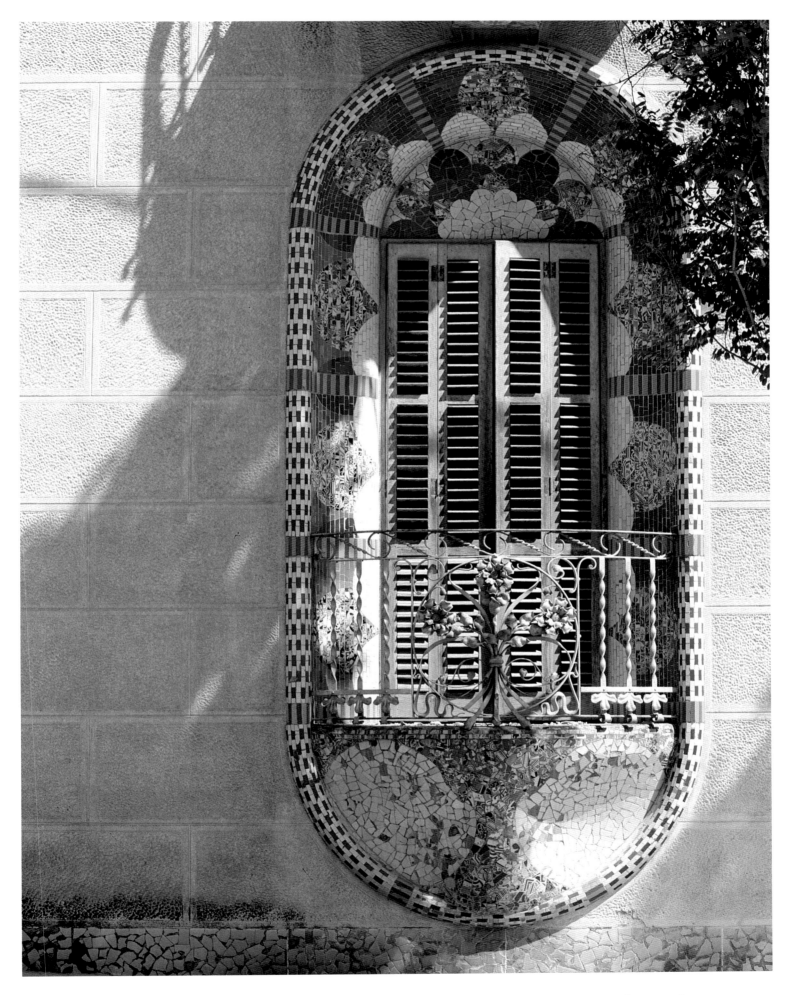

2

Descendants
of Viollet-le-Duc

The bold decision to extend Barcelona outside its old walls by building the vast *Eixample* area between the Plaça de Catalunya and the village of Gràcia created a city that was highly rational but equally unprepossessing. Along the new streets planted with scrawny, immature shrubs appeared long vistas of identical two-storey houses with rusticated masonry on the ground floor and high cornices to hide the terraced roofs. The Hausmannian ordonnance of flat façades with strong horizontal features led at every crossroads to great cants, which accentuated the impression of gigantic urban voids.

It needed more than the scholarly application of classical proportions to give life to these austere, repetitive houses where only an occasional triple arch or a projecting columned porch broke the monotony of rows of apertures and piers, giving a façade a certain individuality.[1] The invention of the Parisian-style corner rotunda, clever though it was and its almost immediate transformation into the bow window by Rafael Guastavino[2] was still not enough to correct the faults of the inordinately extended urban landscape, where the lower façades did not match the scale of the generous roadways planned by the engineer Ildefons Cerdà. This street scheme, which had been designed for large buildings, was slow to be completed. It was only after 1870 that the first four-storey buildings began to appear and these had a raised ground floor and an attic storey which often disguised their true size.[3]

It was some time before the construction of the new quarter was completed. Slow to develop, the alignment often alternated rental property, private family houses and simple ground-floor shops creating a highly irregular crest line. In this unfinished area, with the path of the urban rail system cutting through it, the aristocratic architecture of large family houses soon broke free from the constraints imposed by alignment and party walls. Moving into private housing estates the architecture became more imaginative – in the Renaissance or Moorish style[4] – as if to relieve the intrinsic boredom of the urban scheme. The Barcelona Cerdà had designed was too large, too empty and decidedly lacking in charm.

No doubt this was the feeling that lay behind the anti-establishment attitude of the work produced in the 1880s. It began with Josep Vilaseca i Canovas who, in 1884, created the Francesc Vidal art workshops on the Carrer de la Diputació. This modest neo-Gothic building, embellished with a set of blind arches on the cornice and two large lancet windows with gable and pinnacles, housed the studios of one of the greatest merchants and creators of furniture in Catalonia at the turn of the century. It was symbolic of a renaissance in the decorative arts and was the start of a new era under the influence of the masters of the French diocesan school.

The architecture Vilaseca and his friends produced owed a great debt to Viollet-le-Duc and his innovatory experimentation in the field of decoration (notably the extraordinary tomb of the Duke de Morny in the Père-Lachaise cemetery) and to the work of his pupils Victor Ruprich-Robert (whose *Flore Ornementale*, summarizing his classes at the Ecole de dessin de la Ville de Paris, was published between 1866 and 1876) and Emile Boeswillwald, who had built the imperial chapel in Biarritz between 1864 and 1865. It is possible the Catalan architects were unfamiliar with Pierrefonds or the décor of the choir chapels of Notre-Dame. They were, however, close enough to have visited Carcassonne and Saint-Sernin in Toulouse and, if they went as far as the Atlantic coast, could have visited Roquetaillade or Abbadia which are among the finest examples of Viollet-le-Duc's furniture and painted décor work. This geographical proximity played a significant role in the transformation of Catalan architecture from the beginning of the 1880s.

The pioneer of this revolution in the decorative arts in Barcelona was Josep Vilaseca[5], who, between 1883 and 1885, converted the Bruno Quadros building, on the Pla de la Boqueria in the middle of La Rambla, for use by an umbrella merchant. The Japanese-inspired décor of many-coloured parasols on the façade is a magnificent example of modern decorative art and in fact the colour and design of the oriental ornamentation is so effective that the systematic distribution of the apertures is forgotten. Another example of the architect's talent is the polychrome triumphal arch he built for the entrance to the 1888 Universal Exhibition in the Parc de la Ciutadella.

At the same time the Conservatory in the Parc de la Ciutadella was being built from the plans produced by Josep Fontserè i Mestres; this huge greenhouse with its cascading aisles has one of the most beautiful interior spaces of the nineteenth century. It accompanies the monumental fountain (1875–1881) by the same architect, an imposing structure with a triumphal arch clearly influenced by the Palais Longchamp d'Espérandieu in Marseilles; here the dramatic setting within the landscape prevails over the rigours of classical tradition to the point where conventions of style are abandoned. The impressive Law Courts by Josep Domènech i Estapà and Enric Sagnier[6] complete this series of buildings that symbolize the change taking place in Barcelona. Although the architecture may appear more conventional than that of the Café-restaurant (built for the Exhibition by Lluís Domènech i Montaner and which later housed some of the most remarkable modern decorative art produced in Catalonia), it is expressive of a profound desire for a renewal of the forms and language of architecture after so many centuries of classicism.

One of the people who best represents this desire for change is Elies Rogent i Amat, the founder of the Barcelona School of Architecture.[7] The first architecture courses in Barcelona had been given by Antoni Cellers in 1817 at the Escola de la Llotja, but at that time teaching was still under the control of the Academia de San Fernando in Madrid. In 1844 the school made a partial break from this tutelage and in 1850 became an "Escola de Mestres d'Obres", retaining autonomy within the provincial fine arts academy. The teachers at the school were the archi-

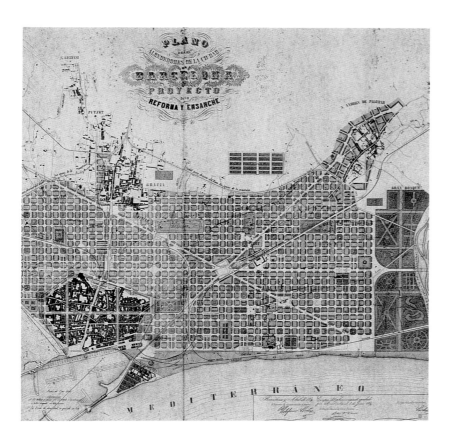

Ildefons Cerdà i Sunyer
L'Eixample
Barcelona, 1859
City development plan

tect of the diocese, Francesc de Paula del Villar i Lozano, Elies Rogent,
who taught composition, and Joan Torras, who taught construction. In
1870 it became the Barcelona School of Architecture and the teaching
body was increased by several new members (Leandre Serrallach i Mas,
August Font i Carreras, Antoni Rovira i Rabassa) and by two assistants,
Lluís Domènech and Josep Vilaseca, who had both returned from a trip
round Europe after obtaining their diplomas in 1873. This team was to
give a decidedly modernist slant to the training given at the school.

Elies Rogent, the new director, was convinced of the need to supple-
ment the artistic training of architects with a solid scientific and techni-
cal grounding but, following the example of Viollet-le-Duc, he also
wanted to establish an historical element, if only to combat the excesses
of the prevalent historicist atmosphere: "We fully understand", he
wrote[8], "that the doubt and vagueness that consume us make it impossi-
ble for us to return to the paths of the lost tradition (medieval architec-
ture as a traditional, national and Christian form of architecture). Since
we cannot go back we must become eclectic, like it or not – by which I
mean that we must wander constantly in search of the unknown." This
declaration, which could have been borrowed from César Daly, is simply
a pretext for freely affirming the principle of modernity. From the open-
ing of the school Rogent, as director, made Viollet-le-Duc's *Dictionnaire
raisonné de l'Architecture ...* compulsory reading, and he devoted a large
part of his theory course to the concepts of the author. It is clear that for
Elies Rogent a return to history was in no sense a retreat to the past,
rather it was a way of liberating oneself from it by discovering, through
the manipulation of different motifs, those forms most appropriate to
the expression of modern needs. This is the message of the *Entretiens sur
l'Architecture*[9] that he wished to promote, and the fact that he succeeded
owed more to the influence he had on the new generation than to his
own work as an architect.

The controversy surrounding the completion of Barcelona Cathe-
dral, following the competition held in 1882, is a clear demonstration of
the modernist opposition to any type of historical pastiche, however
authentic it might be. A petition was circulated among Catalan archi-
tects demanding that the design by Joan Martorell i Montells should be

used, not that by Josep Oriol Mestres i Esplugas and August Font i Car-
reras, which was the one the jury had chosen. Their design for the cathe-
dral aimed to reproduce faithfully the spirit of the fourteenth-century
building it was their task to complete. They wanted to give the façade a
magnificent openwork spire which, to the untutored eye, would appear
authentic. Joan Martorell's design respected the layout of the building
on the lower levels but crowned it with a far more slender spire rising
from the ethereal base of a transparent belfry.

This interpretation was not so much historicist as fantastical recall-
ing the cathedral towers of Strasbourg and Cologne and the great
Romantic designs of Schinkel. It was an evocation of the Middle Ages
that was both more powerful and more meaningful than any pastiche.
It comes as no surprise to learn that Martorell's draughtsman on this
project (and his greatest support) was the young Antoni Gaudí[10], who
defended the idea of a renaissance of medieval art against historicism.
The Sagrada Família, where Gaudí took over as architect in 1883, replac-
ing the neo-Gothic design by Paula del Villar i Lonzano, demonstrates
how far he wished to take this revival of a lost culture.

The free interpretation of the Gothic tradition, which was highly
accessible to contemporary architectural design, can be found in several
of the works of Joan Martorell, who was more successful in adapting the
spirit of the French diocesan school in Catalonia than Paula del Villar.
The geometrical severity and the conflicting effect of mass in the church
of Les Saleses (1882–1885) borrows heavily from Emile Vaudremer and
Saint-Pierre de Montrouge, but adapts the formula to achieve far more
compact expression and decorative effects that are clearly inspired by
Viollet-le-Duc ("Violletist", to use the term coined by the Catalans).
The interplay of brick and mitred arches also recalls both the imperial
chapel at Biarritz and the detail of the spire at Saint-Sernin in Toulouse.[11]
French rationalism influenced Catalan architects to such an extent that
it was quite natural that, when Gaudí came to build the chapel of the
Jesús-Maria college in Tarragona in 1878[12], he should take as his model
the church of Saint-Eugène in Paris by Louis-Auguste Boileau (1854).
This modern Sainte-Chapelle, with its three naves and cast-iron
columns, epitomized the interpretation of the Gothic in the industrial
era, although, at the time, Viollet-le-Duc had rather denigrated the
project.

Similarly, the 1878 Universal Exhibition in Paris, inspired by Viol-
let-le-Duc and orchestrated by his disciples, was to be the perfect
demonstration of modernity in architecture. The abundant use of glass,
iron and brick in the pavilions at the exhibition provided a long-awaited
response to the question of an "Art Nouveau" raised at the Great Exhibi-
tion of 1851. It rose above the differences between schools – the classical
versus the Gothic during the previous generation – and the issue of
whether eclecticism constituted a failure to create a genuine twentieth-
century style. The new Paris envisaged by Joseph Antoine Bouvard, Paul
Sédille and Gabriel Davioud was a fascinating place gleaming richly with
materials and colour, brick and mosaic. It was a revelation and an inspi-
ration, providing a model for the first works of Catalan modernism – the
Editorial Montaner publishing house by Domènech in 1881, and the
Casa Vicens by Gaudí in 1883.

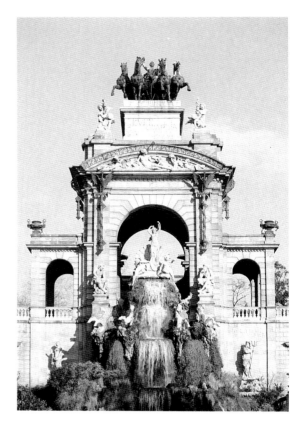

Josep Fontserè i Mestres
Fountain
Parc de la Ciutadella
Barcelona, 1875–1881
Central section

However, the influence of modernism, as opposed to the classical tradition passed down by the masters of the Academy, cannot alone explain the great diversity of work produced during the 1880s. The temperaments of the different artists working at this time of profound change were quite dissimilar, not to say contradictory. While Domènech and Vilaseca clearly belonged to the neo-Gothic tradition descended from Viollet-le-Duc and his pupils, the extreme austerity of the Palau Güell proposed by Gaudí is utterly disconcerting. The studied asceticism of the architectural references is accompanied by a determination not to be drawn into historical quotation or to succumb to an appealing décor. The building could, therefore, be viewed only as a kind of manifesto at variance with the trends of his generation. The reverse was true of the Els Quatre Gats Café, designed by Josep Puig i Cadafalch in 1895, which marked a return to decoration that was so passionate and excessive that it would itself become a new style, later to be known as "Art Nouveau". And yet Puig i Cadafalch's aim had simply been to revive a regional tradition that had been stifled by academicism. During the last quarter of the nineteenth century the latent opposition between rationalism and decorativism became apparent. Architects could exploit it by contrasting structure with finish, skeleton with décor. But the contradiction between these two approaches to form was now so blatant that synthesis was no longer capable of unifying them. Art Nouveau would attempt to find a solution to this dilemma.

Josep Fontserè i Mestres
Conservatory
Parc de la Ciutadella
Barcelona, 1883 (plan),
1887–1888 (execution)
Interior view

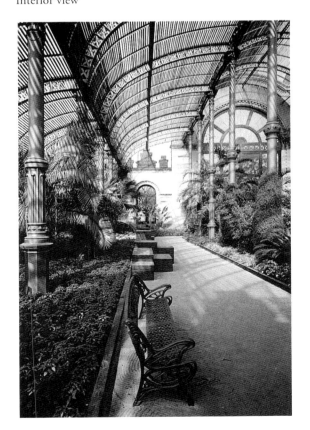

Homage to the Master of Modern Architecture

The Palau Güell (constructed by Antoni Gaudí on the Carrer Nou de la Rambla, Barcelona, between 1886 and 1889) was a meditation on medieval architecture. It was built for the wealthy industrialist Don Eusebi Güell, who had made his fortune in textiles and, having lived on the other side of the Atlantic, had a keen interest in the Arts and Crafts movement. It was Gaudí's task to create for his patron a building that would successfully combine the historicism with which he was familiar and his passion for the new.

This monumental edifice, situated on a narrow site in a heavily built-up area, impresses with the austerity of its ashlar façade, which is completely bare of sculpture. The entire composition depends on a continuous transgression of the vertical plane of alignment, the wall opening out with staggered rows of columns or projecting forward into the narrow space of a closed balcony. The idea was borrowed from the *Dictionnaire raisonné ...* by Viollet-le-Duc, where the article "Construction" shows a similar elevation (though on a more modest scale) of a medieval house in Cluny, and is followed by an imaginary restoration of a medieval gallery, based on the corridor of the Sainte-Chapelle of the Palais de Justice in Paris. When Viollet-le-Duc wrote this article he was no longer looking with the eye of an historicist, suddenly escaping from the objectivity of his references and inventing a way of managing space that was entirely his own; he would return to it at Pierrefonds in the Salle des Preuses. When Gaudí embarked on this course of architectural invention based on historicist observation, he was simply following in the footsteps of his master.

Antoni Gaudí
Palau Güell
Façade on the Carrer Nou de la Rambla
Barcelona, 1886–1889

ABOVE:
Elevation
LEFT:
Entrance porch
FACING PAGE:
View from below

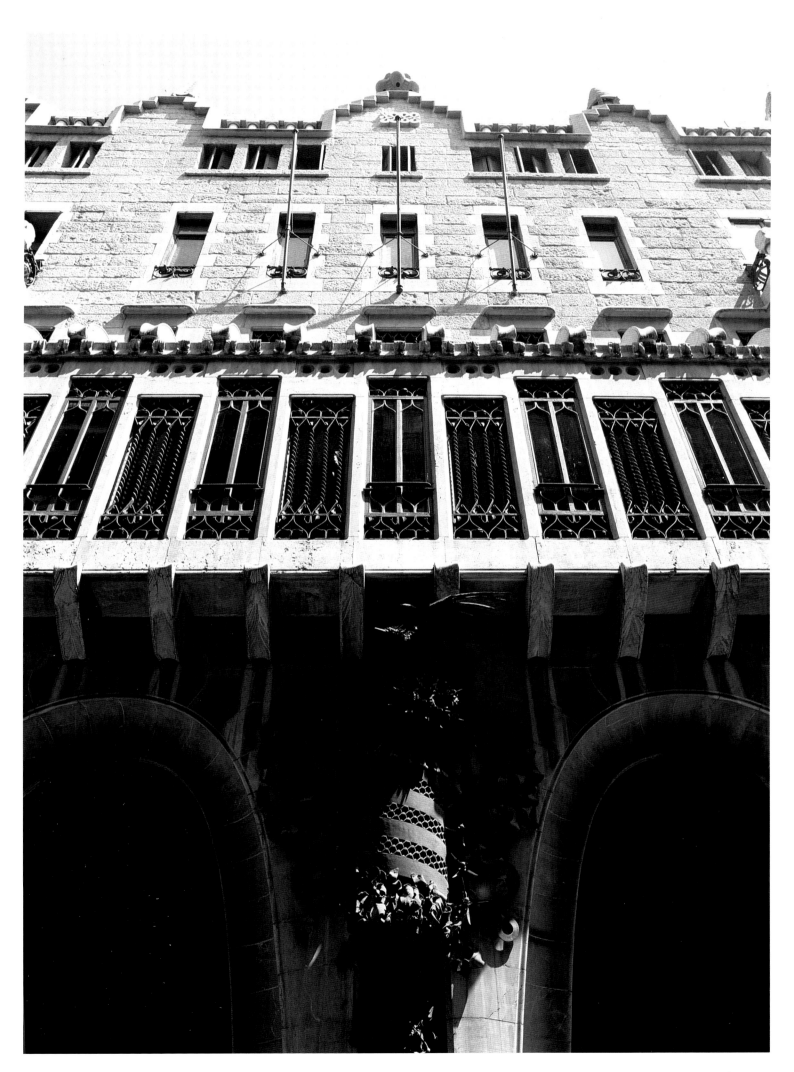

Left:
Eugène Viollet-le-Duc
Dictionnaire raisonné ..., 1854–1868
Palais de Justice, Paris
Connecting gallery, 13th century

Right:
Eugène Viollet-le-Duc
Dictionnaire raisonné ..., 1854–1868
12–13th century house in Cluny
Façade wall seen from within

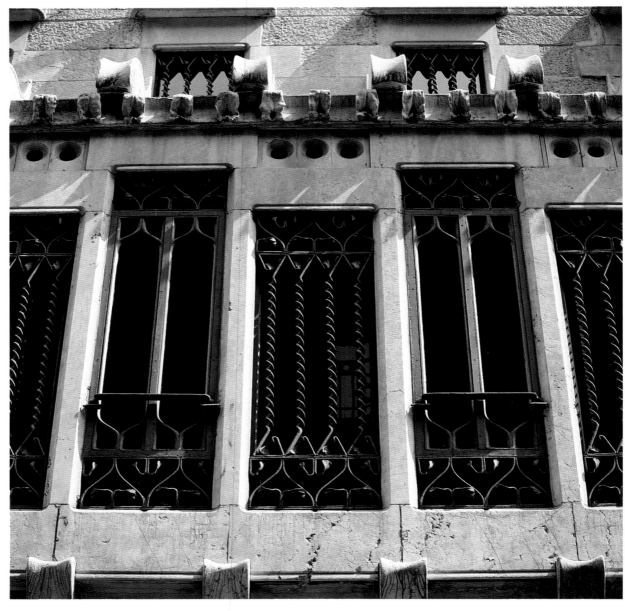

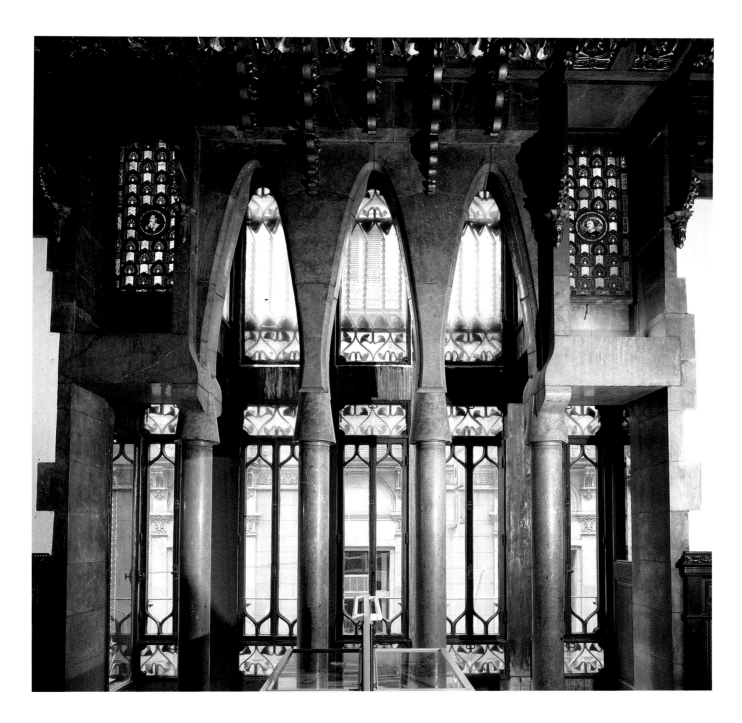

Facing Page Below:
Antoni Gaudí
Palau Güell
Barcelona, 1886–1889
Loggia windows

Antoni Gaudí
Palau Güell
Barcelona, 1886–1889
First-floor living room, Loggia arches

Above:
Front view
Right:
Interior view from below

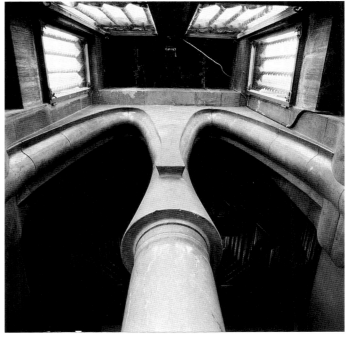

The same is true of the Palau Güell's interior: the strange Palladian design of the large central chamber is unexpected in a disciple of the neo-Gothic, though not if one is familiar with the work of Viollet-le-Duc. In the nineteenth of his Entretiens ... he contemplates an English-style country house (inspired by Warkworth House) in which everything is arranged around a vast central hall that encompasses the stairs and is crowned by a lantern. The architect praises the compact nature of this arrangement and the rationality of having communications based around a focal well. In the extraordinary hall of the Palau Güell Gaudí merely made use of a model created by the master of French neo-Gothic. He did, however, adapt it to his Mediterranean culture by incorporating the decorative detail of the Mirador de la Reina (c. 1362) from the Alhambra palace in Granada.

He completed his design with two impressively original areas: the underground stables (their ventilation system again appears to have been borrowed from Viollet-le-Duc, while the vaulting on springing stones and the brick tile arches show evidence of a careful study of the article "Construction" from the *Dictionnaire* ...) and the roof spaces with their amazing elliptical skylight and medieval-inspired chimneys, which create a sculptural landscape of a quite fantastical nature and give the first sign of a mystical tendency (a reinterpretation of the hill of Calvary) that would later dominate Gaudí's career.

This historicist modernism – if such a strange term is possible – is also clearly reflected in the Bishop's Palace at Astorga and Les Teresianes college in Barcelona. This time Gaudí finds inspiration in the kitchens and infirmary at the Abbey of Sainte-Marie de Breuteuil (also from the *Dictionnaire* ...). He makes use of the simple rectangular space and the row of columns to create symmetrical divisions but alters the central shaft by creating a narrow light well similar to that in the Palau Güell. The detail of his architectural expression now breaks free from historicist quotation and focuses almost entirely on the plastic effects he can achieve with parabolic brick structures – a logical development from the Gothic vault. For Gaudí the *Entretiens* ... were a springboard for the remarkable liberation of his plastic expression, which from now on owed nothing to literal quotation.

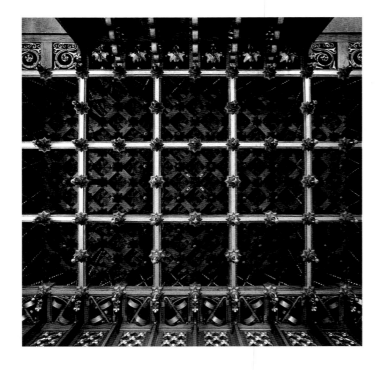

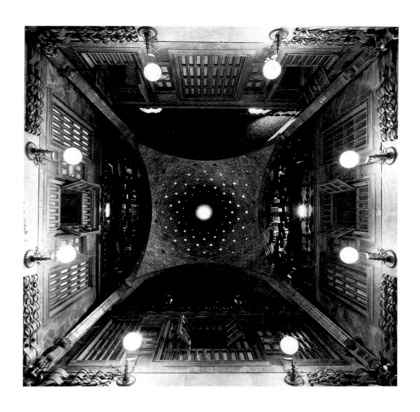

Antoni Gaudí
Palau Güell
Barcelona, 1886–1889

FACING PAGE ABOVE:
Cross section
First-floor living room

FACING PAGE BELOW:
Ceiling detail
RIGHT AND BELOW:
Cupola in the central hall

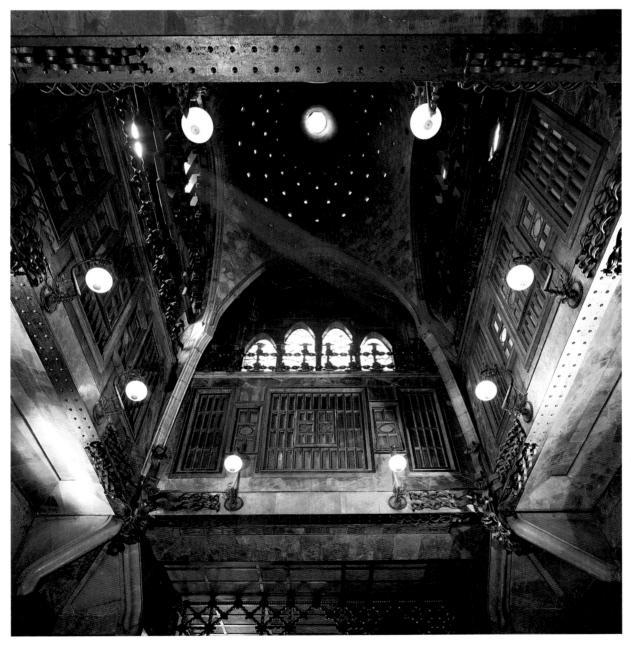

Antoni Gaudí
Les Teresianes college
Barcelona, 1889–1894
South-east façade

FACING PAGE ABOVE LEFT AND BELOW:
General view and windows
FACING PAGE ABOVE RIGHT:
Cross section
ABOVE:
First-floor gallery

Constructive Rationalism

The passion demonstrated by the Catalan architects for the constructive rationalism of the French historicist school was not always as radical as that shown by Gaudí at the start of his career. For most architects the wall alone provided sufficient focus for their architectural expression and allowed the use of a conventional decorative rhetoric which focussed on the recurring theme of dialogue between masonry and wall space, the framework and the panel or between the skeleton and the infilling. The wall was no longer an expressionless piece of masonry, but now had jambs and arcades with aperture casings and recessed compartments created for purely decorative effect. One can sense the delight in the materials: the contrast between brick and quarry stone, between ashlar and tile or rendering. A network of graphic line and coloured ornamentation created a register of detail contrasting with the shadows cast, on a larger scale, by the framework of the wall itself. A pure exercise in expression, this formal rationalism was nevertheless extremely elaborate and, at times, not dissimilar to the "Third Republic style" in vogue for the architecture of hospitals and schools on the other side of the Pyrenees. Both shared the same admiration for the concepts of Viollet-le-Duc and his disciples.

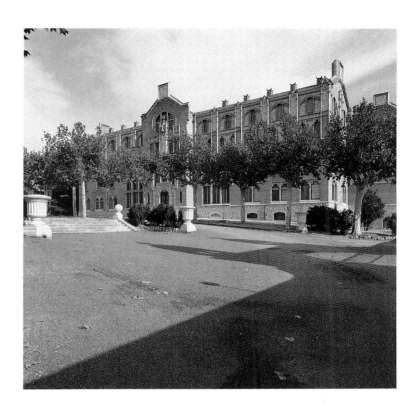

Camil Oliveras i Gensana
Casa Provincial de Maternitat
Barcelona, 1889–1898
Ave Maria building, North-east façade

Facing Page Above:
View of the entrance
Facing Page Below:
Windows

Right and Below:
Lluís Domènech i Montaner
Pere Mata Institute
Reus, 1897–1919
V.I.P. Building, West façade
General view and detail

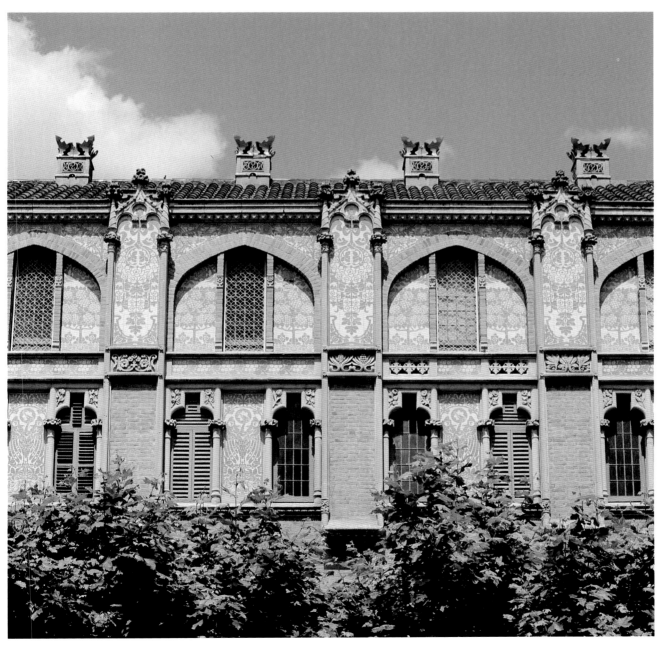

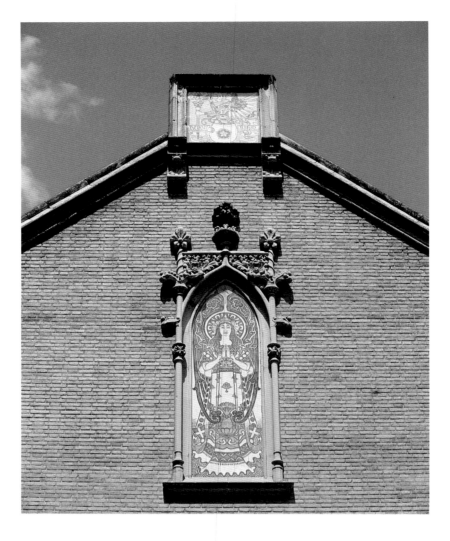

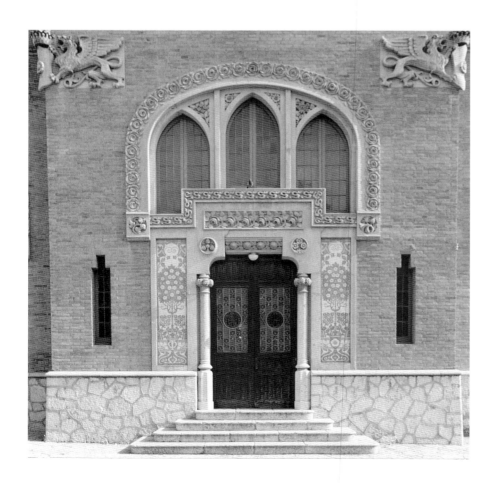

Lluís Domènech i Montaner
Pere Mata Institute
Reus, 1897–1919
V.I.P. Building, west façade

FACING PAGE ABOVE:
Side gable feature
RIGHT, FACING PAGE CENTRE
AND BELOW:
Windows and entrance

BELOW:
V.I.P. Building, east façade
Upper gallery window

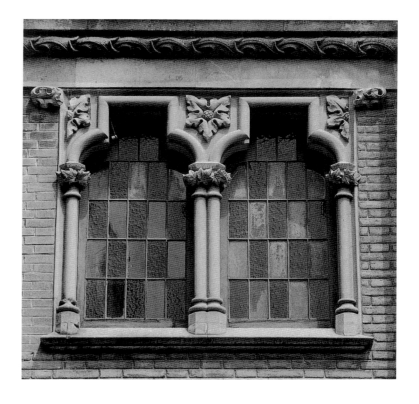

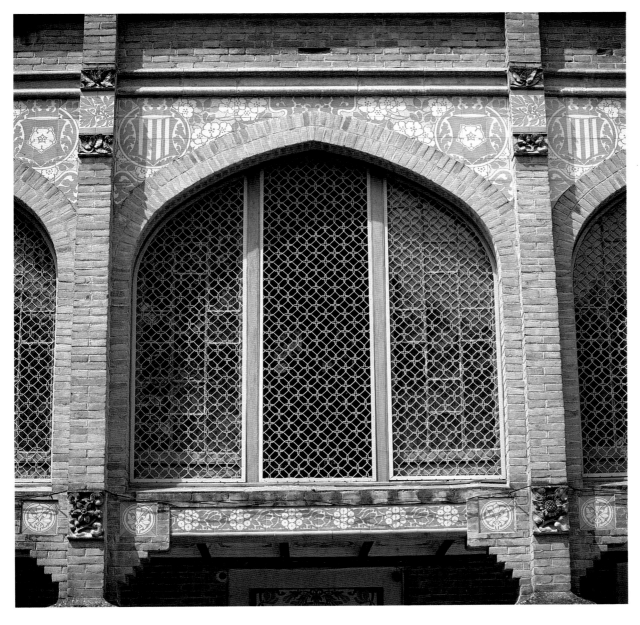

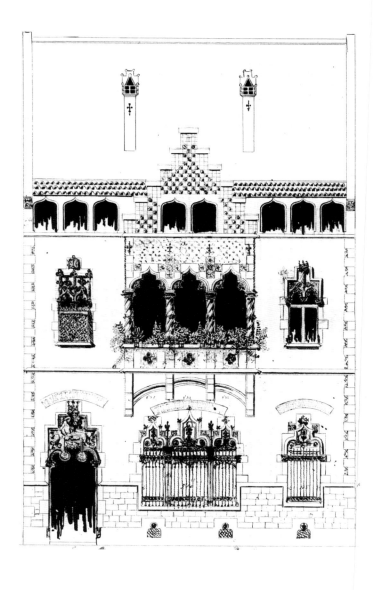

Regionalist Historicism

Although at first the rediscovery of historical architecture had revealed a neglected heritage of abbeys and châteaux under threat from contemporary economic and social developments, it soon became the focus for national and regional identity, which embraced this cultural heritage as the ideal medium in which to express itself. In the Europe of Nations history became a powerful lever. Historicism, both a faithful reflection and an embodiment of the political concerns of a generation, emphasized one or another aspect of the nation's heritage and played a major role in strengthening the image of the political or ideological movements that it reflected.

It is therefore not surprising to see the importance that the historicist movement had for Catalonia. The start of the movement coincided with the restoration of Alfonso XII in 1875 and the birth of the Catalan sense of identity. Catalonia was in economic and political terms the most advanced region in Spain. The essence of this cultural identity was embodied in the celebrated historicist Josep Puig i Cadafalch who, before going on to represent his region in the Mancomunitat of Catalonia (of which he was president from 1917 to 1923), was one of the outstanding exponents of Catalan Art Nouveau. An intellectual connected with the artistic avant-garde of Barcelona, Puig i Cadafalch was the chosen architect of the city's financial circles and in 1917 began the impressive plan to develop the Montjuïch hill for the electrical industries exhibition. Although he was a regionalist he nevertheless believed that the development of Catalonia must take place within the context of Spain as a whole and was strongly opposed to provincial autonomy.

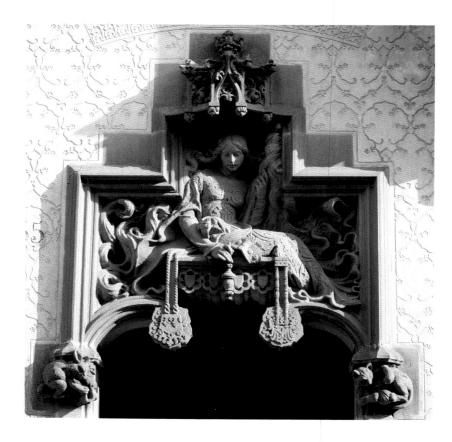

Josep Puig i Cadafalch
Casa Coll i Regàs
Mataró, 1897–1898
Façade on the Carrer d'Argentona

Facing Page Above:
Elevation
Facing Page Below:
Pediment over entrance
Right:
Small window pediment
Below:
Central gable

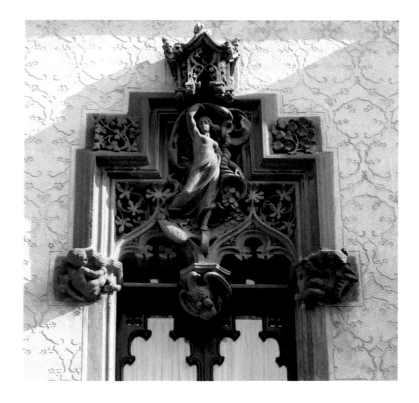

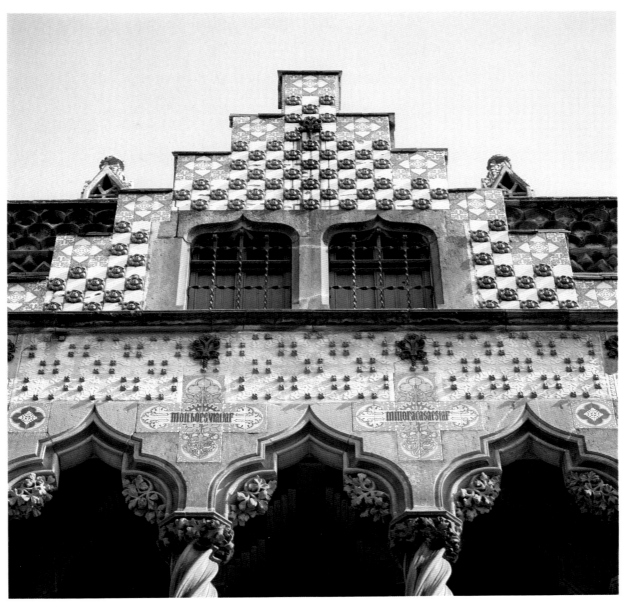

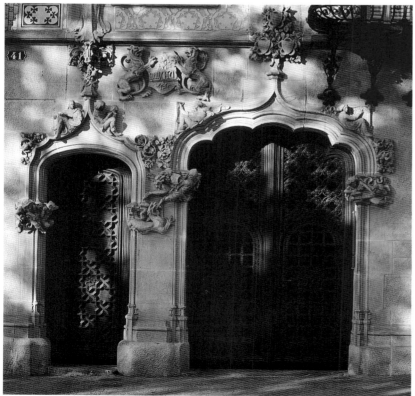

Josep Puig i Cadafalch
Casa Amatller
Barcelona, 1898–1900
Façade on the Passeig de Gràcia

ABOVE:
First-floor window
LEFT:
Pedestrian and carriage entrances
FACING PAGE ABOVE:
Second-floor window
FACING PAGE BELOW:
Elevation

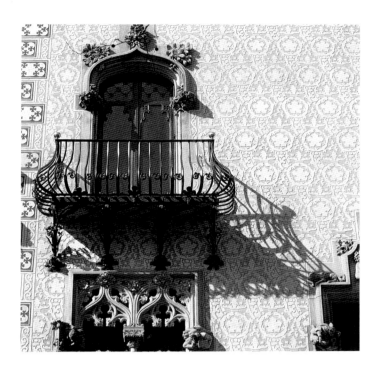

His position as a moderate led to his disappearance from the political scene under the dictatorship of Primo de Rivera, and then to his exile during the Spanish Civil War. He returned to Catalonia only in 1941 and devoted himself to writing an in-depth study of *L'Art wisigothique et ses Survivances,* which was published after his death, in 1961.

Puig i Cadafalch's artistic achievements display the same ambiguity as his political opinions, shifting between centralism and separatism. He was passionate about Gothic art but was only influenced by one, remarkable period, that of the Catholic monarchs at the end of the fifteenth century, which was also the time of national unification. Although he studied Romanesque architecture, this was really a prelude to his study of the era of the Visigoths, the first centralizing power in medieval Spain. Through skilful rhetorical subterfuge he forcefully asserted that Spanish art in fact had its roots in Catalan art, and could thus justify the paradox of producing regionalist art in a national style. A comparison between his work (which focuses principally on late Gothic) and that of Gaudí (whose influences were the austere and monumental art of thirteenth- and fourteenth-century Catalonia) reveals, implicitly, the fundamental difference between regionalists and separatists within the intellectual élite. This aesthetic divide reflects the social and political division between the Catholic, traditionalist milieu (to which Gaudí belonged) and the world of upper middle-class commerce. Each found the art that best suited it. Alongside the haughty grandeur of Catalan architecture appeared the more varied charms of middle-class Gothic with its Flemish and German influences.

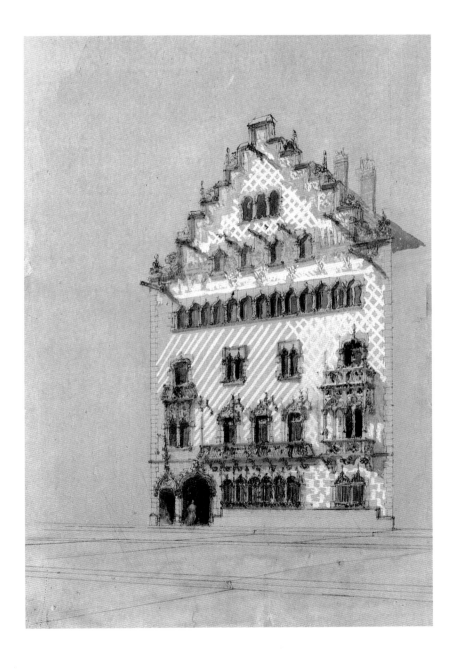

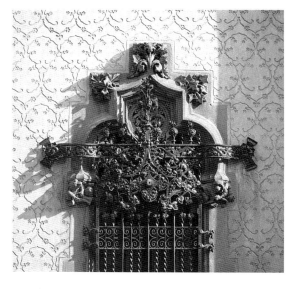

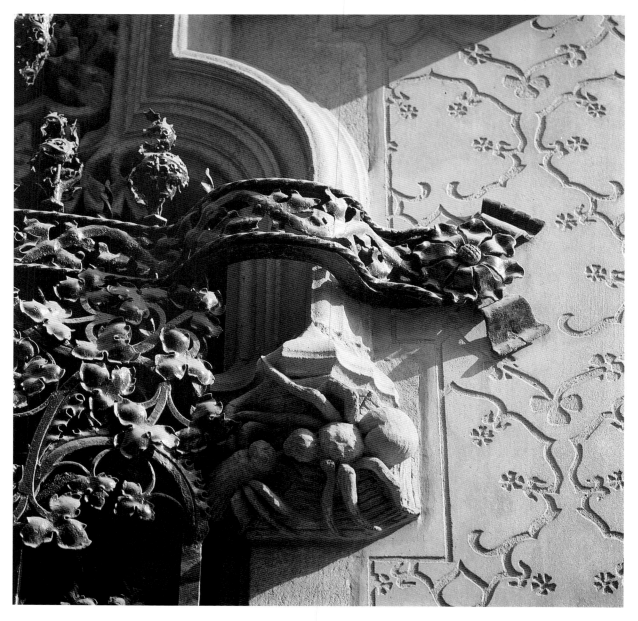

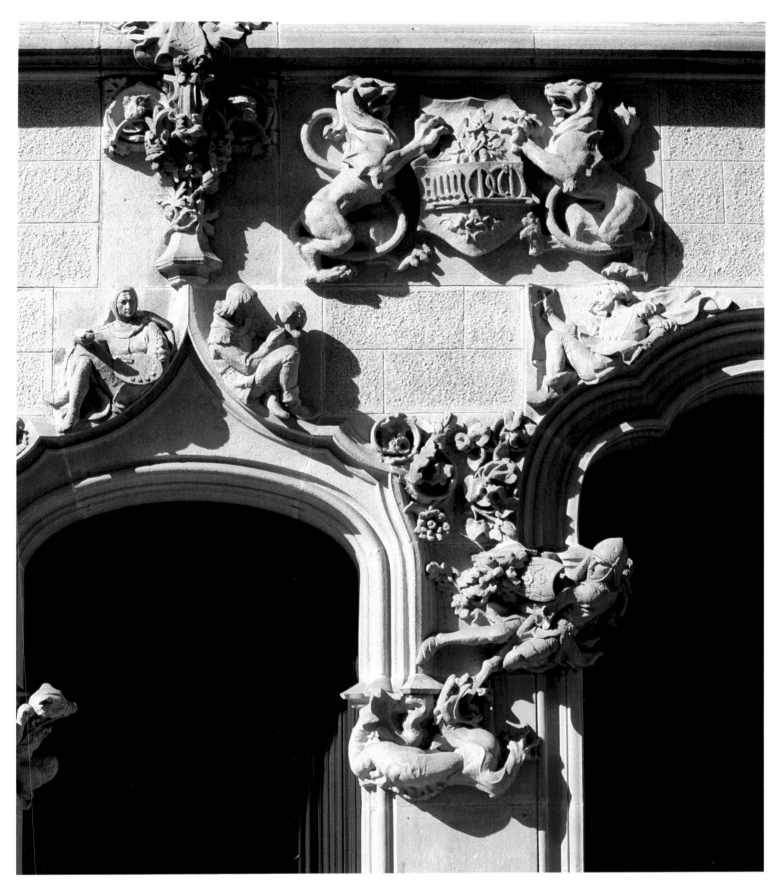

FACING PAGE:
Josep Puig i Cadafalch
Casa Coll i Regàs
Mataró, 1897–1898
Ground-floor windows
Sculptures by Eusebi Arnau i Mascort,
wrought iron by Manuel Ballarín and
Esteve Andorrà

ABOVE:
Josep Puig i Cadafalch
Casa Amatller
Barcelona, 1898–1900
Pedestrian and carriage entrances, details
Sculptures by Eusebi Arnau i Mascort,
ornamentation by Alfons Juyol

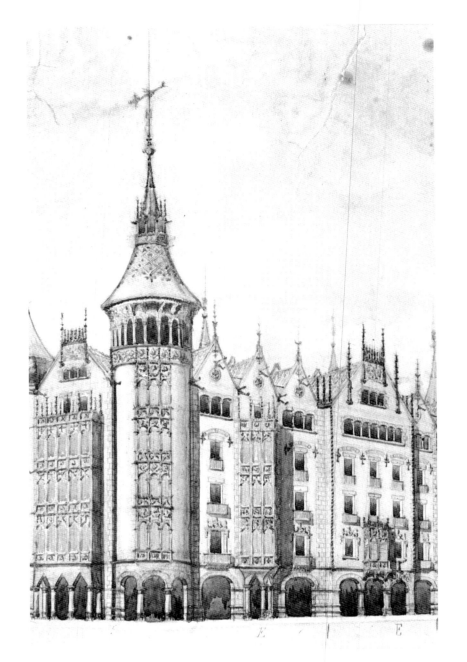

Architectural Language in the Urban Landscape

Building private mansions with the appearance of more modest middle-class houses on the grand avenues of the city was, in itself, a considerable challenge. Constructing rental apartments in the new *Eixample* district was yet more so, but this was the task to which Puig i Cadafalch set his mind and his undoubted talent. The architectural language he chose was not the traditional controlled architecture of fascias and cornices inherited from Haussmann but one based on the vertical and accentuation of the outline – gables and pepper-box turrets – and with a halting metre that recalled the rhythm of medieval houses. His task was made all the more difficult by the fact that the interior had to be divided into separate apartments on a floor-by-floor basis. While the danger of exposing a succession of individual plots could be avoided, the features of the outline would reveal the internal arrangements, a functional analysis that objectivized the historical reference as in the Amsterdam Stock Exchange, where the pattern of the gables made the internal division into offices apparent.

Within Catalonia the originality of this architectural language provoked a very lively reaction from critics. On 10 November 1907 Alejandro Lerroux published an article in *El Progreso* entitled "Separatismo y Arquitectura". This vindictive piece accused Puig i Cadafalch of committing a "crime against the unity of the nation" and cited in particular the motto that accompanied the figure of Saint George on the pediment of one building, which proclaimed, "Patron Saint of Catalonia, restore to us our liberty". Aside from these purely political criticisms, this adaptation of the medieval repertoire to the architecture of modern buildings was a success. The twin legacy of the French historicist school here came into its own, producing buildings that demonstrated both functional efficiency and historicist sources.

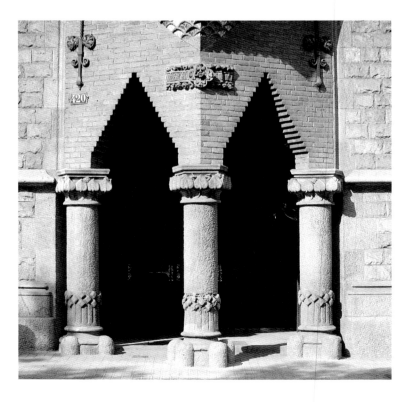

Josep Puig i Cadafalch
Casa Terrades or "de les Punxes"
Barcelona, 1903–1905
Façade on the Avinguda Diagonal

Facing Page Above:
Perspective view
Facing Page Below:
Main entrance
Right and Below:
Oriel window details

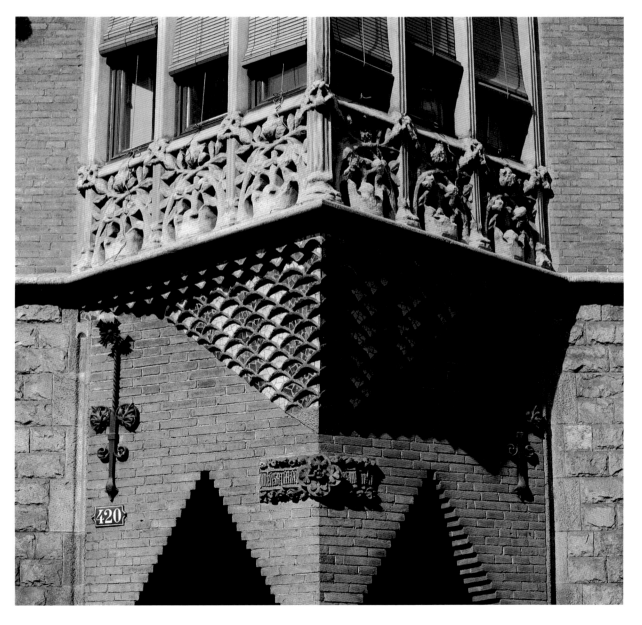

Above, Left and Facing Page:
Josep Puig i Cadafalch
Casa Terrades or "de les Punxes"
Barcelona, 1903–1905
Façade on the Avinguda Diagonal
Ceramic features on gables

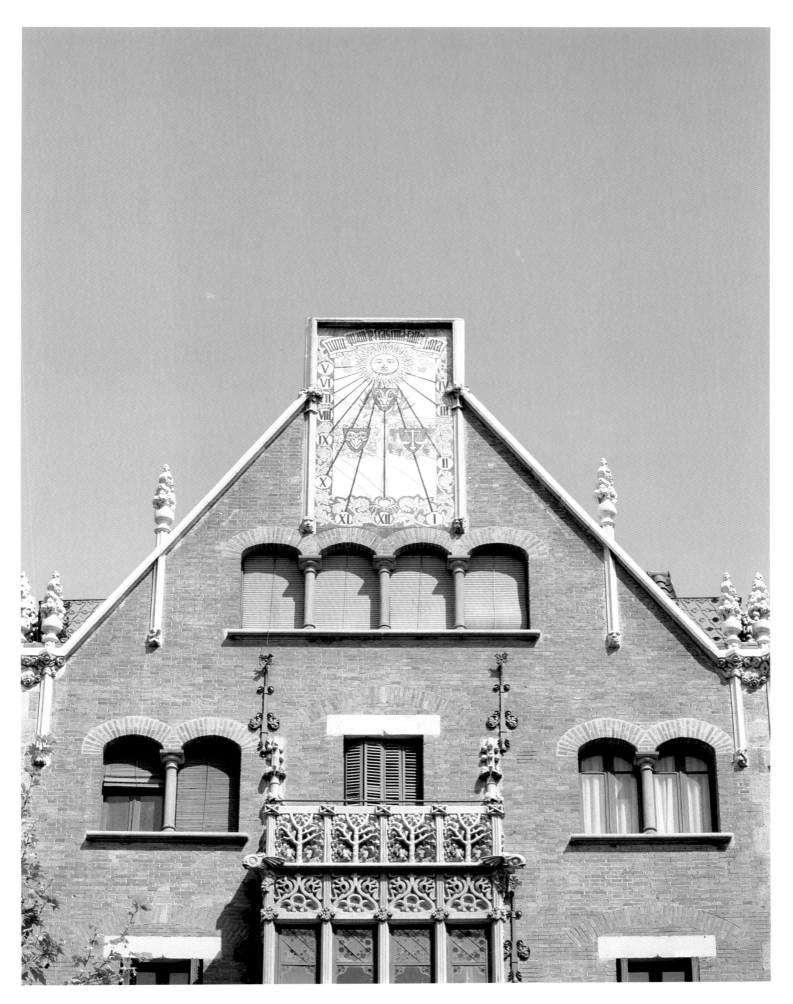

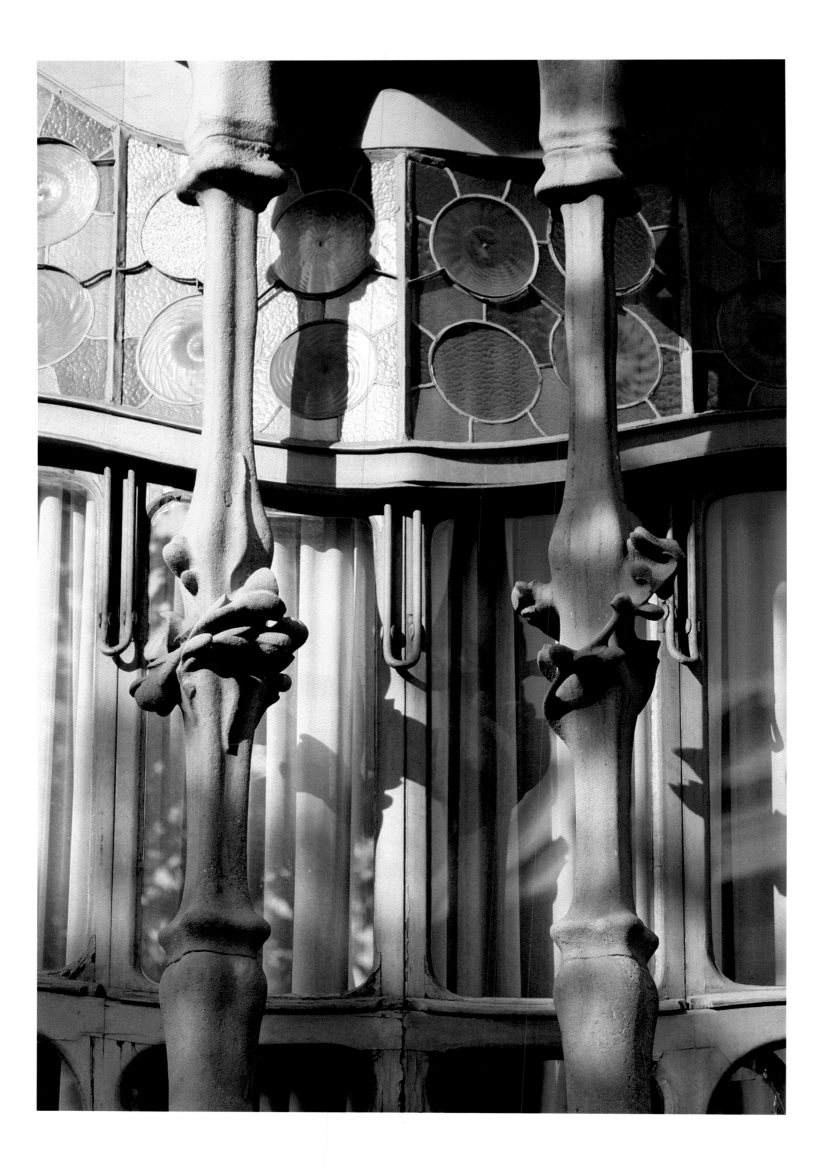

3

ART NOUVEAU

Did Art Nouveau really exist in Barcelona? This is a question that needs to be asked, particularly since Catalan historians classify artistic trends at the end of the nineteenth century and in the first third of the twentieth century under the single heading of "modernism". This period, which began with the restoration of King Alfonso XII in 1875 and ended with the Spanish civil war in 1936, was a long and varied one. It might well be argued that the succession of different and often contradictory artistic movements was less important than the overall unity of an avant-garde that both challenged the past and sought to create a new language appropriate to the demands of the modern era.

However, another possible approach – and one that has been taken for some years now[1] – is to focus on the development of these successive trends, which were reflections of international movements (but each with its own values, references and plans) rather than treat them as one movement combined together under a single and over-reductive title. In fact modernity, though a global force in contemporary art, took up many finely differentiated positions in its struggle against the academic tradition inherited from classicism and, from one generation to the next, this radically altered the nature of the movement. The analytical view of architectural language taken by the rationalists as successors to the French diocesan school in the 1880s was opposed to the desire for plastic unity that was soon to be demanded by the Art Nouveau movement. And Art Nouveau, with its passion for the decorative, had little in common with the formal austerity of the modern twentieth-century school of architecture which, strictly speaking, is usually referred to as modernism.

This development, which began at the end of the 1880s (and which would soon lead to the recognition of an Art Nouveau movement) relied on a strange but successful combination of nationalism and regionalism and regionalism and decorative art. The main demand of the time was for liberty, for freedom from the traditional constraints imposed by classical order and its conventions. And, this being the case, it was impossible for Art Nouveau ever to become a unitary force, even though it may often have been tempted. The key to the movement was freedom of individuality and the proliferation of forms of expression. Each work would be unique, distinctive, a skilful blend created by the unique chemistry of the contradictory elements that produced it. Specificity became far more important to architectural expression than the respect for the norm that had been dominant for so long.

The link between individual freedom and artistic freedom is obvious and has long been demonstrated. However, individual freedom can be easily confused with a people's right – as a group of individuals – to

self-determination. Art therefore became both an expression of the individual and of the group to which that individual belonged. It soon had to act as arbiter in those conflicts that were bound to arise between the legitimate expression of individuality and the consensus essential to the group, namely between anarchy and totalitarianism. This question is at the centre of the debate on Art Nouveau. Was it the spontaneous burgeoning of a creative imagination freed from all constraint or a desperate attempt to maintain a formal consensus between overtly different types of expression?

The ambiguity of this debate within modern art is reflected in its muddled concept of the relationship between nationalism and regionalism. Let us return once more to Viollet-le-Duc, the voice of the artistic avant-garde: "While it may be right for art itself", he wrote, "to have no nation, each expression of art must have a national origin, and can only be considered as art where this is the case"[2]. The debate on nationalism and internationalism[3] had begun but the door remained open to regional expressions of culture, some of which could well be at odds with national trends. Although there was general agreement about the need to reject any imposed artistic norm, it would prove more difficult to decide the limits of the different cultural regions, as there was far more at stake than the simple matter of artistic expression. By determining the group image, a cultural region determines the existence of the group and, to some extent, the way it is represented.

The notion of "regionalism", so close to the heart of Catalan tradition, could not escape this contradiction, which mirrored the relationship between the province as a whole and the central power in Madrid. In 1855 the Catalan politician Duran i Bas referred for the first time to the originality of his region in an article entitled "Catalanismo no es provincialismo", which became a springboard for political regionalism in Catalonia. The creation of the Jocs Florals in 1859 revived an ancient medieval tradition and reflected an awareness of Catalan individuality in the context of Spain as a whole.[4] The Café-restaurant designed by Domènech i Montaner for the Universal Exhibition of 1888 became a concrete symbol of these ambitions. The language of the building remained neo-Gothic – influenced by the American architect Frank Furness[5] – and the constructional element openly rationalist. However, from behind the exterior of this four-towered castle, its battlements decorated with majolica shields, the intrinsically Catalan nature of its design shone through, inspired by authentic examples of regional art. Architects attending the national architects' conference in Barcelona that year referred for the first time to the topic of "artistic regionalism"[6] and were right to do so.

The way was open and during the years that followed it would be exploited by the historicist architect Josep Puig i Cadafalch, who popularized the notion of artistic regionalism in three successive articles that appeared between 1891 and 1893.[7] However, his interpretation of this trend was by no means as regionalist as he claimed. By concentrating on the study of décor and referring back to an historicist culture that was far more Spanish than Catalan, Puig shifted the debate from regionalism to Art Nouveau. It is obvious that he was more interested in ornament for its own sake than as an expression of any sort of Catalan identity.

Lluís Domènech i Montaner
Café-restaurant at the Universal Exhibition or "Castell dels Tres Dragons"
Barcelona, 1887–1888
Majolica shields motifs by Alexandre de Riquer

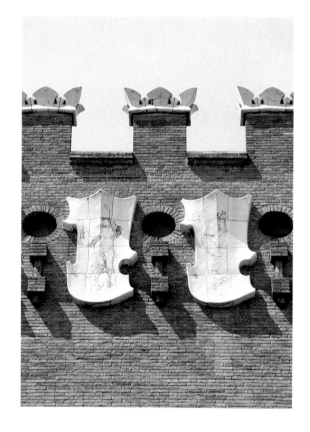

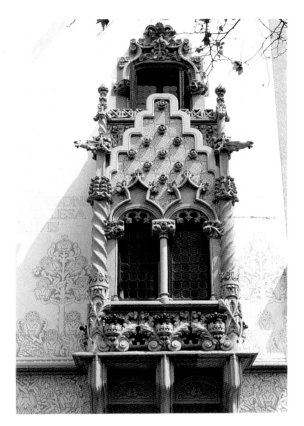

Josep Puig i Cadafalch
Casa Macaya
Barcelona, 1898–1901
First-floor loggia
Ceramics by Pujol i Bausis

He was a modernist, and the importance he attributed to originality in creation rather than the exact nature of its sources meant that he remained one. For him the medieval references were part of the rules of the game, providing a basic compositional model, a starting point from which everything was possible. The influence of the Anglo-Saxon Arts and Crafts movement can be seen in every stroke, as if Ruskin or William Morris had personally guided his hand. Influence from abroad spread with the monthly journal *The Studio*, which played a key role in the birth of Art Nouveau.

The first work by Puig i Cadafalch, the Casa Martí i Puig, housed the Els Quatre Gats café, which became the meeting-place for Barcelona's artistic avant-garde. Here the architect remained faithful to a flamboyant neo-Gothic style similar to that used by Domènech i Montaner or the young Gaudí. It was only some time later, when designing the Casa Coll i Regàs and the Macaya and Amatller houses that he demonstrated his passion for decoration, making almost immoderate use of polychrome tiling and sgraffiti. It was the Els Quatre Gats café[8], however, established by Pere Romeu in imitation of the Chat Noir café in Paris, that remained the symbol of the Catalan artistic renaissance. With décor by Ramon Casas, it counted among its daily patrons Santiago Rusiñol, Miguel Utrillo, Raimon Casellas and Enric Clarasó. The menus were designed by the young Pablo Picasso, who made his début there.

Josep Puig i Cadafalch appears to have been completely unaware of the way in which the Art Nouveau movement was developing in Brussels and Paris during these years. His architecture did not show the influence of Horta, nor of Van de Velde (whose work he almost certainly did not know) but rather that of William Morris and Richard Norman Shaw or even perhaps William Burges and George Gilbert Scott, who had been the masters of the previous generation. The influence of William De Morgan, a ceramicist from the Century Guild, founded by Mackmurdo in 1882, is also apparent in his tiling for the Casa Coll i Regàs, the first of his mature works.

Was Puig ever influenced by the floral style of Art Nouveau? To look at his work one would say not. But this is not the whole story. Like Horta and Van de Velde in Belgium, but using a different repertoire, Josep Puig was clearly part of the movement to revive the decorative arts that was so important during the second half of the nineteenth century. And this is where the problem lies: it was not simply a matter of exploiting the new materials available, which offered far greater possibilities than traditional building methods allowed, but of finding products that could satisfy the period's fascination with the repertoire of ornament. In the classical tradition decoration was merely used to interpret a discourse based on the celebration of a unified system of proportion which itself reflected the hierarchical nature of the building within society. Now that these conventions had been shattered, freedom of form emancipated decoration from these rules of propriety. Ornamentation existed in its own right, totally independent of structure or function. It was a matter of pure pleasure, of form for form's sake.

The completely arbitrary nature of this development opened a world of opportunity for décor. It was not by chance that, from the middle of the century onwards, there was a major increase in publications special-

izing in the repertoire of ornament and its history. First to enter the lists was Owen Jones, whose *Grammar of Ornament* was published in London in 1856 following on from the Great Exhibition of 1851. He was followed by Christopher Dresser, whose *Principles of Decorative Design* appeared in 1873, and by Gottfried Semper, who in 1860 published *Der Stil*, which gave an account of the theoretical foundations of the modern movement and the major role assigned by it to ornament.

Teachers from the Department of Practical Art in London thus opened the way to the historical studies that would become a French speciality: *L'ornement polychrome* by Albert Racinet began publication in Paris in 1869 whilst the *Deuxième série de l'Ornement polychrome* appeared in 1885. There was an increasing receptiveness to non-Western art forms: *L'art arabe d'après les monuments du Kaire…* by Achille Prisse d'Avennes, 1869–1877, *Les Arts arabes* by Jules Bourgoin, 1873, *Architecture et décoration turques au XV* siècle* by Léon Parvillé with prefaces by Viollet-le-Duc, 1874. In 1877 Viollet-le-Duc himself produced a work entitled *L'art russe*, having written the preface to another surprising work, *Cités et ruines américaines* by Désiré Charnay, 1863. Anglo-Saxon authors added to the studies of Far-Eastern art with: *The Grammar of Chinese Ornament* by Owen Jones, 1867, *A Grammar of Japanese Ornament* by Thomas W. Cutler, 1880 and *The Ornamental Arts of Japan* by George Ashdown Audsley, 1882.

The numerous studies of the ornamental repertoire through the ages were a valuable source for the Arts and Crafts movement. The wealth of examples gave artists working at the turn of the century remarkable freedom and allowed the utmost sophistication in their work. The decorative arts, elevated to the rank of a major art form, now became in their own right exercises in plastic expression – on the same level as historical painting or allegorical sculpture. The artists gave the best of themselves, certain of being understood and appreciated.

In Catalonia the passion for ornament was to acquire a special significance. In France art was taken over by the ornamental approach derived from the Gothic tradition and the lavish design of profiles and linkages in architectural mouldings turned Art Nouveau into a kind of "flamboyant Louis XV style" that was subtle yet excessive. Catalan architecture followed a different path, that of ceramic ornamentation, which had its own, long-established rules based on the Muslim concept of abstract geometrical decoration. The reinterpretation of this traditional eastern art form via Mudejar art gave it a new actuality and new meaning and it thus became an emblem of Spain's individual identity within Europe as a whole. Combining it with the rules of Gothic decoration would do the rest, creating a perfectly coherent system in which the imitation of nature became an integral part of a purely geometrical concept of form – Villard de Honnecourt reinterpreted by Eugène Grasset … . Blessed by these advantages, the Art Nouveau artists of Barcelona were able to be both profoundly modern and scrupulously historicist, adopting both the Gothic and the Japanese styles. But, above all, they were Catalan and their numerous sources remained subordinate to their specific cultural intention, which was to bring about a genuine renaissance of their own regional traditions.

Catalan Art Nouveau was late to develop, only blossoming in the

Adolf Ruiz i Casamitjana
La Rotonda
Barcelona, 1906–1918
Belvedere
Mosaic by Lluís Bru i Sallelas, ornamentation by Alfons Juyol

final years of the nineteenth century. Its development was on an impressive scale, however, and it managed to withstand the rapid obsolescence the movement suffered in other countries of Europe. Although the Turin exhibition of 1902 was generally held to be the swan song of the Art Nouveau movement – soon to be replaced by other, less decorative tendencies – it would seem that Catalonia continued uncompromisingly along the path laid out by the modern school and was determined to explore all aspects of the movement, regardless of developments taking place elsewhere in Europe. The surprising insularity of the Mediterranean region was to make the 1900s in Catalonia one of the most significant periods of Art Nouveau.

The Casa Lleó Morera (1903–1904) and the Palau de la Musica Catalana (1905–1908), both by Domènech i Montaner, are not late manifestations of a movement in decline, they are the most beautiful and most significant works of their time as are Gaudí's Casa Batlló and Casa Milà. Domènech worked together with Josep Pey and Joan Carreras on the Casa Lleó Morera to create a total work of art – the ideal to which Art Nouveau aspired – blending architecture, furniture, stained glass and painted décor into one complete whole that would be a triumph for the decorative approach. No less brilliant is his achievement in the Palau de la Musica Catalana, where he worked with the sculptors Miguel Blay and Eusebi Arnau and the ornamentalist Lluís Bru, creating spectacular effects such as the flight of winged horses on the ceiling and the Allegories in relief on the apse.[9] This decorative virtuosity, which at last managed to blend architecture and ornament into one inseparable whole (contrary to the rationalist approach of the previous generation), reached perfection in the works created by Gaudí after 1900. From the Parc Güell via the Casa Batlló and Casa Milà to the Sagrada Família, Gaudí's work displays in the dynamics of its form, the unity of a purely plastic concept in which décor and structure are governed by a common law overriding all those contradictions that had haunted architects for half a century.

Ignasi Mas i Morell
The "Monumental" Bullring
Barcelona, 1915–1916
Stair tower
Mosaic by Mario Maragliano

The New Architecture

The abandonment of the classical rules of composition established by four centuries of use was a cultural turning point just as important and just as demonstrative as the Renaissance had been in relation to medieval traditions. The style of architectural language that gradually became established during the nineteenth century and that Art Nouveau would bring together focused on the expression of internal function through the treatment of space, scale, distribution and connection, the entire theory of which is contained in that bible of modernity, the Entretiens … of Viollet-le-Duc. It was the new architecture that appeared in Chicago and Brussels (Sullivan and Wright, Hankar and Horta) that made it possible for the "Catalan Renaissance" to take off.

This can be clearly seen in the work of Domènech i Montaner, who, first in Reus and then in Barcelona, applied its principles in a more generalized way. The classical façade had been a curtain of stone, divided by convention into three sections (the basement, piano nobile and crown), combined by the systematic alternation of solids and spaces of equal value. The urban façade was simply one vast piece of décor which was given the appearance of a noble dwelling infinitely repeated down the long vistas of thoroughfares. Art Nouveau architecture, however, demanded freedom of composition and individuality for the façades that it created. The "block of discord" on the Passeig de Gràcia is a perfect demonstration of this system where the aesthetically different façades (by Domènech, Puig and Gaudí) standing side by side must have seemed very strange to those brought up in the tradition of classical urban order.

Variations on the treatment of façades

ABOVE:
Josep Vilaseca i Casanovas
Casa Enric Batlló
Barcelona, 1891–1896

LEFT:
Antoni Rovira i Rabassa
Casa Josep Codina
Barcelona, 1898

FACING PAGE BELOW:
Jeroni F. Granell i Manresa
Casa Jaume Forn
Barcelona, 1904–1909

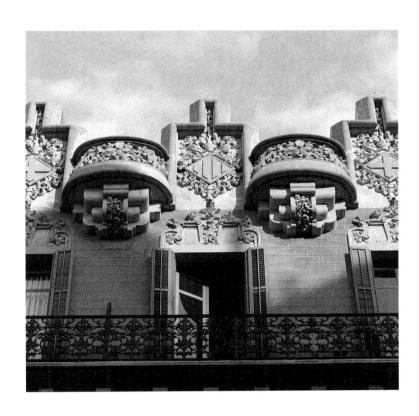

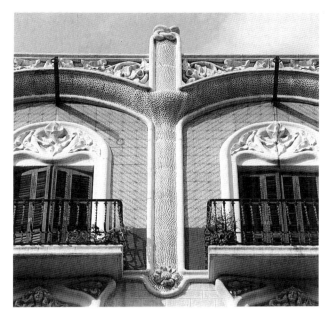

ABOVE:
Jeroni F. Granell i Manresa
Casa Rossend Capellades
Barcelona, 1904–1906

LEFT:
Adolf Ruiz i Casamitjana
Casa Llorenç Camprubí
Barcelona, 1900

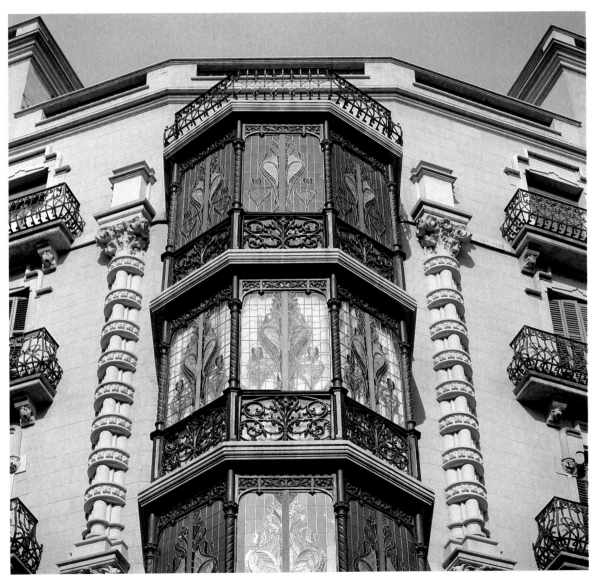

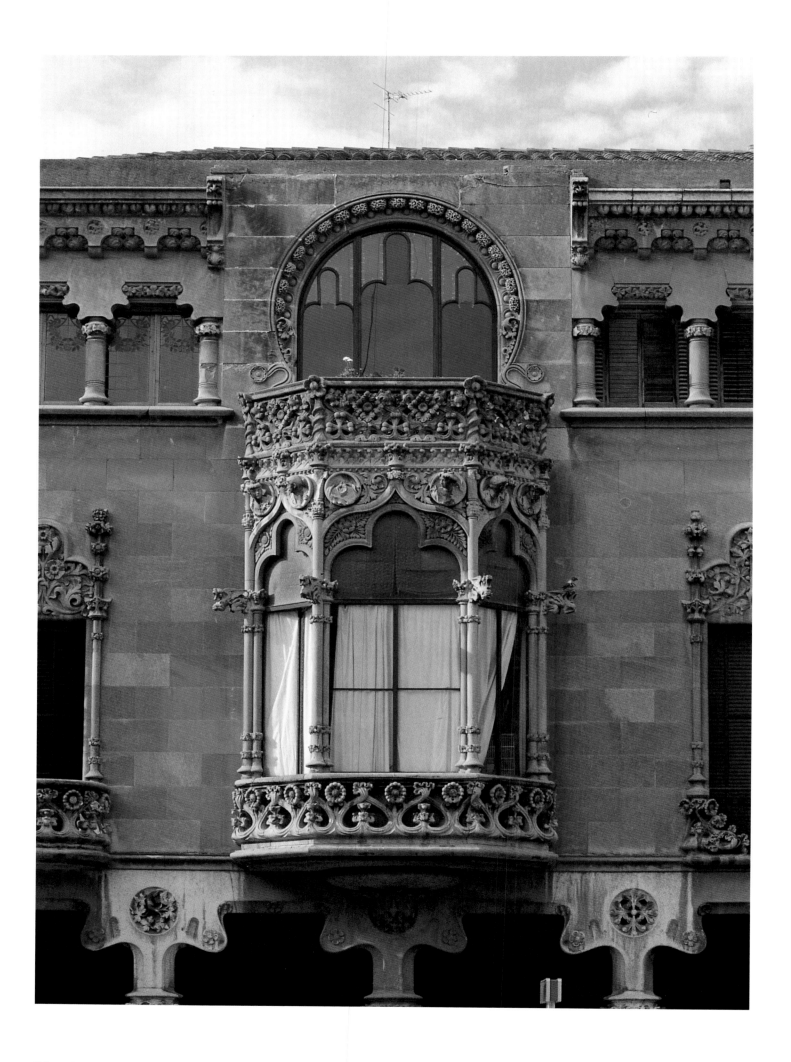

Corner windows, windows in rows, round windows, bressumers, oriels and balconies – the entire repertoire of formal features was used to break up the flatness of the façade and reshape the regularity of its divisions. The function of the commercial premises on the ground floor was described, the interior plan of the apartments could be read from the outside of the building and the urban status of the building signalled by the appropriate features of its outline. This new language, which was a refined meditation on the medieval house and its elements, was the true language of modernity.

It was not the result of purely formal considerations but the reflection of a major technical development in the history of construction: the transition from load-bearing masonry walls to metal structural frames and hence the inevitable reference to the wood-frame structures of the Middle Ages. The regularity of classical openings obeyed rules of good construction, and required the use of narrow crossings and strict upper levels for both solids and spaces. Any liberty taken with these principles posed a threat to the long-term survival of the building. As the new metal framework made it possible to reduce the number of load-bearing elements, removing some interior walls and freeing up façades, it was no longer necessary for the façade to show such systematic respect for the law of statics and it thus ceased to be the "wall container" that had preoccupied masons for four centuries. Instead it became a shell surrounding the interior space and its functions, the point of contact between the world outside and the world within. The invention of the open plan in twentieth-century modern architecture gave concrete form to this transformation by developing the plastic resources associated with the liberation from the constraints of construction. However, by the end of the nineteenth century this lesson had already been learnt and widely applied.

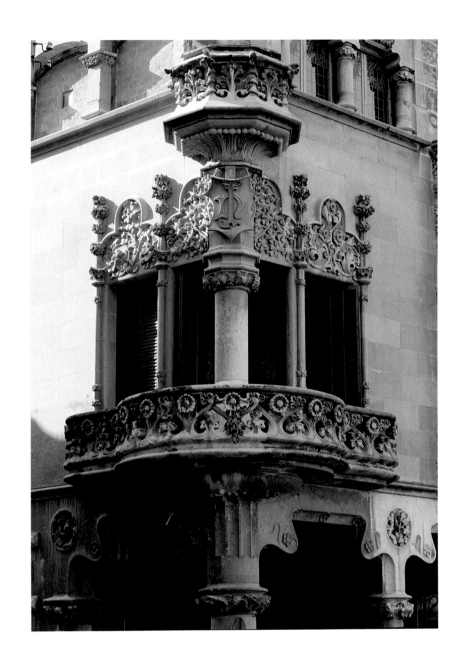

Lluís Domènech i Montaner
Casa Navàs
Reus, 1901–1907
Façade Plaça del Mercadal

FACING PAGE:
Central section
ABOVE:
Corner loggia
RIGHT:
Arcade pillar

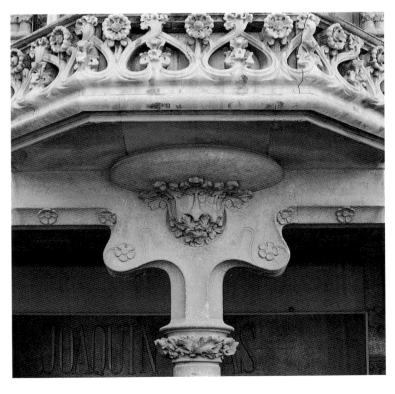

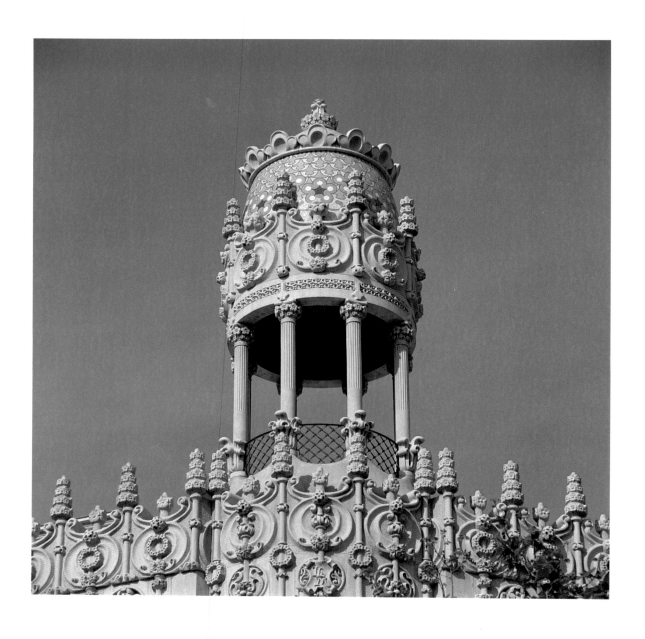

Lluís Domènech i Montaner
Casa Lleó Morera
Barcelona, 1903–1905
Façade Passeig de Gràcia

<small>ABOVE:</small>
Belvedere
<small>FACING PAGE:</small>
Central section
Sculptures by Eusebi Arnau i Mascort,
ornamentation by Alfons Juyol

<small>LEFT:</small>
Paul Hankar
House of the painter Ciamberlani
Brussels, 1897
Detail of façade design

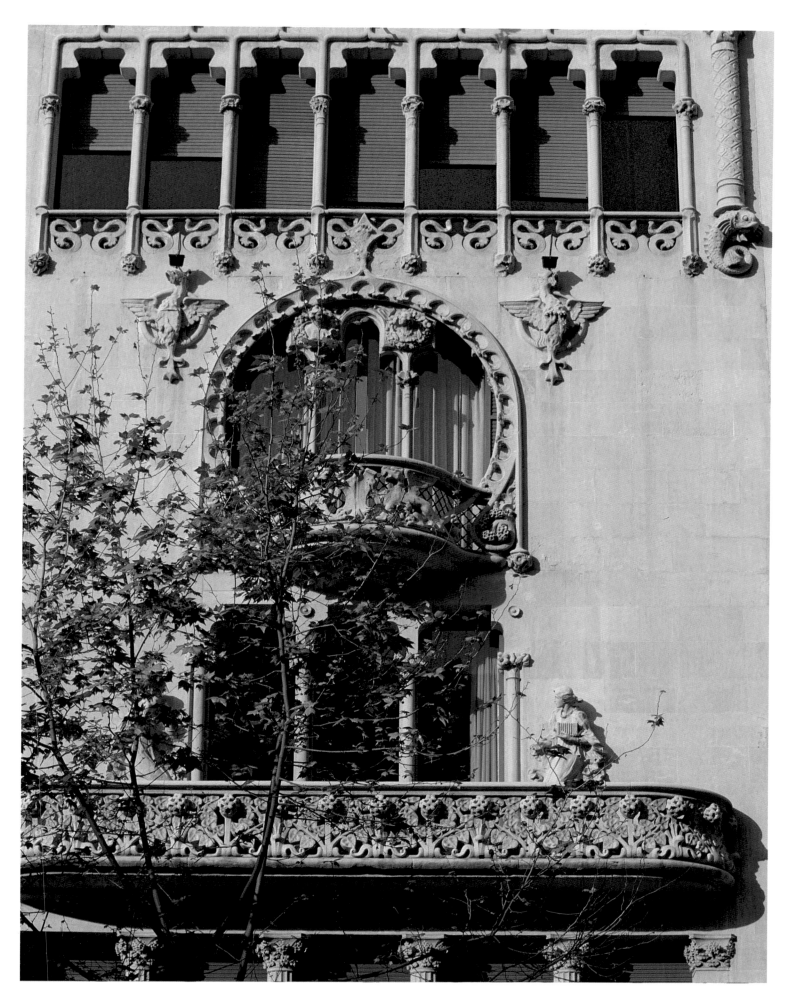

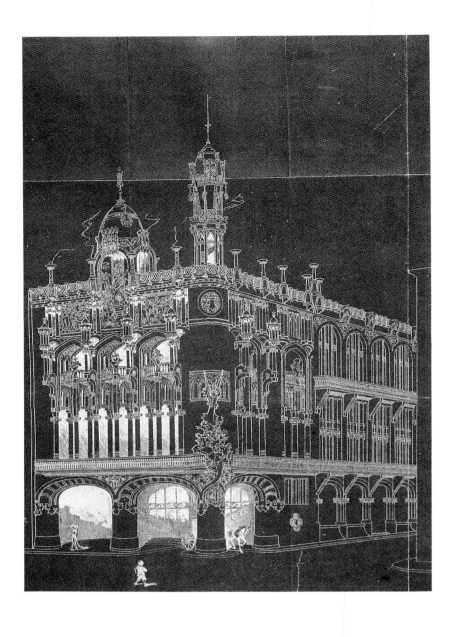

Ornament and Structure

The revolution in composition also affected décor, completely changing its relationship with architecture. The remarkable ornamental saturation introduced by Charles Garnier for the Paris Opéra during the 1860s now became an everyday event and buildings were covered with a shimmering coat of shapes and colours that competed with the traditional effect of light and shade. Here again all rules of proportion and all classical propriety were shattered. From the lively interplay of forms strange, unharmonious, weak or powerful details emerged, lyrical accents from a symphonic palette of surprising variation.

There was freedom in the very richness of the discourse, in the unbounded association of its elements, in the variety of their reinterpretation and their erratic combinations: deep caves of shadow, changes of rhythm, spaces cut short, saturation with fine materials and unusual reliefs. The stage area in the Palau de la Musica Catalana, decorated by Lluís Bru and Eusebi Arnau with a design of tile fragments and mosaic, with its wonderful allegorical figures in white stucco, is a fine example of the application of an ornamental technique popular with their generation and, in fact, not dissimilar to that used by Klimt in Austria. The large, in-the-round female figures Domènech added, at a later date, to the front of the balconies of the Casa Joaquim de Solà-Morales in Olot, were a splendid example of the use of decoration as an almost deviant commentary on the structure. For, challenging the functional scheme which reflects the organization of the building's structure, there appears this decorative strangeness which expresses the use to which it has been put, thus disrupting the discourse which itself is at variance with the emblems on display. Art Nouveau often retained a close relationship with the symbolism that had been present at its birth.

Lluís Domènech i Montaner
Palau de la Musica Catalana
Barcelona, 1905–1908

Above:
Perspective view

First hall loggia
Left:
View from below
Facing Page:
Colonnade

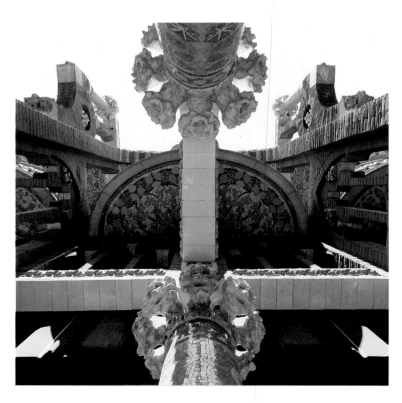

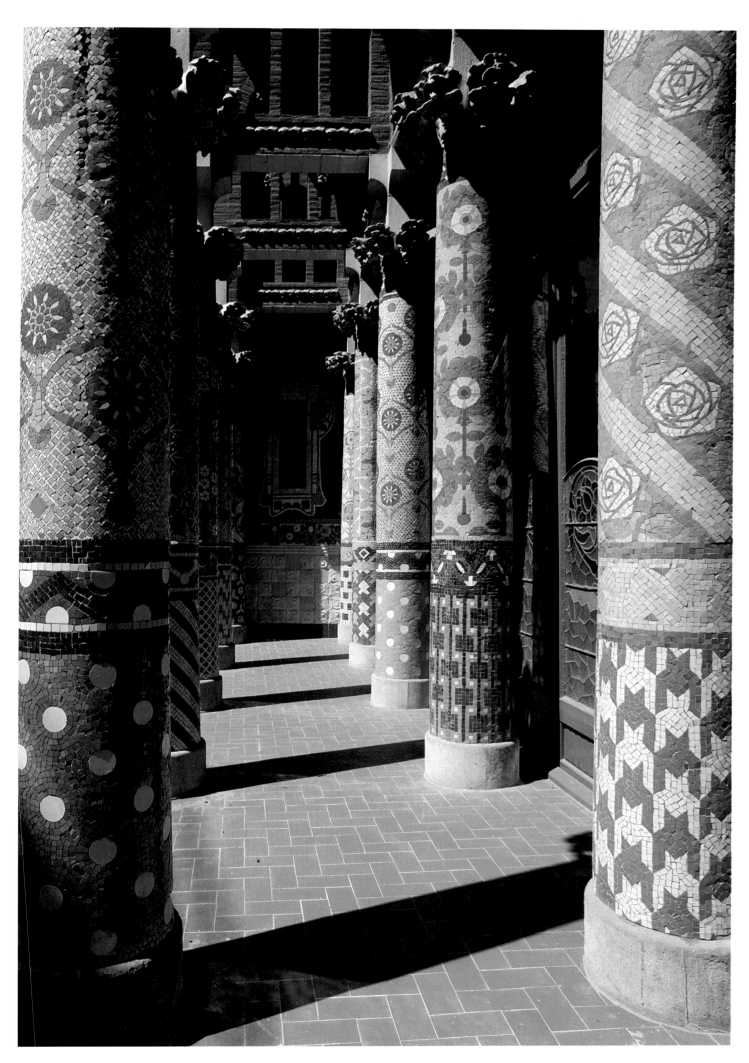

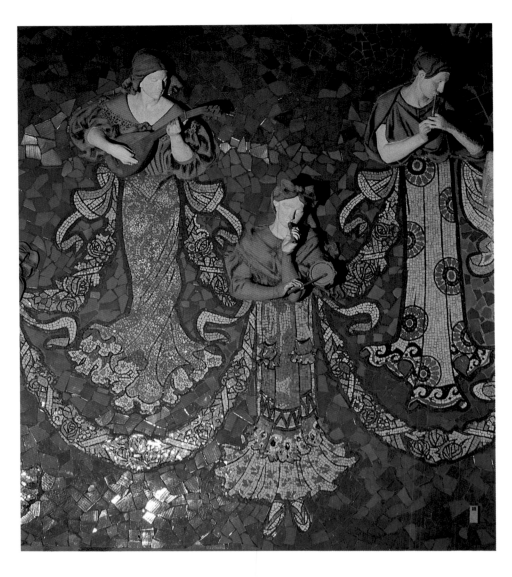

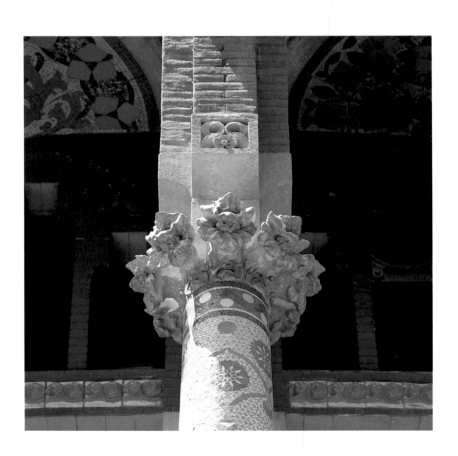

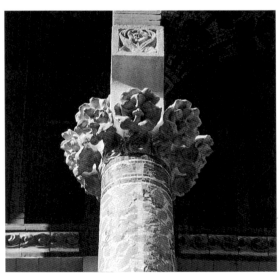

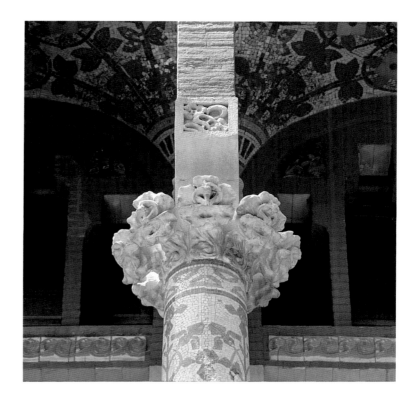

RIGHT, FACING PAGE CENTRE
AND BELOW:
Lluís Domènech i Montaner
Palau de la Musica Catalana
Barcelona, 1905–1908
First hall loggia
Colonnade details

LEFT:
Gustav Klimt
The Kiss, c. 1905–1909
Brussels, Palais Stoclet
Mosaic panel design

RIGHT AND FACING PAGE:
Lluís Domènech i Montaner
Palau de la Musica Catalana
Barcelona, 1905–1908
Concert hall, stage area
Musical allegories,
sculptures by Eusebi Arnau i Mascort,
mosaic by Lluís Bru i Salellas

Facing Page, Above and Left:
Lluís Domènech i Montaner
Casa Joaquim de Solà-Morales
Olot, 1913–1916
*Façade on the Passeig El Firal,
upper floor loggia*
Female consoles, sculptures by
Eusebi Arnau i Mascort

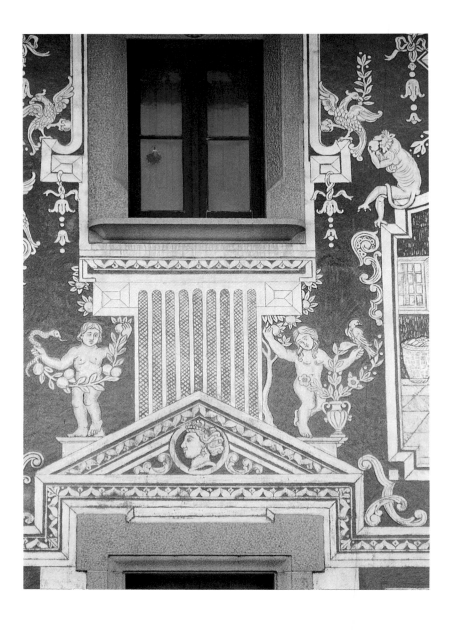

Sgraffito

Sgraffito, an old technique of wall ornamentation, is similar to fresco but made bolder by the outlining of the contours and is achieved by cutting away the upper layer of the wall finish so that the lower layers, already coloured black, show through. It was used in fifteenth-century Florence and survived for a considerable time in Germany. It was redis-covered in the nineteenth century by Gottfried Semper and became one of the preferred forms of expression for monumental painting during the Art Nouveau period.

Sgraffito had never disappeared in Catalonia, however, where it was still frequently used on the façades of elegant eighteenth-century buildings, and its use became even more common (and was considered to be more authentically regional) at the end of the nineteenth century. Within the decora-tive arts its role was similar to that of Portuguese *azulejos*, creating small-scale interest to relieve the large architectural expanses of buildings by embelleshing them with the fantasy of its detail and an element of surprise.

Nothing could have suited Art Nouveau better. On both floors and internal walls, floral ornamen-tation replaced anecdotal scenes and inventive architecture, creating a décor the monumental scale of which (or, the reverse – excessive miniatur-ization) contrasted fiercely with the customary proportions dictated by the openings. This was a total work of art in which the purely visual practice of confronting scale and formal discourse trans-formed the most humble building into an artistic monument. The ambition that art should be enjoyed in all places and circumstances was the aspiration of a period vehemently opposed to the decay of its environment and which wished to rectify the situation by giving artistic production a more important role within society. In this sense Art Nouveau followed very much in the tradition of the nineteenth century.

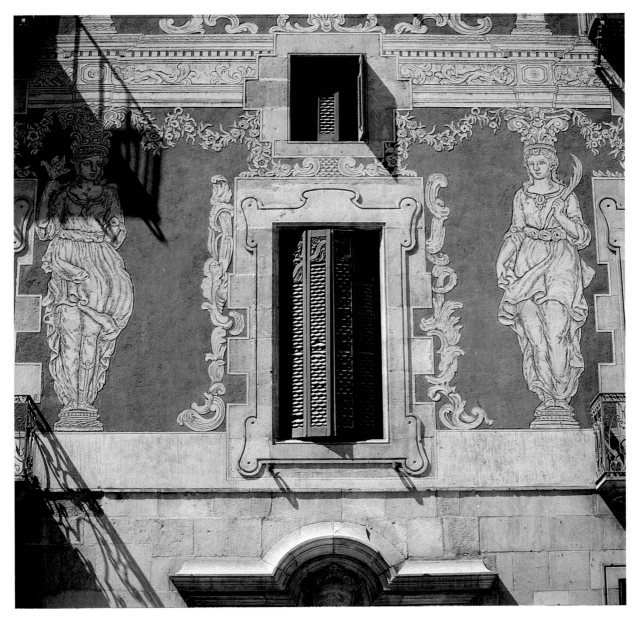

Facing Page Above:
Casal Núria
Sant Julià de Vilatorta, late 18th century
Façade sgraffiti

Right, Below and
Facing Page Below:
Joan Garrido i Bertran
Casa del Gremi dels Velers
Barcelona, 1758–1763
Façade sgraffiti

Josep Puig i Cadafalch
Casa Macaya
Barcelona, 1898–1901

Inner courtyard windows
Below:
Façade on the Passeig de Sant Joan
Sgraffiti by Joan Paradís

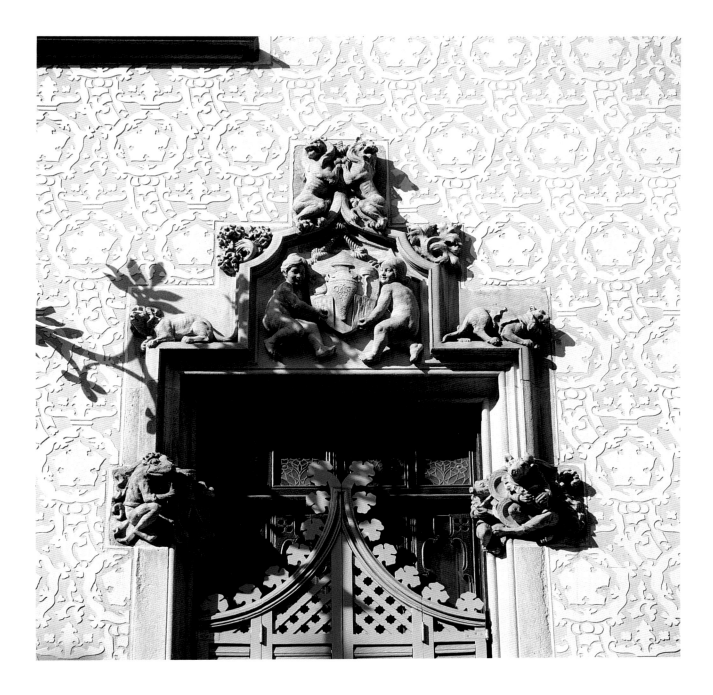

ABOVE:
Josep Puig i Cadafalch
Casa Amatller
Barcelona, 1898–1900
Façade on the Passeig de Gràcia
Sgraffiti by Joan Paradís

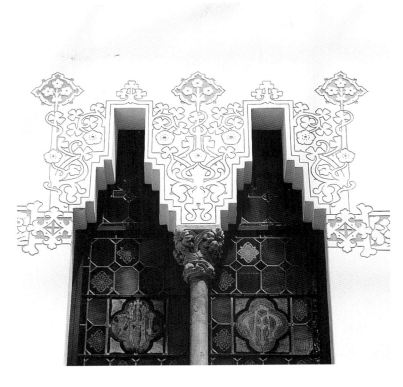

ABOVE:
Antoni Maria Gallissà i Soqué
Casa Llopis i Bofill
Barcelona, 1902–1903
Façade on the Carrer de València
Sgraffiti by Antoni Maria Gallissà i Soqué

LEFT:
Josep Plantada i Artigas
Casa Josep i Ramon Queraltó
Barcelona, 1906–1907
Façade on the Rambla de Catalunya

FACING PAGE:
Jeroni F. Granell i Manresa
Casa Jeroni F. Granell
Barcelona, 1901–1903
Façade on the Carrer de Girona

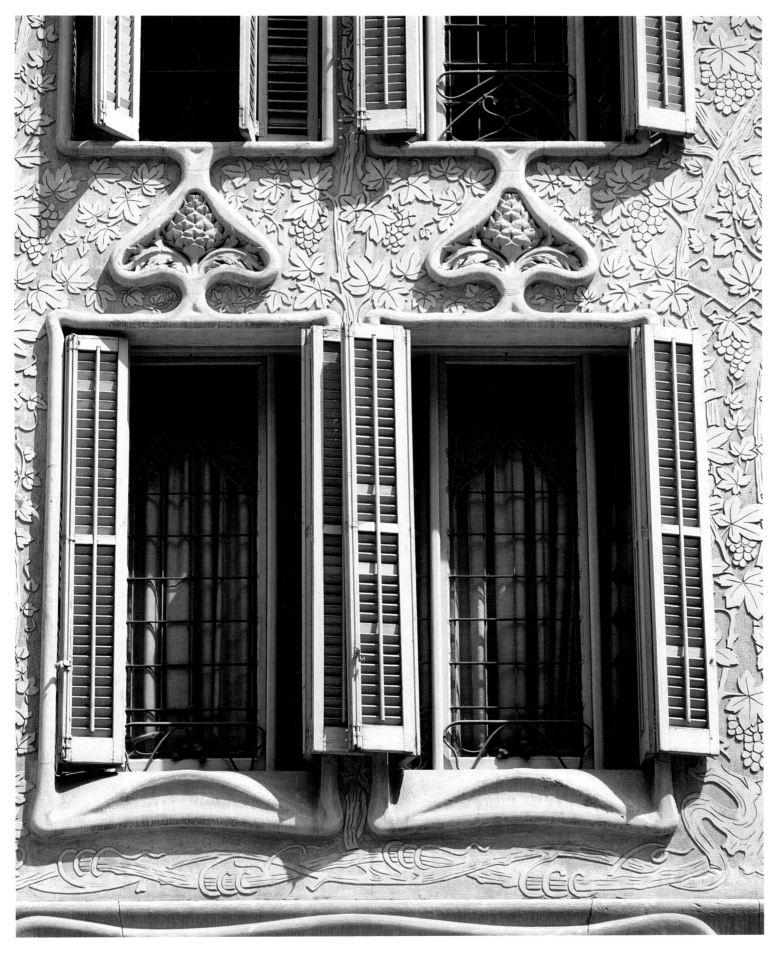

Achieving Synthesis

The aspirations of Art Nouveau were, in many ways, contradictory. On the one hand the movement sought to give total freedom to creative expression which logically would produce as many different forms of individual plastic expression as there were artists. Whilst on the other hand it sought consensus on style, and embracing the floral style encouraged this ambition. From the middle of the nineteenth century there was an aspiration to achieve genuine unity in art, overcoming any contradiction between artist and style.

Gaudí's development towards an art of synthesis that blended architecture with décor is a remarkable reflection of this. Abandoning the analytical language of ornament and its contrast with structure (which he had used in his early, Mudejar-inspired works), he sought to define a unified language in which ornament was merely a commentary, an explication of a constructional skeleton. By rejecting the rhetoric of contrast, he sought to blend ornament with structure.

This aim, which had been apparent since the building of the Casa Batlló, was realized in the Sagrada Família project: here Gaudí makes clear reference to Boileau's "cathédrale synthétique", adopting some of its broad outlines. The almost absurd intention behind the French architect's design had been to combine the plan of St Peter's in Rome, the elevation of Chartes Cathedral and the spatial features of the Alhambra. Yet Gaudí manages to embrace all these elements in the Sagrada Família; the sectional drawing of the church is simply a meditation on the one published by Boileau in the first version of the *Nouvelle forme architecturale ...* in 1853.

Antoni Gaudí
Casa Batlló
Barcelona, 1904–1906

ABOVE:
Façade on the Passeig de Gràcia
Mosaic by Josep Maria Jujol
LEFT:
Sketch
FACING PAGE:
Entrance hall
Imitation mosaic finish

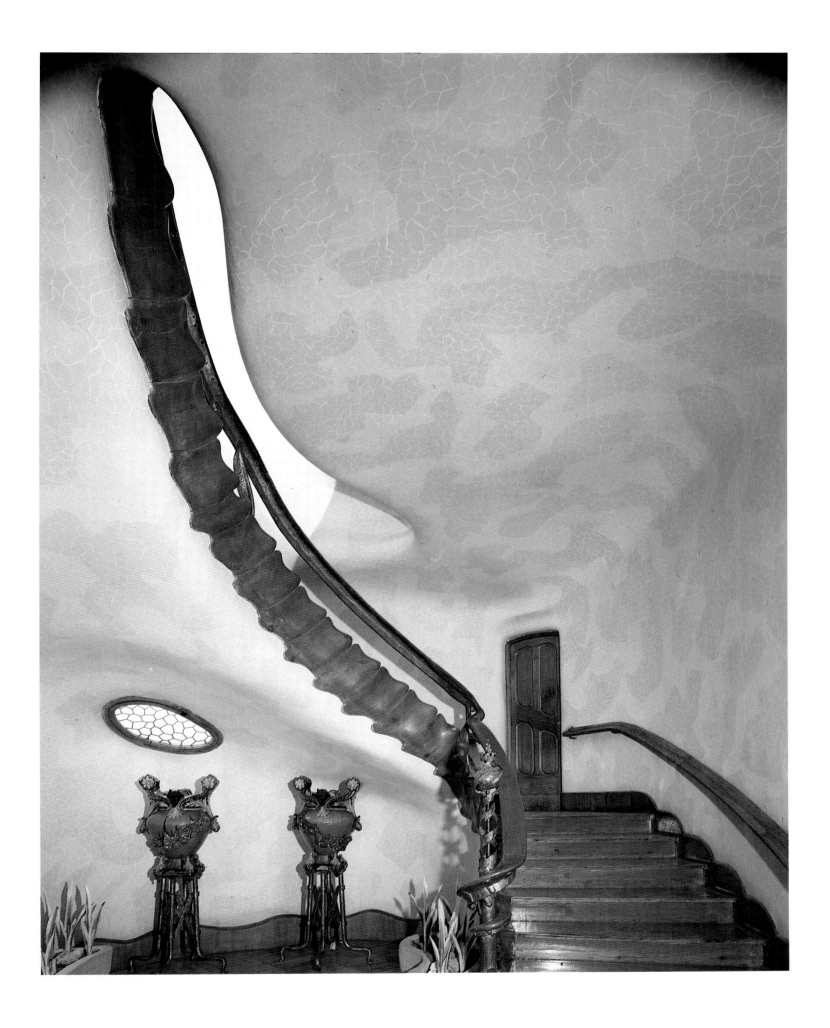

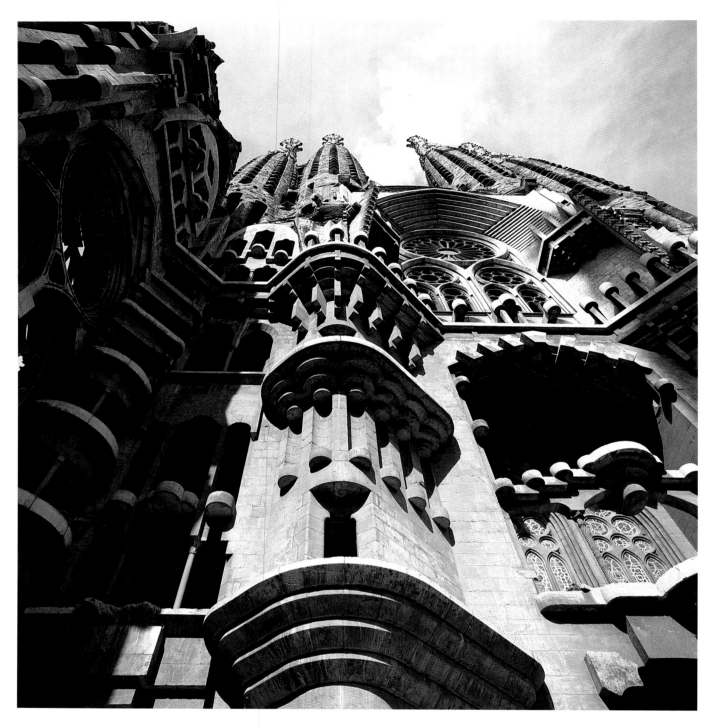

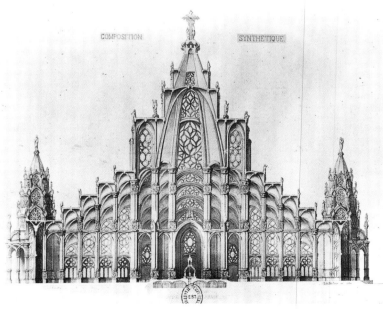

Louis-Auguste Boileau
Nouvelle forme architecturale ..., 1853
Cathédrale synthéthique
Cross-section

He begins with the Gothic style, correcting any defects such as flying buttresses – the building's "crutches" according to Boileau – and extending its possibilities with, for example, the translucent nature of the walls and the reflection of light on the curves of the vaults which thereby create a magical space inside the building. But Gaudí goes further still and surpasses Boileau by combining structure and ornament in one harmonious whole, which transforms the basilica into a poem of faith.

Gaudí draws on evolutionist philosophies of the time (extending Lamarck's theories and applying them to architecture) and imitates the constructional organization of the creations of nature to build an extraordinary repertoire of forms, the organic quality of which is also closely related to its symbolic value. This was an extreme experiment in synthesis that, through its very scope, went well beyond all other attempts of the period. It earned Gaudí the reputation he rightly enjoys in the history of art. The project was his response to a basic aspiration to go beyond the contingencies of period and of style and achieve a *system* of thought that would be as objective as scientific thought and would lead to the creation of a timeless art existing outside all individual or social contingency. Some years later the same ambition would inspire the exponents of the Bauhaus school in their desire to create an architecture of the future that would be the "crystal symbol of a new faith".

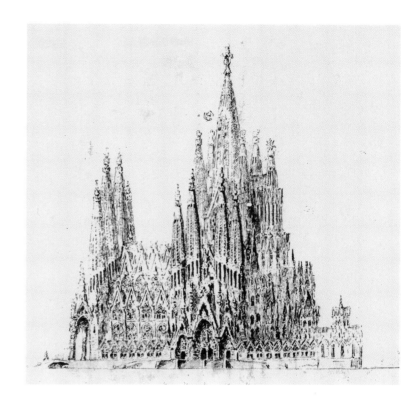

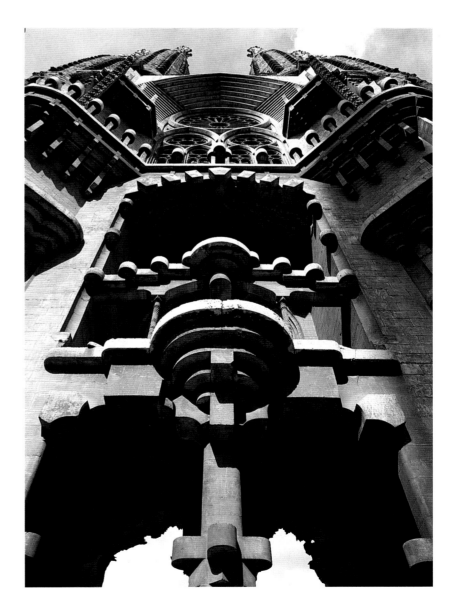

Antoni Gaudí
Expiatory Temple of the Sagrada Família
Barcelona, 1883–1926
Nativity façade, 1893–1903

<small>Right and Facing Page Above:</small>
Interior views
<small>Above:</small>
General view from maquette, 1915

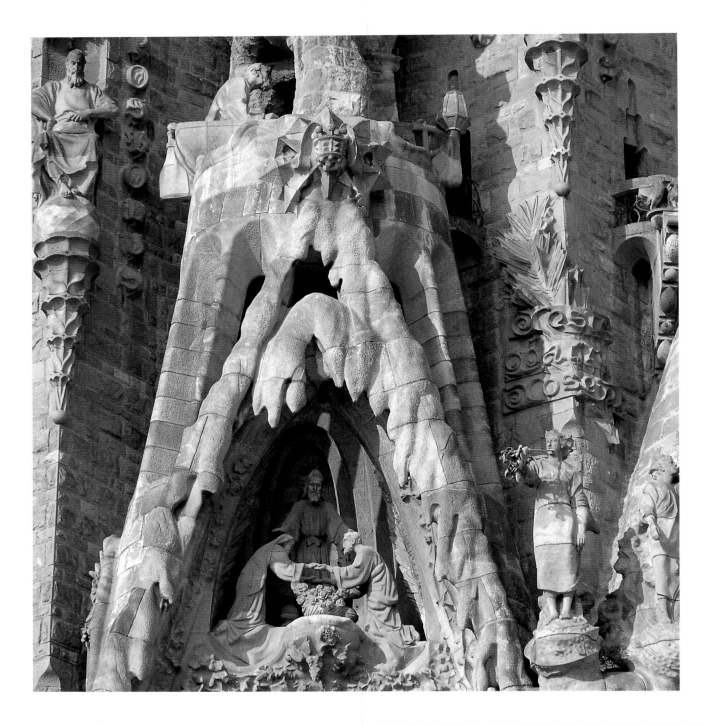

Antoni Gaudí
Expiatory Temple of the Sagrada Família
Barcelona, 1883–1926
Nativity façade, 1893–1903

ABOVE:
Door of Hope:
"Betrothal of the Virgin Mary and
Saint Joseph"
RIGHT:
Door of Faith:
"Presentation at the temple"
FACING PAGE:
Door of Charity, central door:
"Coronation of the Virgin Mary",
sculptures by Llorenç and Joan Matamala
from maquettes by Gaudí

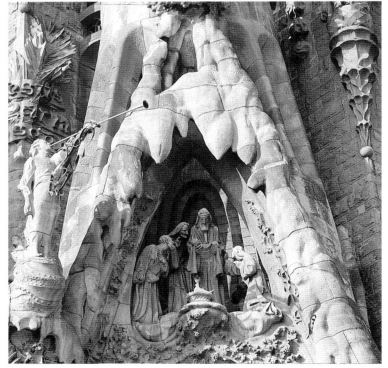

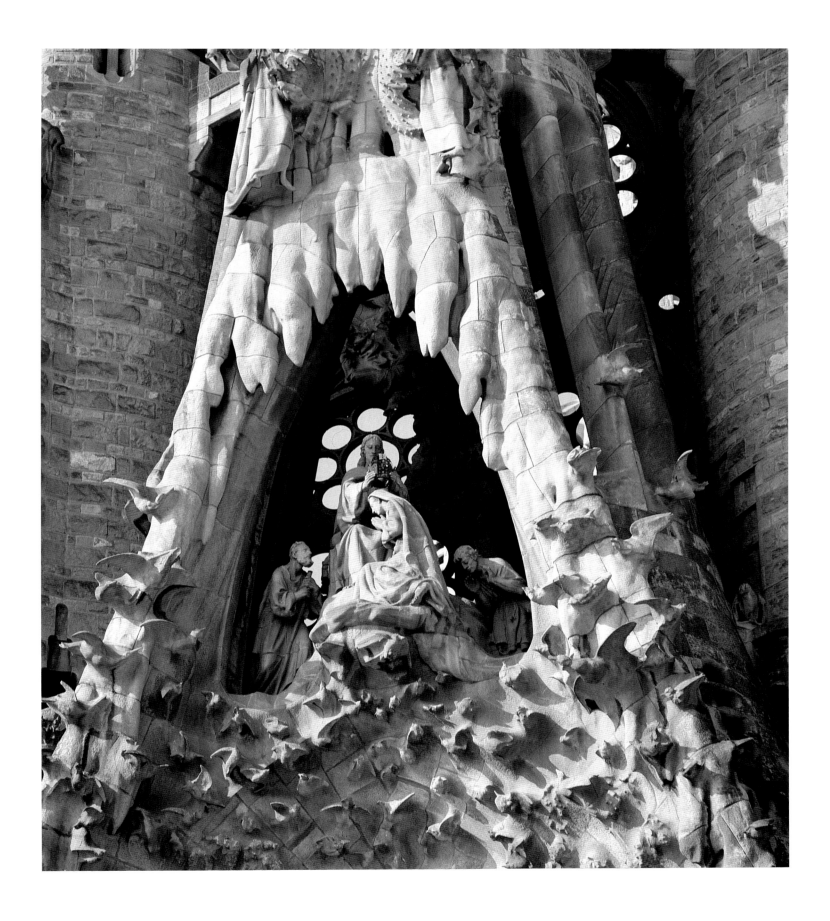

4

THE SANT PAU HOSPITAL

Catalan modernism was a skilful blend of the dominant artistic trends in Europe at the end of the nineteenth century. It was the product of an encounter between the rationalist preoccupations of the French diocesan school and the decorative inclinations of the Arts and Crafts movement in England. It also reflected perfectly the spirit of a genuinely *modernista* avant-garde dedicated to creating a plastic language that would be free from the historicist references common at the time. In another sense, however, it was a movement built on the legacy of symbolism and the historicist school *stricto sensu*. This diversity of intention and means gave birth to an inventive, experimental and protean form of art in which every creation provided an opportunity to confirm a hypothesis, learn a new lesson or improve on what had been achieved.

The careers of these artists did not follow an unbroken path; their work could not be analysed in terms of a coherent set of principles or as the product of an established school. It was precisely this freedom and artistic invention that gave the Belle Epoque that richness and proliferation of expression that made it so interesting. While the classical system had been strongly prescriptive, from the very outset Art Nouveau was individualistic, almost anarchical, laying down no rules other than the personal and proclaiming as its creed the total autonomy of the work of art.

Nevertheless, the very diversity of these works allowed them to communicate, to converse one with another and from one place to another, thereby making even clearer the expression of their individual characteristics. One can look at the heterogeneous nature of these buildings or the contrast between them (in particular, the very apparent distinction in the architectural conversation taking place on the controversial "block of discord") but one can also focus on the richness of this architectural "conversation" which, building by building, demonstrates extreme diversity of intention and treatment. This confrontation between different architectural languages also gives rise to an ongoing debate on the meaning and future of art arising out of a certain vision of the world which it is the task of art to interpret.

The most significant of these confrontations is the contrast between Gaudí's Sagrada Família and Domènech's Sant Pau Hospital situated at two extremities of one short urban vista. The two buildings were constructed at the same time over a period of more than a quarter of a century. One was the expression of the mystical passion of its creator, while the other was largely determined by the very strict criteria of its functional requirements. Yet both buildings belong to the neo-Gothic trend in Art Nouveau and share that thirst for modernity that was inescapable at the time. The confrontation between the master,

Domènech, and Gaudí his pupil is nothing less than fortuitous, the two buildings standing as they do, one opposite the other, provided each architect with an opportunity to make a powerful statement about the fundamental values of his architectural ethics. Let us leave aside the question of Gaudí's intentions at the Sagrada Família, which, in any case, are already familiar[1], and try to gain a better understanding of what lay behind Domènech's plans for the Sant Pau Hospital.[2]

Both buildings are clearly on a monumental scale and occupy a special place in the urban landscape of the *Eixample*. They are to the north of the city, on the flat area that precedes the higher ground on which the Guinardó and Parc Güell are situated and to the right of the Glòries Catalanes crossroads. It is at this point that the three main thoroughfares of the new city converge: the Gran Via de les Corts, tangential to the line of the old city walls, on La Rambla, the Avinguda Diagonal, with its imperative oblique cutting through the residential quarters designed by Cerdà (and providing this nondescript area with a certain structure) and the Meridiana, which stretches across the city from the stronghold of the Ciutadella, creating a second and opposite oblique, on a north-south axis crossing right through the districts to the east.

In the obtuse angle formed where these two diagonal roads meet runs the short Avinguda Gaudí which connects the transept of the Sagrada Família with the entrance building of the Sant Pau Hospital. Both architects exploited the orientation of their buildings to emphasize their articulation within the urban scheme. Gaudí respects the southwest/north-east axis of the Gran Via running parallel to the city and the port. The chancel of the Sagrada Família faces the hills in the background while the main façade faces the sea. The Avinguda Gaudí meets the façade of the transept of the Nativity at an oblique angle, with the colossal mass of this structure forming a point of reference on a scale appropriate to the size of the city. At the opposite end of the Avinguda Gaudí is the Sant Pau Hospital, constructed on the diagonal on a vast plot of land. Here it was not a question of a monumental construction organizing the city about itself but rather of chance creating an oasis of vegetation in this vast built-up area and prolonging the tree-lined avenue that allowed the city to breathe. The "dialogue" between these two buildings underlines the difference in their monumental status between major status and intermediate, sacred and utilitarian (a "facility" as we would call it now), mass and empty space, mineral and vegetable, city and green space, urban and non-urban.

Domènech rejected all these possibilities (refusing to exploit what must have been a tempting confrontation) and focused on a single idea: the specific demands entailed in building a hospital and building it within the city. Air and light became his principal theme. Not only was the site slightly terraced, sloping downhill towards the port, but the axis of the diagonal avenue ran exactly north-south. He therefore simply had to locate the buildings one behind another, opposite the avenue, so that they would enjoy the best orientation available and the best light. His adoption of a pavilion structure, in the French tradition, would do the rest; the hospital became an island of vegetation within the city and, by maximizing the potential offered by the oblique, he made it an integral feature of the urban layout.

Lluís Domènech i Montaner
Santa Creu i Sant Pau Hospital
Barcelona, 1902–1911 (first phase)
General plan, 1901–1903

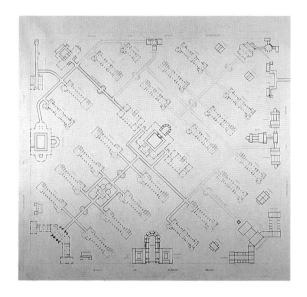

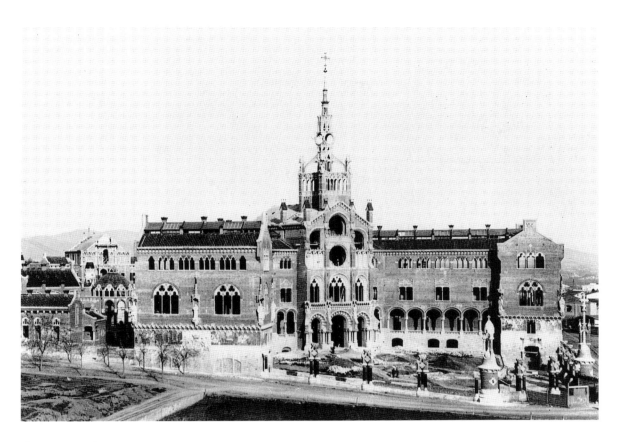

Lluís Domènech i Montaner
Santa Creu i Sant Pau Hospital
Barcelona, 1902–1911 (first phase)
View during construction

When Domènech was commissioned to carry out this project in
1901 he already had behind him more than twenty years of experience as
an architect. He was at a turning point in his professional career but in
the reverse direction to that later taken by Josep Puig. Domènech had
been a member of the Jove Catalunya since 1869. He became president
of the Lliga de Catalunya in 1887, and in 1892 of the Unió Catalanista. It
was from this position that he was elected to the Cortes in 1901, having
become director of the Barcelona School of Architecture the previous
year. Three years later he would decide to abandon his political career
and occupy himself exclusively with his activities as an architect.
Having experienced the political life, Domènech found his preferred
form of expression to be through architecture; his decision also coincid-
ed with certain major projects such as the Sant Pau hospital, the Casa
Lleó Morera and the Palau de la Musica Catalana. The refinement
he brought to the Sant Pau Hospital is a reflection of this complete
devotion to architecture.

Domènech was to work on this project until his death. The plans
date from 1902 and were executed at various intervals between 1903 and
1930. The administration building at the entrance to the hospital was
completed in 1909, the observation, operating and surgical wings in 1911
and the following year they were together awarded the Barcelona City
Hall prize. Work then slowed down and the medical buildings were
not completed until 1928, five years after the architect's death (the rear
section of the hospital having been built to plans modified by his son,
Pere Domènech i Roura). Every morning for more than ten years
Domènech and his colleagues met on site: his son Pere, who would take
over from his father in 1914, the architects Català, Bona and Puig i Janer,
the sculptors Pau Gargallo and Eusebi Arnau, the caster Francesc
Modolell and the ceramicist Francesc Lata.[3] This collaboration produced
a work of astonishing maturity in which the contribution made by the
decoration is fully integrated into the architectural concept, in a form
less free, it is true, than in the case of Gaudí, but equally demanding.

The tall façade of the administration building provides the entrance
to the complex at the point where the two roads meet. It is constructed
on a right-angle plan with two wings extending out from either side of a

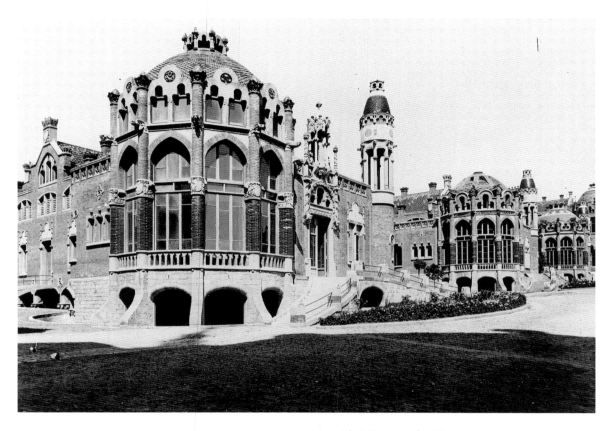

vast, covered passage. This tripartite structure is very reminiscent of Viollet-le-Duc's *Entretiens …*, to which Domènech still remained faithful, even at this rather late date. Not only is the right-angle plan exactly that proposed by Viollet-le-Duc for an affluent private house[4], but the outline of the central pavilion is so similar to the town hall design the French architect spent a long time developing, as to be mistaken for it.[5] Onto this basic outline, Domènech grafted some impressive details, in a language not dissimilar to that used by Lucien Magne for the main entrance to the church of the Sacré-Coeur in Montmartre. To these details he added enormous buttresses with receding profiles topped by extraordinary statue-columns created by Pau Gargallo. These anticipate strikingly the work of Hildo Krop and Johan Melchior van der Mey at the Scheepvaarthuis in Amsterdam in 1913, demonstrating, as if it were necessary, the neo-Gothic sources of Dutch expressionism. The heavy, flared columns, borrowed from Hankar, and the abundant floral ornamentation of the friezes and capitals in the early Parisian Gothic style, complement this original decoration, the medieval sources of which were taken up again by Art Nouveau, and even by early Art Deco.

Behind this impressive, if somewhat conventional façade, the vast covered hallway conceals the most spectacular of surprises: a space rich in background effects of fluidity, transparency and luminosity under a veil of delicate cupolas clothed in glazed ceramic in tones of mauve. The main corner staircase, of triangular design, is splendidly conceived, disappearing obliquely into the shadows. The austere stairwell of brick surrounding it is simply a vessel for the rich décor of lavishly sculpted balustrades and decorated risers, below a skylight turret of brick, stained glass and mosaic, cut away like an Arabian dome. On the first floor are light-filled galleries under barrel vaulting of mosaic or tiling in the palest shades. The overall effect is achieved by the assertion of a spatial plan devoted to the dramatic effect of light and the subtle interplay of its reflections on the coloured, matt or gleaming walls dressed in marble, limestone or stoneware, brick, tile and enamel.

The scheme culminates on the first floor with a vast three-span hall, the Sala d'Actes. This room, with its huge stained-glass features, recalls a chapel. Walls of exposed brick and a ceiling of ribbed vaulting dressed

in glistening mosaic converse with narrow walkways embellished by open-work railings to which the architect, inspired by late Gothic, has added a long dedicatory frieze.[6] Along the lower section of the walls is a curious panel of tiles and mosaic formed by the unexpected combination of hexagonal tiles and high-relief glazed terracotta. And under the triumphal arch that separates the aisles there is a kind of clerestory emblazoned with the coat of arms of Catalonia. Below this is pew seating, behind which is a wall covered by a large trompe l'oeil drapery with floral motifs in an embroidered style but executed entirely in mosaic. The virtuosity of the detail is disconcertingly noticeable and the surprising spatial scale, the dramatic effect of the crossings and the intensity of the natural light that enters through the glass screen of the façade and bathes this shallow area only make it more remarkable still.

The architect could have stopped at this point, in the bridging space to the main hall that covers the entrance passage but, instead, behind the monumental façade of this public building, he reserves some new developments that will give fresh impetus to the composition. There is a hidden world behind this building – a small planted square on a slight incline with a sculpted stone crucifix in the centre. Immediately opposite is the façade of the operating wing, which echoes the façade of the main entrance but on a smaller scale. To each side and rising on the terraced slope are the rotundas of the surgical and medical buildings. These terminate, between the kitchens and the pharmacy, in the large transverse section housing the technical services and marking the geographical centre of the site.

Behind this a new series of buildings extends the composition in every direction: to the west gynaecology and obstetrics; to the east the main plant, laundry and workshop laid out down the slope; to the north a group of six buildings for infectious diseases. The cruciform layout on the diagonals of the square is completed on either axis by a dispensary and a church to the left and the right of the entrance, then by the children's hospital and the water tower on the other side. The complex finishes, symbolically, at the end opposite the entrance, with the morgue and a reception building for the relatives of the deceased, set off to the right to optimize use of an area of land that is not strictly rectangular.

Despite its apparent rigidity, the site plan is one of immense richness, taking advantage of the strong contrast between the front and rear sections on either side of the central technical block and exploiting the difference in incline between the main axis, where the composition rises harmoniously on level areas, and the secondary axis, which is far more uneven and provides views down over the lower area of the site. It is clear that Lluís Domènech was inspired by the pavilion-style scheme of the Paris hospitals and in particular Charles Questel's plan for the Asile Sainte-Anne (1863–1867). Domènech displays greater subtlety than Questel, however, in the contrast he creates between interior and exterior and the succession of viewing points he provides inside the hospital; the systematic nature of the plan does not prevent him from achieving a perfectly controlled gradation of space and form.

The beauty of the external areas goes hand in hand with the astonishing variety of ornament applied to the façades. Within this "garden hospital" each building has its own character, with a wealth of material

Lluís Domènech i Montaner
Santa Creu i Sant Pau Hospital
Barcelona, 1902–1911 (first phase)
Surgical wings, 1903–1911
Hospital ward

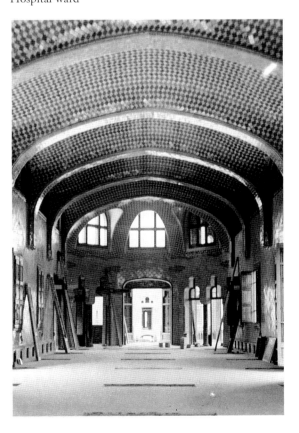

and colour details giving it individuality. The scheme always remains the same: a large rectangular room preceded by a rotunda and a terraced ante-room with an adjoining turret. The large room is used as a waiting room for patients, the ante-room is the entrance and the rotunda houses the examination room, which has huge stained-glass windows to provide plenty of light. But, in every case, the formal treatment varies: the glazed tile domes are supported on different types of arcature punctuated by tall pinnacles or even on a series of alternating trefoils and tabernacles. Colour and scale undergo a careful gradation relating to the degree of slope on the site and become fundamental to the architectural and ornamental scheme.

These arrangements may seem rather eccentric but are by no means arbitrary. They are based on concepts of hygiene established in pavilion-style hospitals at the end of the nineteenth century. The idea of the examination rooms in the rotundas is borrowed from the public hospital in Antwerp, built by Bæckelmans between 1870 and 1880, and the military hospital in London built by Andrew Clarke and E. Ingress Bell, in 1883; the primary purpose of these "hood-style" buildings is to provide ventilation to the wards and thus ensure hygiene. Similarly the "ogival" vaulting of the wards is inspired by the system perfected by Casimir Tollet in 1872 to improve ventilation in large wards.[7] On the exterior the roof pattern is punctuated by an abundance of chimney stacks which, in the rationalist tradition going back to Labrouse and Louis Duc, act as ventilation shafts, continuously renewing the air in the rooms below.

The deep commitment to hygiene is evident even in the smallest detail. It lies behind the vaulting of the wards and also their considerable under-ceiling height, over five metres, as in the Lariboisière hospital in Paris. It explains the two-tier windows (large casement windows below and mezzanine openings in the penetration of the vaults), their exceptional size and the systematic use of louvred shuttering to protect the façades from the heat of the sun in these southerly climes. Similarly it accounts for the systematic use of glazed ceramic on all the surfaces (floors, walls and ceilings), allowing them to be washed repeatedly and thus avoid all risk of infection or contamination. And, finally, the main disadvantage of the pavilion system, the separation of the different buildings, is addressed by providing a network of underground tunnels and ramps which create indoor access to the different services; this system provided an opportunity for some fine architectural effects in the treatment of the openings for the stairs leading underground at the front of each pavilion.

Nothing could have been more rational than this design, in which the imaginative element is entirely dictated by rules of hygiene. Even the iconography is dictated by the nature of the project. The huge decorative mosaics on historical themes, the statues of the patron saints to which each building is dedicated, the monograms with the coat of arms of Catalonia or the initials of the benefactor (the "G" is for Pau Gil, who financed the construction of the building) all recall the charitable purpose of the building and its place in Catalan society. The complex is an outstanding achievement, a celebration of hygiene and modernity but also an unconditional demonstration of the cultural tradition that is an intrinsic part of Catalan life and the geography and history of the

Lluís Domènech i Montaner
Santa Creu i Sant Pau Hospital
Barcelona, 1902–1911 (first phase)
Surgical wing, 1903–1911
Corner tower, blind arcade

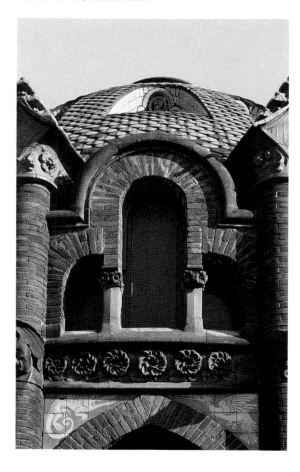

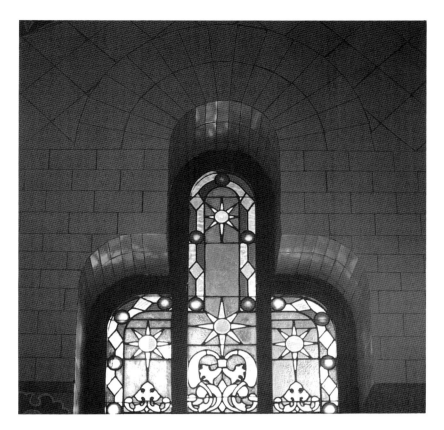

Lluís Domènech i Montaner
Santa Creu i Sant Pau Hospital
Barcelona, 1902–1911 (first phase)
Surgical wing, 1903–1911
Corner tower, stained glass in the
consultation room

region. Gaudí's mission in creating the Sagrada Família was mystical, Domènech's at Sant Pau was highly rationalist, but both architects shared that epic dimension that, typically, transformed Art Nouveau in Catalonia into a totally original expression of a regional culture. On the site of the Sant Pau Hospital so many different aims met and mingled that it was difficult to believe that one day they would come together in such a remarkable synthesis. How can it be claimed that Art Nouveau was a purely "decorative" form when, as here, the decoration served the aims of the project so successfully as to make them accessible and meaningful to all? Lluís Domènech might feel justifiably proud of his achievement in this demanding and imaginative undertaking. In the Sant Pau Hospital Catalan Art Nouveau finally solved its contradictions but lost none of the richness of its sources or the spontaneity of its inventions.

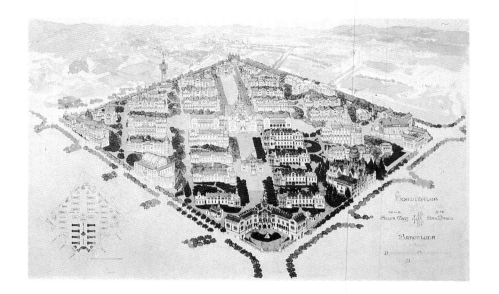

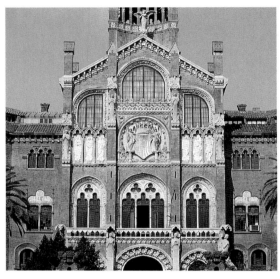

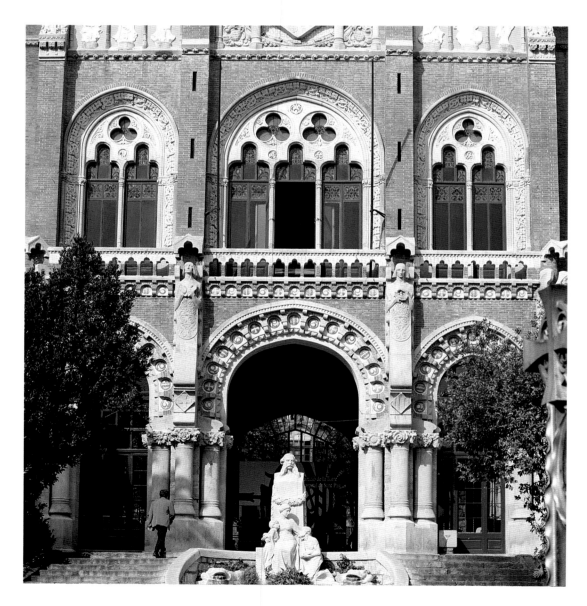

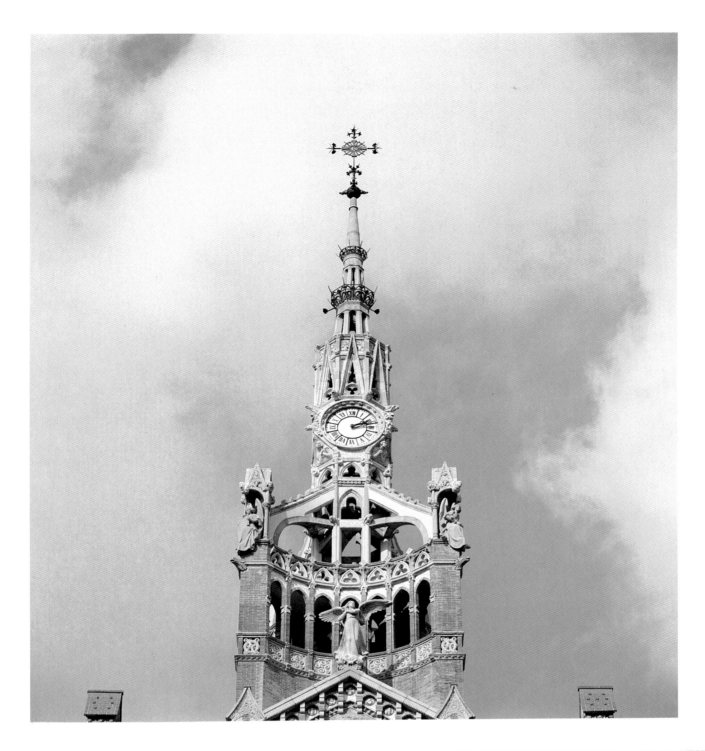

Lluís Domènech i Montaner
Santa Creu i Sant Pau Hospital
Barcelona, 1902–1911 (first phase)

FACING PAGE ABOVE LEFT:
General perspective view

Administration building, 1903–1909
FACING PAGE ABOVE RIGHT
AND BELOW:
Façade of the main section
ABOVE:
Belfry
RIGHT:
Elevation

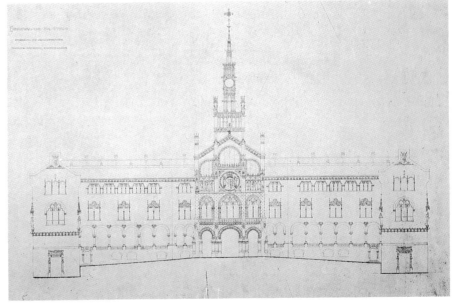

LEFT AND BELOW:
Lluís Domènech i Montaner
Santa Creu i Sant Pau Hospital
Barcelona, 1902–1911 (first phase)
Administration building, 1903–1909
Windows on the side sections, stained
glass by Antoni Rigalt i Blanch,
mosaic by Lluís Bru i Salellas

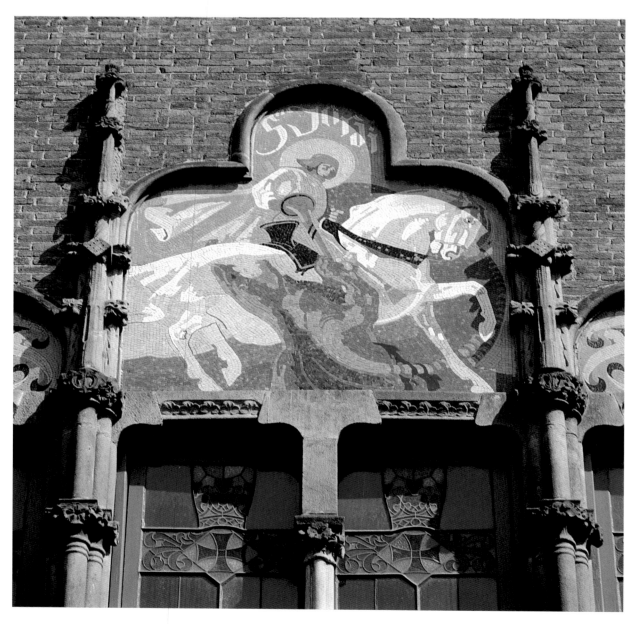

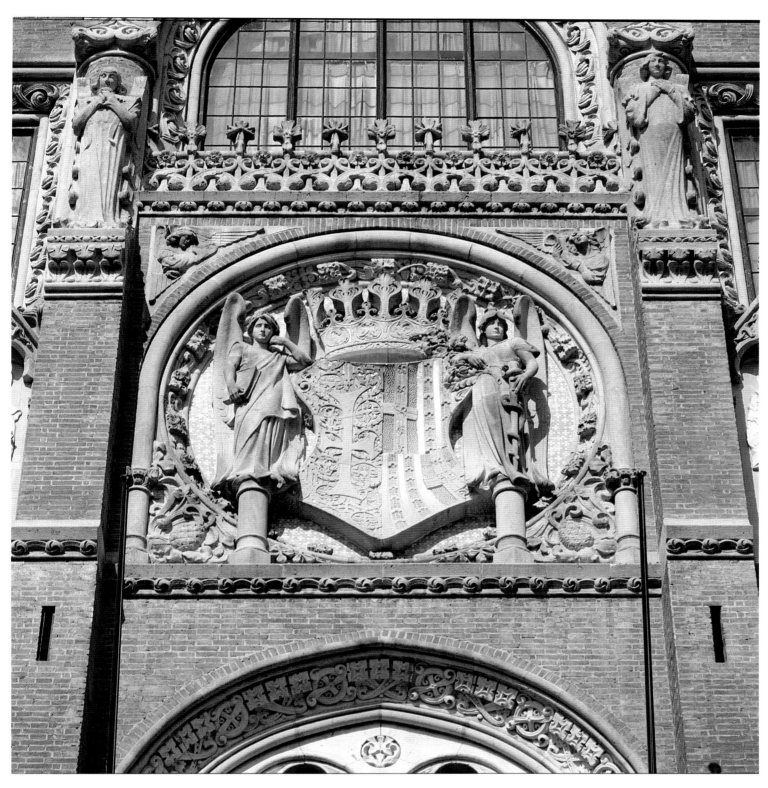

Above:
Lluís Domènech i Montaner
Santa Creu i Sant Pau Hospital
Barcelona, 1902–1911 (first phase)
Administration building, 1903–1909
Coat of arms on the main section,
sculptures by Eusebi Arnau i Mascort,
ornamentation by Francesc Modolell

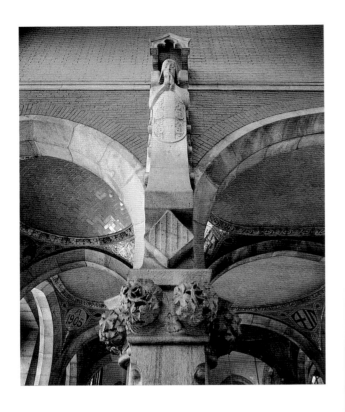

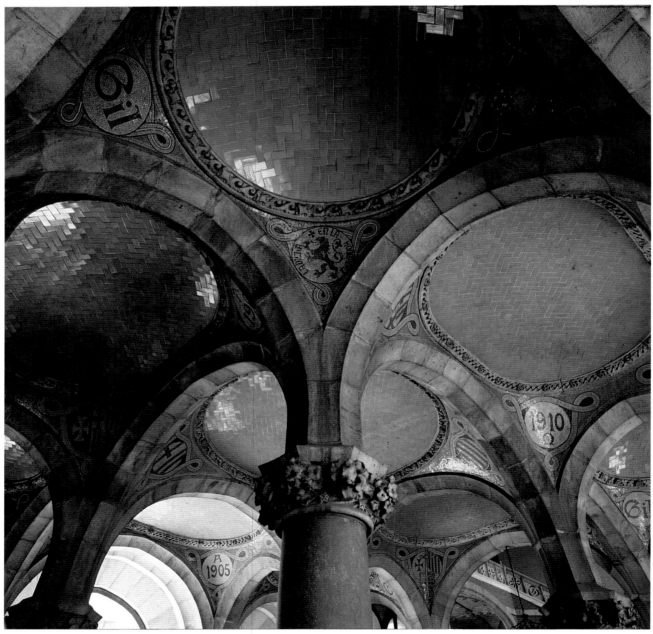

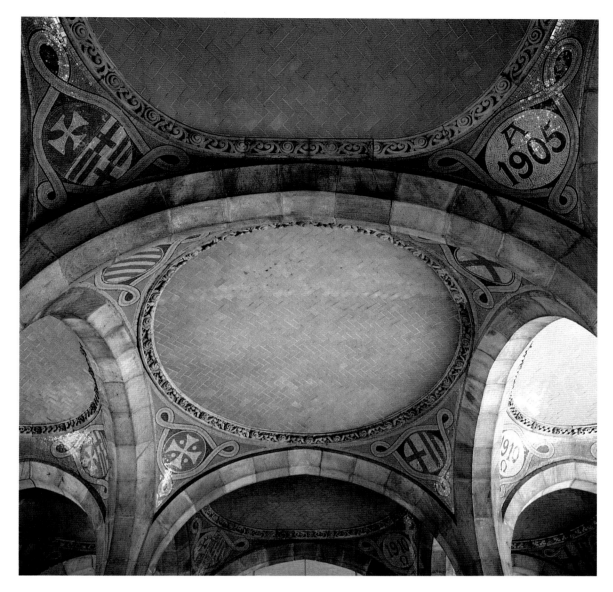

Lluís Domènech i Montaner
Santa Creu i Sant Pau Hospital
Barcelona, 1902–1911 (first phase)
Administration building, 1903–1909
Central hall

<small>Facing Page Above:</small>
Angel by Pau Gargallo
<small>Above and Facing Page Below:</small>
Columns and cupolas
<small>Right:</small>
Cross section

Left:
Great Mosque at Cordoba
Side cupola preceding the
mihrab d'al-Hakam II, 965–968

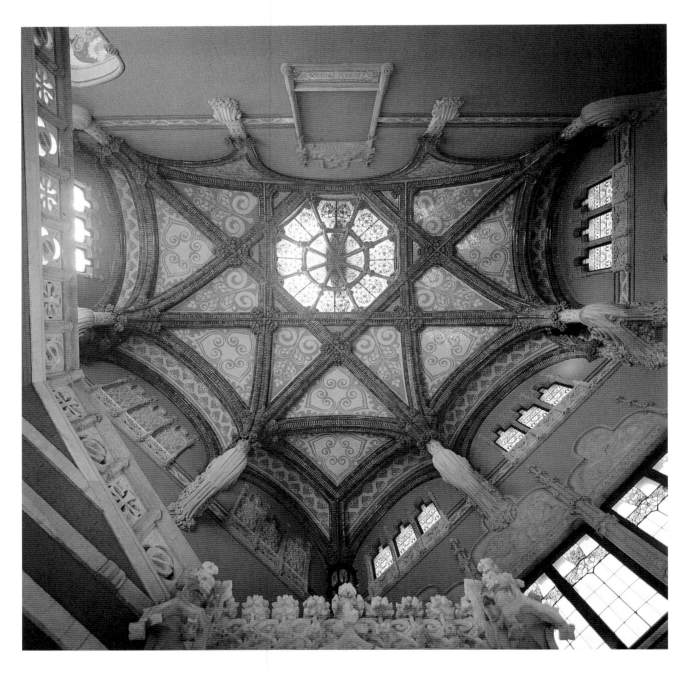

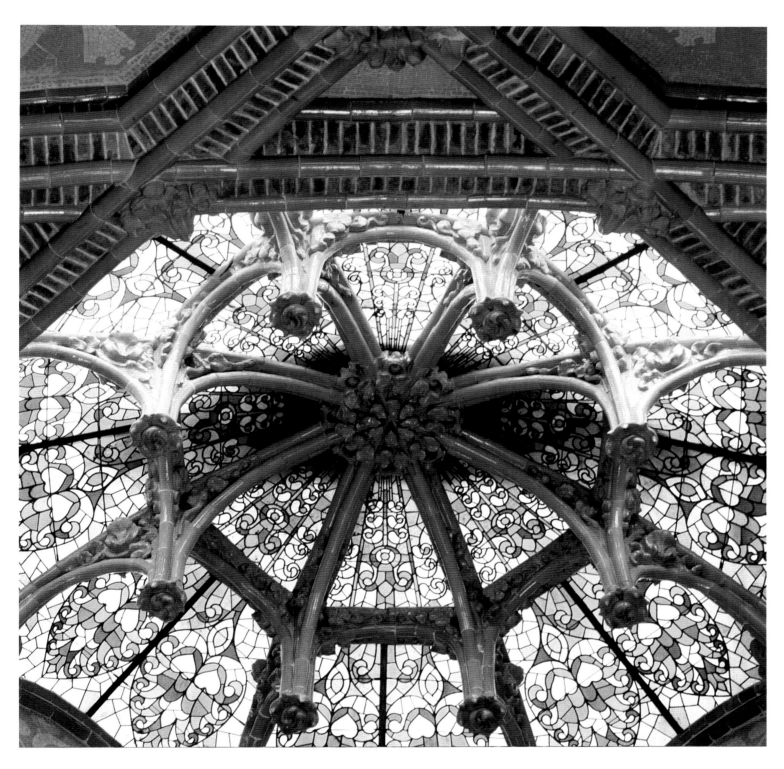

Lluís Domènech i Montaner
Santa Creu i Sant Pau Hospital
Barcelona, 1902–1911 (first phase)
Administration building, 1903–1909
Main staircase in the central hall
General view and glass vault,
stained glass by Antoni Rigalt i Blanch

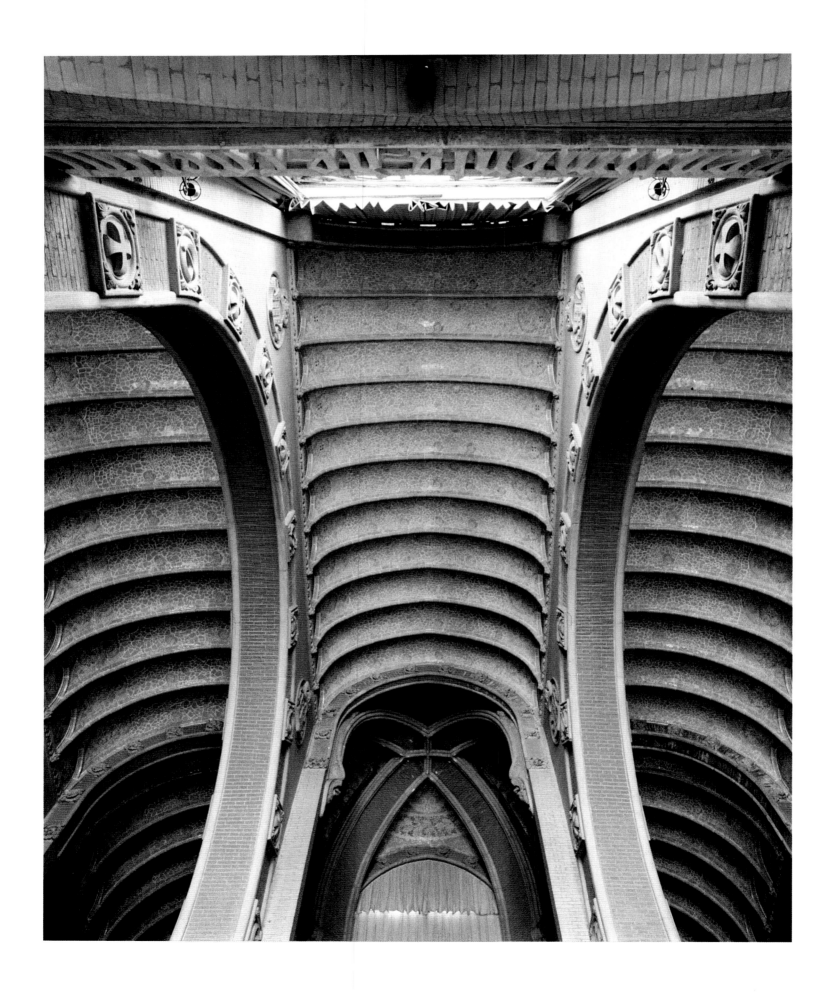

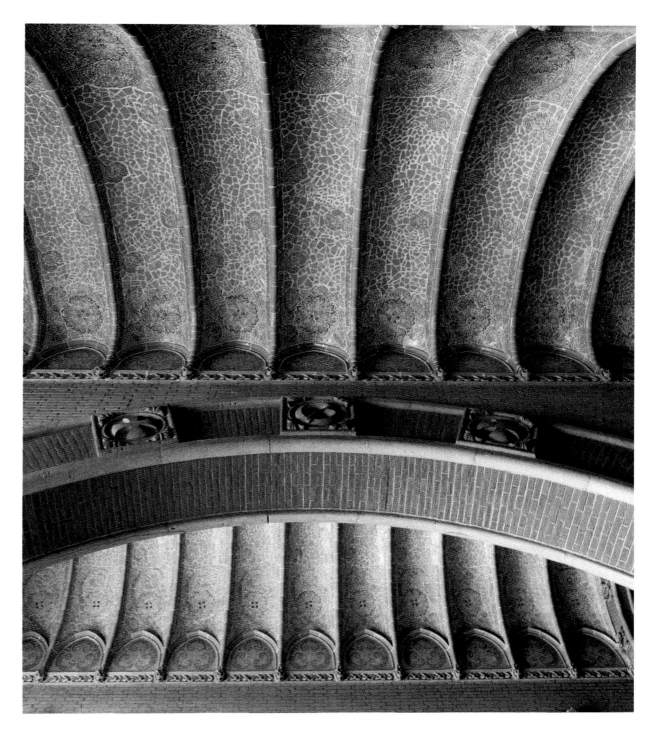

Lluís Domènech i Montaner
Santa Creu i Sant Pau Hospital
Barcelona, 1902–1911 (first phase)
Administration building, 1903–1909
Sala d'Actes

Above and Facing Page:
General view and vault detail
Left:
Front view

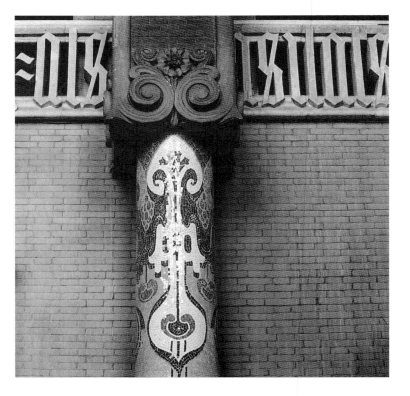

Lluís Domènech i Montaner
Santa Creu i Sant Pau Hospital
Barcelona, 1902–1911 (first phase)
Administration building, 1903–1909
Sala d'Actes

Right:
Wall decoration
Below:
Trompe l'œil drapery above pew, mosaic by
Mario Maragliano from cartoon drawings by
Francisco Labarta, ceramics by Francesc Lata

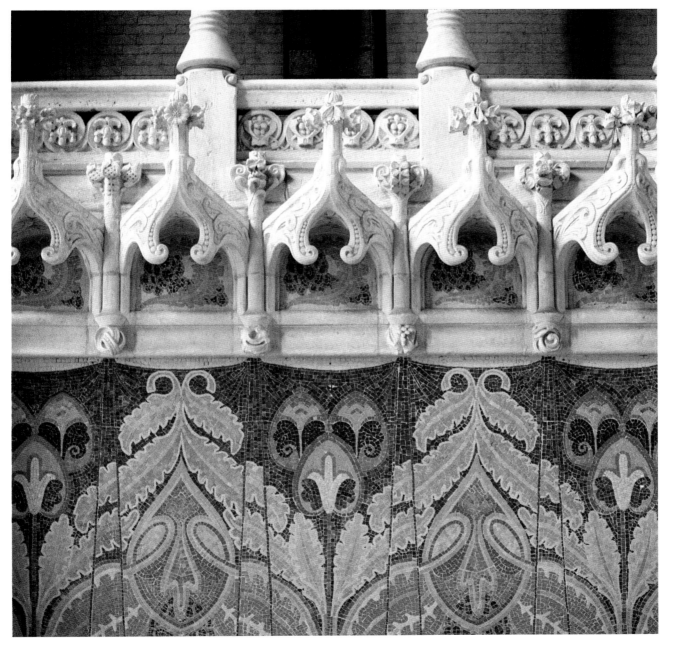

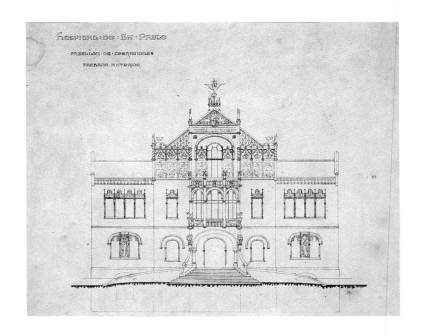

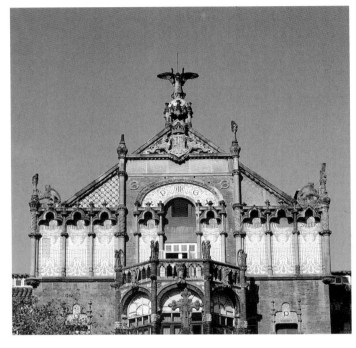

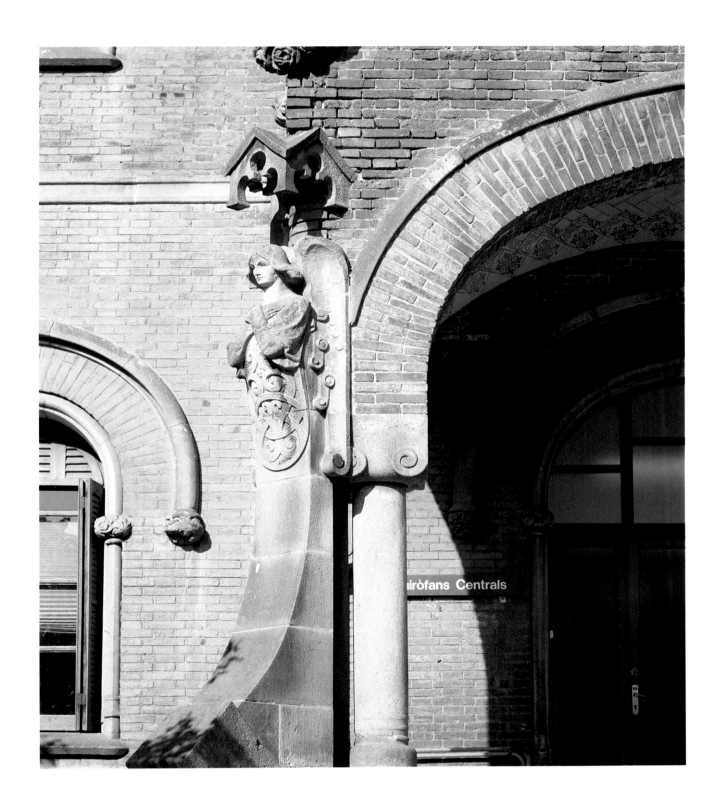

Lluís Domènech i Montaner
Santa Creu i Sant Pau Hospital
Barcelona, 1902–1911 (first phase)
Central operating wing, 1903–1911

RIGHT AND FACING PAGE ABOVE LEFT:
Front and side elevations
FACING PAGE ABOVE RIGHT:
South-west façade
FACING PAGE BELOW:
Access and side wings
ABOVE:
Angel on the entrance porch,
sculpture by Pau Gargallo

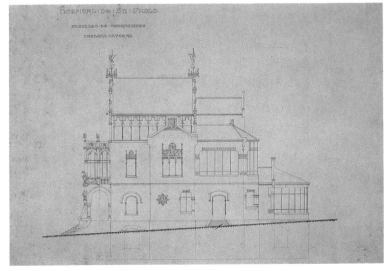

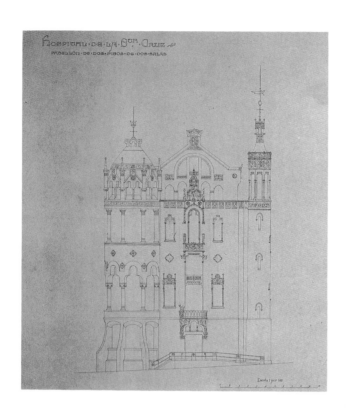

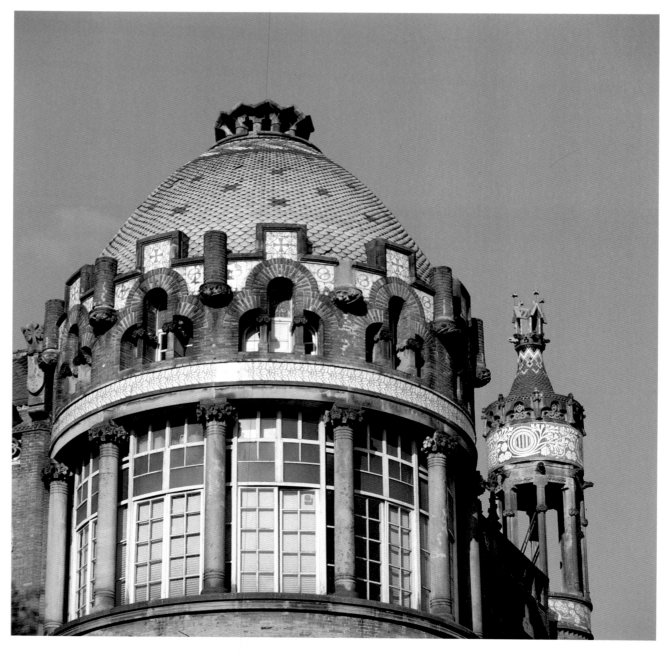

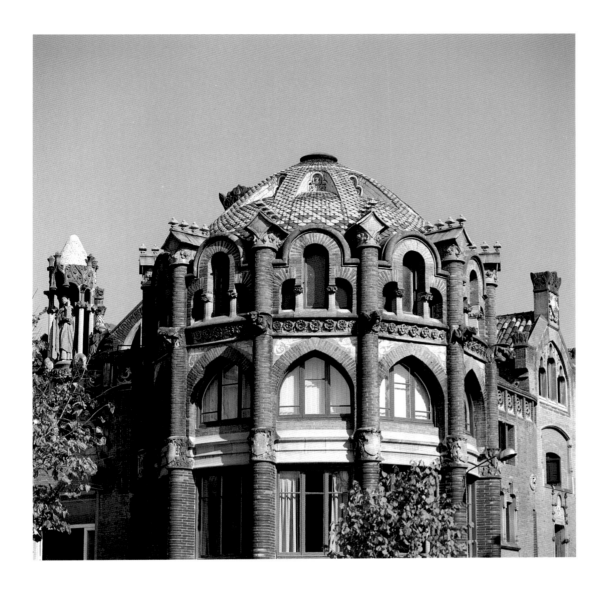

Lluís Domènech i Montaner
Santa Creu i Sant Pau Hospital
Barcelona, 1902–1911 (first phase)
Surgical wings, 1903–1911

FACING PAGE ABOVE:
Front elevation
ABOVE AND FACING PAGE BELOW:
Domes on the corner towers
RIGHT:
Cupola in the consultation room

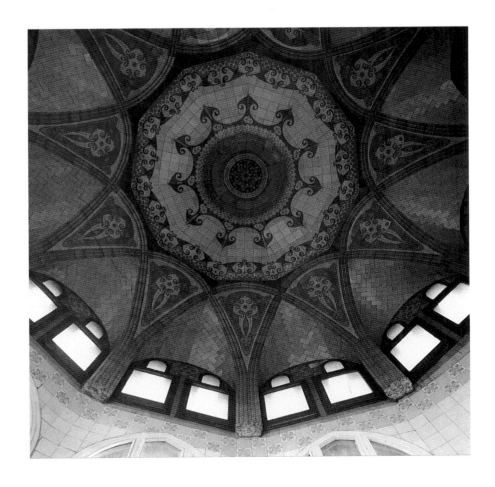

Lluís Domènech i Montaner
Santa Creu i Sant Pau Hospital
Barcelona, 1902–1911 (first phase)
Sant Leopold surgical wing, 1903–1911

Left and Above:
Architraves
Facing Page:
Canopy over the entrance, sculptures by
Eusebi Arnau i Mascort

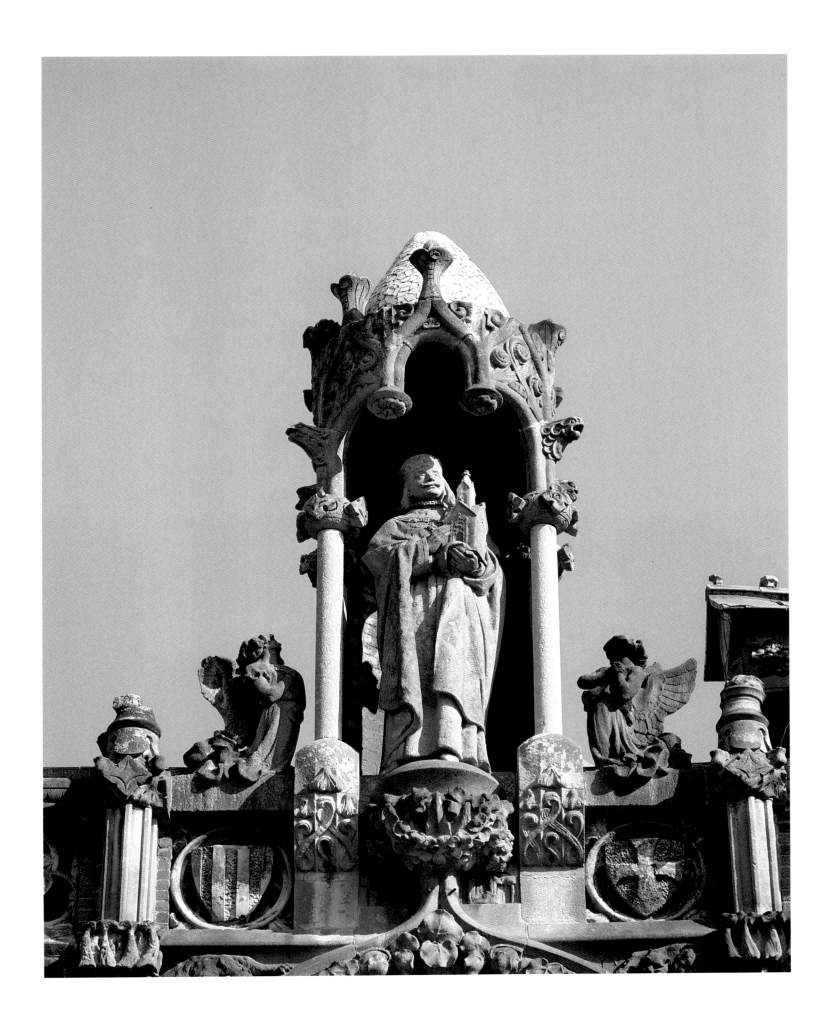

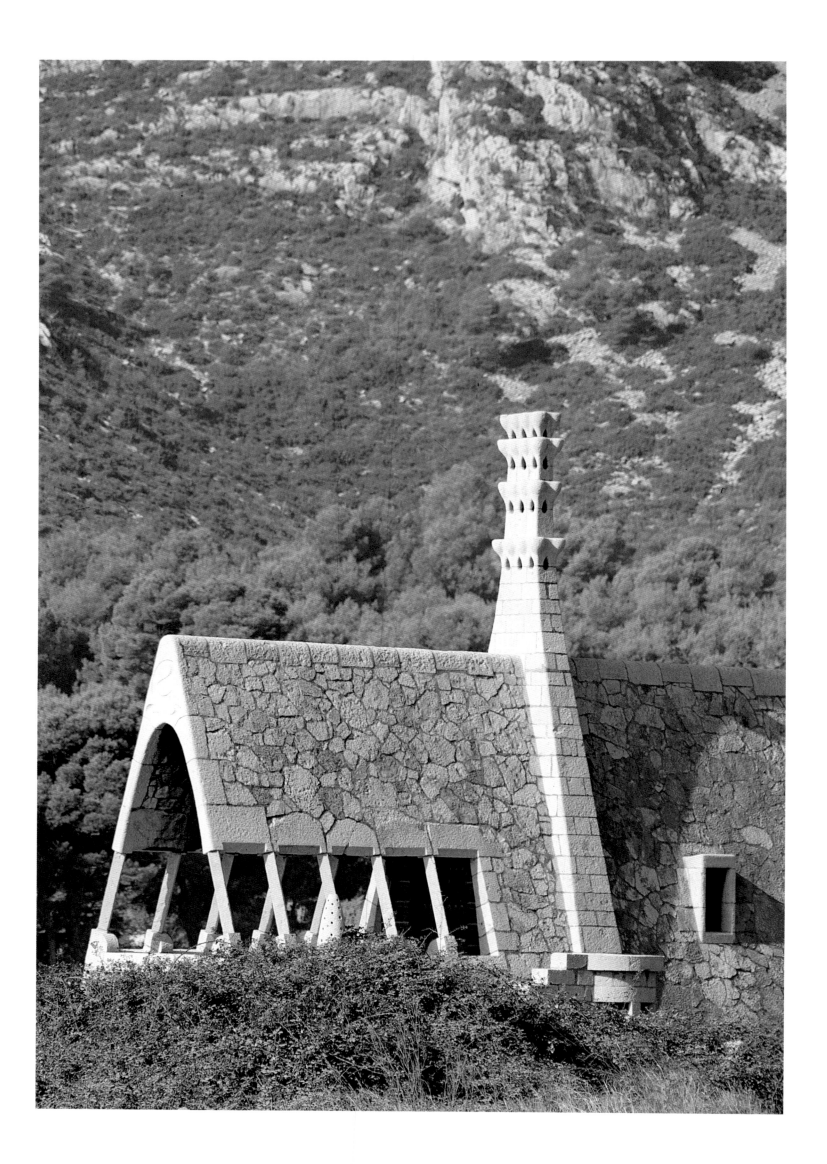

5

THE TRILOGY
OF MODERNITY

In concerning itself exclusively with form, modern art implicitly recognized its limitations. The opposition so forcefully expressed between structure and ornament, between a conceptual and a plastic approach was not sufficient to compensate for the obvious absence of genuine meaning in artistic form, a fact to which both symbolism and surrealism in turn repeatedly referred. Like the eye of Siva, this "third eye" that art represents is the soul's window on the world. The invention of a new plastic language could be justified only by revealing its ideological meaning, that agonizing metaphysical question which arises in every debate on art: modern man already had sufficient difficulty deciding where he stood on the division between mind and body, between the world of the emotions and the world of the intellect, without the issue of the soul complicating his existential approach still further. Yet it was on precisely this point that twentieth-century art revealed itself to be deeply divided and apparently incapable of achieving that synthesis it expected from the new order.

"Antoni Gaudí", writes Siegfried Giedon[1], "was the founding father of organic architecture as we know it today. In Gaudí the instinct of the builder was coupled with a bold imagination for the plastic. He assimilated a rich inheritance particular to his own region: the Gothic, Churrigueresque and baroque, and Moorish tiling. At the same time his work reflected a desire for a new modelling of the architectonic and plastic, which reached its peak during the first decade of the twentieth century." The hope for a new organic unity for architecture runs through Giedon's work and is what leads him to name Gaudí, a major figure, as the obvious creator of the movement. It was indeed Barcelona's good fortune to have nurtured such an outstanding figure in contemporary art as Gaudí during the extraordinarily dynamic period the city experienced in the last quarter of the nineteenth century.

Josep Puig i Cadafalch, writing about his own achievements[2], says "this work is the fruit of a collective effort, of the collaboration between unconscious visionaries, conscious precursors, masters and their students". His implicit tribute to his colleague Gaudí, the "unconscious visionary", is coupled with the respect he feels for the generation of artists who were the true creators of Catalan modernism – Elies Rogent, Joan Martorell, Josep Vilaseca and Lluís Domènech – without whom the new architecture would not have existed. This more comprehensive view is helpful in enabling us to gauge better the role played by Gaudí's school, established around the master's exceptional figure, and the influence that it exerted in Barcelona during the first two decades of the century. If we compare the furniture designed by Gaspar Homar i Mezquida – in the same tradition as Francesc Vidal's work (then in the

Casa Lleó Morera influenced by Lluís Domènech) – with that designed by Gaudí for the Casa Calvet and the Güell chapel or by Josep Jujol, his pupil, we can see the profound difference between a purely formal vision of Art Nouveau and the vision that Gaudí was determined to promote. Freedom of form in itself would clearly make no sense if the intention were not to reveal the deepest meaning of the work, if the desire to give pleasure were not subservient to the determination to convey a message about the role of art within society.

Throughout his life Gaudí was obsessed with this fundamental question and, like so many of his contemporaries, his starting point was the applied arts, as a key element within modern art. As a member of the committee of the industrial arts exhibition held in Barcelona in 1880, he strongly criticized the copying of historical models based on masterpieces in museums. He demanded that the prevailing eclecticism be challenged by "the training of both general taste and industrial taste"[3] and recommended, in particular, the creation within the School of Architecture of a school specializing in the decorative arts. The young architect's passion for the industrial arts could be seen both in his cast-ironwork designs, such as that for a monumental fountain in the Plaça de Catalunya in 1877 and the street lamps in the Plaça Reial the following year[4], and in his early works, the Casa Vicens, 1883–1888, and the Finca Güell, 1884–1887. In fact he anticipated the Art Nouveau infatuation with the decorative arts during the last decade of the nineteenth century.[5]

Paradoxically, at the very time that the trend Gaudí had so enthusiastically supported was triumphant throughout Europe, he appeared to turn away from it. The severity of the Palau Güell and the Güell Wine Cellar is in a very different vein from the exultant neo-Gothic of the "Castell dels Tres Dragons" (the café-restaurant designed for the Universal Exhibition) by Domènech i Montaner or the "Quatre Gats" by Puig i Cadafalch. Not only had Gaudí lost interest in décor *per se* but his work was becoming more purely architectural both in the placing of structures and in their relationship to the site (for example, in the Güell Cellar) and in the arrangement of interior space, the treatment of transparency and the modulation of light, as in the Palau Güell. He displayed the rationalist preoccupation with structure, revealing himself to be an unquestioning descendant of the diocesan tradition. His architecture became that of a builder and, with its extraordarinarily pure plastic qualities, was to have a decisive influence on Francesc Berenguer i Mestres and Joan Rubió i Bellver, who would continue to use it until the 1930s with a heightened sensitivity to materials and a disconcertingly systematic graphic language.

Gaudí's concentration on the constructional aspects of his work was an implicit criticism of the weaknesses inherent in a fashionable movement, which he himself abandoned because he had achieved the maturity he needed to create his own work. Gaudí's reinterpretation of the rationalist tradition is therefore extraordinarily dynamic. Far from appearing to be an imitation, it is enhanced by the rejection of all formalism, which led him to create free forms foreign to the historicist repertoire of the diocesan school. Inspired by a careful study of Viollet-le-Duc's *Entretiens* ..., Gaudí managed to create a new grammar of

Antoni Gaudí
Casa Milà or "la Pedrera"
Barcelona, 1906–1910
Window in the inner courtyard

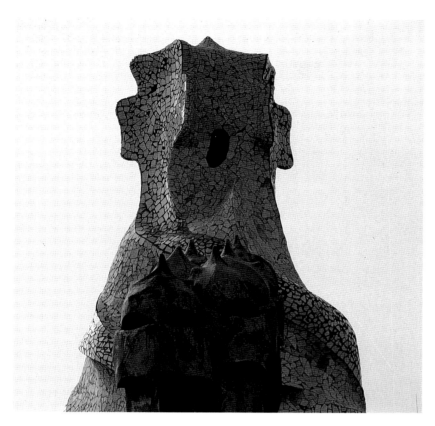

Antoni Gaudí
Casa Milà or "la Pedrera"
Barcelona, 1906–1910
Terrace roof
Stair exit and ventilation chimneys

form, the originality of which was far superior to the scholarly render-
ings of his contemporaries, no matter how gifted. For his disciples Gaudí
thus became the head of a school as opposed to the purely decorative
tendency that characterized Art Nouveau as a fashionable movement.

The question raised by Gaudí was soon taken up all over Europe
by the first exponents of modern art. He, however, needed more: the
opposition between form and structure, trim and skeleton only served to
increase the very antithesis that Art Nouveau wished to reduce. Gaudí in
his turn also had to return to décor but he brought to it the same free-
dom of form and design that he had created for structure. His acquain-
tance with the architect Josep Maria Jujol i Gibert, an outstanding sculp-
tor and colourist, was therefore decisive as he was to collaborate with
Gaudí on some of the most important projects of the century (the Parc
Güell, the Casa Batlló, the Casa Milà, etc…). Jujol took the forms
drawn by Gaudí, reinterpreting them, giving them that freedom and
plastic coherence that would make them inseparable elements of the
work.

The two architects, inspired by the organic philosophy of Semper
and, before him, by the evolutionist theories of Lamarck and Darwin
used the same repertoire, collecting plants, minerals, bones and shells as
potential models. They worked together, each taking over from the
other until the design of the detail had reached the same level of coher-
ence as that of the space and structure. Jujol never forgot this experience
and carried it on into his own work with almost as much originality as
his master, Vistabella and Montserrat being proof of this.

Having broken free of the antithesis between structure and décor,
Gaudí now no longer simply achieved formal unity in his architecture
but he sought to make it the instrument of his creative thought. This
approach was totally original and gave a far more ambitious significance
to architecture than had previously been the case. A monument was
normally a mere expression of power, of the enjoyment of possession or
identification with the group. Gaudí's ambition was to create a language
whose forms would be capable of conveying messages other than pride,
pleasure or suitability and which would attain a discourse comparable
with that of poetry and literature. This was by no means an easy ambi-

tion – stone being far better known for its qualities of silence than of eloquence – but Gaudí was an architect who liked to rise to a challenge.

He was fifty years old and had a brilliant local career behind him when he discovered symbolism. He had, however, been coming into contact with it for more than quarter of a century in the artistic circles of Barcelona, in the thinking of Ruskin, the operas of Wagner, the wallpaper designs of William Morris and the paintings of Rossetti.[6] At the beginning of the twentieth century Ruskin's theories took on a new meaning and the death of this prophet of the arts in 1900 coincided with the appearance of Robert de la Sizeranne's work *Ruskin ou la religion de la beauté*[7] and with the translations by Marcel Proust in the *Mercure de France*. And in 1898 J.K. Huysmans produced *La cathédrale*, a work that was quite astonishing in its similarities to Gaudí's mystical plan for the Sagrada Família. Inspired by Adolphe Didron's theories on "the cathedral as mirror of the world", Huysmans produced the most impressive overview of symbolism in medieval art and architecture. He took Chartres Cathedral as his model and, exploiting the architectural language, gave form to the "synthetic cathedral" of which Boileau and Viollet-le-Duc, as architects, had only dreamt.

All that remained was for the project to be realized in Barcelona and Gaudí worked until his death to see this accomplished. The chapel at the Colonia Güell[8] provided him with an opportunity to test out his plan on a more modest scale, although the building never progressed beyond the level of the crypt. This structure was exceptional both for its strange inverted composition (based on a model made from string and sacks of sand photographed and then turned upside down to produce the skeleton of the structure) and for the determining role now played by the symbolic; the themes were the Holy Trinity and the life and death of Christ. Gaudí returned to this emotional experiment in form and space, on a far more ambitious scale, in the church of the Sagrada Família, a bold synthesis[9] of the Gothic balance in architecture and the mystical vision of religious iconography. He also returned to it in the Parc Güell, which is an almost pantheistic hymn to nature, and in the Casa Milà, a curious meditation on the mysteries of the rosary.

Many critics have been disconcerted by the new personal direction taken by Gaudí as mystic and architect and have judged him to be a mad visionary, a poet or a builder pure and simple. The ambiguity of these views, which made it possible for both Le Corbusier and Salvador Dalí (and Jørn Utzon and Philip Johnson) to declare themselves disciples of Gaudí, reveals the richness of his nature. Gaudí, like his pupil Josep Maria Jujol, simultaneously embraced "surrealism, the baroque, expressionism, abstraction and the vernacular"[10].

This poses a fundamental question concerning Gaudí's modernity. Gaudí inherited the legacy of constructive rationalism and European Art Nouveau but also opened the way to entirely original concepts of artistic creation. It would not be unreasonable to compare his work with that of the *Blaue Reiter*, and in particular the paintings of Kandinsky, abstract form and powerful expressionism being common to the work of both artists. Does this mean that Art Nouveau led to a form of artistic expressionism and that, within the field of architecture, Gaudí became its most significant exponent? It is a good question, that allows for a reinterptre-

Francesc Berenguer i Mestres
Antoni Gaudí
Güell Wine Cellar
Garraf, 1895–1901
Sketch by Francesc Berenguer

tation of the work produced by Gaudí between 1900 and 1910, which becomes both less extreme and less marginal than is currently allowed, and we are able to see the links between Gaudí's own philosophy and the avant-garde movements in other major cities of Europe. It also helps us to grasp the significance of the somewhat unusual work produced by his pupils during the same period.

It is worth recalling, in conclusion, that the major exhibition mounted as a tribute to Gaudí in 1910 as part of the autumn exhibition of the Société Nationale des Beaux-Arts was organized on the initiative of another great architect, Anatole de Baudot, who also found himself in this period of transition between two centuries. It is not surprising that Baudot, who was a pupil of Viollet-le-Duc, a champion of the use of reinforced concrete and the theoretician who wrote *L'architecture, le passé et le présent*, should see Gaudí as the greatest formal inventor of his generation. In Weimar Germany Hermann Finsterlin, Hans Scharoun and even Bruno Taut took up the baton of this intuitive and passionate vision of the world of architecture as *total art*. Gaudí's project became the aspiration of an entire era.

Antoni Gaudí
Expiatory Church of the Sagrada Família
Barcelona, 1883–1926
Nativity façade
Tower detail, 1903–1926

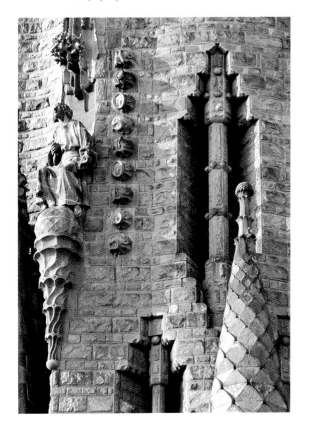

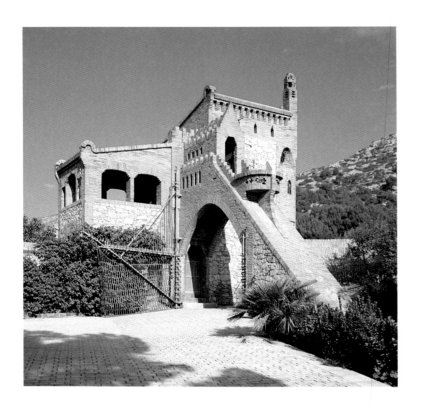

Mass, Colour and Place

Until the modern period architectural tradition, a set of conventions that transformed any building, whatever its type into a sort of box of masonry, embellished by external decoration, had never been challenged. With the birth of modernism came a concern, borrowed from sculptors and painters, for the purely plastic aspect of the building which revolutionized completely the way in which architects viewed their own work.

When Francesc Berenguer and Antoni Gaudí built a wine cellar for Eusebi Güell at Garraf, near Sitges (in an area frequented by all the artists of their generation), they showed great sensitivity to the beauty of the coastal site and the impressive fissure running through it. The style of the Güell Wine Cellar, with the line of its main beam and the sharp point of its roof almost completely concealing it, is a variation on what could have been a medieval manor house. The structure becomes little more than a "line in the landscape", its powerful ridge emphasizing the fault line and creating a deflection away towards the infinite panorama of the sea.

From this break in the earth's surface there emerges a plastic creation of surprising richness. The transparent screen of the porch in cutaway style, the lines of crenellation and the outline of the bell turret reflect the totally unexpected internal arrangement of this outbuilding with the service arrangements on the ground floor (delivery area, cellar and caretaker's accommodation), and above this on the first floor the owner's apartment, somewhat curiously divided by a central partition, and lastly, the narrow roof space with its chapel and loggia facing the sea.

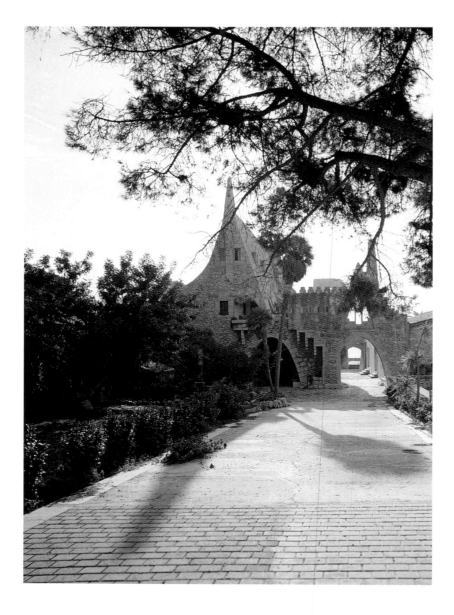

Francesc Berenguer i Mestres
Antoni Gaudí
Güell Wine Cellar
Garraf, 1895–1901

Above:
Porter's lodge
Left:
View of the entrance
Facing Page:
South façade

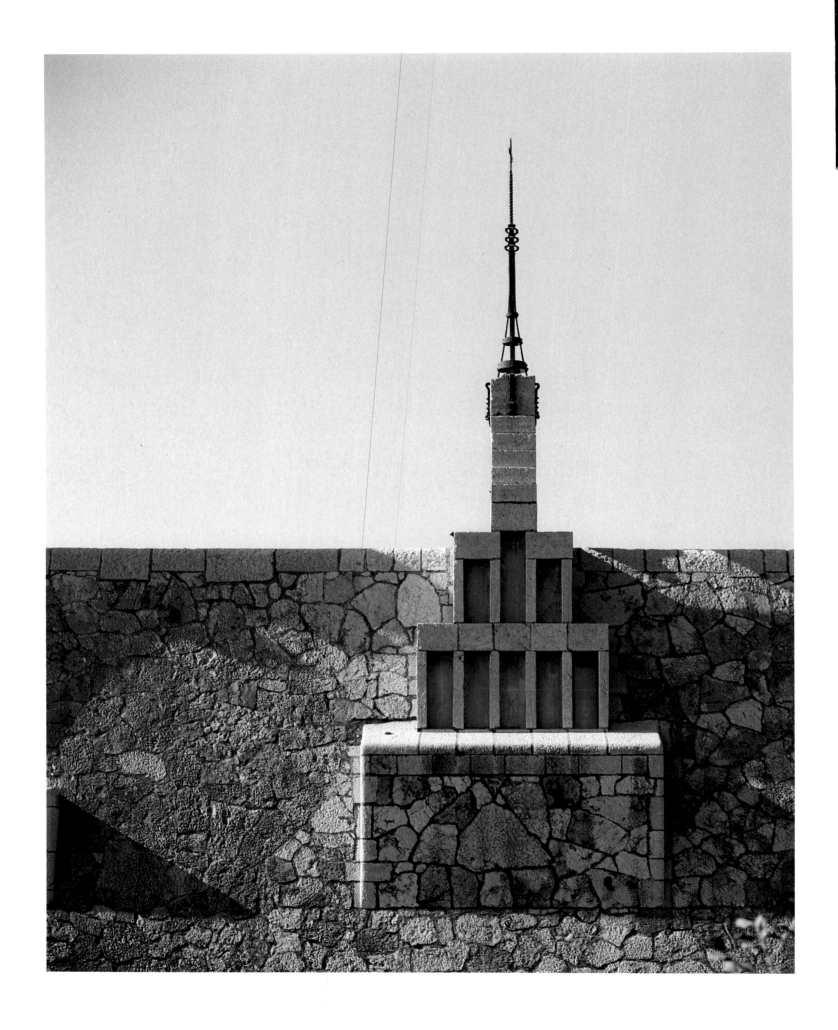

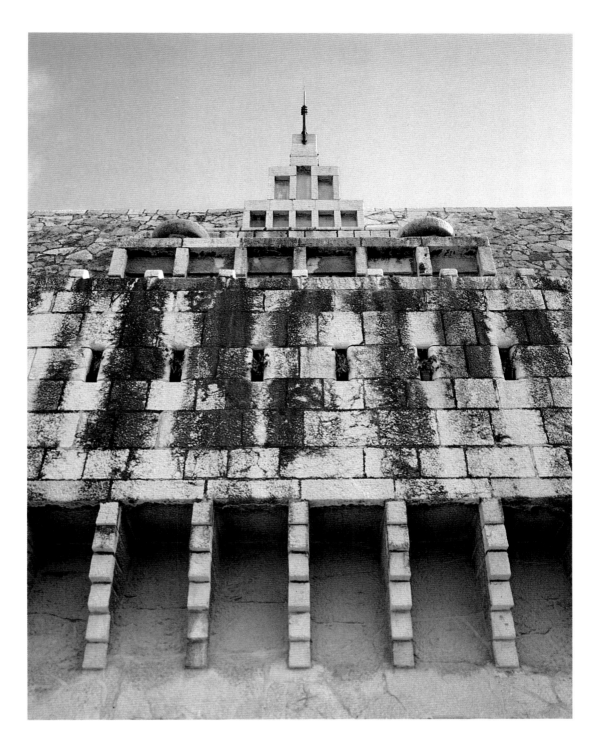

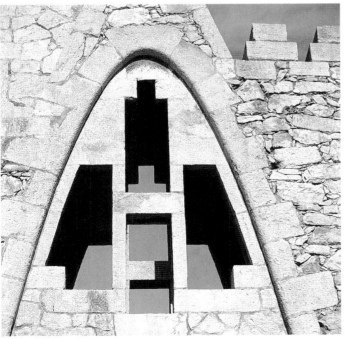

Francesc Berenguer i Mestres
Antoni Gaudí
Güell Wine Cellar
Garraf, 1895–1901

FACING PAGE:
Pinnacle
ABOVE:
"Bartizan"
LEFT:
Entrance porch detail

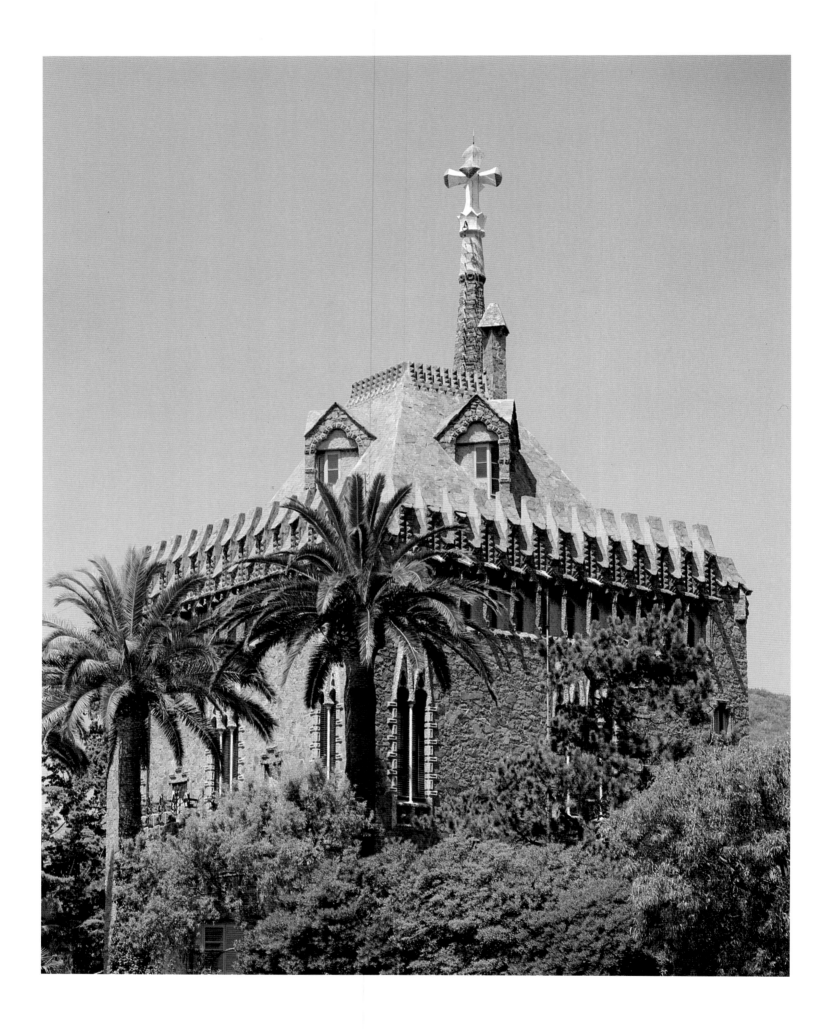

The entire architectural interpretation is based around this chapel and its altar, which explains the internal division of space and the curious bartizan skirting the obstacle. The impressive plastic unity that characterizes the building comes from the development of a single idea on different scales – from the general to the detailed.

Gaudí designed the Bellesguard country house just outside Barcelona in a similar way. It is like the donjon in an operetta, with machicolations more conducive to contemplating the view than providing the building's defence. The structure is a mass of rough quarry stone in green and ochre tones under a roof swallowed up by the same material. The design hinges entirely on the discreet projection of the stair building and the splayed bow window that lights the main drawing room.

The whole effect is achieved by the contrast between the stone mass of the exterior and the milky whiteness of the interiors. The subtle internal arrangement is determined around the views from the building itself as well as its orientation. Gaudí, who based his design loosely on two private houses built by Victor Horta in Brussels, places the large spiral staircase in the corner recess opposite the mezzanine-style half-storeys on the rear façade, creating three large regular spaces on the principal floor on the side of the building that benefits most from light and rural views. Here again all the details are dictated by that all-important relationship between exterior and interior, which also informs the fundamental link between the building and its location.

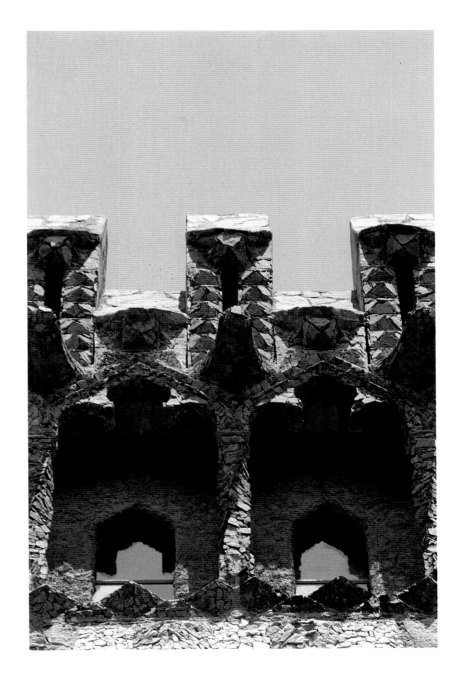

Antoni Gaudí
Torre Figueras or "Bellesguard"
Barcelona, 1901–1902

FACING PAGE:
Corner of south-west and south-east façades
ABOVE:
Roof crenellations
RIGHT:
South-west façade

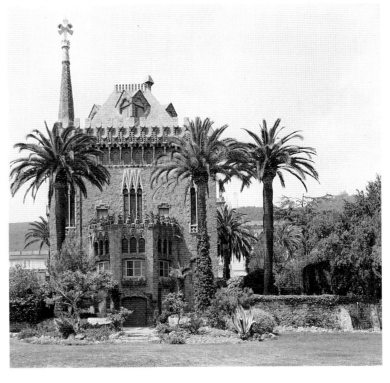

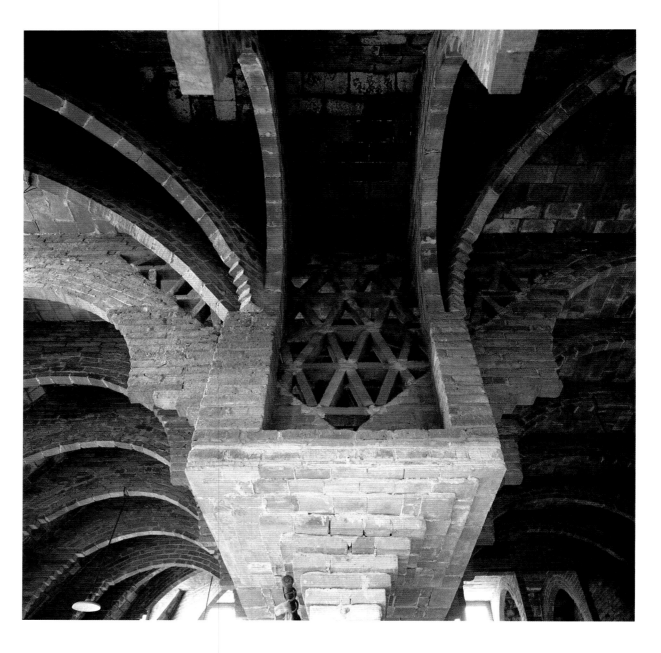

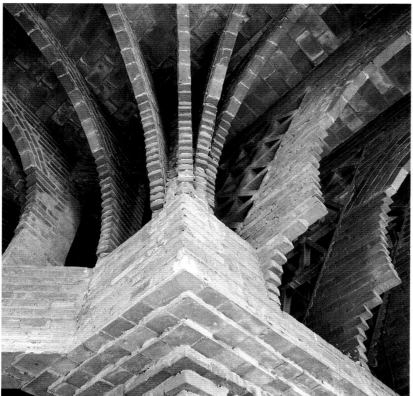

Antoni Gaudí
Torre Figueras or "Bellesguard"
Barcelona, 1900–1902

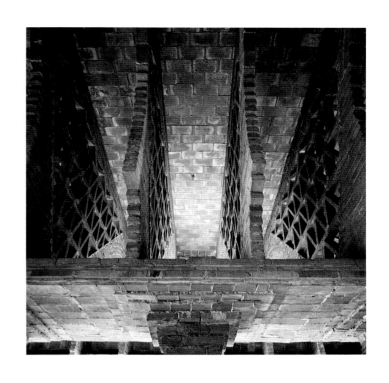

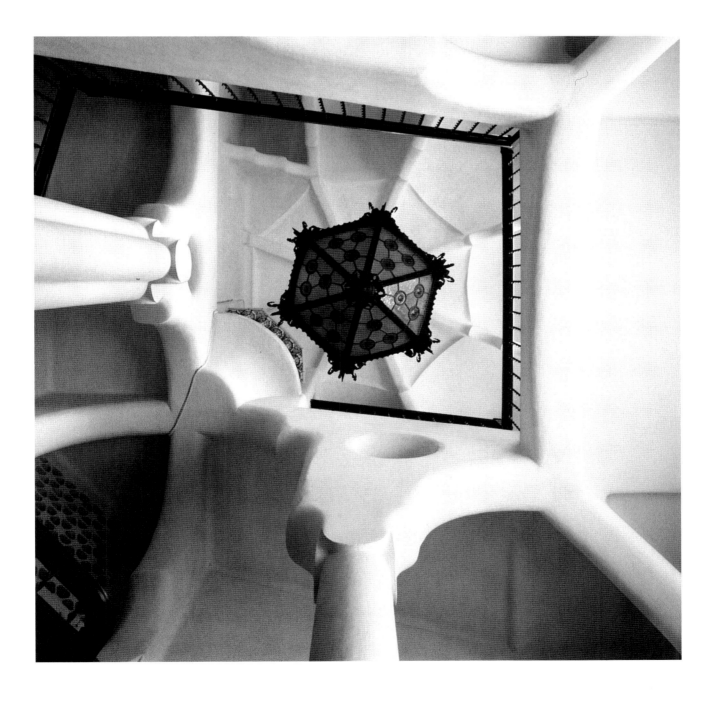

LEFT:
Joan Rubió i Bellver
Casa Rialp
Barcelona, 1908–1910
Belvedere

BELOW AND FACING PAGE BELOW:
Joan Rubió i Bellver
Casa Golferichs
Barcelona, 1900–1901
Façade on the Carrer Viladomat
Corner loggia and window

Juan Rubió i Bellver

In its efforts to free itself from the analytical con-
structive rationalism inherited from the nineteenth
century, the modern school took a purely plastic
approach to architectural form. Even where moder-
nity remained in touch with history and the histori-
cist tradition, it was still determined to rid itself of
imitation and invent new forms that would reinter-
pret this influence.

Joan Rubió i Bellver, a disciple of Gaudí,
was less bold than his master in linking detail with
the general scheme, but always sought to maintain
the unity and identity of the scheme – a corner
loggia-balcony accentuated by the overhang of the
roof; the uneven outline of a bell turret- belvedere
exploiting the curve; the persistent repetition of
vertical or oblique hatching as a commentary on a
single, carefully emphasized architectural motif (for
example, the bay, the arch, an opening or the roof).
Even in his late works, at the end of a long career
during which he became a restorer of medieval
monuments in the historicist tradition, Rubió i
Bellver would still maintain the need for plastic
unity. His design for the chapel of the Asil del Sant
Crist, at Igualada, blends the detail into a facing of
irregular bond in ochre tones intercut with dark
shadows and melds all the expressive detail into the
mass of the building. By so doing he manages to
reconstitute the unity of a composition threatened
by the loss of detail which had become obsessive,
impoverished and unrelenting.

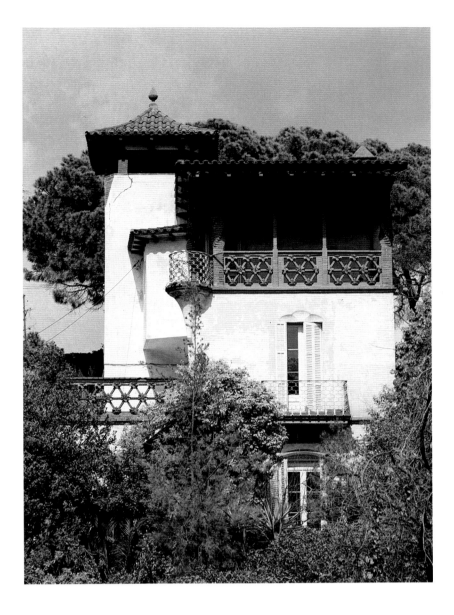

ABOVE:
Joan Rubió i Bellver
Casa Manuel Dolcet
Barcelona, 1906–1907
General view

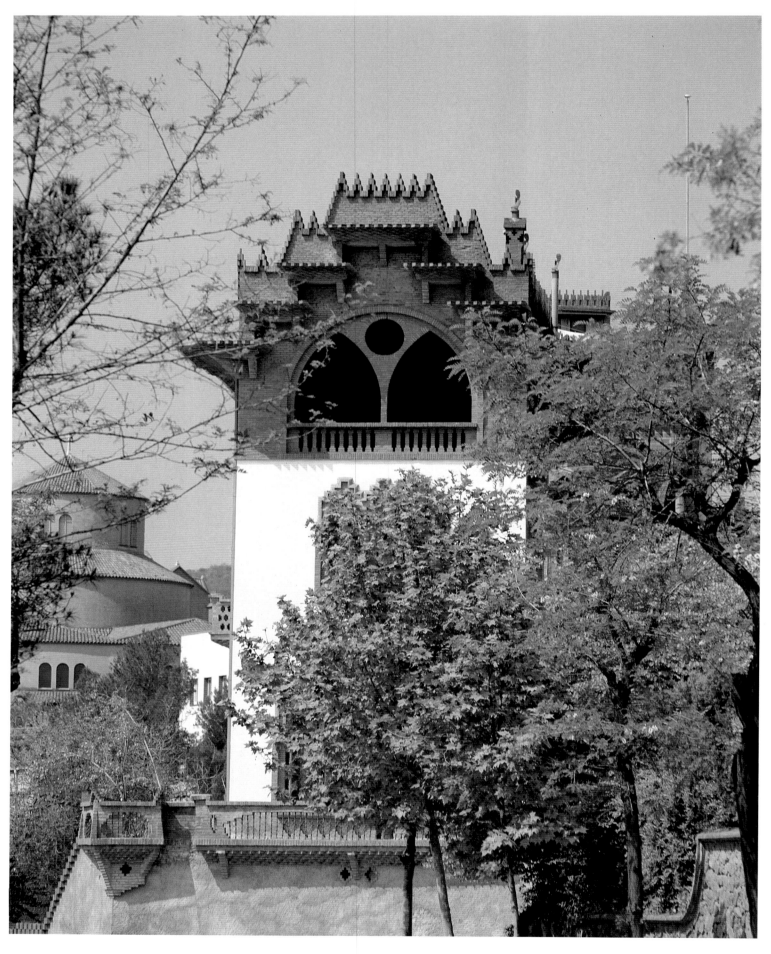

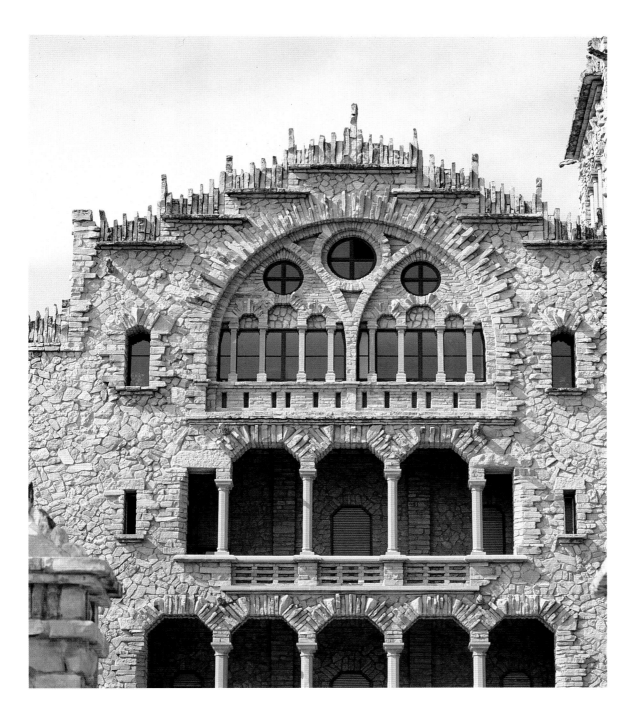

Right and Facing Page:
Joan Rubió i Bellver
Casa Roviralta or "el Frare Blanc"
Barcelona, 1903–1913
Façade on the Avinguda del Tibidabo
General view and detail of the open roof

Above:
Joan Rubió i Bellver
Asil del Sant Crist
Igualada, 1931
South-east façade
Central section

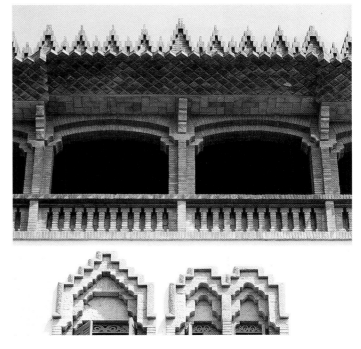

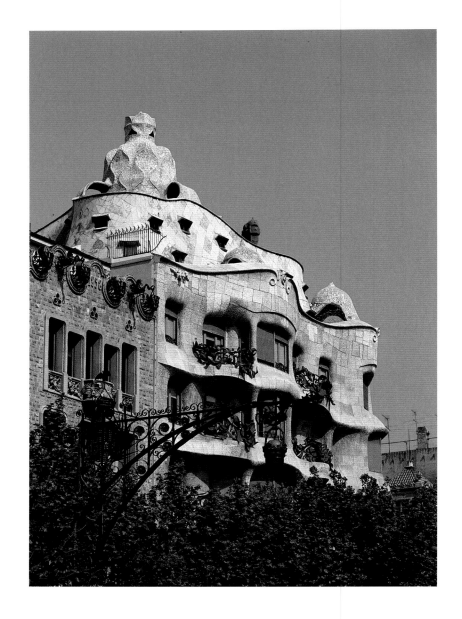

Sculpture in the Round

When preoccupations with construction are super-seded by the plastic treatment of form the whole of architecture becomes sculptural. This is all the more impressive when it is free from any figurative connotations. Gaudí's Casa Milà, for example, is not a monumental statue to the Virgin with the folds of her blue robes or her crown of gold concealing windows and floors, unlike Bartholdi's colossal Statue of Liberty in New York, where this is to some extent the case. Gaudí's vast architectural poem recalls the watery depths of caves and the seashells and seaweeds that were its inspiration.

The curious sensuality of these curves may amuse us, but we must, at the same time, recognize the mastery of form required to achieve these shapes, which create a totally unified plastic construction. Gaudí's approach is one of total art, which does not allow the individual elements of the work to be perceived independently. From the iconographical theme to the constructional scheme and formal elements taken as a whole, right down to the very last detail, there is no break in the chain. It is as if the meaning is inseparable from the language that expresses it.

In a certain sense art becomes limitless. All those divisions imposed by custom have disappeared: between symbol and construction, space and structure, mass and volume, solids and voids, the decorative treatment of features and ornament, etc… All this is demonstrated in the Parc Güell, where one can no longer be sure where nature ends and architecture begins as both appear to be the expression of a single idea extending beyond human will, and beyond its time and place. The extraordinary blossoming of detail in Gaudí's mature work is a manifestation of both his sense of structure and the inexhaustible imagination for the plastic that was the guiding force of his work.

Antoni Gaudí
Casa Milà or "la Pedrera"
Barcelona, 1906–1910

ABOVE AND FACING PAGE:
Façade on the Passeig de Gràcia
CENTRE AND LEFT:
Plans for the third floor and ground floor

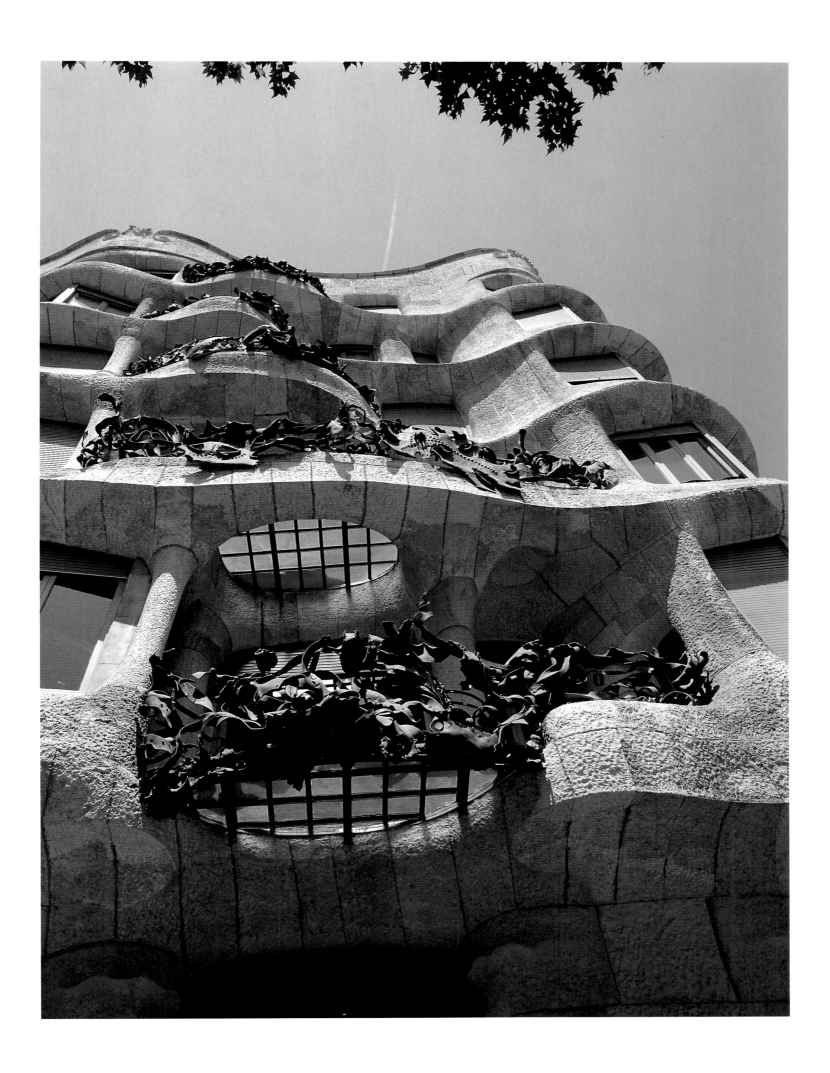

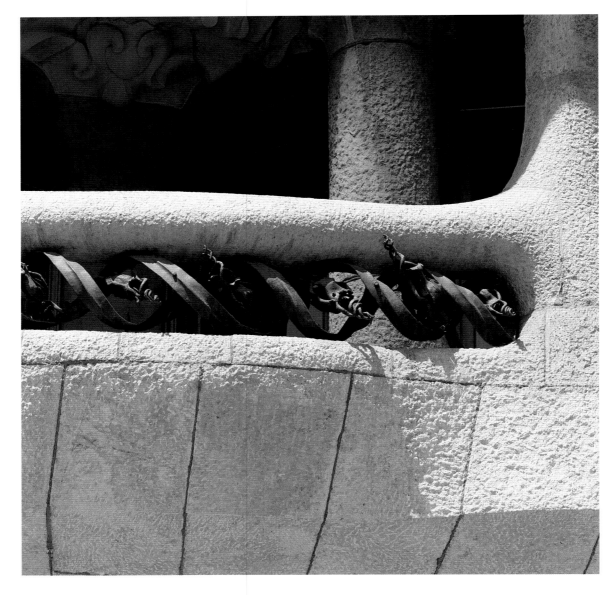

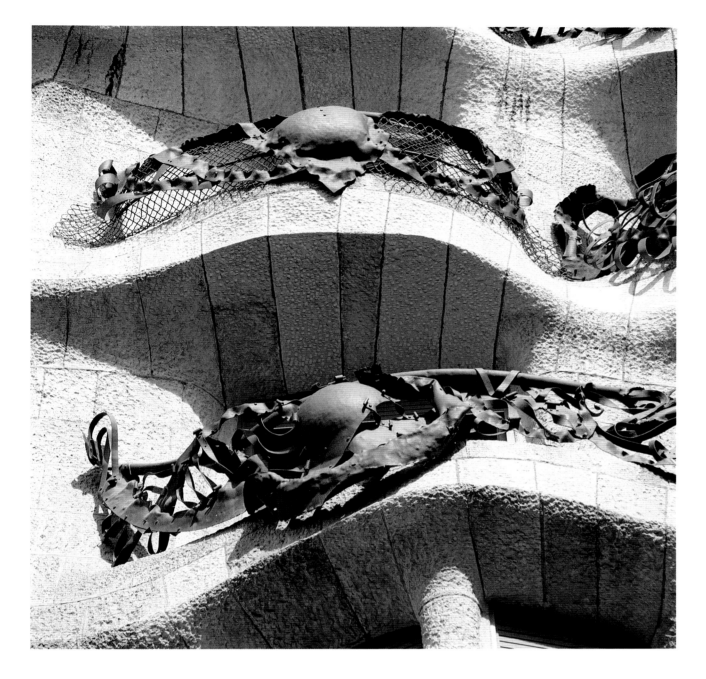

Antoni Gaudí
Casa Milà or "la Pedrera"
Barcelona, 1906–1910
First-floor apartments

RIGHT AND FACING PAGE ABOVE:
Living-room ceilings,
stuccowork by Josep Maria Jujol i Gibert
FACING PAGE BELOW:
Detail of entrance loggia
ABOVE:
Wrought ironwork on the balconies

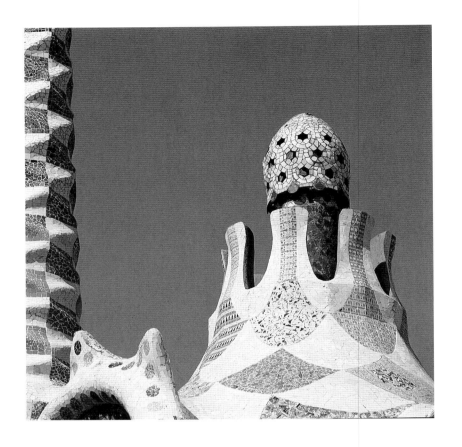

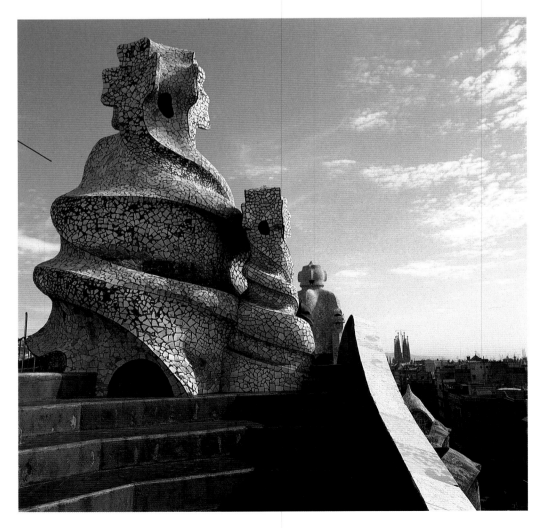

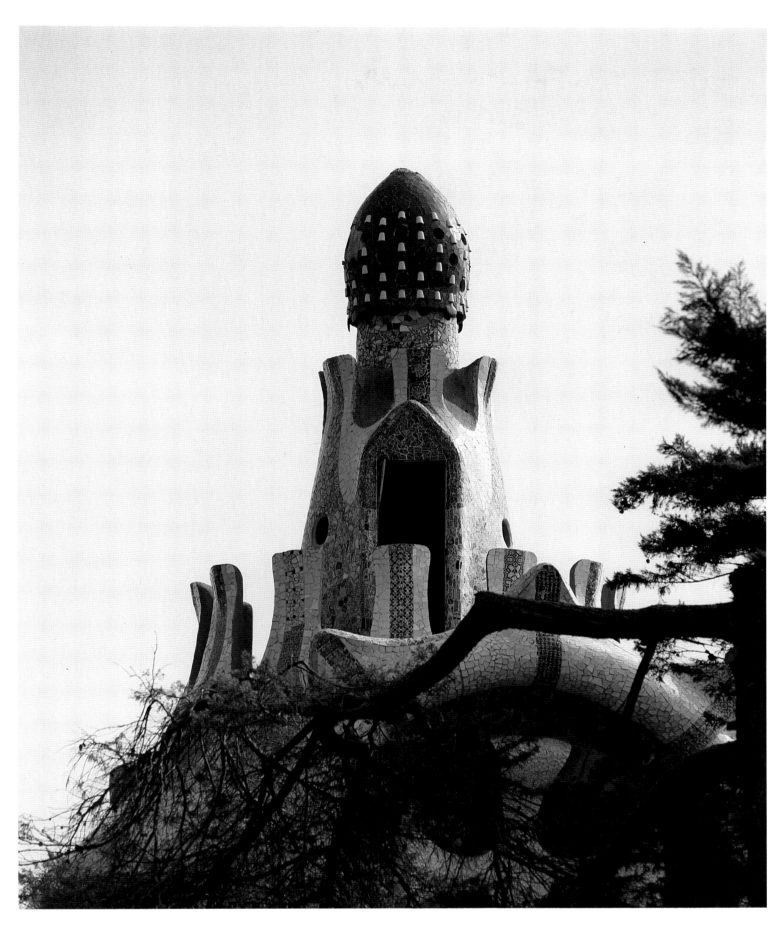

Antoni Gaudí
Parc Güell
Barcelona, 1900–1914

Above and Facing Page Above:
Details of the roof and entrance buildings
Facing Page Centre:
House of the painter Lluís Graner, 1904

Facing Page Below:
Antoni Gaudí
Casa Milà or "la Pedrera"
Barcelona, 1906–1910
Roof exit to stairs

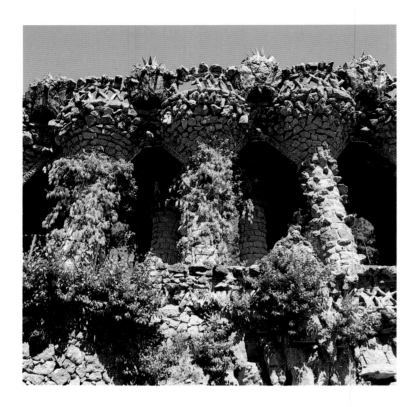

Left, Below and Facing Page:
Antoni Gaudí
Parc Güell
Barcelona, 1900–1914
Park terraces
Porticoed promenades

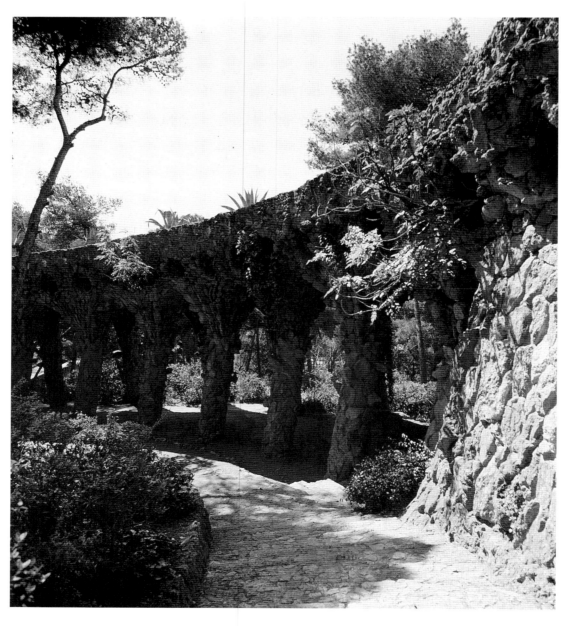

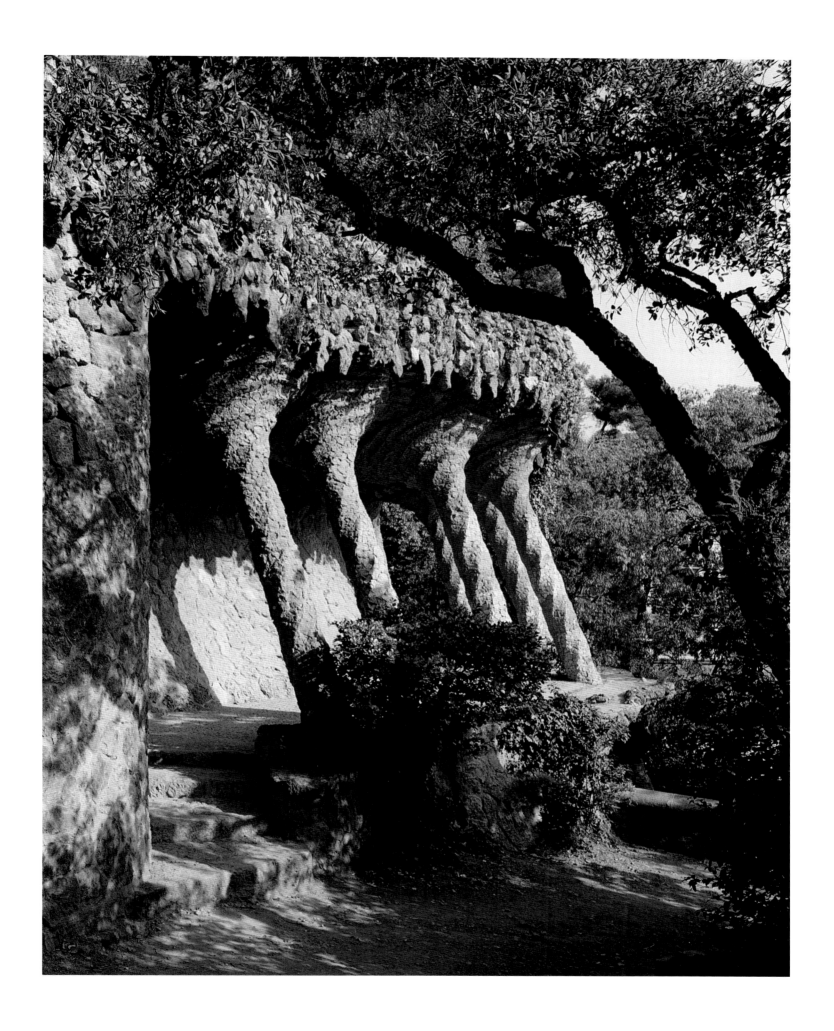

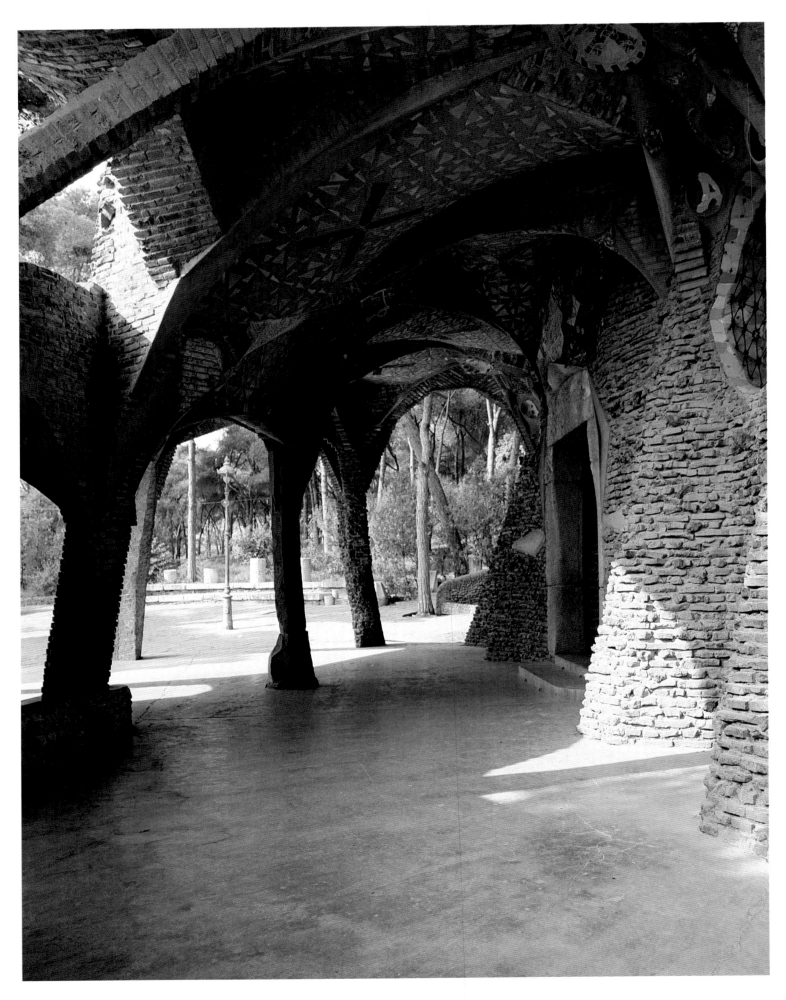

Structure

Gaudí's passion for the constructional skeleton of a building was equalled by that for ornament as symbol. In both the church of the Sagrada Família and the crypt of the Güell Chapel at Santa Coloma de Cervelló the same spectacular examples of structural inventiveness, based on real-life experience of construction, can be found. The extraordinary device of steel wire, string and canvas sacks filled with sand that enabled him to perfect the skeleton of the latter building without resorting to calculations is one example.

The symbolic aspect is just as apparent here where the structure is based on a purely visual approach as it is in the sculptural décor of the Casa Milà. Gaudí ignores any obvious logic and combines inclined columns and rising vaults with slanting ceilings, requiring a totally unconventional stone and brick structure. The symbolism of numbers, the structure's ascending spiral, the tragic contrast of light and space all have an essentially religious meaning. The whole building expresses the glorification of the faith that had become the architect's single purpose in life. There was one area where ordered thought had still to be applied, however, for simple reasons of common sense and that was in the constructional rationality of the building. Here Gaudí is able to demonstrate the limitations of a technical tradition founded on Euclidean rules of geometry and presents structures which are equally logical, although not derived from any of the conventions of the genre.

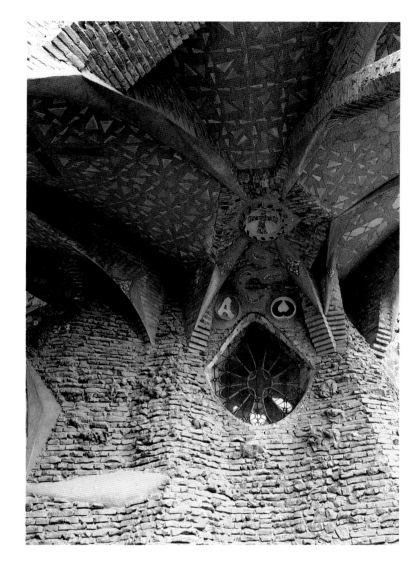

Antoni Gaudí
Chapel at the Colonia Güell
Santa Coloma de Cervelló, 1898–1915
Crypt (only part completed), 1908–1915

Above and Facing Page:
Entrance porch, general view and vaulting
Right:
Drawing for the chapel

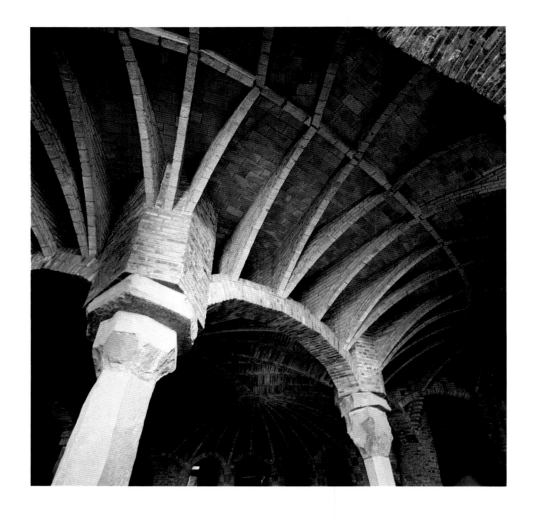

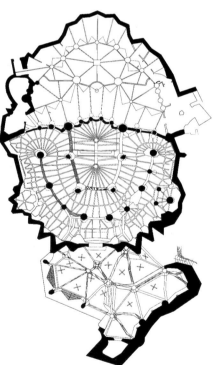

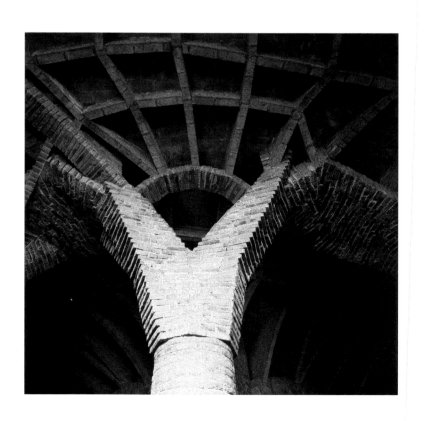

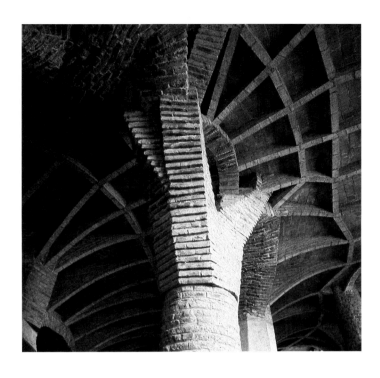

Antoni Gaudí
Chapel at the Colonia Güell
Santa Coloma de Cervelló, 1898–1915
Crypt (only part completed), 1908–1915

FACING PAGE ABOVE AND BELOW,
RIGHT AND BELOW:
Interior structure
FACING PAGE CENTRE:
Plan of ceiling structure

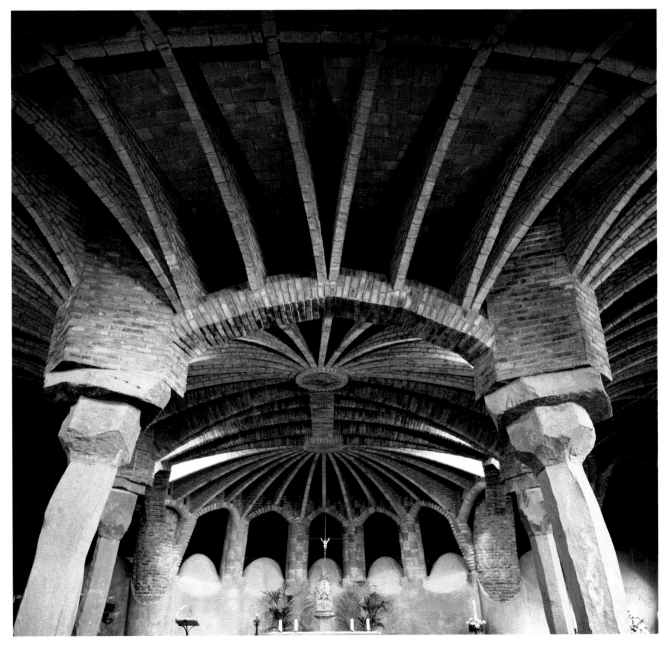

Above, Below and Facing Page:
Antoni Gaudí
Chapel at the Colonia Güell
Santa Coloma de Cervelló, 1898–1915
Crypt (only part completed), 1908–1915
Stained glass, interior and exterior views

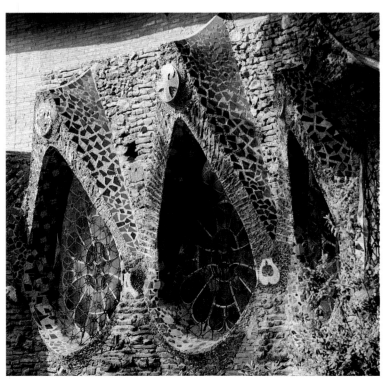

Josep Maria Jujol

Another of Gaudí's disciples, Josep Maria Jujol, did for structure what Joan Rubió, with his purely plastic interpretation of the modern decorative repertoire, had done for ornament. Jujol borrowed some extraordinary constructional solutions from Gaudí and, in the case of the church of the Sagrat Cor in Vistabella, created a composition based on the diagonals of a square and incorporating an hexagonal pyramid supported on four points, one of the latest and finest examples of an aesthetics of construction derived from careful study of medieval historicism.

At the end of his career Josep Maria Jujol created that extraordinary group of "unfinished chapels" at the shrine of Montserrat. These present examples of the organic structures of the Catalan school in all their purity, particularly since the masonry is brick and stone and there is no use of reinforced concrete.

No doubt many engineers would have been proud to have achieved the perfection of these parabolic structures which so eloquently describe the force that they support, but few would have been capable of handling them with such maturity of plastic expression.

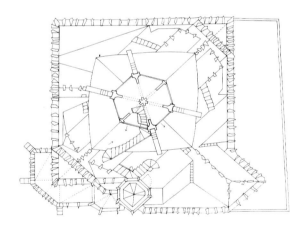

Josep Maria Jujol i Gibert
Church of the Sagrat Cor
Vistabella, 1918–1923

FACING PAGE:
North-east façade
ABOVE:
Entrance porch detail
CENTRE:
Roof plan
RIGHT:
Church plan

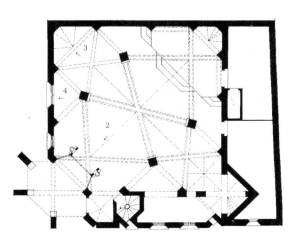

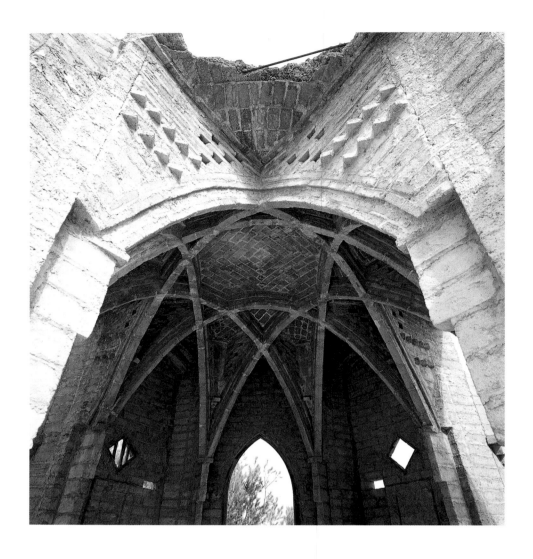

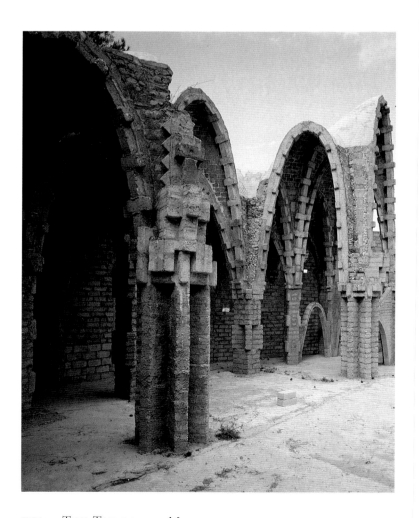

Josep Maria Jujol i Gibert
Shrine of Montserrat (unfinished)
Montferri, 1926

Above and Left:
Structural details
Centre:
Longitudinal section
Facing Page:
General view

6

CATALONIA

REDISCOVERED

Regionalism as a philosophy of architecture[1] is, to say the least, an ambiguous notion. Not only did the borderline between regionalism and nationalism remain uncertain throughout the final years of the nineteenth century but the meaning of the word "regionalism" itself later developed to mean a sort of "ruralism" – very different from the original intentions of the style.

When, in 1878, Domènech declared the need for a "national"[2] form of Catalan architecture he was close to the position that would be taken by Puig some ten years later: regionalism was then defined as a trend that was anti-academic, anti-classical and anti-centralist (opposed to Spain's capital city, and its cultural hegemony). The neo-Gothic form of expression favoured by the modern school could therefore emerge as proud and monumental as the academic tradition that it challenged; and, although it was to change during the decade that followed, this was purely a transition from rationalist analytics to ornamental rhetoric, from modern Gothic to Art Nouveau. The confrontation between these two models, between classical and modern architecture, in both cases therefore referred back to a scholarly tradition, to a culture that had nothing in common with the vernacular traditions of rural architecture.

In this context it is significant that the first country houses built by Josep Puig are not very different from his urban dwellings. Both are steeped in the same historicist references; both are always skilful adaptations devised to suit the modern way of life but are based on a medieval typology that is itself totally determined. The questions the architect appears to have asked himself concerned more the treatment of space and form than their definition, which had been established within the historicist repertoire of the academic tradition. Where a typological problem does occur it is because a familiar aspect of the architecture has had to be adapted to meet new conditions of occupation. This is the case with rental property built with party walls on wide, deep plots of land where the tall façade and separation into floors is foreign to medieval culture. In these circumstances the architect finds himself negotiating (as skilfully as his talents allow) between two opposing typologies: the traditional historical system and the new system invented by modern society but which, as yet, lacks coherence with the past.

The question still remained as to whether such a negotiation could be successful. The problem was not an easy one. Viollet-le-Duc, faced with the phenomenon of Haussmann's approach to planning, spent his whole life searching for a solution to the problem of transposing the model of the medieval house into the typology of the urban building and only found it at a very late stage; he put forward a number of ideas on the treatment of semi-detached houses in an urban milieu and of

country houses. However, although he was aware of this development, he nevertheless failed in the difficult task of adapting the traditional models of the country house to the contemporary suburban style.

"I am", he writes[3], "most attached to the country house because this is how the majority of people live and this type of building has grown in favour considerably during the last fifty years. [...] There are two different approaches possible for such requirements. I shall call them the English mode and the French mode.

The English mode consists of combining together a number of main sections each containing one or two rooms, in accordance with the owner's taste or preference, often having only a ground floor and displaying little concern for overall symmetry; each of these sections is of a height suited to the room it contains with openings made according to the preferred orientation, and access arrangements added as satisfactorily as possible. This approach to the rural dwelling demonstrates that sense of the practical for which the English are known.

The French mode consists of constructing a detached building – i.e. one main, symmetrical building – in which the services, instead of being scattered about as in the English mode, are grouped together on several floors under a single roof. This is the old traditional French approach and it has its advantages. The true French country house has always been a scaled-down version of the French country château that appeared in the sixteenth century, just as the English cottage is a scaled-down version of the English manor house of the Middle Ages with its buildings scattered about according to the owner's preference."

Although the adjective "French" may seem rather narrow to us now ("Latin" would be more appropriate), Viollet-le-Duc's analysis of the traditional French rural residence as one centralized structure is nevertheless extremely perceptive. The fact that the historical origins of the traditional model can be traced so far back explains why it persists, even in contemporary society.

Where, however, could one find an architectural model for the new form of housing spreading so rapidly in the modern world, the suburban housing estate? This is not easily answered for these houses were no longer country houses nor were they town houses. Rather they were houses built on the outskirts of town. From the rural tradition they borrowed the principle of detachment and lack of concern for alignment but, at the same time, were placed side by side on estates that totally compromised their independent status.

Regionalism, by taking a new approach, attempted to find a solution to this problem, which had already occurred in a less serious fashion in the residential areas of resort towns (spas and seaside resorts) built from the middle of the century onwards but which had now become more acute with major developments growing up on the outskirts of towns. The invention of vernacular quotation by the picturesque tradition at the end of the eighteenth century had provided the perfect key. The solution must be a response to the demands made by the new residential and urban way of life but must draw on the values of authenticity associated with the rural tradition. However attractive they may have been, the Trianon *bergeries,* the Swiss-style chalets at Arcachon (and the Normandy farmhouses at Trouville and Vésinet) were no more than a

Josep Puig i Cadafalch
Casa "El Cros"
El Cros d'Argentona, 1899–1900
Window grille

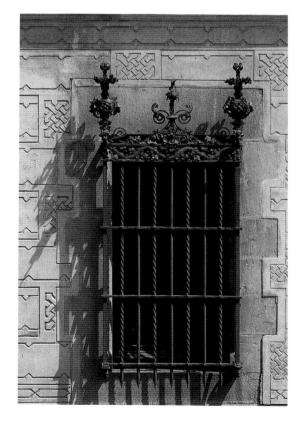

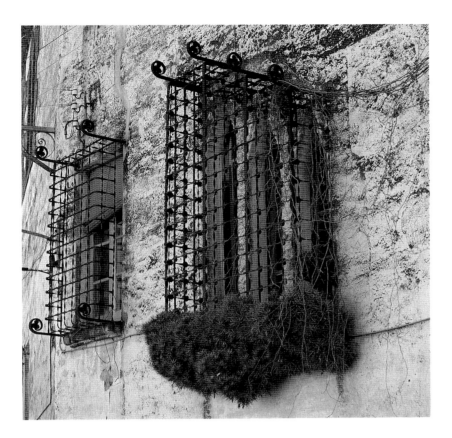

Josep Puig i Cadafalch
Casa Puig i Cadafalch
Argentona, 1897–1900
"Mozarabic"-style grilles

superficial interpretation of the moral ideal[4] that domestic architecture should convey. By the end of the century all architects from Wright, via Sédille and Luytens, to Muthesius were aware of their responsibility in this respect and strove to find a solution.

And so, by the beginning of the twentieth century a new type of regionalism was developing, a modern regionalism that, without concessions of style, sought to integrate the new architectural and urban approach into the conventions of tradtional space. Catalonia was very conscious of the originality of its culture and would therefore play a leading role in this development, making the transition from historicist regionalism to modern regionalism almost imperceptibly. We turn once again to the work of Josep Puig, who, having already attempted to reinterpret the house in accordance with the constraints imposed by urban building requirements in the Casa Macaya and the Casa de les Punxes, the latter being a fine example of post-Haussmann architecture, took on the challenge of transposing the country house to the Barcelona suburbs. The Casa Avel·lí Trinxet 1903–1904, on the Carrer Còrsega, Barcelona, gave him the opportunity. Abandoning the Flamboyant Gothic repertoire, he designed a highly traditional *masía* (country house) with a large gable and used the somewhat heavy symmetry of the typical three large openings in the façade – the whole in a charming and popular Rococo style.

The transformation is not simply formal; it reveals a desire to revive a type of habitat and a way of life that before the industrial revolution had been typified in the country house just outside the city. It mattered little that loyalty to the Gothic style and its historicist sources diminished with the adoption of this new, fundamentally vernacular aesthetic: the problem was not one of the style itself but of the meaning attributed to it. As was the case with the "Queen Anne" style in England, the purpose of this neo-Rococo style (it was in fact more neo-rustic) was to express the values of a tradition that had become almost timeless, by combining the remains of the medieval tradition with the popular transposition of the classical language.[5]

Taken together, these two sources constituted a type of basic

Josep Maria Jujol i Gibert
Mas Bofarull
Els Pallaresos, 1914–1931
Corner tower balcony

cultural substratum indifferent to modes and styles. This needed to be given new life by adapting the rules of modern life to accommodate it, but without damaging what was to some extent an ahistorical objectivity[6], the bearer of values superior to those of fashion and taste.

The curious thing about this modern regionalism was that, at the same time, it pursued two clearly opposing aims. The first was contextual, that is, that there should be integration with custom and regional tradition so that unbroken continuity could be established between past and present, between tradition and creation. This idea had already been clearly expressed in the early days of the modern school, which sought to combine the relationship with the past and the development into the future as one unified whole. However, the second aim of regionalism, very different from the first, was that it should become, without nostalgia or concession, a reflection of the period of which it was a part.

The somewhat paradoxical desire that regionalism should be an expression of its time was no doubt a response to the eclectic climate of the nineteenth century.[7] This war of styles created a need to establish some permanent values, values of an ethical rather than an aesthetic character, first among which was man's relationship with nature – a topic raised during the early days of Romanticism as a response to the industrial revolution. But it was also necessary to prevent culture being locked into the past, to free it from the shackles of style and to ensure that it was very much of its period. Both these approaches, each in fact equally ethical, came together in a project that took its most important formal elements from tradition but also confirmed the need for them to be reinterpreted. After all, was this not what the classical Renaissance itself had done four centuries earlier?

The main feature of these residential *masías* built in the suburbs of Barcelona and in Catalan seaside resorts was the ease with which they embraced the trends of the decorative fashion of the time. In outline they remained typical country houses: a large gabled façade with curves and reversed curves, and the belvedere tower topped with a pavilion roof but the detailing was borrowed both from the early Art Nouveau style

and the many variants of the modern style, from the last touches of neo-Gothic to the highly international forms of the Secession, including some strange and disturbing variations in the Japanese or Cubist style.

While the architecture itself became commonplace, the décor took on a symbolic significance, becoming a characteristic system of signs expressing the association between the rustic and the modern. It has its own discourse which, in a break from tradition, is in no sense tautological; the values it is responsible for conveying are collective, going beyond the mere technical purpose of the construction or the naïve symbolism of prolific ornamentation. However strange this décor may at times become, particularly in the case of Jujol, its function is more essential than the somewhat superficial stylistic decoration that typified the eclectic mode. It seeks to express its period using all the resources of the poetic language at its disposal. Freed from historicism, the Catalan regionalist movement was thus able to produce a more fundamental reflection of the expectations of modern society than the scholarly historicism that had preceded it; however, by breaking with its own past it also demonstrated its limitations.

Josep Maria Jujol i Gibert
Casa Solé
Els Pallaresos, 1927
Window grille

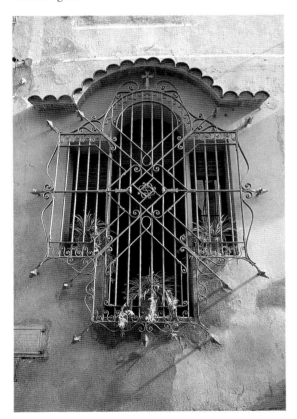

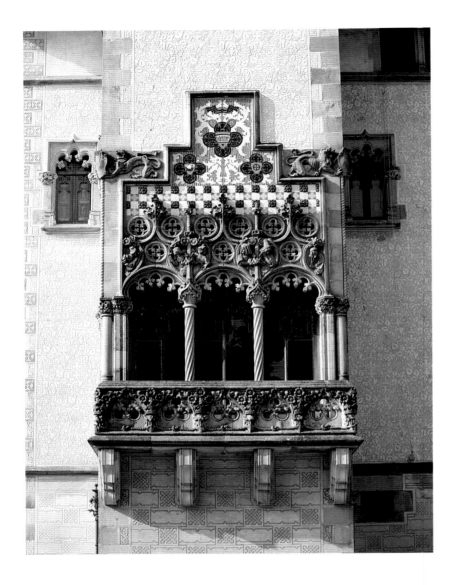

The Importance of Ornament

Art Nouveau, which inherited the nineteenth-century passion for reviving the applied arts, could have been little more than an exercise in style based on decorative wall treatment. Ornament, however, broke free from this supporting role and took centre stage, exploiting form for its own ends. All kinds of variation became possible using figure and context, surface and depth, form and content; various graphical systems based on materials and colours were combined on walls, floors and vaulting. The sole purpose of their arrangement was to surprise and seduce through a display of virtuosity from the designer and skill from the craftsman.

Puig i Cadafalch's architecture was conventional in its treatment of mass – the architecture of an historicist re-establishing the links with the medieval culture of his region. When he accentuated the cubic outlines of his "four-towered" country houses, in a scholarly regularization of late Gothic, and when he took inspiration from the striking light and shade in the courtyards of the patrician mansions in Barcelona's Barri Gòtic, he was simply imitating and reviving forgotten models.

The ornamentation he applied, however, had a quite different purpose; as was the case with Viollet-le-Duc at Pierrefonds and Roquetaillade, the décor became the most important aspect. He striated roofs with bands of colour, embellished door and window surrounds, arches and loggias, smothered walls, chimneys and furniture, adorned handrails and edges of ceilings with a lacework fringe of ever-increasing dimensions until it finally took over the whole space and location. This was a struggle between architecture and décor, with décor finally becoming responsible for generating architecture. From Owen Jones to Gottfried Semper, this was a trend that had fascinated the entire nineteenth century.

Josep Puig i Cadafalch
Casa "El Cros"
El Cros d'Argentona, 1898–1900

ABOVE:
East façade loggia
FACING PAGE:
South façade seen from the lake

LEFT:
Josep Puig i Cadafalch
Casa Macaya
Barcelona, 1898–1901
Elevation

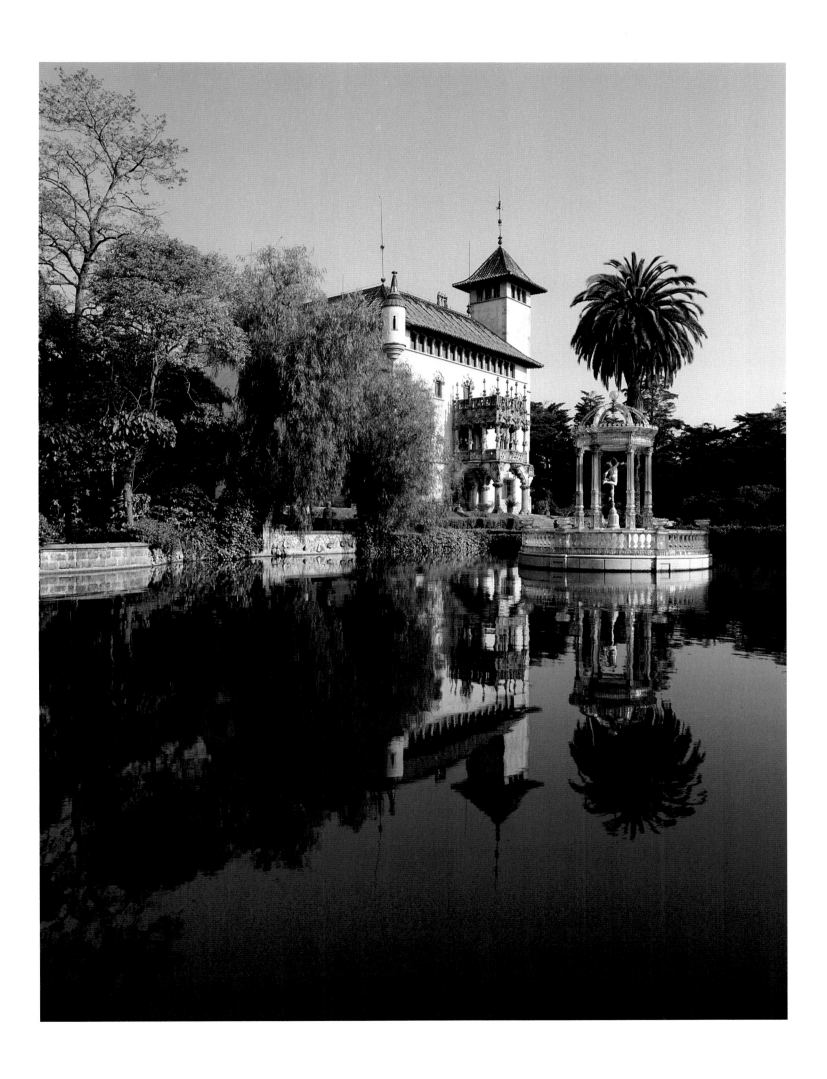

Below:
Josep Puig i Cadafalch
Casa "El Cros"
El Cros d'Argentona, 1899–1900
Entrance hall

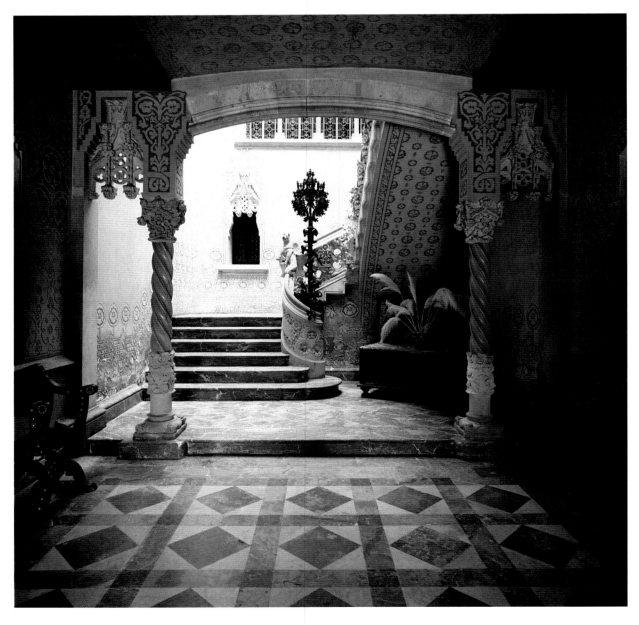

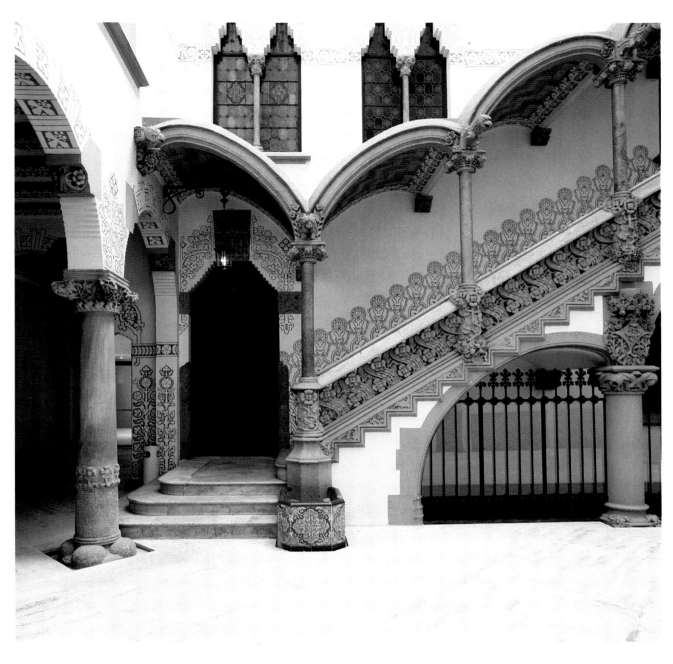

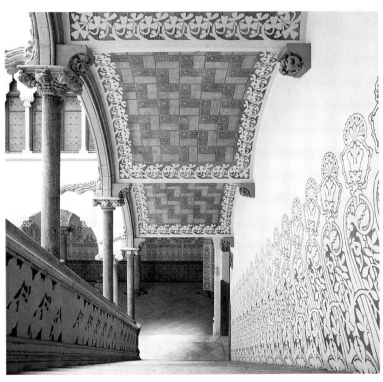

ABOVE, RIGHT AND
FACING PAGE ABOVE:
Josep Puig i Cadafalch
Casa Macaya
Barcelona, 1898–1901
Inner courtyard
Stairway details

The Catalan "Masías"

Nothing could have been better suited to this ornamental style of architecture than popular tradition. Ornament took over from the elaborate compositions of the scholarly tradition and, faced with stereotypical formulas of distribution and arrangement of space, responded by enriching the décor of the buildings.

Puig i Cadafalch was the first to turn to the outline of the Catalan *masías* using the curves and reversed curves of their large gables and the rather cumbersome silhouette of the square tower at the side in his designs for private houses on the outskirts of the city of which the villa Muntadas on the Tibidabo is an early example. He was followed by Manuel Raspall, who, to the north of the city in the summer resort of La Garriga and its surroundings, built an impressive collection of picturesque villas embellished with an abundant décor of sgraffiti and ironwork. And Josep Jujol would show himself to be equally imaginative when, at a rather late date, he turned to this repertoire for his country houses both for the old *masía* d'Els Pallaresos, which he restored for his own use, and for the curious Can Negre at Sant Joan Despí with its unlikely bow window in the form of a sedan chair decorating the gable.

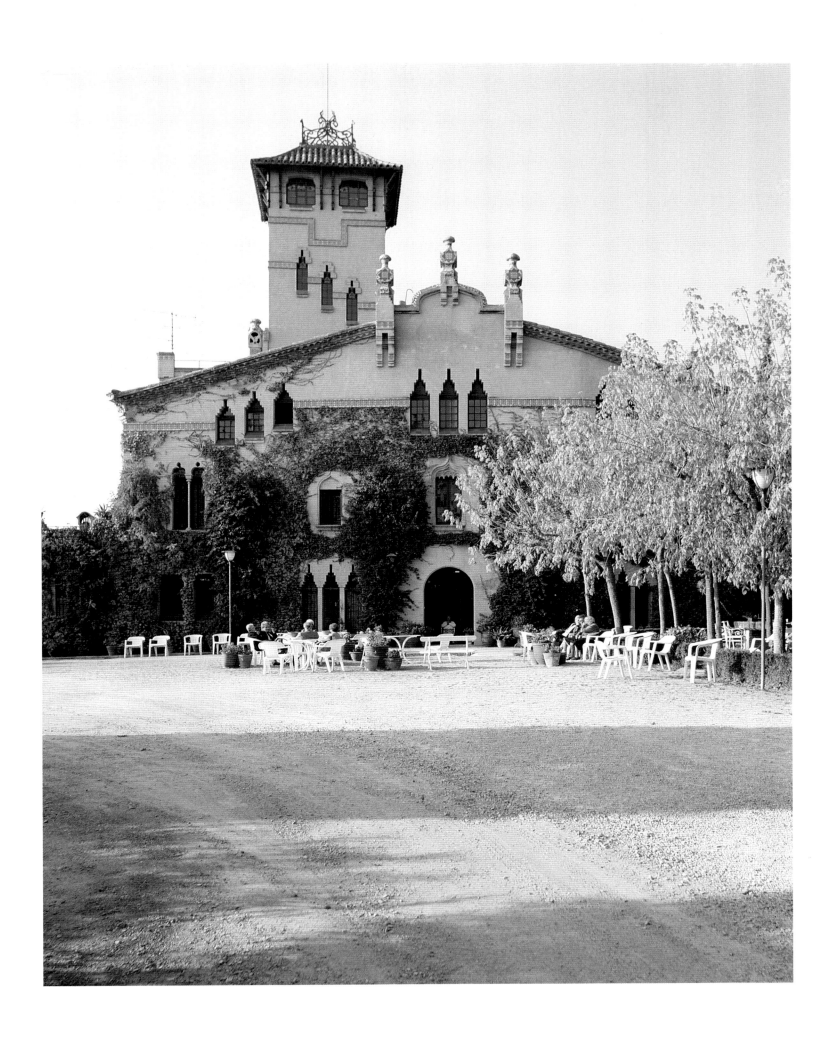

Manuel Joaquim Raspall i Mayol
Casa Barbey
La Garriga, 1909–1911
South-west façade

Left:
View of garden
Below:
Gable detail

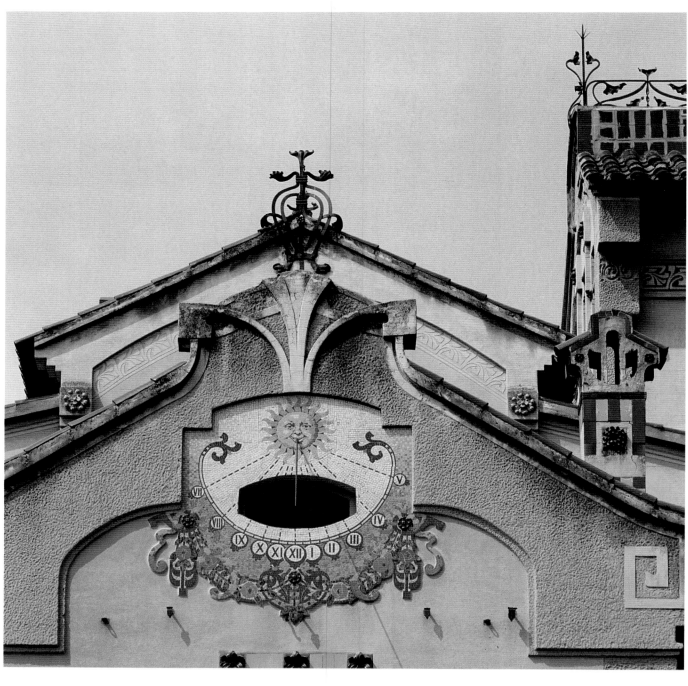

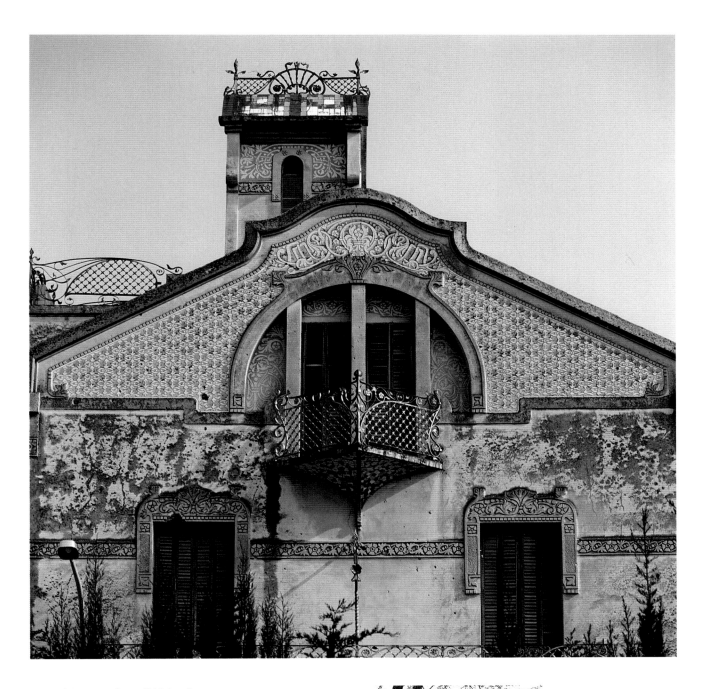

Manuel Joaquim Raspall i Mayol
Torre Iris
La Garriga, 1911

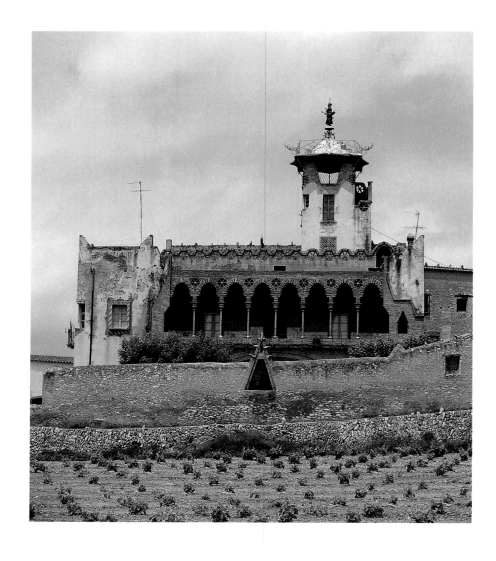

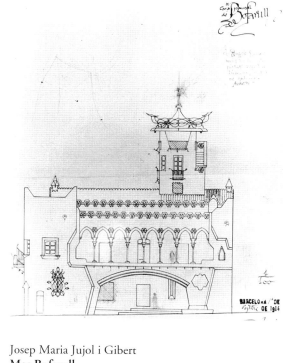

Josep Maria Jujol i Gibert
Mas Bofarull
Els Pallaresos, 1914–1931

ABOVE:
East façade
CENTRE:
Elevation
LEFT:
Village street and west façade
FACING PAGE:
View of road to the vineyard

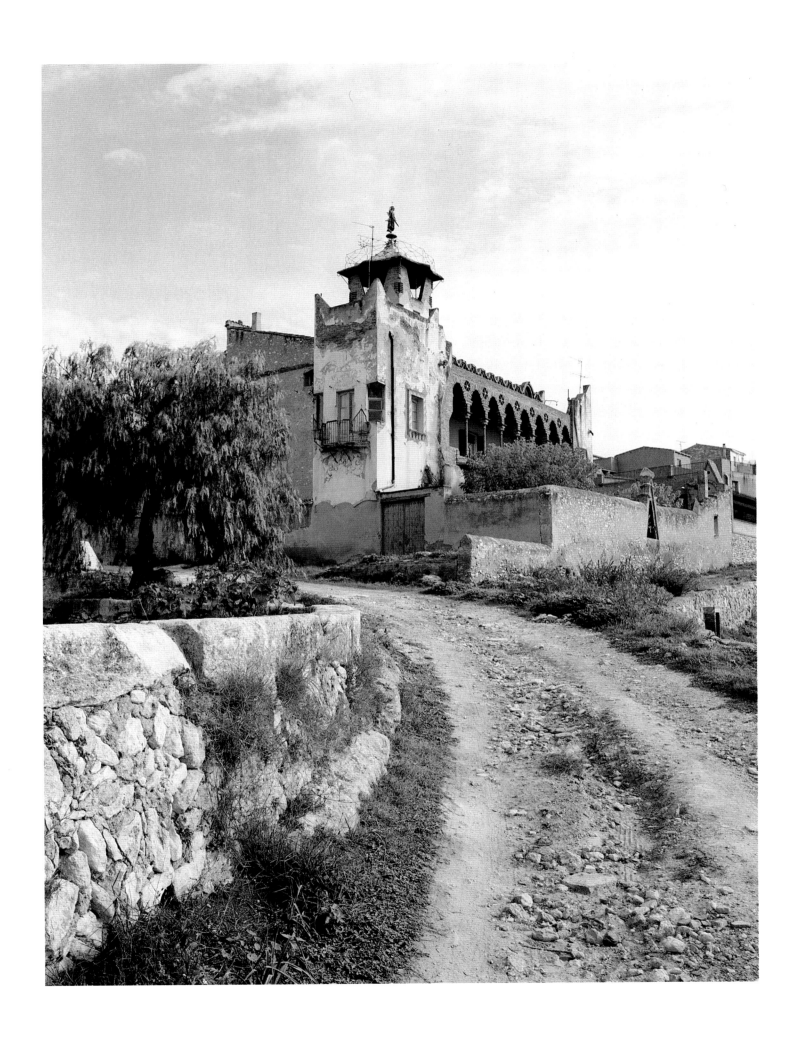

LEFT:
Can Llibre
Cardedeu
18th century, restored c. 1900
Façade on the Plaça Sant Joan

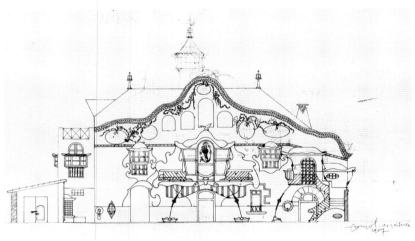

Josep Maria Jujol i Gibert
Can Negre
Sant Joan Despí, 1914–1930

ABOVE:
Elevation
LEFT AND FACING PAGE:
Façade on the Plaça de Catalunya
Gable and small loggia

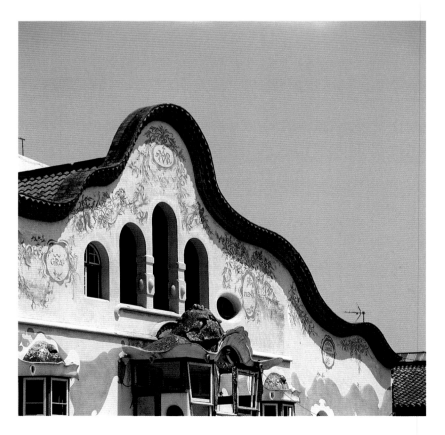

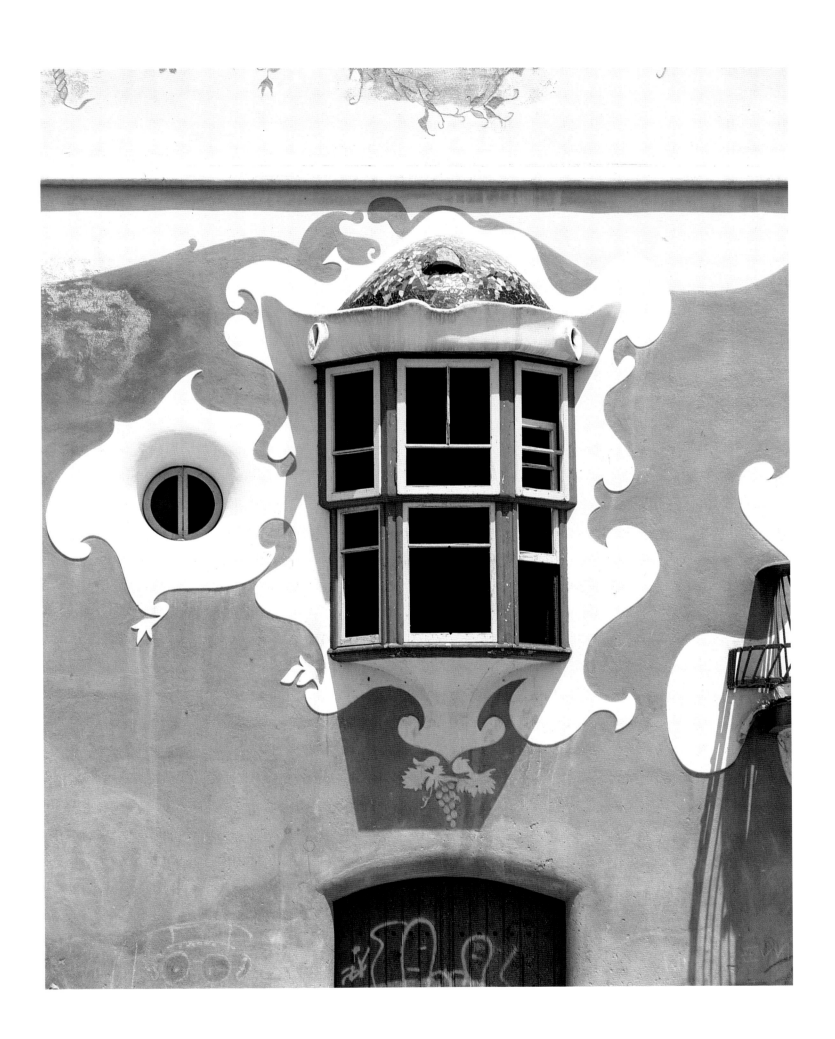

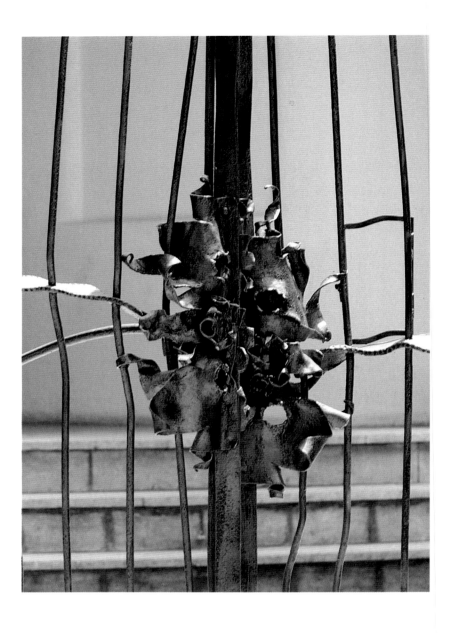

Formalism

When decoration becomes dominant it can lead to the creation of free forms whose only justification is the delight of their arrangement. From the beginning of the contemporary period this was a latent tendency in late eighteenth-century picturesque architecture but, with the birth of modern art in this century, it found clear and almost savage expression.

The Torre de la Creu in Sant Joan Despí, with its cylindrical towers topped by hemispherical calottes, depends for its effect on the very strangeness of its repertoire; the building looks as if it could have been taken from a cartoon strip. It is an interesting example as it enables one to see the extent to which architecture relies, expressively, on the conventions of a formal grammar established by use – an architectural culture recognized and accepted by all. The invention of a new language, without references, not only severs the relationship with the past, it also destroys any possibility of analysis or comparison with other works and it becomes a language without meaning because its words have no context.

The nineteenth century, overusing its links with the past, was accused of impotence and its "paraphrase" architecture rejected as pastiche. However, when the twentieth century broke free from all sources it entered equally dangerous territory. The arbitrary nature of these contextless forms was just as disappointing.

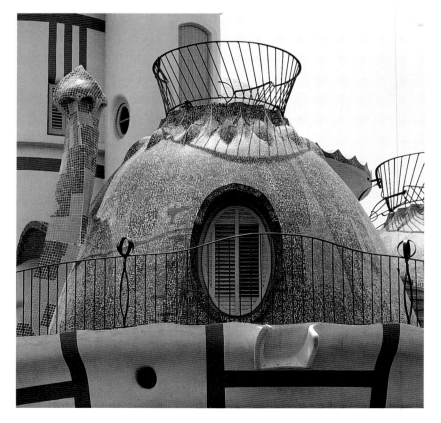

Josep Maria Jujol i Gibert
Torre de la Creu or "Torre dels Ous"
Sant Joan Despí, 1913–1916

ABOVE:
Entrance grille
LEFT:
Roof domes, mosaic by Tecla Jujol
FACING PAGE:
South-west façade

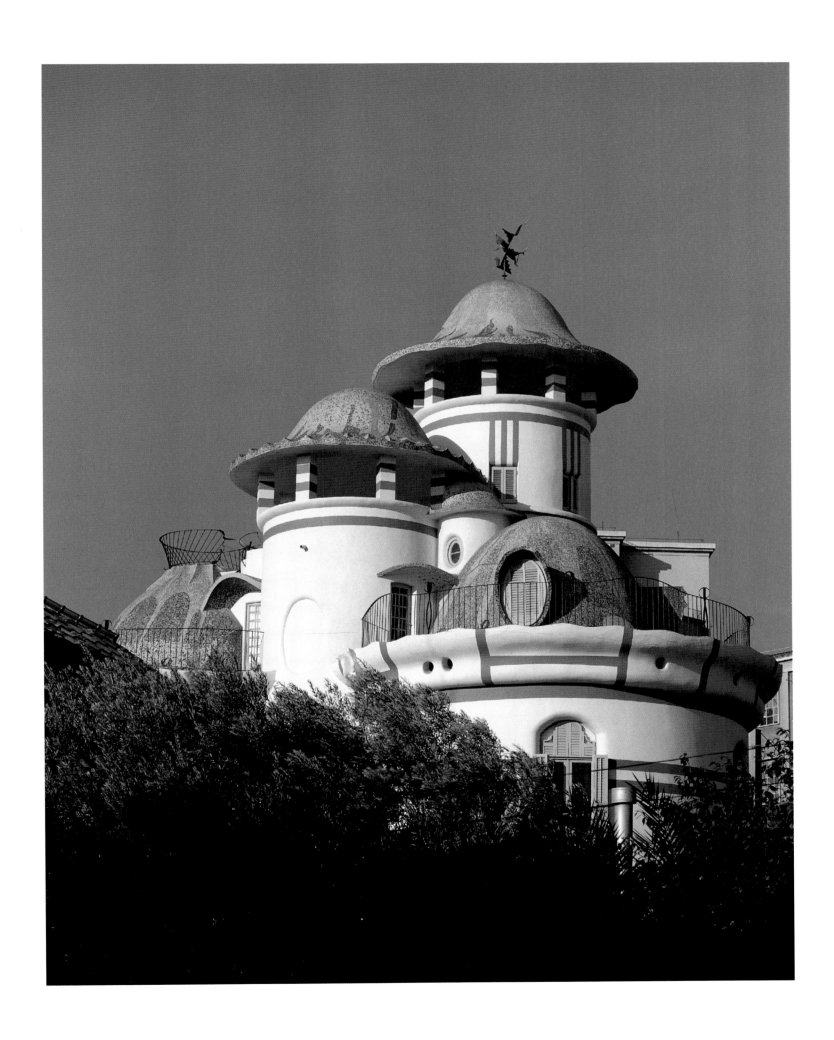

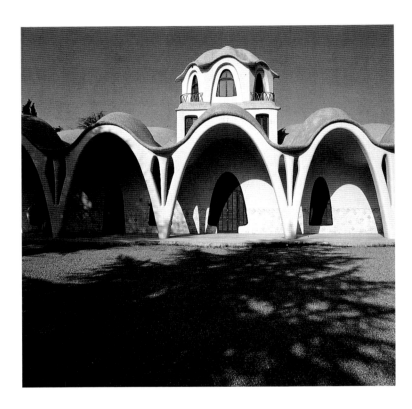

Lluís Muncunill i Parellada
Masia Freixa
Terrassa, 1907–1910

Left:
South façade
Below:
Portico

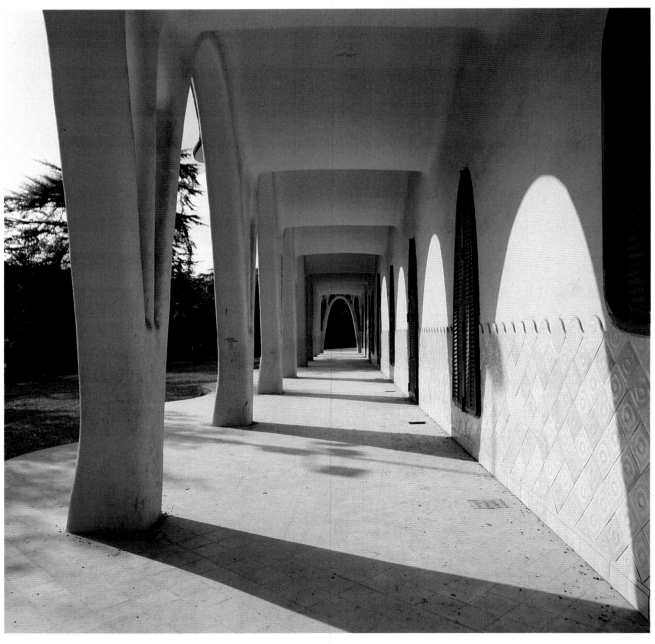

Modernity needed to avoid both these pitfalls and it is certainly no accident that for some time the rhetoric of industrial architecture served to justify it. This was not simply an ideological pretext but it established a new formal repertoire based on the significance long attributed to this specific field of construction – the utilitarian building. The overall effectiveness of such transpositions, and their limitations, can be assessed in the work of Lluís Muncunill. His Masía Freixa in Terrassa embraces the principles of brick industrial architecture established by the Catalan school in hollowed-out parabolic arches and domical vaults in flat brick. This was, in fact, a conversion as the building was originally designed to house a textiles workshop; it was only on its completion that the owner decided to turn it into a country house. This makes the building all the more unnerving as it displays the language of industrial construction. Its repertoire is familiar but it is more difficult to accept it in the context of a country house. If this first venture had been followed up the situation would have been different and the transposition of industrial architecture to a rural setting would have become perfectly acceptable.

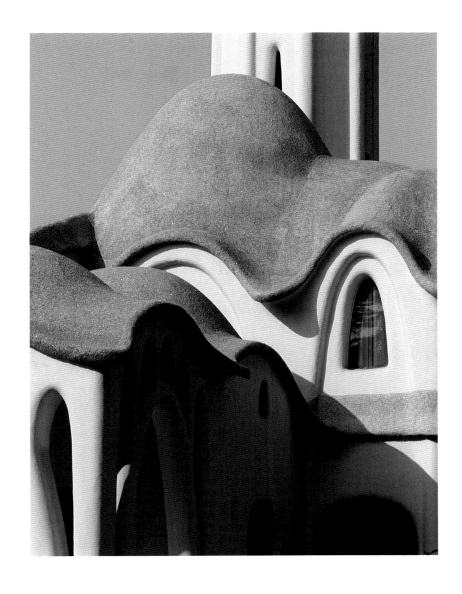

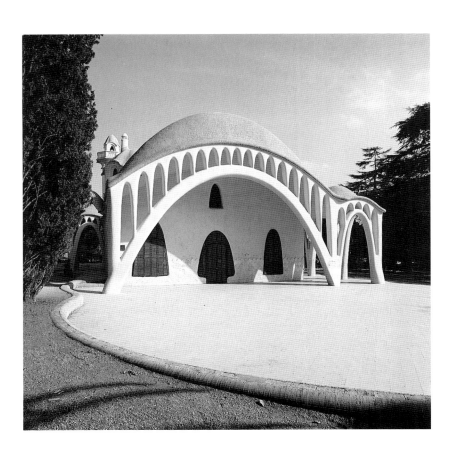

Lluís Muncunill i Parellada
Masia Freixa
Terrassa, 1907–1910

ABOVE:
Roof detail
RIGHT:
West façade

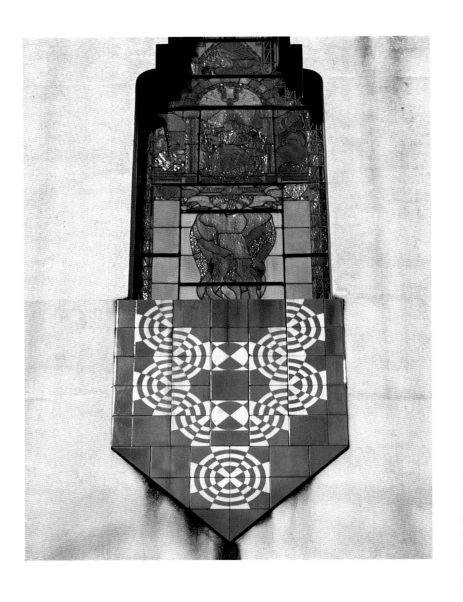

International Regionalism

Once the traditional *masía* had been given new life the question of style no longer really applied; the forms, which had been reduced to their essentials, sufficed to evoke a regional tradition that survived in the layout of the buildings, their exploitation of mass and the arrangement of important detailing such as gables, chimney stacks, oriel windows and balconies. The fact that twentieth-century living conditions and the housing-estate system no longer had anything in common with the rural tradition was unimportant. In no sense was this an attempt to re-establish a rural way of life that was no longer relevant.

And therefore, far from making ornament part of a regionalist metaphor, architects emphasized its modern qualities; together with the revival of regionalism the aim was also to demonstrate the extent to which this architecture was an expression of its time. The twin aims of international regionalism, which seemed to be a contradiction in terms, spread through the whole of twentieth-century Europe. The most modest of private houses was affected by this rapidly developing fashion as floral-style Art Nouveau was superseded by the geometric aesthetic in cities such as Darmstadt and Antwerp and by the architectural purism of a Voysey or the starkness of a Hoffmann.

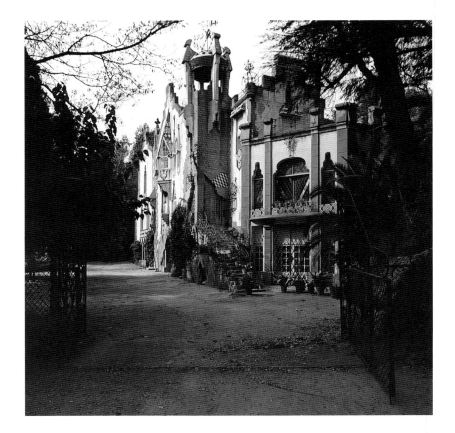

Eduard Maria Balcells i Buigas
Casa Lluch
Sant Cugar del Vallès, 1906
South façade

Facing Page Above:
Window
Below:
Loggia
Facing Page Below:
View from main gates
Right:
Belvedere

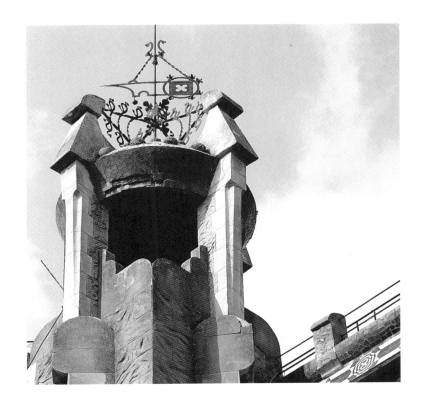

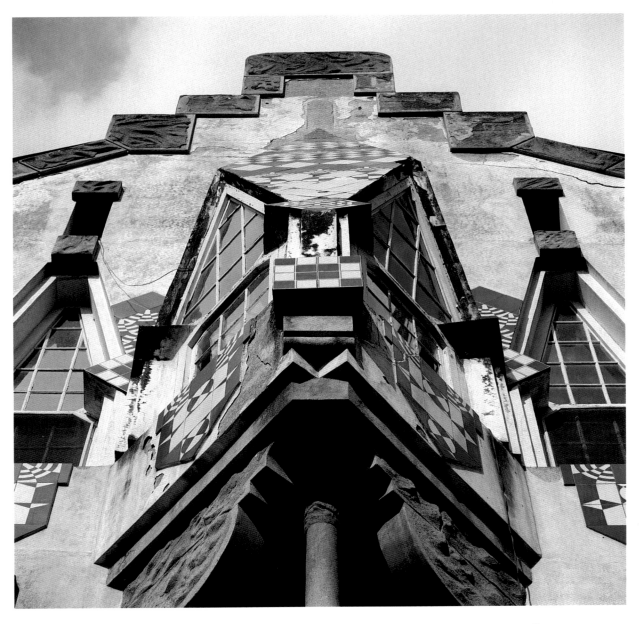

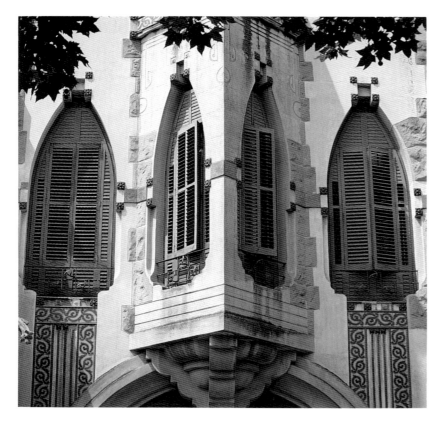

Eduard Maria Balcells i Buigas
Casa Àngela Gual
Cardedeu, 1910

LEFT AND BELOW:
South façade
Loggia and round window

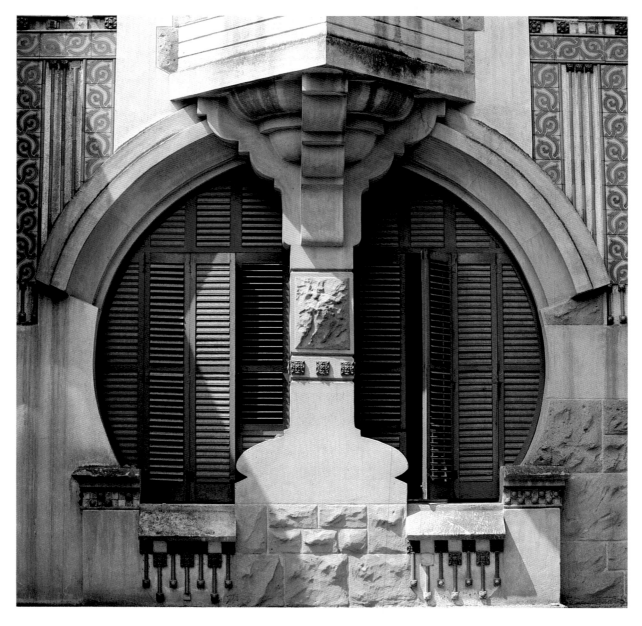

This was an architecture propagated through journals as amazingly versatile decorative stylistics flourished all over Europe in an immediate, and sometimes unexpected, response to the exposure given to them by the press. The pages of journals such as The Studio and Art et Décoration were instantly absorbed and the most appealing details immediately taken up and developed by thousands of regional architects. And, because these architects had never had the opportunity to view on site the works they were simulating, their transpositions became all the more delectable. The Catalan version of this international architecture as produced by Eduard Balcells and Rafael Masó is undeniably original and blends the fashionable repertoire with the most characteristic features of the Catalan school. This produces a certain exotic quality that is just as exciting as the decorative exercises in the Mudejar style attempted during the previous generation. At a time when the dialogue between ornament and structure was tending to break down, the peaceful coexistence of these two conventions, architecture and décor, was to some extent reassuring.

Eduard Maria Balcells i Buigas
Casa Àngela Gual
Cardedeu, 1910

West façade
Above:
Ceramic screen
Right:
South elevation

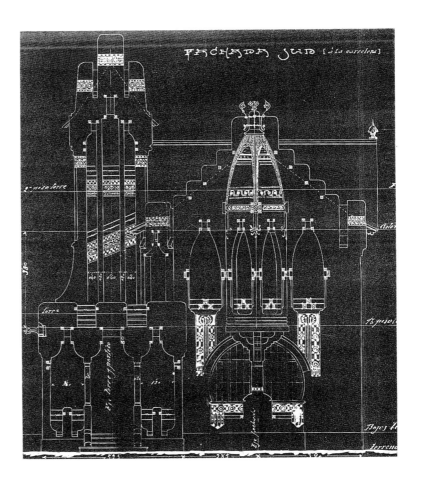

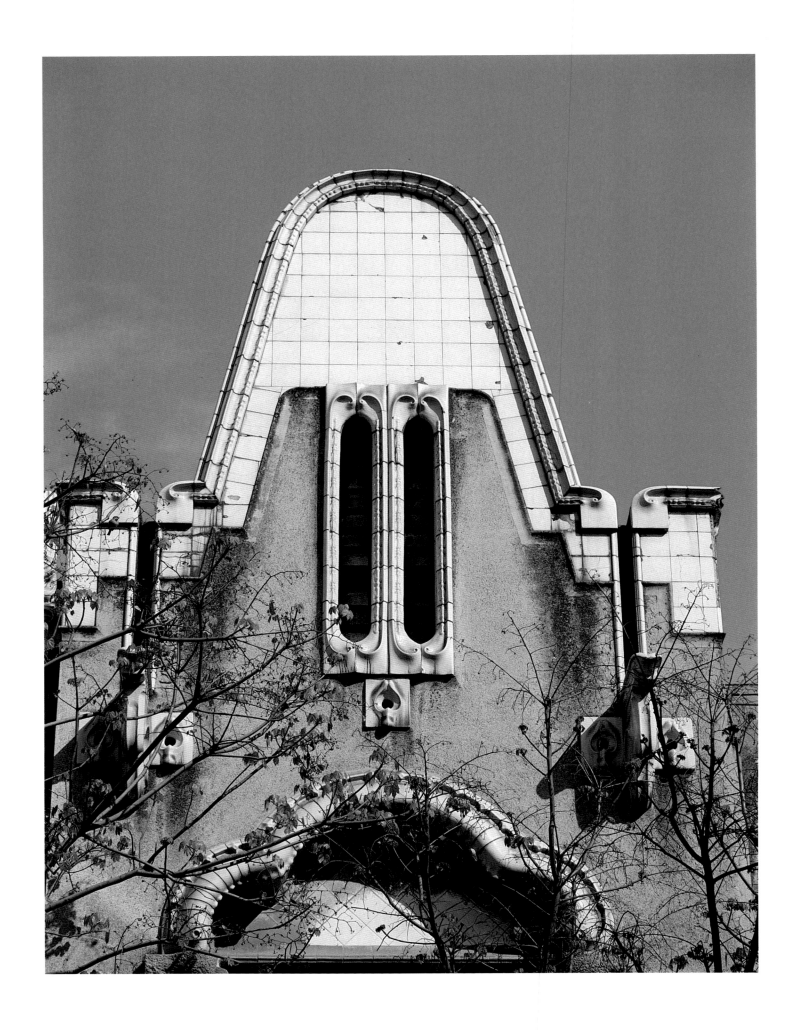

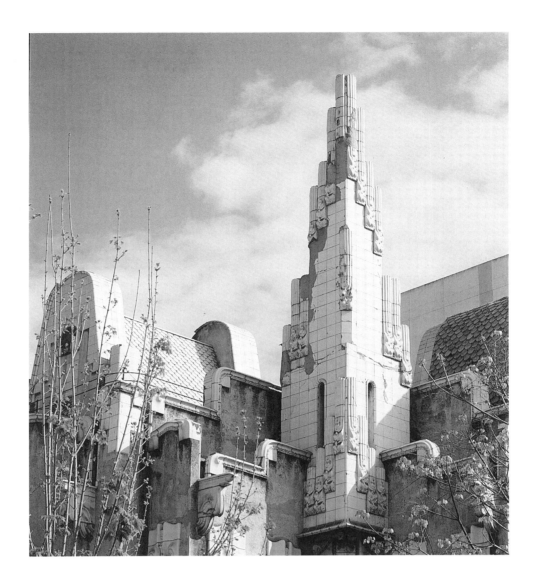

Rafael Masó i Valentí
Farinera Teixidor
Girona, 1910–1911
Houses and offices
Façade on the Carretera de Santa Eugènia

Above, Right and Facing Page:
Details
Centre:
Elevation

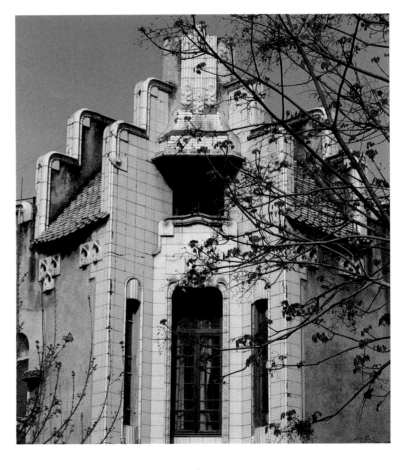

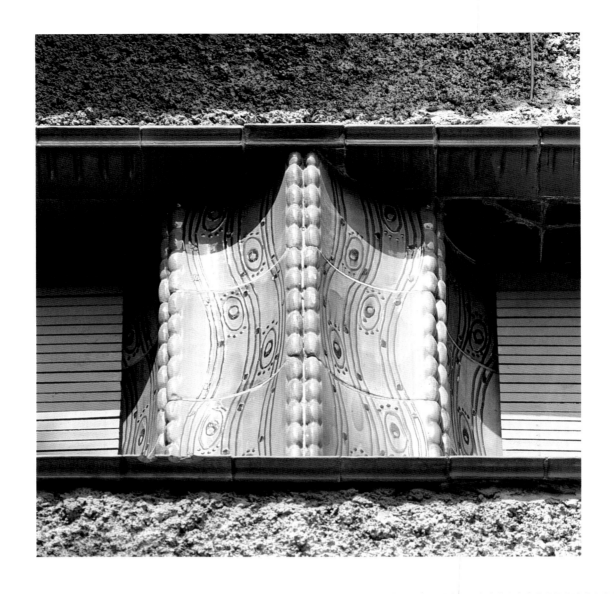

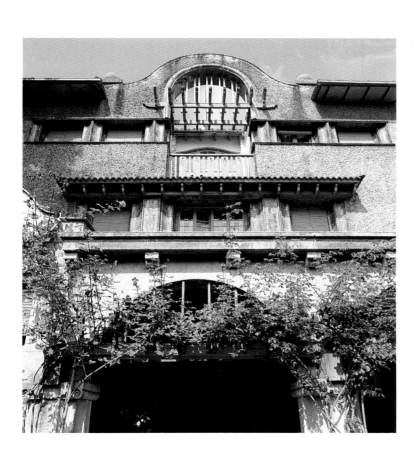

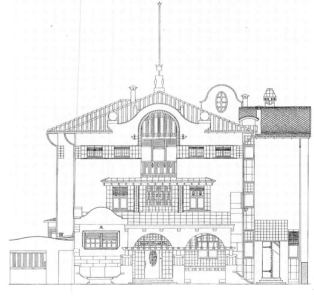

Rafael Masó i Valentí
Casa Masramon
Olot, 1913–1914
Façade on the Carrer de Vayreda

Above and Facing Page:
Window details
Centre:
Elevation
Left:
View from below

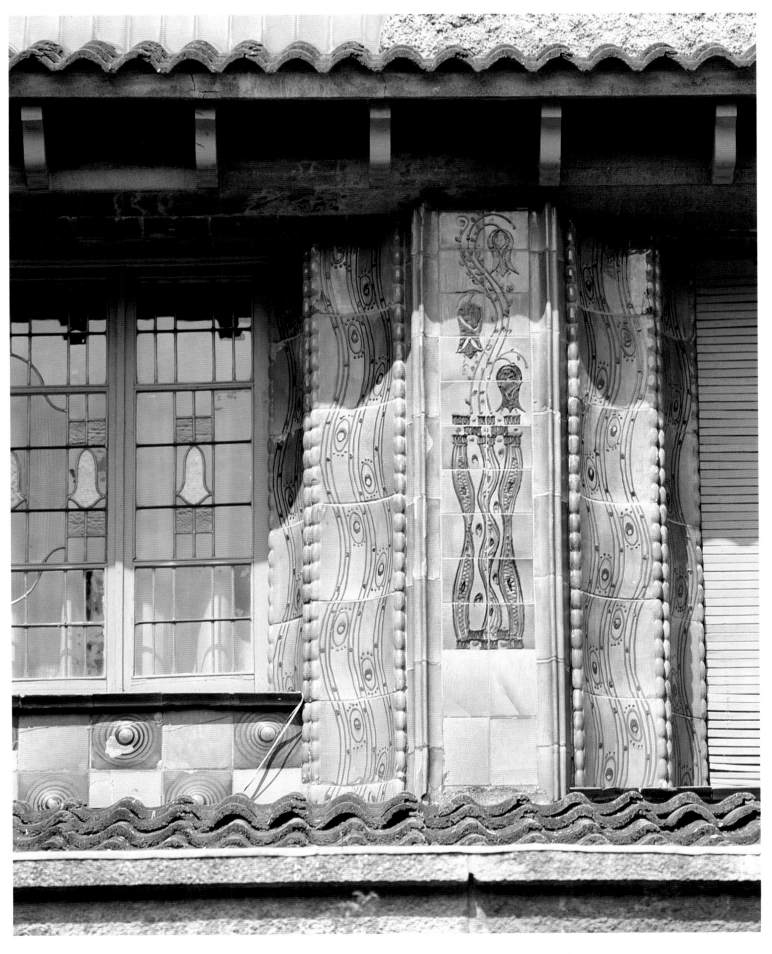

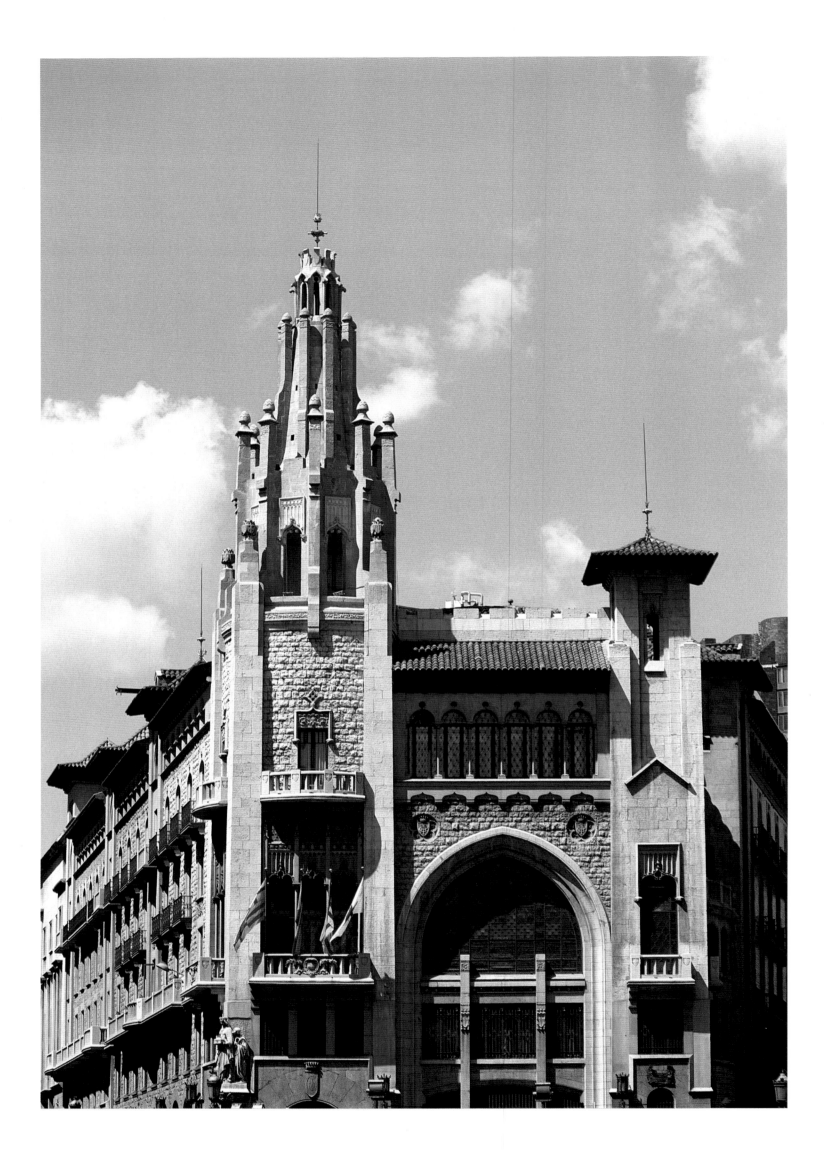

7

THE APOTHEOSIS
OF RATIONALISM

After a generation of prosperity that began in 1875 with the restoration of Alfonso XII, the first years of the twentieth century in Spain brought a growing number of problems. The loss of the American colonies (Cuba and Puerto Rico) and of the Philippines in 1898 was the first of these setbacks. The development of the Catalan sense of identity, threatening the authority of the central power, only exacerbated this instability, it was the social question, however, that surfaced, coming to a head in 1909 with the conflagration of the Semana Trágica in Barcelona. Threatened by anarchy, Spain became ungovernable and the political crisis of 1917, followed by the Moroccan disaster of 1921, resulted in General Primo de Rivera's coup d'état. For the next fifteen years the country was in a state of turmoil that would climax with the Spanish Civil War. Although Spain had been spared the ordeal of the First World War, this period would give the country some of its darkest hours.

In such a context it was virtually impossible for artistic trends to continue to develop. The end of the nineteenth century had been a period of brilliance leading to the early birth of a far-reaching modern movement; the first decade of the twentieth century, however, saw the gradual decline of Catalonia as a centre of the arts. Pablo Picasso left for Paris in 1904 and Raimon Casellas, the critic of *La Veu de Catalunya*, ended his life in 1910. The writer Joan Maragall disappeared in 1911, as did Isidre Nonell, the best painter of his generation, and from then on the modern movement retreated into isolation. Antoni Gaudí devoted himself exclusively to the Sagrada Família project and Josep Puig more or less abandoned his career in architecture to pursue one in politics, until he was forced into exile by the situation and went on to earn himself a reputation abroad as an historicist. These careers, with their upheavals, curtailments and changes, were, of course, a reflection of the disruption that gripped the country during one of the most unsettled periods of its history.

In most European countries Art Nouveau had been no more than a prelude to the birth of the modern movement that followed on from it and dominated the period between the wars. The trip made by Le Corbusier at the end of the first decade of the century, during which he visited Auguste Perret in Paris and Peter Behrens in Berlin, gives an indication of where the key centres of the movement were to be found. Despite his avowed admiration for Gaudí, Le Corbusier did not go to Barcelona to work. By that time the influence enjoyed by the Catalan school was over, Barcelona, like Vienna and Brussels, had ceased to occupy centre stage. The same was true of Prague, which, following the outstanding period it enjoyed at the end of the nineteenth century, saw a gradual exodus of its artists and intellectuals.

When Jeroni Martorell published an article in 1903 reviewing the various trends in modern architecture[1] he was, unwittingly, tracing the course of a division between two generations: the rationalist generation that had dominated the scene for quarter of a century culminating with the 1888 Exhibition, and the Art Nouveau generation whose fate was as brilliant as it was short-lived. Less than ten years later, around 1905 – after the exceptional years that produced the Casa Lleó Morera, the Casa Batlló, the Casa Milà and also the Palau de la Musica Catalana – this blossoming of architecture would come to an abrupt end, leaving on their own those working within the field of the arts proper. Art Nouveau was late to arrive in Catalonia but moved quickly beyond the conventions of the decorative style, boldly embarking on plastic expressionism, which placed it in the vanguard of the period. This triumph was short-lived however, for as soon as the second decade of the century began there was a complete change of focus.

If we turn once again to Josep Puig, who is an excellent representative of his generation, it will help us to understand the change of direction that was taking place. When building the Casimir Casarramona model textile works (1909–1911), Puig wanted to demonstrate the technical originality of the Catalan vault with its use of narrow bricks. Given the legacy of late nineteenth-century rationalism, his purpose was both technological and cultural. However, this was an important step as can be seen if we compare this building with the Codorniu wine cellars built between 1901 and 1904 and designed at the time using a strongly Gaudíesque architectural language. From behind the regionalist discourse there now emerged functional concerns – economy and efficiency of construction – which ran counter to the principal concerns of the artist. Puig, who had so brilliantly decorated the Casa Amatller, adopted a self-critical role, only retaining the most efficient (rather than the most demonstrative) constructional forms offered by modern architecture.

Puig's involvement in politics had taught him to confont everyday reality and this had no doubt dampened his artistic fervour. He had, however, entered politics from the ranks of the Lliga Catalana in order to see his plans to a satisfactory conclusion. At first his interest was primarily professional and he saw politics as a lever he could use to achieve his plans for the city. It comes as no surprise to learn that Puig the artist and decorator was also passionately interested in town planning. Architecture interested him only as a medium or a link – a medium for the ornamental treatment of surfaces and a link in the urban scheme. The treatment of space *per se* and of structure (two very decisive aspects of Gaudí's work) were of little concern to him. Here we see the contrast between the two: Gaudí, an architect in an intensely personal dialogue with creation; and Puig, more the director for whom architecture was simply one element in a continuous series of activities that extended from the smallest ornamental detail to the global shaping of a landscape. For Gaudí his project was an entity to which, if necessary, he would adapt the existing environment, whereas for Puig the reverse was true, he saw himself in a purely supporting role, making the best of an existing context which itself was his guide. One was an artist, the other an intellectual.

As a result of his involvement with the political and economic situa-

Josep Puig i Cadafalch
Plaça de Catalunya
Barcelona, 1918–1923
Development plan

Josep Puig i Cadafalch
Museum of Antiquities
Barcelona, 1920
Design for the Electrical Industry Exhibition

tion in Catalonia, Josep Puig gradually abandoned his artistic endeavours in order to focus better on the demands of the professional circles in which he worked. The decisive turning point came in 1905 with the city planning competition which was won by the Frenchman Léon Jaussely who was a major figure in modern French urban history. Puig was without doubt partly responsible for the success of this project, which would leave a deep and indelible mark on the urban history of Barcelona[2]; he became its champion, emphasizing the importance of the twin aspects of order and beauty – qualities that should be found in the modern, rational and monumental city – and the reverse of Ildefons Cerdà's over-systematic *Eixample.*

This movement, which shared the concerns of Daniel Burnham in Chicago ("The City Beautiful") and those of Frenchman Jacques Greber in Philadelphia, criticized the purely technical approach to design, as used by Cerdà, and the failure to take into account the urban scheme as a whole. The regionalist criticism (the plan had been imposed by Madrid) supported the social criticism, which concerned the fact that the design of the urban scheme was left in the hands of private interests who lacked any overall vision or interest in seeing this vision brought about, as it often ran contrary to their private concerns. Equally it also supported the political criticism as to the role of the institutions in the promotion of public art and whether urban art was its ideal form of expression.

The design for Barcelona is neo-Haussmannian, similar to that which Louis Bonnier wanted to use in Paris at the same period. It is particularly interesting as it seeks to create a synthesis between the artistic freedom demanded by Art Nouveau and the rules of urban order derived from the Haussmann tradition. In Paris the overall scale was modest (the Boulevard Raspail, the Avenues of the Champ-de-Mars and the Passy estates) but in Barcelona it took on far more impressive proportions. To the vast public areas of Cerdà's plan were now added large, regular blocks of buildings, the outlines of which were given interest by some monumental features (domes and corner towers) in the most important areas of the urban landscape. The whole city was in fact remodelled, its structure elucidated by a monumental composition that made it possible to identify key points within the urban landscape as a whole such as the Plaça de Catalunya, Montjuïc hill, the Passeig de Gràcia, etc.

In 1914 Josep Puig, together with Lluís Domènech, began work on the alignment of the Via Laietana that would complete the communications with the old part of the city. He then worked on plans for the Plaça de Catalunya (1918–1923) and for Montjuïc hill, and, in 1920, as part of the electrical industries exhibition, he designed the impressive museum of antiquities that would dominate the urbanization of this sector. As an architect Puig completely abandoned all suggestions of the Gothic style that had marked his early period. Nor did he show any interest in regionalism. In response to the demands of architectural representation, which were completely different from those that had concerned him when working in private architecture, he embraced a "fine arts" style using domes and columns. During the same period, he also constructed, in reinforced concrete with Louis XIV décor, two very

important buildings[3], the deliberate banality of which reflected their ordinary status in the urban hierarchy.

The preoccupation with architectural and urban order is a recurring theme of the period, for by enabling architects to treat urban design as a work of art, it rescued their artistic aspirations. And Puig was not the only architect in Barcelona to make this change of direction; indeed, he was outdistanced by his competitor, Josep Goday i Casals, who was awarded the 1911 architecture prize for the Post Office building at the bottom of the Via Laietana.[4] However, Puig continued to develop his work in this field and achieved great success with his plans for the 1929 Exhibition. The huge eighteenth-century style monumental fountain that dominates the Plaça d'Espanya was designed by Josep Jujol with the collaboration of the sculptor Miquel Blay. Jujol also built the Workers' Palace, which he adorned with colonnades similar to those of Bernini, while Puig i Cadafalch's Palace of Alfonso XIII was inspired by a curious reinterpretation of Spanish baroque.

The fact that the major figures of Catalan modernism had abandoned their own language was not without its problems and the unlikely juxtaposition of Puig's building with Mies van der Rohe's glass and steel German pavilion demonstrated this very early on. Critics at the time, faced with this retrogressive step, reacted harshly; they connected it, somewhat rashly, with the political totalitarianism of the period, forgetting that the same phenomenon had occurred at the Columbus Exhibition in Chicago in 1893 and at the Paris Exhibition of 1900. As far as architecture was concerned it was as if modernity and representativity were contradictory terms.

Nevertheless, the atmosphere of political instability throughout this period certainly played its part in the development of the monumental style. To compensate for the uncertainties of the time the representational aspect of public architecture increased and slipped, no doubt unwittingly, from the expression of public art towards the expression of power. We should remember, however, that there is a great difference between the somewhat tired academic monumentalism of Josep Puig and his team and the frozen, inhuman beauty of the monuments of the Nazi regime: not only was Puig no Albert Speer but Puig's vision of urban planning was radically different from the totalitarian plans of the Third Reich.

In such a context the late works of Gaudí's school are all the more impressive.[5] The events of the Semana Trágica threatened the very foundations of the State and modern architecture – judged to be too independent – was expelled beyond the city boundaries. This all happened slowly and so the two fine buildings erected by Enric Sagnier in 1917 for the Caixa de Pensions on the Via Laietana remained faithful to the spirit of modernism, as did the large Cases Rocamora building on the Passeig de Gràcia with its domes and pinnacles (Bonaventura and Joaquim Bassegoda i Amigó, 1914–1917). But these were the last examples and in the 1920s modern architecture deserted the city.

Like the aristocrats living on *terra ferma* in sixteenth-century Venice, the major landowners, who were the architects' preferred clients, left the city. They had property built in the region's seaside resorts or on their own land when this was not taken over for use by public institutions.

Josep Puig i Cadafalch
Palau Alfonso XIII
Designed 1920, built for the
Universal Exhibition
Barcelona, 1929
Corner belvedere

The projects commissioned were no longer luxury houses but utilitarian buildings needed to develop their business operations.

In this difficult situation the last modernist architects gave the best of themselves: Cèsar Martinell, a loyal disciple of Gaudí and author of the first major biography of the architect[6], adopted the model of Josep Puig's Codorniu Wine Cellars to build two cellars for co-operative use, at El Pinell de Brai and at Gandesa in 1917 and 1919 respectively. These are the true apotheosis of the architectural rationalism produced by the modern Catalan school. The purity of structure, the extreme simplicity and plastic beauty of the form combine to create captivating areas of space that are among the most beautiful in Catalan art. These late works were an astonishing synthesis, drawing not only on Puig and Gaudí (being, after all a logical progression from Les Teresianes college thirty years before) but also on Barcelona's Gothic *Drassanes* and the perfection of space and structure. This extraordinary achievement is the result of half a century of Catalan modernism traversed by successive phases of rationalism, Art Nouveau and regionalism.

Of course one cannot really compare Cèsar Martinell, who built co-operative wine cellars in rural areas, with Josep Puig, who received official commissions for major public projects. Nevertheless, the radical contrast between the approaches of two artists working at the same time, in the same city and who had been part of the same movement reveals a deep division in the artistic ideology of the modern period. The architect is now confronted with the difficult choice between "the pure and the impure" in the words of Antoine Grumbach[7], between the modern and the official. Art Nouveau believed in the possibility of achieving a unified language, of uniting form and content; it now appeared that this aspiration was mistaken – that empty form and hidden content must necessarily be in opposition. Art, like Goethe's Faust, had succumbed to the illusion that time could stand still. Catalan modernism was no more than a brief moment of balance in the turbulent history of the modern world.

Josep Puig i Cadafalch
Palau Alfonso XIII
Designed 1920, built for the
Universal Exhibition
Barcelona, 1929
View of the Mies van der Rohe pavilion

Industrial Buildings

In 1873 Joan Torras began to experiment with composite constructions, combining metal trusses with brick vaulting for his metal workshops in Barcelona. The point of these structures was to limit the use of metal while ensuring more effective protection against fire. The fires that took place during the Paris Commune in 1871 had highlighted this problem revealing the lack of resistance of metal to fire; a conference to discuss the matter was even organized in London by the Royal Institute of British Architects.

Fifteen years later Joan Torras had sufficiently perfected his system to be able to apply it on a large scale in his new company workshops in Poble Nou, Barcelona. Using thin brick tiles bound with plaster – a traditional method of Catalan vaulting – he created eight centimetre thick arches on metal trusses fourteen metres in length. The interiors of these workshops, roofed by thin, unsupported tunnel vaults, are truly monumental. Many other industrial premises would adopt the principle which was patented in the United States by Rafael Guastavino, a former pupil of Torras. Later, in order to adapt to the demands of shift work, the vaults were converted to saw-tooth northlight roofs with parabolic curves so light they seem to float away above the truss rods. This established a new model for the industrial workshop. It was particularly well-suited to the textile industry as it allowed machines to be positioned without restriction on the floor area and had the added benefit of providing an even light free from glare or backlighting. In this respect it was far more rational than the side-lit workshops on several floors that had become common in England after the end of the eighteenth century.

ABOVE:
Rafael Guastavino i Moreno
Clot del Moro cement works
Castellar de N'Hug, 1901
General view

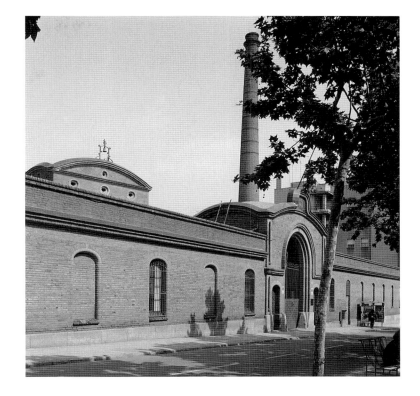

Lluís Muncunill i Parellada
Aymerich, Amat i Jover textile factory
Terrassa, 1907–1909
Machine room

Below and Facing Page Below:
Detail and general structural view
Right:
Perimeter wall and entrance

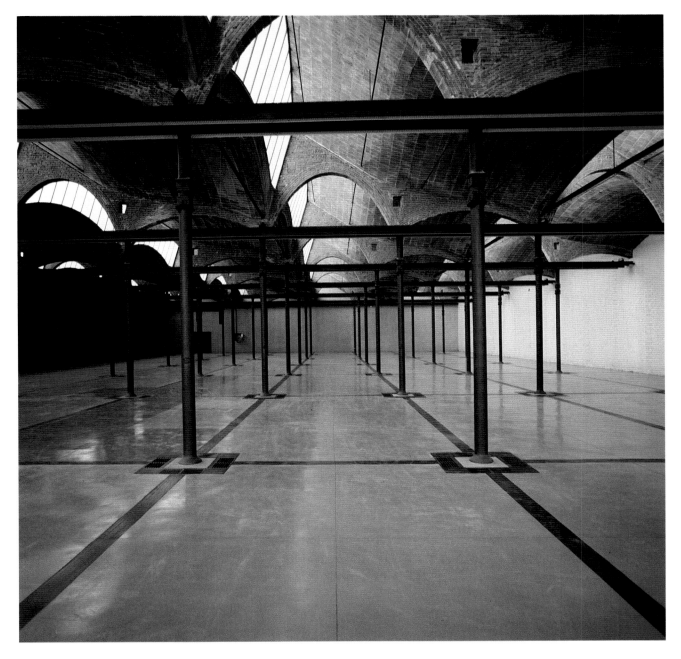

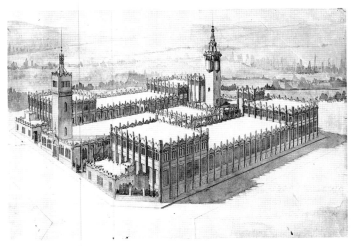

Josep Puig i Cadafalch
Casimir Casarramona textile factory
Barcelona, 1909–1911

Above and Facing Page Below:
Belfry and façade detail
Centre:
General perspective view

It was therefore quite natural that Lluís Muncunill should make use of this model when he came to build the Aymerich, Amat i Jover textile factory at Terrassa between 1907 and 1909 and which today remains one of Catalonia's greatest monuments to industrial architecture. He was followed by Puig i Cadafalch, who brought a "fine arts" splendour to his design for the Casarramona model factory at Montjuïc, exploiting the possibilities of brick construction by combining brick pillars and Catalan vaulting and totally rejecting the use of metal and its inherent dangers. This palace to industry, combining symmetry, gradation and axiality and culminating in the silhouette of a cutaway belfry, is the most outstanding example of an architectural style that is not only rational, but modern and typically Catalan. It represents the proud response of the old world to the new world of North America with an equally vigorous declaration of its cultural identity and technological progress. The building provided a highly original alternative to the concrete structures favoured by engineers. Far from being simply a regional curiosity, Catalan vaulting offered an effective and cost-efficient solution for industry. One can understand why this experiment was so often repeated in Catalonia, although later buildings tended to be more for agricultural use than industrial purposes.

Above and Facing Page Below:
Ignasi Oms i Ponsa
Farinera La Florinda
Manresa, 1912–1913
Façade details

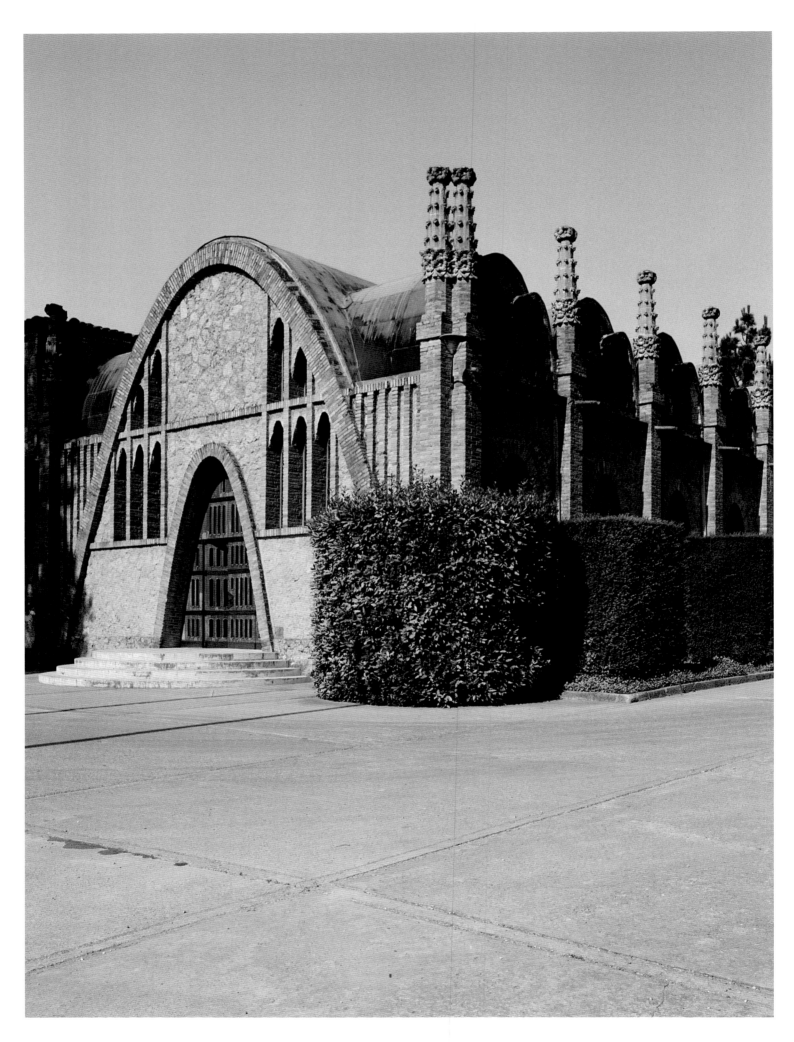

The Codorniu
Wine Cellars

The wine cellars at Sant Sadurní d'Anoia designed by Puig i Cadafalch in 1901 are the perfect expression of a construction system based on the use of Catalan vaulting. The building is a long tunnel of parabolic section shored up by a row of brick abutments connected by transverse vault cells, on the principle of the early basilica. It was not this classical model, however, that most influenced Puig i Cadafalch but the extraordinary *Drassanes*, the former dockyards erected at the end of La Rambla during the fourteenth century. The rigorous structure of this building with its pillars and arches of masonry enclosing vast areas of space fascinated modernist architects. By combining this structure with Catalan vaulting Puig achieved one of the architectural masterpieces of his period. It was a construction that was no doubt of less immediate appeal than his sumptuous houses but a great deal more effective in the extreme purity and simplicity of the means employed.

Josep Puig i Cadafalch
Codorniu Wine Cellars
Sant Sadurní d'Anoia, 1901–1904
Dispatch warehouse

FACING PAGE:
General view
ABOVE:
Vault sections on the north-east façade
RIGHT:
South-east façade elevation

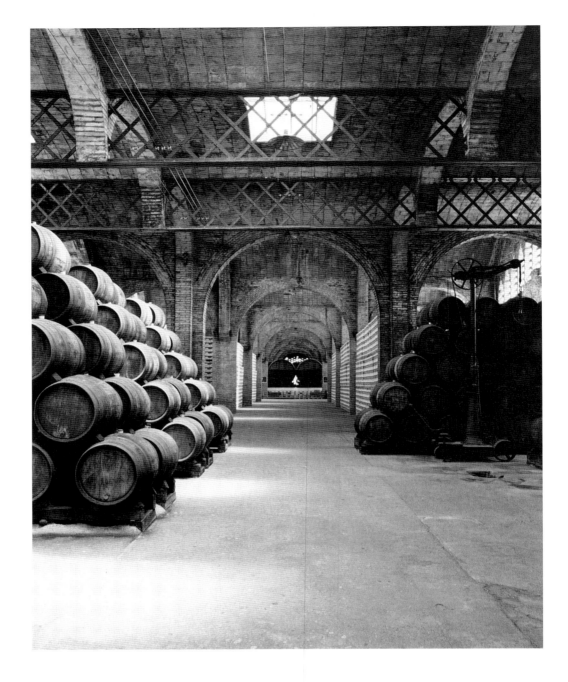

Josep Puig i Cadafalch
Codorniu Wine Cellars
Sant Sadurní d'Anoia, 1901–1904
Pressing room, enlarged by Lluís Bonet i Garí

ABOVE:
Main cellars
FACING PAGE:
North-west façade

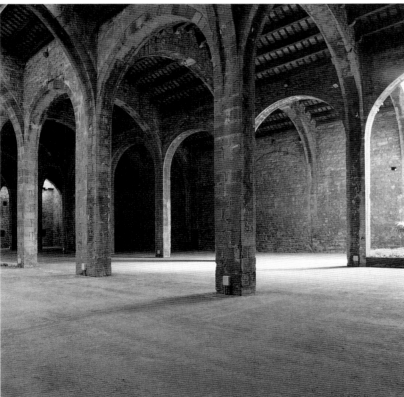

LEFT:
Arnau Ferrer
Principal architect
Reials Drassanes (Royal dockyards)
Barcelona, XIV–XVIIth century
Interior view

Cèsar Martinell

Cèsar Martinell, a disciple of Gaudí and later his historiographer, built a large number of wine cellars in Catalonia. He adopted the model established at the beginning of the century by Puig i Cadafalch but created a number of different versions from the most simple (Cornudella de Montsant) to the most ambitious (El Pinell de Brai). In the half-light of these brick basilicas stand impressive rows of cement vats with narrow walkways running along their top. Halfway from ground level the walkways dissect the bold brick structure and the hollowed-out walls that extend it, below the bowed arch of the segmental ceiling. This creates a contrast between two very different worlds, one, light and airy, glorifying the grand scale of the architecture with its arches and vaults, and the other disappearing into the subterranean obscurity of the enormous, grey, dusty tanks.

At El Pinell de Brai, Cèsar Martinell even abandoned the roof covering of Catalan vaulting to give full force to the enormous brick arches that cross the void of the room under the roof purlins. This was a conscious return to the purity of the *Drassanes* structure. Outside, the broad, flattened gables of the parallel naves that constitute the building blend with the mass of village roofs and from a distance all one can see is the unusual cutout of their lancet windows. Closer still, the façade has an entertaining tale to tell with its picturesque ceramic frieze running right across the building. The prolixity of the decorative detail forms part of an ambitious structure which is all the more impressive as the effusive nature of the decoration does not lead one to expect it. Martinell reveals himself to be a true disciple of Gaudí in the way in which he uses contrasting scale to develop the personality of the building. It is a gradual process of discovery: first location, then function and finally the hidden monumentality of the building are revealed. Martinell's ability as a builder was matched by his skill as an architect.

LEFT:
Lluís Domènech i Montaner
(Pere Domènech i Roura collection)
L'Espluga de Francolí, 1913-1914

Cèsar Martinell i Brunet
Agricultural Syndicate Wine Cellars

Facing Page Above:
Rocafort de Queralt, 1918
Right:
Cornudella de Montsant, 1919
Below:
Nulles, 1918–1919

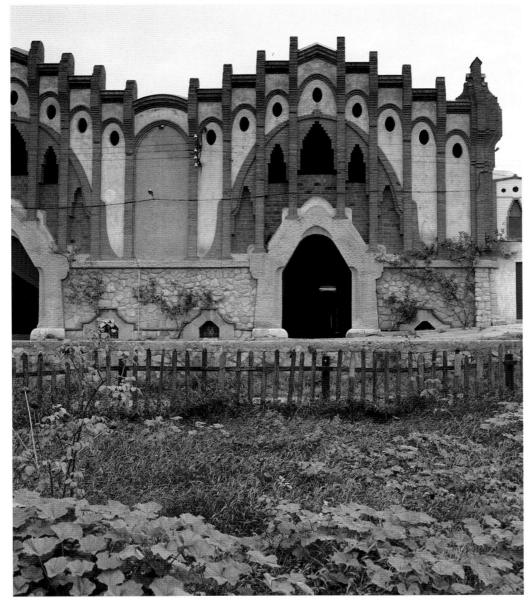

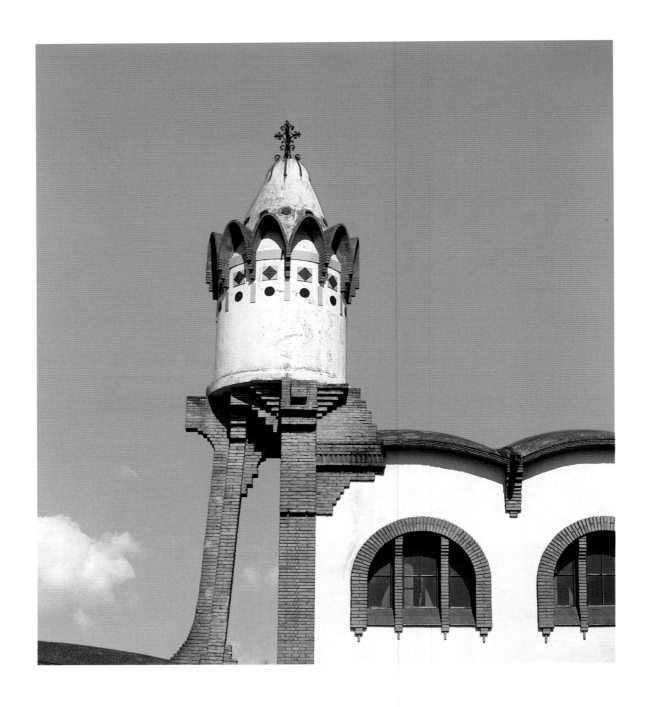

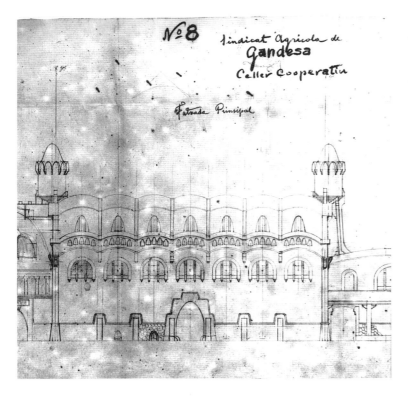

Cèsar Martinell i Brunet
Agricultural Syndicate Wine Cellar
Gandesa, 1919

ABOVE:
Water tower and south façade
LEFT:
Main façade, elevation
FACING PAGE:
West façade

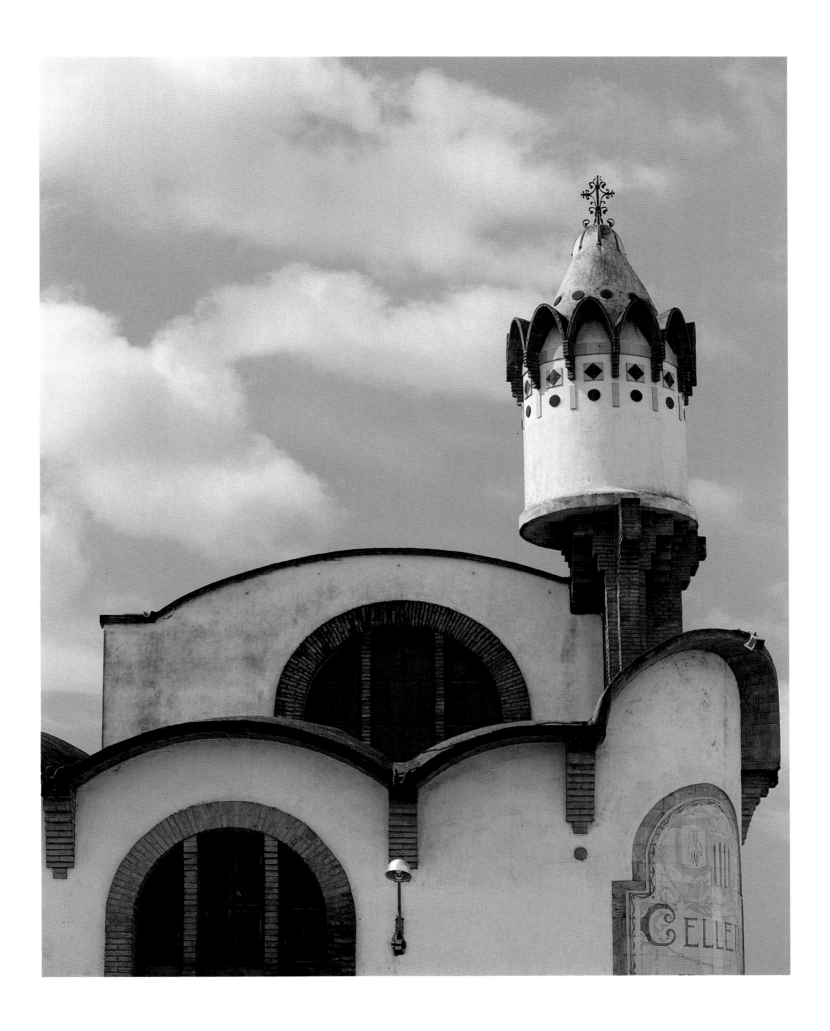

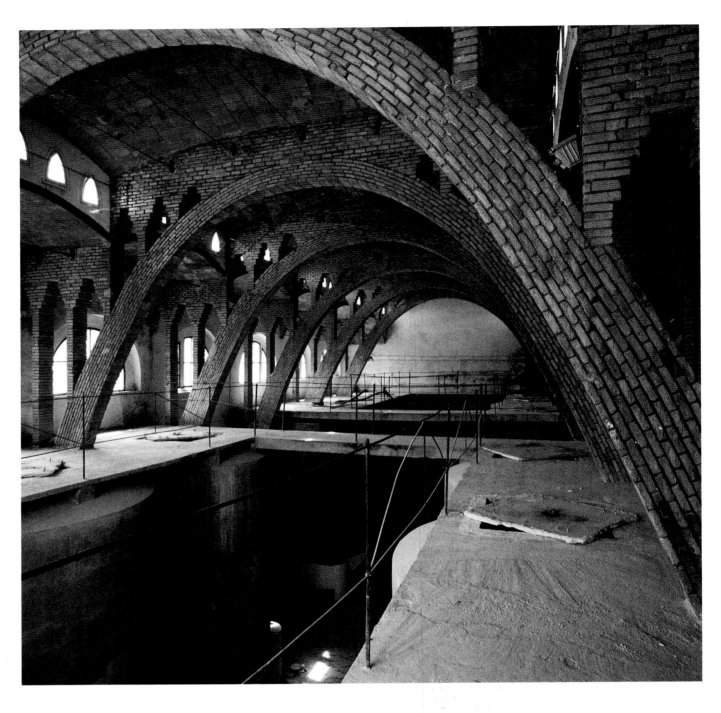

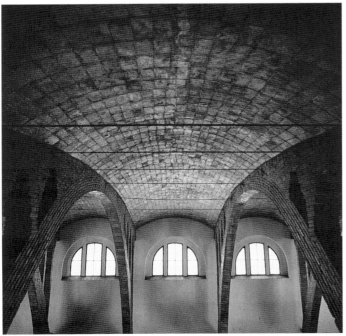

Cèsar Martinell i Brunet
Agricultural Syndicate Wine Cellar
Gandesa, 1919
Vat room

<small>Above and Facing Page Below:</small>
Interior views
<small>Left and Facing Page Above:</small>
Structural details

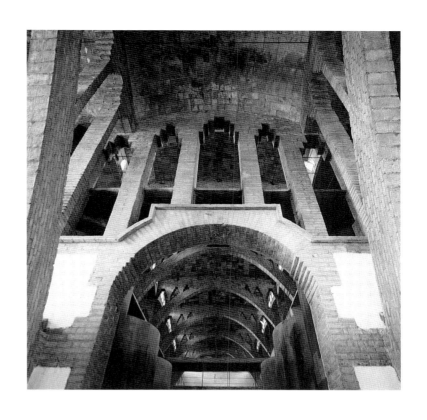

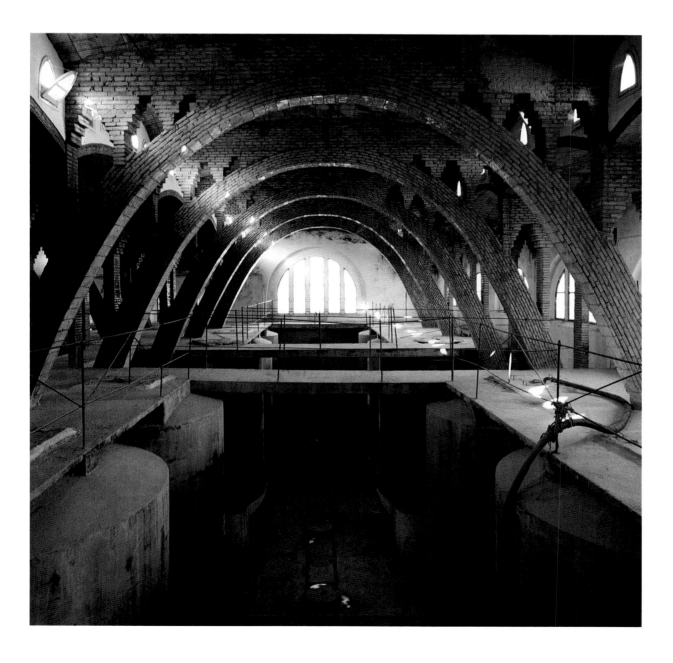

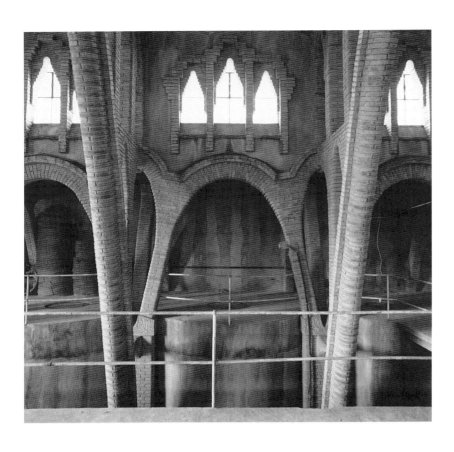

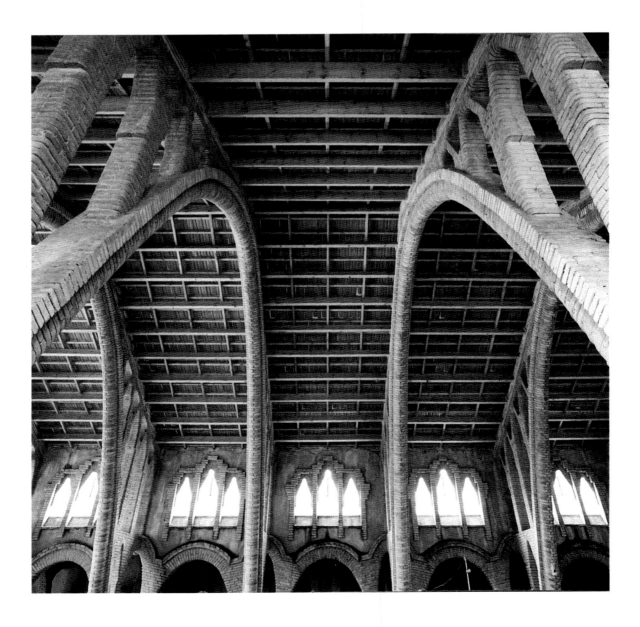

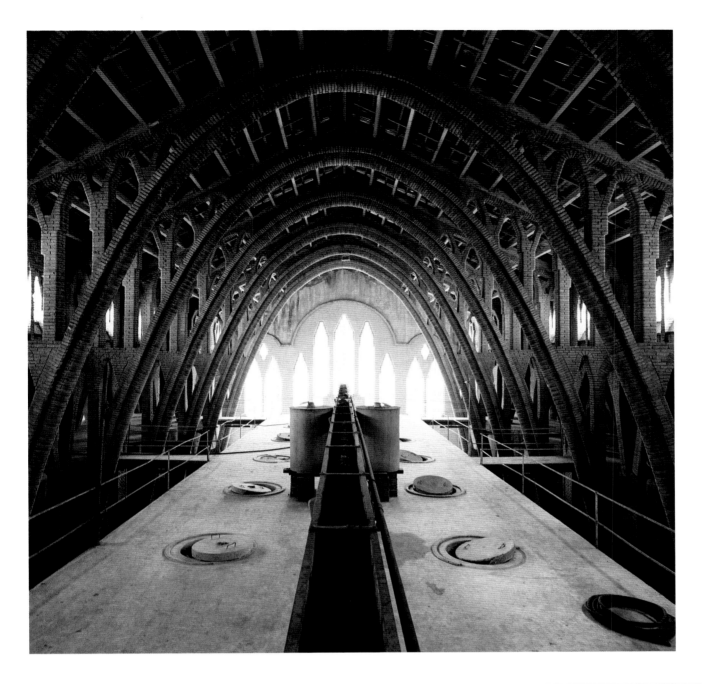

Cèsar Martinell i Brunet
Agricultural Syndicate Wine Cellar
El Pinell de Brai, 1917–1921
Vat room

Facing Page:
Structural details
Right and Above:
Interior views

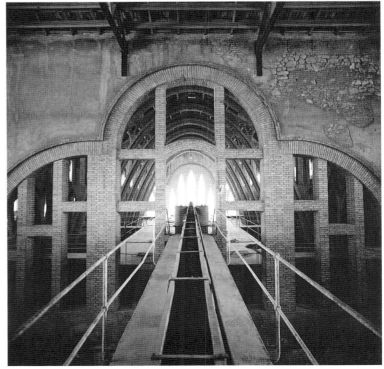

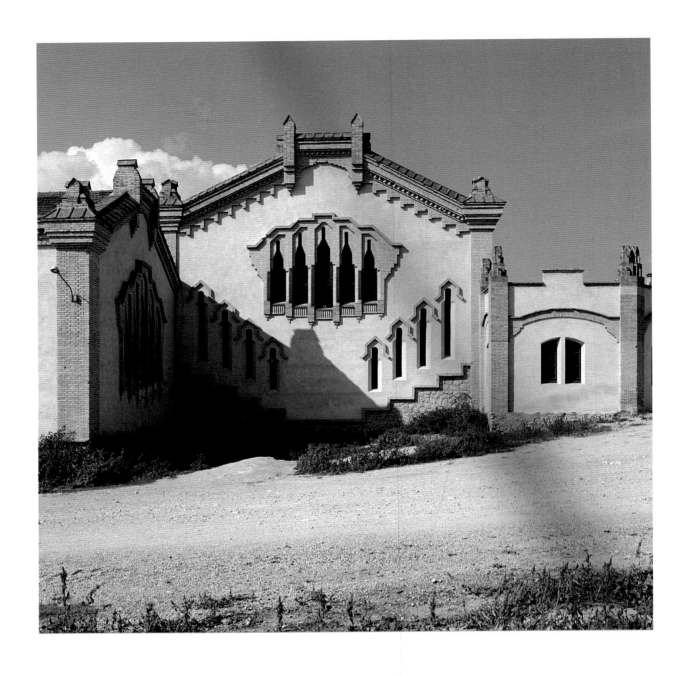

Cèsar Martinell i Brunet
Agricultural Syndicate Wine Cellar
El Pinell de Brai, 1917–1921

ABOVE AND FACING PAGE:
Side buildings
General view and detail
LEFT:
Main building
South-west façade

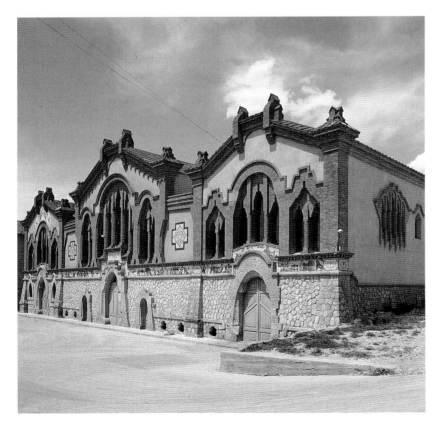

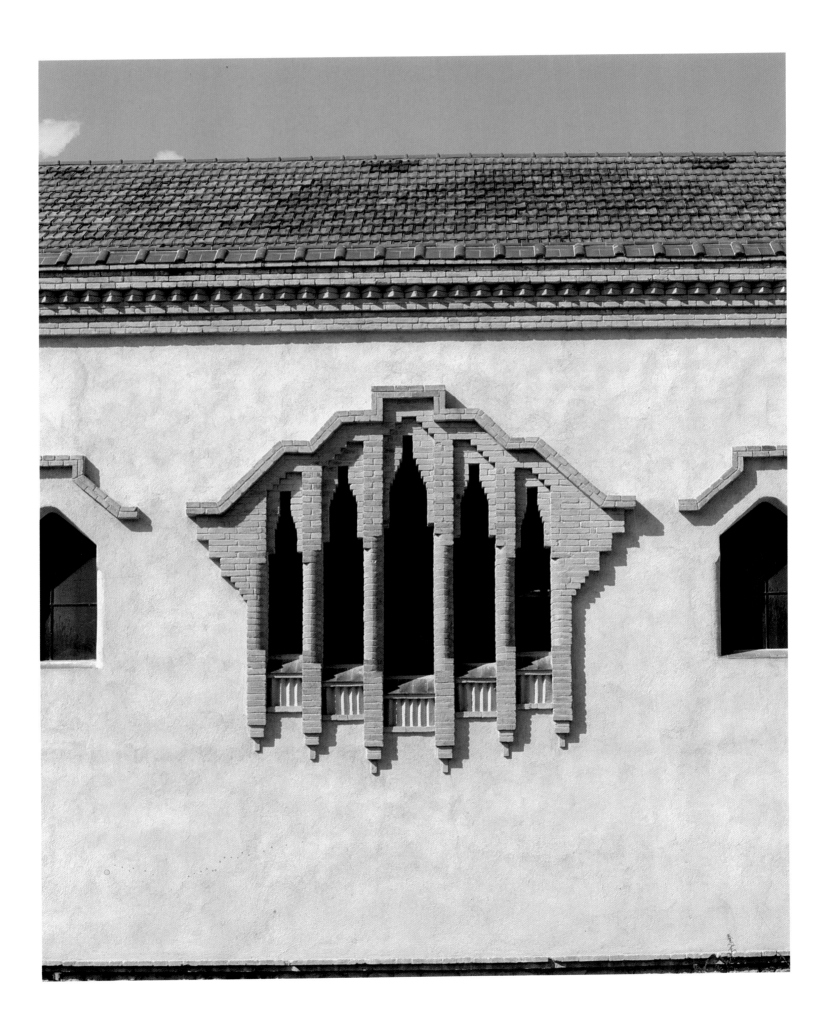

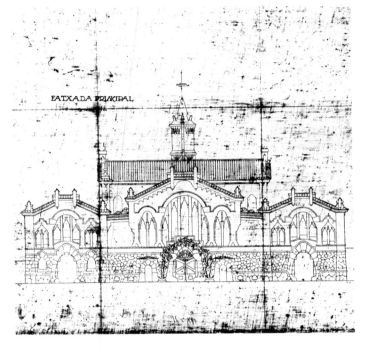

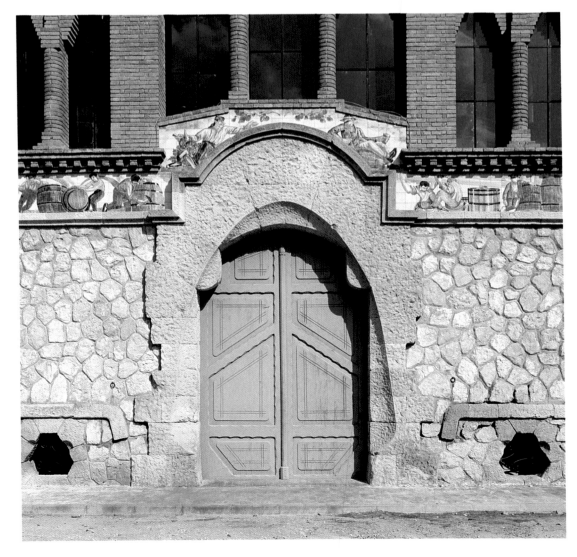

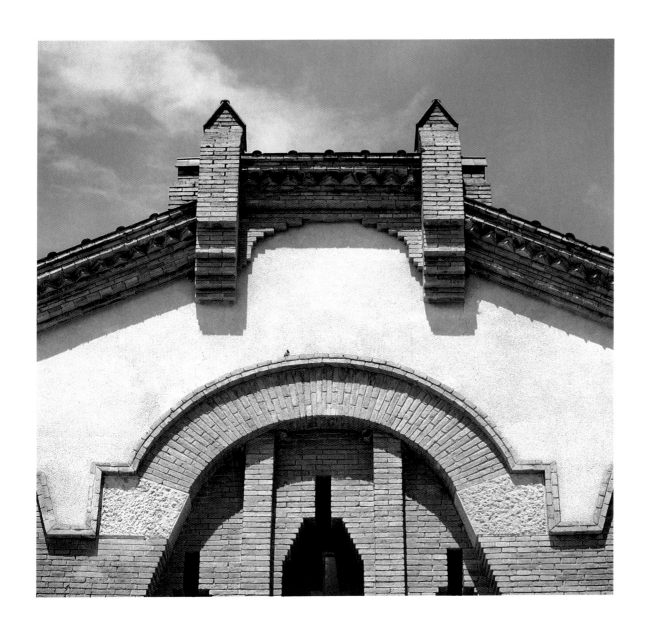

Cèsar Martinell i Brunet
Agricultural Syndicate Wine Cellar
El Pinell de Brai, 1917–1921
South-west façade

Right and Facing Page Above:
Window surrounds
Facing Page Centre:
Main façade, elevation
Facing Page Below:
Main entrance
Above:
Cornice detail

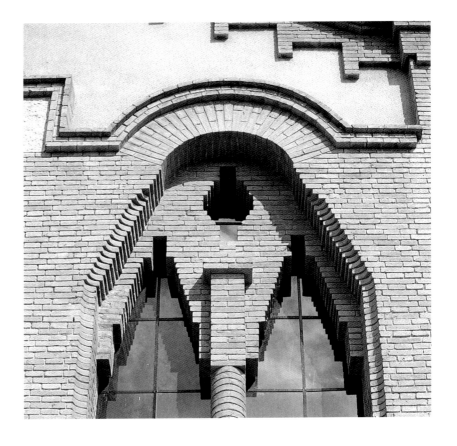

Facing Page, Above and Right:
Cèsar Martinell i Brunet
Agricultural Syndicate Wine Cellar
El Pinell de Brai, 1917–1921
Ceramic frieze on south-west façade
Scenes from a grape harvest from
sketches by Xavier Nogués

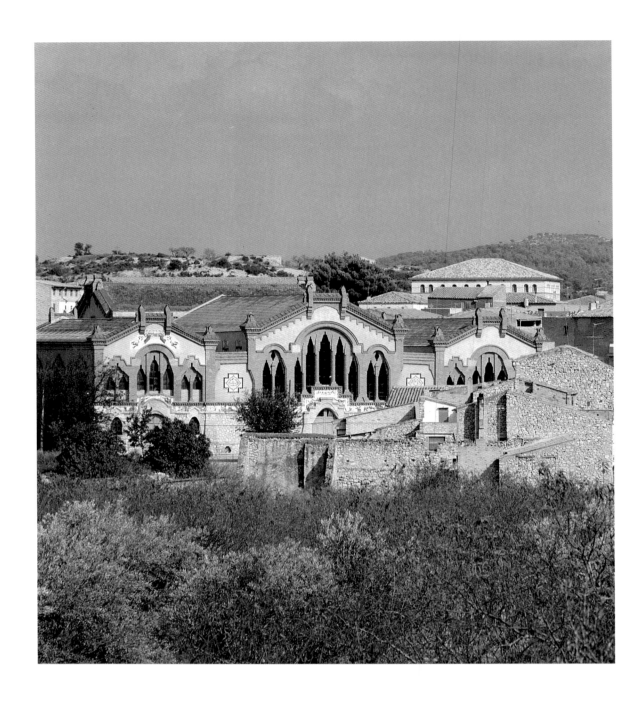

Cèsar Martinell i Brunet
Agricultural Syndicate Wine Cellar
El Pinell de Brai, 1917–1921

<small>ABOVE:</small>
View from the entrance to the village
<small>LEFT:</small>
Frieze on the south-west façade
Grape pickers from sketches
by Xavier Nogués

<small>FACING PAGE:</small>
El Pinell de Brai
Village and Cavalls hills

NOTES

BIBLIOGRAPHY

ILLUSTRATIONS

INDEX

Notes

Prelude

1. For many years Cerdà's plans for Barcelona were neglected by historians of urban development but were reinstated by Oriol Bohigas (*Barcelona entre el Pla Cerdà i el barraquisme*, Barcelona 1963), as Aldo Rossi points out in *L'architecture de la ville* (Paris 1981, pp. 194–195 and p. 276, note 7 – 1st edition, Padua 1966). The Catalan term *Eixample* (*Ensanche* in Spanish) refers to the area of urban development in the city after 1859, beyond the city walls, which were demolished in 1854.

2. Very recently the city of Barcelona, with the 1992 Olympic Games in sight, decided to enhance the "bourgeois" heritage of the modern part of the city by organizing (jointly with *El Modernisme*, the major exhibition held by the Museum of Modern Art, Barcelona 1990, the catalogue of which has been one of our principal sources) an exhibition of architecture and town planning devoted to *El Quadrat d'Or. Centre de la Barcelona modernista*. The catalogue, edited by Albert Garcia Espuche, draws on three major studies of the city: that by Albert Garcia Espuche himself, *Barcelona a principis del segle XVIII: la Ciutadella i els canvis de l'estructura urbana* (E.T.S.A.B., 1987), the work by Xavier Tafunell Sambola, *La construcción residencial en el crecimiento económico en Barcelona (1854–1897)* (Autonomous University of Barcelona, 1988) and by Txatxo Sabater, *Primera edad del Ensanche. Arquitectura doméstica* (E.T.S.A.B., 1989). The exhibition catalogue was also published in the form of a guide by the municipality (*El Quadrat d'Or, 150 casas en el centro de la Barcelona modernista*, Barcelona 1990). A great deal of our information on the architecture and town planning of Barcelona comes from these recent works, which have provided an update on the key study by Oriol Bohigas, *Arquitectura modernista*, published in 1968 in Barcelona and republished twice (in 1973 and 1983) in two volumes with additions under the title *Reseña y catálogo de l'arquitectura modernista*.

3. Joan Lluís Marfany, *Modernisme català i final de segle europeu. Algunes reflexions* in *El Modernisme*, op.cit., vol. 1, pp. 33–44 (quotation p. 42).

4. The publication in 1906 of the *Glosari* by Eugeni d'Ors signalled the birth of this modern neo-classical school, which was more international in character and a great deal more prescriptive. This work was followed by numerous articles by the same critic in *La Veu de Catalunya*, then, in 1911, by the publication of the *Almanac dels Noucentistes*, which gave an assessment of the trend, confirming its existence by the number of its exponents – painters, writers and architects. Among the architects the most significant figure remains Rafael Masó, who personifies the transition from Art Nouveau to *noucentisme*.

I
Art and Industry

1. See the well-researched article by Pilar Vélez, *De les relacions entre l'art i l'indústria, 1870–1910*, in the catalogue of the *El Modernisme* exhibition organized by the Barcelona Museu d'Art Modern in 1990 (Barcelona 1990, vol. 1, pp. 225–240).

2. For details of the misadventures of Deane and Woodward in Oxford see Renée Losier, *L'architecture et le fer en Grande-Bretagne au XIXe siècle* – thesis for the Ecole des Hautes Etudes en Sciences Sociales, Paris 1991. On the subject of the Crystal Palace and Horeau's projects, Françoise Boudon and I have discussed the impossibility of executing Horeau's plans in *Hector Horeau 1801–1872*, catalogue for the exhibition at the Musée des Arts Décoratifs de Paris (1979).

3. See Assumpció Feliu I Torras, *L'Architecte Juan Torras i Guardiola (1872–1910) et son œuvre*, MA thesis, Université de Haute-Bretagne, Rennes, 1986 (summarized in *Koiné* 1 (5), Madrid 1986, *Un siglo de conquistadores. Juan Torras i Guardiola (1827–1910), arquitecto catalán*, pp. 55–61).

4. A biography of Emile Müller was written by Hélène Guéné for *The Dictionary of Art*, London (1996). Our information is derived from her article.

5. The catalogue of the *El Modernisme* exhibition (op. cit.) has a large number of reproductions of decorative ceramics from the following companies: Pujol i Bausis in Esplugues de Llobregat and Cosme Toda in L'Hospitalet de Llobregat. These are taken from the designs of the most eminent architects and decorators in Catalonia (vol. 2, cat. nos. 29–52). It also shows, under the heading *paviment hidràulic*, floor tiles produced by the firm Casa Escofet,Tejera y Cía (nos. 241–242). The *Album-Catàlech* published by this company in 1900 shows a number of projects using small tiles (13 by 13 cm). A study of ceramics and mosaic (often classified under the same heading in Catalonia) has been made by Teresa Navas, *El mosaic hidràulic. Una art aplicada al segle XIX*, in *Butlletí Informatiu de Ceràmica*, no. 37, Barcelona, April–June 1988.

6. Just when it was thought that the ideal companion for existing structures had been found, because of the precision of size it offered and its qualities as a covering, the new metal framework arrived. The transposition attempted by Gaudí and Domènech, following examples at the 1878 Paris Exhibition, was bold but led to even more conclusive results.

2

FOLLOWERS OF VIOLLET-LE-DUC

1. This was the case with the Palau Samà, built in 1868 by Josep Oriol Mestres i Esplugas at the crossroads of the Passeig de Gràcia and the Gran Via. The elegance of the building stems from the exceptionally fine proportions of the Corinthian columns at the entrance porch; these were echoed in cast iron in the hallway and around the courtyard, treated as a small arcaded yard.

2. In 1868 Elies Rogent had used the softening effect of rotundas to replace the cant in the Evarist Arnus house on the Passeig de Gràcia; though these rotundas were simpler than those designed by Haussmann in Paris. Adopting the same idea, Rafael Guastavino used glazed bow windows on the small corner cants of the Dominga Juera del Vilar house, which dates from 1869–1870, also on the Passeig de Gràcia.

3. The Josep Munne building (Pau Martorell, 1869) and the Enric Losada building (Josep Rosés, 1870), situated opposite the Palau Samà on the Passeig de Gràcia already had a three-storey elevation, with, in the case of the second, an additional half-basement for servants and an attic at the top of the building. On less grand thoroughfares the buildings would accommodate a ground-floor shop at street level and four square storeys of equal size, a rather unprepossessing arrangement for which the Italian-style balustrade along the edge of the roof did little to compensate.

4. The Gibert house built in 1860 by Josep Oriol Mestres on the Plaça de Catalunya was neo-Gothic in style with Tudor elements. The Antoni Almendro house (Jeroni Granell i Barrera, 1871) and the F. Taltavull house (Josep Xiró Jordà, 1874) on the Carrer Pau Claris were in the Moorish style, while the Salvador Piera house (Emili Sala i Cortès, 1874) on the Carrer de Balmes was inspired by the French Renaissance. These early examples did away with the classical ordonnance common a decade earlier, for example, in the elegant "Xalets d'en Salamanca" designed by Elies Rogent in 1865.

5. Rosemarie Bletter, *El arquitecto Josep Vilaseca i Casanovas. Sus obras y dibujos. Un catálogo razonado*, Barcelona 1977.

6. A brief biography of Catalan architects by Raquel Lacuesta appears in the appendix of the catalogue of the *El Modernisme* exhibition held by the Barcelona Modern Art Museum, 1990, vol. 2, pp. 312–324. Sagnier's highly official career (Santi Barjau Rico, *Enric Sagnier i Villavecchia, 1858–1931*, University of Barcelona BA thesis, n.d.) also included the construction of some beautiful buildings at the turn of the century: the Casa Tomàs Roger on the carrer Ausiàs Marc (1892–1894), the Casa Isidra de Pedro on the Carrer Diputació (1895) and the Casa Juncadella on the Rambla de Catalunya (1899; no longer in existence, this won the prize for the best building in Barcelona in 1901). Domènech i Estapa is best known for the Catalana de Gas i Electricitat building, 1893–1895.

7. Assumpció Feliu i Torras, *La fondation de l'Ecole d'Architecture de Barcelone en 1875*, doctoral dissertation, Rennes, Université de Haute-Bretagne, 1987.

8. E. Rogent i Amat, *La Arquitectura catalana en la primera mitad del presente siglo*, Barcelona 1901. See P. Hereu, *Vers una arquitectura nacional. Teoria i Història d'arquitectura a les lliçons d'Elies Rogent*, University of Barcelona, doctoral thesis, 1980.

9. The first volume of the *Entretiens …* appeared in 1863. The second, delayed by the war of 1870, did not appear until 1872. During these ten years there was a considerable development in Viollet-le-Duc's way of thinking and his passion for modernism was confirmed.

10. Gaudí produced the final drawings of Martorell's design for the cathedral façade: his drawing was published in 1887 in *La Renaixença* (with a cartouche by Domènech) at the very time that work on the prize-winning design by Josep Oriol Mestres and August Font was getting under way. Gaudí had worked with Martorell before, in 1878, when, at the suggestion of Eusebi Güell, he had been commissioned to design the furniture for the funerary chapel of the Marqués de Comillas, which had been designed by Martorell.

11. In the background here we can clearly see the idea of a "Visigothic" culture on both sides of the Pyrenees, the symbol of which could be the mitred arch.

12. This chapel in Tarragona has been attributed to Gaudí but this is not certain. It was convincingly argued by Joan Bassegoda Nonell in *Los proyectos de Gaudí para las religiosas de Jesús y María (1877–1882)*, Barcelona n.d. (1969). Two chapels were built for this order: the first, in Sant Andreu de Palomar, was built from the plans of Joan Torras in 1881 and decorated by Gaudí; the attribution to Gaudí of the second, built in Tarragona 1878–1879, is based on the fact that the vicar-general of the bishopric at the time was Joan Baptista Grau i Vallespinós, who, like Gaudí, came from Reus and was his patron (some years later he commissioned him to design the bishop's palace in Astorga). It is also certain that Gaudí was familiar with the work of Boileau. He took direct inspiration from the "cathédrale synthétique" when drawing up the plans for the Sagrada Família, even regarding the dimensions of the building and combining the plan of Saint Peter's in Rome and the outline of Chartres. Also, during the early days of his career he showed a passionate interest in cast iron, but lost all interest in it later.

3

ART NOUVEAU

1. Francesc Fontbona, Francesc Miralles, *Del modernisme al noucentisme. 1888–1917*, in *Història de l'art català*, Barcelona 1985, vol. VII, pp. 13–160.

2. E.E. Viollet-le-Duc, *Entretiens sur l'architecture*, vol. 2, Paris 1872, XXᵉ Entretien, p. 397. Another passage, p. 369 (relating to the old domes in the lower streets of Geneva), is more openly regionalist, contrasting the tawdry nature of the residential architecture with the "healthy, practical and robust" nature of traditional peasant architecture.

3. As discussed with great lucidity by Jacques Gubler in the context of Switzerland (*Nationalisme et internationalisme dans l'architecture moderne de la Suisse*, Lausanne 1975).

4. As quoted by Assumpció Feliu i Torras, *La fondation de l'Ecole d'Architecture de Barcelone en 1875*, op. cit., p. 27.

5. The scheme displays strong similarities to the Guarantee Trust and Safe Deposit Company building in Philadelphia, built by Frank Furness 1873–1875 (and published in the *American Architect and Building News* of 22 September 1877; cf. James F. O'Gorman, *The Architecture of Frank Furness*, Philadelphia Museum

of Art exhibition catalogue, 1973, p. 91). Domènech would in turn influence Ferdinand Dutert's handsome paleontology gallery at the Paris Natural History Museum, 1894–1895.

6. Judith C. Rohrer, *Artistic Regionalism and Architectural Politics in Barcelona c. 1880–c. 1906*, doctoral thesis, Columbia University, 1984.

7. J. Puig i Cadafalch, *Regionalisme artistich*, in *La Veu de Catalunya*, 13 September 1891, p. 423; *Art català: la exposició d'arts decoratives* and *Del esperit regional en la decoració de las obras d'art industrial*, in *La Renaixensa*, 20 March 1892, p. 317, and 2 January 1893, p. 35.

8. M. McCully, *Els Quatre Gats. Art in Barcelona around 1900*, Princeton 1978. The catalogue of the *El Modernisme* exhibition (Barcelona 1990) also devotes considerable space to the subject (vol. 2, pp. 65–84).

9. The Palau de la Musica Catalana, built at the same time and on the same lines as the famous Salle Gaveau in Paris by J. Hermant, would have suffered from dreadful acoustics due to the reverberation of sound on the glazed side walls if the architect had not taken care to break this up by creating a screen of columns and arches in front of the wall. The article on the Salle Gaveau in *L'Architecte* (September 1909) also points out that the considerable overhang of the dress circle and the solution of a perforated apse containing the organ were particularly favourable to the acoustics. Despite the similarity of their design, there was a total contrast in the method of construction of the two concert halls. The Salle Gaveau was made of reinforced concrete whereas the Palau de la Musica was of iron and brick and the rich décor of the building designed by Domènech was in total contrast to the conventional austere classicism of Hermant's approach.

4
The Sant Pau Hospital

1. See, in particular, Robert Descharnes, Clovis Prévost, *La vision artistique et religieuse de Gaudí*, Lausanne 1969.

2. The Sant Pau Hospital, already amply illustrated in the work by Maria Lluïsa Borràs, *Domènech i Montaner. An Art Nouveau Architect*, New York 1971 (first edition Barcelona 1970), was also the subject of a detailed monograph by C. Bancells, *Sant Pau, Hospital modernista*, Barcelona 1988. The rediscovery of Domènech, like that of Puig, came very late. A special issue of the *Cuadernos de Arquitectura* (Barcelona, 2nd and 3rd quarters of 1963) first brought him attention but it was not until the exhibition by the Barcelona Savings Bank that an overall view of his work was presented (Lluís Domènech i Girbau, Lourdes Figueras i Burruli, *Lluís Domènech i Montaner i el director d'orquestra*, Barcelona 1989).

3. According to M.L. Borràs, op. cit., p. 60.

4. Seventeenth *Entretien*, pp. 283–290, vol. 2 and plate XXXIII of the atlas. Viollet-le-Duc's model goes back to classical antecedents such as La Malgrange near Nancy, and Stupinigi near Turin. The strongest influence, however, is a villa built by Hector Horeau in Primrose Hill, London, in 1855 (see F. Boudon and F. Loyer, *Hector Horeau 1801–1872*, Paris, supplement to the *Cahiers de la Recherche Architecturale*, no. 3, n.d., p. 61). The model defined by Horeau and studied by Anatole de Baudot in the columns of the *Gazette des Architectes et du Bâtiment* (1868–1869, pp. 233–234) inspired Viollet-le-Duc's

theoretical projects in the *Entretiens ...*, which were written at the same period. Apart from the Sant Pau Hospital it was little used, except for the Musée de Tournai, designed by Victor Horta in 1903 (but not completed until 1928).

5. Thirteenth *Entretien*, pp. 122–131, vol. 2 and plates XXIIa to XXIV of the atlas.

6. "Lord protect us, benefactors and residents of this Sacred House, on earth as in heaven and inspire in us feelings of charity towards it. Amen."

7. The system of vaulting designed by Casimir Tollet for the Paris hospitals was also applied at Bichat, Saint-Denis and even the hospital in Le Havre. The Tollet company, which specialized in the construction of pavilion-style hospitals, built a hospital in Madrid in 1894 which no doubt served Domènech as a model for the Barcelona hospital.

5
The Trilogy of Modernity

1. Sigfried Giedon, *Espace, temps, architecture*, French translation, Brussels 1968 (first edition, Harvard 1941), p. 518. The author also points out that "Le Corbusier was the first to bring Gaudí's genius to the attention of his contemporaries. He discovered him in 1928 during a trip to Madrid for the competition for the Palais de la Société des Nations. When the CIAM management committee held a meeting in Barcelona in 1932 – at a time when some of us were still under the influence of a purely rationalist conception of architecture – Le Corbusier was very insistent about Gaudí's artistic worth." Although this may seem a surprising statement from someone so modern it is nevertheless significant. It shows Gaudí in a different light from simply a late follower of the nineteenth-century rationalist neo-Gothic.

2. Josep Puig i Cadafalch, *L'Œuvre de Puig i Cadafalch, architecte, 1896–1904*, Barcelona 1904, p. 6.

3. Antoni Gaudí, *L'Exposició d'Arts Decoratives en l'Institut de Foment del Treball Nacional*, in *La Renaixensa*, Barcelona 1 and 2 February 1881, pp. 709–711 and 739–740. This, the architect's only publication, was rediscovered by Judith Rohrer in 1973. It is particularly interesting because it shows his critical view of contemporary work and helps us to understand the direction his own work would take.

4. As a draughtsman with Josep Fontsère's practice from 1873, Gaudí had taken part in the projects for the El Born market and the Parc de la Ciutadella. His passion for cast iron, that most plastic of materials (since it has no form other than that given it by the mould) reveals the sculptor in him. He would later abandon it completely in favour of other types of sculptural effect such as cement finishes or tile fragments. Even when using stone or brick he does so in such a way that the bonding blends into the sculptural unity of free forms, which was his real interest.

5. The exhibition of industrial arts held in Barcelona in 1880 was repeated four years later; in 1888 Domènech built the "Castell dels Tres Dragons" for the Universal Exhibition, which became a showcase for works in the decorative and applied arts. This movement would, in 1894, lead to the opening of the Centre d'Arts Decoratives and to the publication of the journal *El Arte Decorativo*. After this, exhibitions took place with increasing frequency until the early years of the twenti-

eth century. Barcelona's importance in the field of the decorative arts was also acknowledged by Pablo de Alzola y Minondo, who, in *El arte industriel en España* (Bilbao 1892), underlines the dynamism of the cultural institutions encouraged by the municipality.

6. Gaudí had been introduced to Ruskin's theories by his aesthetics teacher, Pau Milà i Fontanals. In the case of Wagner, the composer's work had been performed on numerous occasions in Barcelona since the first performance of *Lohengrin* at the Liceu theatre in 1882. Joan Brull and Josep Tamburini represented the symbolist movement in painting, although not of major significance in Barcelona. Count Güell was interested in William Morris (his own amateur paintings were inspired by him) and organized literary and musical evenings at the Güell mansion.

7. This work, which was published by Hachette in 1897, was reprinted several times up to the 1920s. Early in the century Marcel Proust translated *The Seven Lamps of Architecture* (published in 1849), *The Stones of Venice* (which dates from 1851–1853) and *The Bible of Amiens*, a somewhat later work only appearing in 1885 but whose influence on the continent was considerably greater than Ruskin's earlier writings. The astute interpretation of medieval symbolism in this work paved the way for Huysmans's novel.

8. In my analysis of the Güell chapel (*La Chapelle Güell, laboratoire d'un nouveau langage plastique*, in *L'Oeil*, no. 198, June 1971, pp. 14–21) I owe a great deal to the views on Gaudí's work of Jørn Utzon and his colleague Mogens Prip-Buus. They helped me to understand both the plastic richness of the building – a quality which had already been highlighted by James Johnson Sweeney and Josep Lluís Sert in their work *Antoni Gaudí* (London 1960) and its metaphysical dimension.

9. This synthesis of the history of architecture, a theme taken from Louis-Auguste Boileau, is excellently handled by Domènech Sugranyes in his study of the Church of the Sagrada Família, *Disposició estatica del Temple de la Sagrada Família* (in *Associació d'Arquitectes de Catalunya*, Anuario [Yearbook], Barcelona 1923, p. 20), which simultaneously refers to the early Christian style of Saint-Paul-hors-les-Murs, the Romanesque style of Saint-Sernin in Toulouse and the Gothic style of Cologne Cathedral.

10. The expression is borrowed from the catalogue of the Josep Maria Jujol exhibition held in 1990 at the Pompidou Centre, Paris. The very strangeness of the phrase reveals the change in our attitude towards turn-of-the-century art. We now look beyond the stereotypical appreciation of "floral art" and recognize the true complexity of the period.

6
Catalonia rediscovered

1. The subject has been studied in France by Jean-Claude Vigato, *Le régionalisme dans le débat architectural en France, de 1900 à 1945*, doctoral thesis, Université de Bretagne Occidentale, Brest, 1990. This examination and analysis of the literature of architecture during the first half of the twentieth century should be extended to include other European countries. This would lead to the discovery of a convergence of positions transcending linguistic and cultural barriers in the ways clearly outlined by Jean-Claude Vigato, who established the links between architecture and politics during this period and then showed their fragility.

2. Lluís Domènech i Montaner, *En busca de una arquitectura nacional*, in *La Renaixença*, Barcelona 1878, pp. 149–160. The articles on regionalism by Puig i Cadafalch that appeared between 1891 and 1893 have already been mentioned above (note 7, chapter 3).

3. E.E. Viollet-le-Duc, *Entretiens sur l'architecture ...*, op. cit., 19th Entretien, p. 356.

4. Our sources in this analysis were David Watkin, *Morality and Architecture: the Development of a Theme in Architectural History and Theory from the Gothic Revival to the Modern Movement*, Oxford 1977, and to Anthony Vidler, *Robinson Crusoe et cetera*, in *Il progetto domestico*, catalogue of the seventeenth Milan Triennale, Milan 1986, pp. 80–87.

5. This return to the vernacular had been Philip Webb's major innovation with William Morris's the Red House at Bexley Heath, Kent in 1859. Norman Shaw went on to develop this trend for Bedford Park near London with his creation of the Queen Anne style, which, overcoming the historical contrast of styles, was a synthesis of the domestic tradition of English architecture (Mark Girouard, *Sweetness and Light. The "Queen Anne" Movement 1860–1900*, Oxford 1977).

6. I hope we may be forgiven for using the language of a historical school and adapting it, or even misusing it, for our own ends. This should not however prevent us from noticing the extent to which history has changed in outlook since the beginning of the twentieth century. It had previously concerned itself primarily with the passing of time through the enumeration of factual data (no doubt to justify the distance perceived between past and present, which could thus be seen in contrast), but for more than half a century now contemporary history has focused on permanent qualities, whether ways of life, mainly studied through anthropology, or the cultural structures of civilization, as understood by F. Braudel. This phenomenon is even more pronounced in the case of art historians as it goes hand in hand with philosophical and aesthetic discourses emphasizing the stability of plastic values through history, from prehistory to the present day and explaining how they provide the foundation for a certain formal abstraction. Eugeni d'Ors in Catalonia and Heinrich Wöllflin in Vienna produced interpretations of the baroque aesthetic which, due to their systematic nature, tended to become ahistorical, supporting a cyclical theory that cocked a snook at historical events. Did the twentieth century as a whole in fact become ahistorical, even from the point of view of historians?

7. This is where modern regionalism differs from its model; in the "ruralist historicism" practised in England from the 1860s by artists from the Arts and Crafts Movement both Philip Webb and Norman Shaw remained faithful to their historical sources. The first architect to emancipate himself from historicist imitation (even when free from all convention) was Charles A. Voysey, during the last decade of the nineteenth century. It is without doubt to his influence (and to that of the "Garden Cities" architects) that we owe the development around 1900 of a movement that implicitly condemned authentic historicism and insisted that architects should adapt their historical quotation to the style of their own period. The results of this can be seen (mixed together with the Austrian Secessionist style) in the Casa Masmaron built by Rafael Masó in Olot in 1913, a fine example of the international regionalist style.

7
The Apotheosis of Rationalism

1. J. Martorell i Terrats, *La arquitectura moderna. I. La estética. II. Las obras*, in *Catalunya*, no. 13, September 1903. This article, which gives an account of the trends in the new architecture, provides a list of titles referred to, which gives a good idea of the extent to which the artistic circles of Catalonia were familiar with movements abroad.

2. Manuel de Torres, *El planejament urbà i la crisi de 1917*, Barcelona 1987. Another remarkable article worth consulting, written by Ignasi de Solà-Morales, is *Ciudad ordenada y monumental ... La arquitectura de Josep Puig i Cadafalch en la época de la Mancomunidad*, in the catalogue for the exhibition *Josep Puig i Cadafalch. La arquitectura entre la casa y la ciudad*, Barcelona 1989, pp. 36–65.

3. These were the Casarramona building, 1921–1923, and the Rosa-Alemany building, 1928–1929.

4. The building, not constructed until 1927, used plans drawn up by Josep Goday, an associate at Jaume Torres i Grau.

5. This period has been studied by I. de Solà-Morales in *Sobre Noucentisme y arquitectura. otas para una historia de la arquitectura moderna en Cataluña (1909–1917)*, in *Eclecticismo y vanguardia*, Barcelona 1980, pp. 72–89, and by J.M. Rovira, *La arquitectura catalana de la Modernidad*, Barcelona 1987.

6. Cèsar Martinell's work, *Gaudí, su vida, su teoría, su obra*, which was published in Barcelona by the Colegio Oficial de Arquitectos de Cataluña y Baleares in 1967, had already been published in Milan by Electa in 1955. After 1929 Martinell, who was awarded his architect's diploma in 1916, went on to work in the area of art history. He specialized in the baroque and in the work of Gaudí. The numerous documents he was able to consult before they were destroyed during the Spanish Civil War make his work on Gaudí particularly valuable.

7. This inspired term, coined by Antoine Grumbach as the title to an article that appeared in *Architecture, Mouvement, Continuité* (no. 37, Paris 1975, pp. 47–48), relates to the two terraced buildings (1912 and 1924) in the rue Vavin, Paris, by Henri Sauvage. The first was the famous "stepped house" in reinforced concrete that became famous as a declaration of modern architecture; the second, built in ashlar and with metal floors, was conventional, presumably for reasons of context and clientèle. Nevertheless this was the first time that a critic drew attention to the chronological and aesthetic contradictions in the work of a modern architect. His analysis ought to have been extended to include other figures and, in particular, the multi-faceted figure of Josep Puig. But we also wanted to show that there was a much broader, international phenomenon at work here and that this was not the "betrayal" it had so long been claimed to be. Quite the contrary, it was a demonstration of the contradictory aspects of architectural practice in the modern world.

Bibliography

Exhibition Catalogues

Pionniers du XXe siècle 2. Gaudí. Musée des Arts Décoratifs, Paris 1971.

Ildefonso Cerdá. Colegio Nacional de Ingenieros de Caminos. Canales y Puertos, Barcelona 1976.

Arquitectura industrial a Catalunya, 1732–1929. Caixa de Barcelona, Barcelona 1984.

Antoni Gaudí 1852–1926. Caixa de Pensions, Barcelona 1985.

Inicis de la Urbanística Municipal de Barcelona. Ajuntament de Barcelona, Barcelona 1985.

L'Arquitectura en la història de Catalunya. Caixa de Catalunya, Barcelona 1987.

Elies Rogent i la Universitat der Barcelona. Generalitat de Catalunya et Universitat de Barcelona. Barcelona 1988.

Joseph Maria Jujol. Col·legi d'Arquitectes de Catalunya, Barcelona 1988–1989.

Josep Puig i Cadafalch, la arquitectura entre la casa y la ciudad (Architecture between the House and the City). Fundació Caixa de Pensions, Barcelona 1989.

Lluís Domènech i Montaner i el Director d'orquestra. Fundació Caixa de Barcelona, Barcelona 1989–1990.

El Quadrat d'Or, 150 casas en el centro de la Barcelona modernista, exposition organisée dans le cadre de l'Olimpíada Cultural Barcelona '92. Ajuntament de Barcelona, Barcelona 1990.

El Modernismo, exposition organisée dans le cadre de l'Olimpíada Cultura Barcelona '92. Museu d'Art Modern, Barcelona 1990-1991.

Studies

Bancells Consol, *Sant Pau. Hospital modernista.* Edicions de Nou Art Thor, Barcelona 1988.

Barey André, *Barcelona: de la ciutat pre-industrial al fenomen modernista.* Editorial La Gaya Ciència, Barcelona 1980.

Bassegoda Bonaventura, *El arquitecto Elies Rogent.* Asociación de Arquitectos de Cataluña, Barcelona 1929.

Bassegoda i Nonell Joan, *Puig i Cadafalch.* Edicions de Nou Art Thor, Barcelona 1985.

Bassegoda i Nonell Joan, *Domènech i Montaner.* Edicions de Nou Art Thor, Barcelona 1986.

Bassegoda i Nonell Joan, *Gaudí.* Edicions de Nou Art Thor, Barcelona 1986.

Bassegoda i Nonell Joan, *Modernisme a Catalunya.* Edicions de Nou Art Thor, Barcelona 1988.

Bassegoda i Nonell Joan, *La Pedrera de Gaudí.* Fundació Caixa de Catalunya, Barcelona 1989.

Bassegoda i Nonell Joan, *Jujol.* Edicions de Nou Art Thor, Barcelona 1990.

Bergós Joan, *Gaudí, l'home i l'obra.* Editorial Ariel, Barcelona 1954.

Bletter Rosemarie, *El arquitecto Josep Vilaseca i Casanovas, sus obras y dibujos.* Editorial la Gaya Ciència, Barcelona 1977.

Bohigas Oriol, *Arquitectura modernista.* Editorial Lumen, Barcelona 1968.

Bohigas Oriol (coll. A. González and R. Lacuesta), *Reseña y Catalogo de la arquitectura modernista* (revised version with additions of *Arquitectura modernista*), 2 vols. Editorial Lumen, Barcelona 1983 (1973).

Bohigas Oriol, *Lluís Domènech i Montaner.* Edicions Lluís Carulla i Canals, Barcelona 1973.

Bonet i Garí Lluís, *Les Masies del Maresme.* Editorial Montblanc – Martín, Barcelona 1983.

Borràs Maria Luisa, *Lluís Domènech i Montaner.* Edicions La Poligrafa, Barcelona 1970.

Cabana i Vancells Francesc, Feliu i Torras Assumpció, *Can Torras dels ferros, 1876–1985. Siderúrgia i construccions metàl·liques a Catalunya.* Tallers Gràfics Hostench, Barcelona 1987.

Casanelles Eusebi, *Nueva visión de Gaudí.* Edicions La Poligrafa, Barcelona 1965.

Cirici Pellicer Alexandre, *El arte modernista catalán.* Editorial Aymà, Barcelona 1951.

Cirici Pellicer Alexandre, *1900 en Barcelona. Modernismo. Modern Style. Art Nouveau. Jugendstil.* Edicions La Poligrafa, Barcelona 1967.

Collins George R., *Antonio Gaudí,* collection Masters of World Architecture. George Braziller Publisher, New York 1960 (Spanish edition, Editorial Brughera, Barcelona 1961).

Collin George R., Bassegoda i Nonell Joan, *The Designs and Drawings of Antonio Gaudí.* Princeton University Press, Princeton. New Jersey 1983.

Cuspinera Lluís, *Manifestacions de l'Art Modernista a La Garriga,* 1900–1912, 2 vol. Editorial Rourich, Sant Cugat del Vallès 1988.

Descharnes Robert, Prévost Clovis, *La vision artistique et religieuse de Gaudí.* Edita, Lausanne 1969.

Duran i Farell Pere, Rosell i Colomina Jaume, *La Exposición de 1888 y la Barcelona de fin de siglo.* Off-print of the journal *Barcelona, Metròpolis mediterrània,* Ajuntament de Barcelona, Barcelona 1988.

Flores Carlos, *Gaudí, Jujol y el Modernismo catalán,* 2 vols. Ediciones Aguilar, Madrid 1982.

Fontbona Francesc, *La crisi del modernisme artistic.* Curial Edicions Catalanes, Barcelona 1975.

Fontbona Francesc, Miralles Francesc, *Del Modernisme al Noucentisme, 1888–1917,* História de l'Art Catalá, vol. VII. Edicions 62, Barcelona 1985.

FREIXA Mireia, *El Modernismo en España*. Ediciones Cátedra, Madrid 1986.

GÜELL Xavier, *Antoni Gaudí*. Editorial Gustavo Gili, Barcelona 1986.

HERNÀNDEZ-CROS Josep Emili, MORETÓ I NAVARRO Bel (and collaborators), *Catàleg del Patrimoni Arquitectònic Històrico-Artistic de la ciutat de Barcelona. Ajuntament de Barcelona*, Barcelona 1987.

INFIESTA José Maria, *Modernismo en Cataluña*. Edicions de Nou Art Thor, Barcelona 1976.

JARDÍ Enric, *Puig i Cadafalch, arquitecte, polític i historiador de l'art*. Editorial Ariel, Barcelona 1975.

LE CORBUSIER, *Gaudí*. Editorial RM, Barcelone 1958.

LLINÀS José, *Jujol*. Benedikt Taschen Verlag, Cologne 1994.

LOZOYA Antoni, FOCHS Pere, *Central Vilanova*. Ediciones de la Hidroeléctrica de Cataluña, Barcelona 1987.

MACKAY David, *L'Arquitectura modernista a Barcelona*, 1854–1939. Edicions 62, Barcelona 1989.

MARTINELL Cèsar, *Gaudí, su vida, su teoria, su obra*. Colegio Oficial de Arquitectos de Cataluña y Baleares, Barcelona 1967.

MARTINELL Cèsar, *Conversaciones con Gaudí*. Ediciones Punto Fijo, Barcelona 1969.

MARTINELL Cèsar, *Construcciones agrarias en Cataluña*. Colegio Oficial de Arquitectos de Cataluña y Baleares, Barcelona 1975.

MASINI Lara V., *Antoni Gaudí*, collection I Maestri del Novecento. Sadea Sansoni editori, Florence 1969.

McCULLY M., *Els Quatre Gats. Art in Barcelone around 1900*. Princeton University Press, Princeton 1978.

MENDOZA Cristina y Eduardo. *Barcelona modernista*. Editorial Planeta, Barcelona 1989.

MONTANER Josep Maria, *Barcelona. City and architecture*. Benedikt Taschen Verlag, Cologne 1997.

PUIG I CADAFALCH Josep, *L'œuvre de Puig Cadafalch architecte*, 1896–1904. Edicions Parera, Barcelona 1904.

RÀFOLS J. F., *El arte modernista en Barcelona*. Libreria Dalmau, Barcelona 1943.

RÀFOLS J. F., *Modernismo y modernistas*. Ediciones Destino, Barcelona 1949 (Catalan edition: Modernisme i modernistes, 1982).

RODENT PEDROSA F., *Arquitectura moderna de Barcelona*, Edicions Parera, Barcelona 1897.

SÀBAT Antoni, *Palau de la Música catalana*. Editorial Escudo de Oro, Barcelona 1974.

SERT Josep Lluís, *La cripta de la capilla de la Colonia Güell*, Edicions La Poligrafa, Barcelona 1972.

SOLÀ-MORALES Ignasi de, *Joan Rubió i Bellver y la fortuna del gaudinismo*. Editorial La Gaya Ciència, Barcelona 1975.

SOLÀ-MORALES Ignasi de, *Eclecticismo y vanguardia. El caso de la arquitectura moderna en Catalunya*. Editorial Gustavo Gili, Barcelona 1980.

SOLÀ-MORALES Ignasi de, *Gaudí*. Edicions La Poligrafa, Barcelona 1983.

SOLÀ-MORALES Ignasi de, *Jujol*. Edicions La Poligrafa, Barcelona 1990.

SWEENEY James Johnson, SERT Josep Lluís, *Antoni Gaudí*. The Architectural Press, London 1960.

TARRÚS Joan, *Rafael Masó*. Colegio Oficial de Arquitectos de Cataluña y Baleares, Barcelona 1971.

TORII Tokutushi, *El mundo enigmático de Gaudí*. Instituto de España, Madrid 1983.

VILA-GRAU Joan, RODON Francesc, *Els vitrallers de la Barcelona modernista*. Edicions La Poligrafa, Barcelona 1982.

ZERBST Rainer, *Antoni Gaudí*. Benedikt Taschen Verlag, Cologne 1988.

Guides

BANCELLS Consol, *Guia del Modernismo a l'Eixample*. Ajuntament de Barcelona and Edicions de Nou Art Thor, Barcelona 1990.

HERNÀNDEZ-CROS J. E., MORA G., POUPLANA X., *Guia de Arquitectura de Barcelona*. Col·legi Oficial d'Arquitectes de Catalunya and Ajuntament de Barcelona, Barcelona 1985.

LACUESTA Raquel, GONZÁLES Antoni, *Arquitectura modernista en Cataluña*. Editorial Gustavo Gili, Barcelona 1990.

PLADEVALL I FONT Antoni, PAGÈS I PARETAS Montserrat, *Voici la Catalogne, guide du patrimoine architectural*. Generalitat de Catalanya, Barcelona 1988.

Rutas del Modernismo. Generalitat de Catalunya, Barcelona 1988.

TARRÚS Joan, COMADIRA NARDÍS, Guia de *l'Arquitectura dels segles XIX i XX a la provincia de Girona*. Editorial La Gaya Ciència, Girona 1977.

ILLUSTRATIONS

© Unless otherwise indicated all views are from original photographs by Michel Saudan.

Index

Unless otherwise indicated all buildings are located in Barcelona.

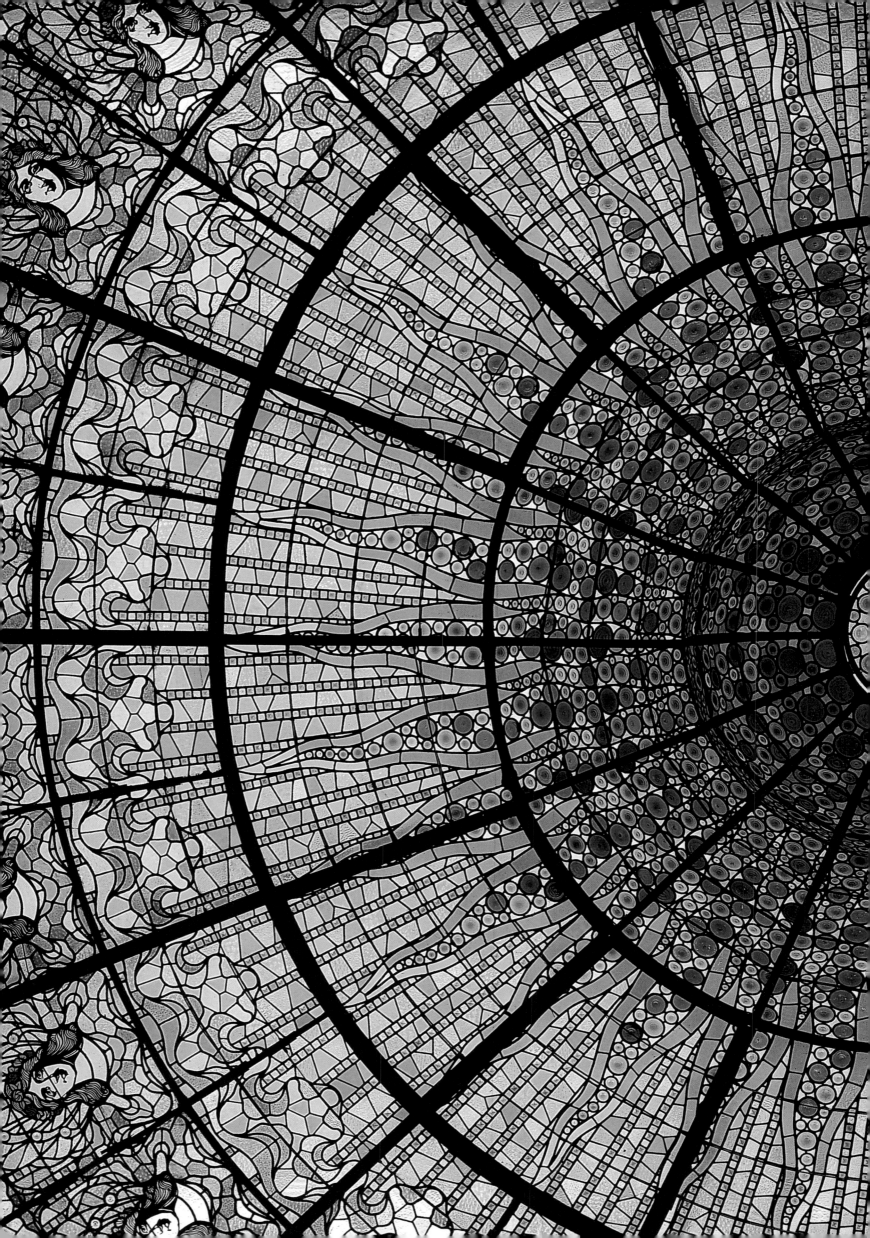